THE INDIE GAME DEVELOPMENT SURVIVAL GUIDE

THE INDIE GAME DEVELOPMENT SURVIVAL GUIDE

DAVID MICHAEL

CHARLES RIVER MEDIA

Boston, Massachusetts

Production: Paw Print Media
Cover Design: Tyler Creative
Cover Image: Don Michael, Jr.

CHARLES RIVER MEDIA
25 Thomson Place
Boston, Massachusetts 02210
617-757-7900
617-757-7969 (FAX)
crm.info@thomson.com
www.charlesriver.com

This book is printed on acid-free paper.

David Michael. *The Indie Game Development Survival Guide.*
ISBN: 1-58450-214-2
ISBN-13: 978-1-58450-214-2

All brand names and product names mentioned in this book are trademarks or service marks of their respective companies. Any omission or misuse (of any kind) of service marks or trademarks should not be regarded as intent to infringe on the property of others. The publisher recognizes and respects all marks used by companies, manufacturers, and developers as a means to distinguish their products.

Library of Congress Cataloging-in-Publication Data

Michael, David (David R.), 1968-
 The indie game development survival guide / David Michael.—1st ed.
 p. cm.
 ISBN 1-58450-214-2 (Paperback : alk. paper)
 1. Computer games—Dsign. 2. Computer games–Programming. I. Title.
 QA76.76.C672M53 2003
 794.8'15—dc21
 2003013158

Printed in the United States of America
07 7 6 5 4 3 2

CHARLES RIVER MEDIA titles are available for site license or bulk purchase by institutions, user groups, corporations, etc. For additional information, please contact the Special Sales Department at 800-347-7707.

To Susan, Davis, and Serene—the best part of being a
work-at-home indie is that you're here, too.

CONTENTS

ACKNOWLEDGMENTS

There are quite a few people I would like to thank for their help in writing this book. First off, to Tamera Shaw-McGuire: thanks for listening, encouraging, and proofreading—and just being a really good friend. I would also like to thank Dan MacDonald for being incredibly enthusiastic and just an all-around nice guy who will agree to proofreading and opining on a moment's notice.

For their help in proofreading the manuscript, I would like to thank Dave Astle, Thomas Buscaglia, James Hills, Justin Mette, and Steve Pavlina. In addition, I would be remiss if I didn't thank Jenifer Niles of Charles River Media, and the anonymous reviewer assigned to the manuscript (you know who you are). You all helped immeasurably with your detailed feedback, suggestions, and examples.

I would also like to thank Matt Moyer for helping me with the Web page questionnaire for the Indie Game Developer Survey.

Many thanks to Don Michael, Jr., the best oldest brother I've ever had, for being able to interpret my semi-literate ramblings about art and come up with the perfect cover art.

And, finally, I must thank Susan. Thank you for believing in me and for always being there when I need you. I couldn't have done this—or much of anything really—without you.

INTRODUCTION

Welcome to *The Indie Game Development Survival Guide*! Whether you are a programmer, an artist, or a sound engineer, this book will enable you to lead an independent game project. You can take your unique and innovative game idea through design, planning, scheduling, development, and testing—all the way to publishing it yourself.

IF YOU CAN MAKE A DEMO, YOU CAN MAKE A GAME

Common wisdom states that if you want to get into the game development industry, you should create a demo. The point of the demo is to show off your skills in programming, art, music, or design. You then send this demo to the companies you want to work for and hope it impresses them enough to offer you a job. Your mileage may vary, of course.

The premise of *The Indie Game Development Survival Guide*, however, is that if you can create a demo, you can create a full game—and you can publish it yourself on the Internet! Why go to work creating someone else's game when you can make your own? With the skills and talents you already have, plus a bit of organization, time management, and maybe a little help from your friends, you can design, develop, and publish the game you've always dreamed of.

AUDIENCE

This book is for anyone who has a great idea for a computer game and wants to see that idea made real. This book is for the small teams of dedicated individuals with limited time and even less funding—but who have an idea they're passionate about.

Whether you are already part of the computer game industry, want to join the industry, or simply want to create a game, this book will lead you through the steps for producing a game as an independent game developer, or *indie*.

What is an independent game developer? The simplest definition is: a game developer is an individual or a company who provides their own funding. That is, they don't receive money from a game publisher to create their game.

The spectrum of independents runs from such industry powerhouses as Id Software and Lionhead Studios to the lone guy in a garage, working on his first title in his spare time.

As all game industry professionals can attest, there are many more game ideas bouncing around in a single publisher or development shop than could ever be created. On top of that, "Game Designer" is easily the most coveted title in the industry. So even if you work for a game development company, it's unlikely that you will ever get the opportunity to start from scratch with your own ideas of what makes a good game, and create that game completely self-guided.

If you dream of making and selling games—*your games*—then this book will help you realize that dream. Whether your background is in coding, scripting, designing, pixel pushing, modeling, skinning, sound effects, composing, or even something completely unrelated to the game development industry—if you are dedicated to seeing your game through to completion, *The Indie Game Development Survival Guide* will help you get from here to there. Do you want to pursue independent game development full time, or even just as a hobby? This book will help you get started—and get finished!

Even if you already consider yourself an independent game developer, this book can help you learn how others have solved game design and preproduction problems, found teams, marketed and promoted their titles, and more. Maybe you didn't realize how many indies there are out there. If so, this book shows you that you're part of a growing community. Just because you're an indie, doesn't mean you have to be alone!

WHAT YOU WILL FIND IN THIS BOOK

The Indie Game Development Survival Guide brings together everything you need to know about designing, building, and selling independent games. This book provides the answers to questions you'll face:

- What is an indie? (Chapter 1)
- Why should I be an indie? (Chapter 2)
- What does it take to be an independent game developer? (Chapter 3)
- Should I form a company? (Chapter 4)
- What types of games are suitable for an indie game project? (Chapters 5 and 6)
- How do I create a game design document? (Chapter 7)
- How do I turn my game design into a series of project milestones? (Chapter 8)
- What is *risk management*? (Chapter 9)
- What are some ways I can find funding for my game? (Chapter 10)

- What kind of team should I have for my project? (Chapter 11)
- How do I handle profit sharing with my team members? (Chapter 12)
- How do find people to help me make my game? (Chapter 13)
- How do I manage my team? (Chapters 14 and 15)
- How do I turn my project production plan into the finished game? (Chapter 16)
- Are there libraries and components available to help build my game? (Chapter 17)
- How should art and sound resources be managed? (Chapter 18)
- What kind of documentation is needed? (Chapter 19)
- How do I find testers for my game? (Chapter 20)
- How do you know when the game is finished? (Chapter 21)
- How do I sell my game? (Chapter 22)
- What kind of price should I choose for my game? (Chapter 23)
- What is a marketing plan, and how do I use one? (Chapter 24)
- How do I handle payments from players? (Chapter 25)
- How do I handle customer support? (Chapter 26)
- What will the future bring? (Chapters 27 and 28)

The answers to these questions, and many more, can be found in the pages that follow. As much as possible, I have tried to give direct advice, drawing from my own experience as an independent game developer as well as from the experience of other successful developers. When several options seem equally valid, all of them are presented with both their advantages and disadvantages so that you can choose the best option for you.

WHAT YOU *WON'T* FIND IN THIS BOOK

While this book strives to provide the most useful and detailed information possible about how to be a successful developer, when it comes to certain development topics, the book takes a high-level approach. Thus, there are no instructions for initializing DirectDraw or discussions about how to utilize dynamic lighting in OpenGL. There is no introduction to C++ programming or any description of the various network protocols. There are also no tutorials for using 3ds max, Maya, or even Paint Shop Pro. Granted, these tools might be useful in developing your game, but they are not the point of this book.

The key to being an independent game developer has nothing to do with being up to date on all the latest rendering techniques, nor does it matter whether you use the most recent version of your favorite compiler, modeler, or sequencer. The key to being an indie is recognizing your own limitations and learning to work within those limitations to *complete* the projects you start.

Successful independent game development is less about the technology you have and more about how you manage yourself, your time, and your ideas. Therefore, *The Indie Game Development Survival Guide* doesn't focus on any particular implementation of 3D scenes. Instead, it focuses on how to take an idea and develop it into a feasible design, how you use that design to plan your production and create your team, how you then lead your team through development/testing and on to release, and how you promote and sell the completed game.

This book also does not present any get-rich-quick schemes. You can do quite well as an independent developer, and there are a good number of indies out there who earn their living (and then some) by making and selling games on the Web. The information in this book can help you achieve the same results, but not without effort on your part. You may have to learn more about running a business than you thought was necessary. Marketing, sales, and promotion are a few of the topics covered, with examples given from my own experience and the experiences of others; but it's up to you to apply what you learn.

Finally, this book does not provide a step-by-step guide to finding a publisher, pitching a game to that publisher, or negotiating a contract. Instead, it is about *independent* game development, including how to publish the game yourself by using the Web.

Book Overview

The structure of the book flows from the beginning of game development to the next step in the process, and the next, culminating in the finished game and how to sell that game. We begin with an explanation of what it means to be an indie, and then the book moves on to game design. From game design, we then move to preproduction, including scheduling and budgeting, before tackling team building and management. Only then do we cover building the game itself. After that, we discuss how to promote and sell the completed game. The final chapters will cover how to build on the foundation we've created.

- **Section I: Indie Basics.** This section begins with a short description of the indie tradition in film and music, using these as the template for the independent game developer. These chapters also discuss what it takes to be an indie game developer. More than skills, the indie needs passion and perseverance.
- **Section II: Game Design for Small- or No-Budget Games.** These chapters cover game design, focusing on keeping the game idea within the primary constraints of little time and less money. These chapters also discuss avoiding 'me too' games and staying out of the

'technology arms race' that has become rampant in the retail game industry.

- **Section III: Production Planning.** With your game design in hand, Section III shows how to use your game design document to break your project into subprojects, or 'milestones' that can be completed quickly. This section also shows how to create a detailed schedule and budget for your game project, and provides tips for creatively funding parts of your project.

- **Section IV: The Team.** Unless you are the game industry's equivalent of the Renaissance Man, and you can design, program, conceptualize, model, *and* compose, you're going to need help to see your game to completion. This section covers building a team, managing the team during the development process, and even compensating them. Finding and screening potential team members is discussed in detail, as are the many and varied ways you can handle profit sharing and compensation.

- **Section V: Building the Game.** These chapters cover seeing the game through to completion in all aspects: gameplay, user interface, documentation, and testing. We discuss the advantages of using third-party and freeware components/libraries to jump start development and maximize productivity. Also, resource management is covered, as well as how to find and manage testers.

- **Section VI: Selling the Game.** With the game complete, Section VI shows you how to self-publish by using the Internet. The all-important aspects of marketing and promotion are discussed, as well as pricing and customer support. Payment handling is covered in detail to help get your income stream flowing as quickly as possible.

- **Section VII: The Future.** This last section of the book discusses how to leverage your just-completed game, your growing community of players, and your resources/procedures for future projects.

The appendices at the end of this book list valuable resources, including third-party components and libraries for such common features as 2D/3D rendering, sound, and more. Also, the results of the *Indie Game Developer Survey* that I conducted during the fall of 2002 are reprinted here. So, don't just take my word for it; see what other developers had to say about their independent games in their survey responses.

This may seem like a lot to learn, and some of it may be a rather radical departure from other books on game development, but indie game development is one of the most fulfilling and rewarding experiences you can have. You will learn more about game development, the game development industry, and even about yourself than you ever thought possible.

Enjoy!

I

INDIE BASICS

This first section of *The Indie Game Development Survival Guide* provides the foundation upon which the rest of the book is built. Chapter 1 begins with the all-important question: "What is an 'indie'?" We briefly discuss the tradition of independents in other industries and show how the current proliferation of independent computer games is a natural part of the computer game industry's growth as a whole.

Then, in Chapter 2 (Why You Should Be an Indie), the discussion moves from definitions and causes to reasons why you would want to be an independent game developer. Also in this chapter, we cover the reasons why *right now* is the best time ever to become an indie.

Chapter 3 (On Being an Indie) talks about the various 'paths' you can take as an independent game developer. This chapter also discusses the three most important traits of the indie: passion, pacing, and perseverance. This growing game community is also covered.

Finally, in Chapter 4 (Getting Started), we will focus on your goals as an indie and show how a little initial preparation can make a long-term difference.

1

WHAT IS AN INDIE?

IN THIS CHAPTER

- The Indie Tradition
- From Indies to Blockbusters to Indies

W hat is an indie? And where do they come from?

The most basic definition of indie (or 'independent game developer,' as we use it in this book) is a game developer, either an individual or a company, who provides their own funding for their project. More specifically, an indie is a game developer who does not receive money from a game publisher to create their game.

Beyond that simple definition, though, there are as many definitions of "indie" as there are indies. At heart, all of them are people who walk their own paths and who follow their own visions. Some recognize the established industry conventions, and maybe even understand them; but they choose to go their own ways. Others are rebels, contrarians that see the establishment as the enemy, or at least something to be avoided. And still others plan to be independent only so long as it takes them to 'make it' and become part of the established industry.

Indies don't spring from a vacuum, however. They have to come from somewhere. After all, you cannot be independent unless there is something from which to be independent. Indies are often the beginning and the inevitable result of an industry that (particularly) contributes to the mass culture.

This chapter begins with a brief look at the indie tradition in film and music. Then the growth of the computer game industry as a part of the mass culture is covered, showing how it is this growth that makes independent game development possible and maybe even necessary.

THE INDIE TRADITION

Some industries have a long tradition of indies. Probably the most popular of these are the film and music industries, both of which are dominated by huge conglomerates that churn out culture for the masses. But these industries have fertile indie scenes where innovation and risk taking are the order of the day.

Indies serve two prime functions. First, they serve the *non*-mass culture. That is, they can profitably target the small subcultures and countercultures that aren't numerous enough to be noticed by the large conglomerates. The term "profitably" is used somewhat loosely in this instance, though; because for a lot of indies, financial profit isn't the goal or even a motivating factor.

Second, indies explore new territory. Nothing is taboo to indies. There is no subject so sensitive or controversial that it can't be touched on or exploited. What the big conglomerates won't risk, the indies dare.

Independent Film

The availability of inexpensive filmmaking equipment, most notably in the form of the handheld video camcorder and, more recently, digital

cameras, has fueled the explosive growth of independent filmmaking in the past couple of decades. Recent advances in personal computer hardware and software have also contributed to this growth by making sophisticated editing and special effects techniques available to almost anyone. Finally, the Internet and the increased number of cable/satellite TV networks have created entirely new distribution channels.

Independent filmmaking, however, originated back at the beginning of the twentieth century when equipment was very expensive, and many of the techniques that are now common were still being developed. Almost as long as there have been moving-picture cameras and film studios, there have been indies. These so-called "maverick filmmakers" created films that the established Hollywood studios wouldn't touch, most often because of controversial subject matter or even because of the people involved, themselves (e.g., race, beliefs, motives, etc.).

Such mavericks range from D. W. Griffith and his controversial epic, *Birth of a Nation* (1915) to Kevin Smith's farce about modern-day convenience store workers, *Clerks* (1994). There are hundreds, possibly thousands of other indie filmmakers who have come and gone, and many more who are even now testing lighting conditions for their first take.

Independent Music

Independent music is as old as music itself, and yet it is still a new phenomenon. Given new life by the growth of the World Wide Web and sites like MP3.com (*http://www.mp3.com*), indie music, like indie film, runs the gamut from gritty garage bands hoping to make it big to acts like Ani DiFranco, who have achieved national and international recognition with little or no help from the established labels.

Like independent film, independent music takes advantage of inexpensive new technologies like the World Wide Web and personal computers. With today's powerful computer hardware and software, the indie musician can have their own sound studio and production facility within arms' reach. And via the Web, a local musician can reach a global audience in ways never before possible.

FROM INDIES TO BLOCKBUSTERS TO INDIES

Computer games are still a relatively new industry, so its indie movement is still forming. Just like film and music, though, computer game indies cover the spectrum from hopeful beginners to seasoned professionals.

Also like movies and music, the computer game industry grew out of the dreams of people striking out on their own. That these isolated dreams grew from humble beginnings into huge media empires does not

mean that individuals, operating alone or in small teams, can no longer be successful. Quite the opposite, in fact.

The Growth of a Dream

The computer game market didn't even exist half a century ago. It only began to emerge from obscurity in the mid- to late-1970s with the original *Pong* and arcade hits like *Space Invaders*, *Asteroids,* and *Pac-man*. The nature of the computer game market has evolved at a rapid, almost overwhelming rate since that time.

Once a novelty with few enthusiasts, computer games have become a cultural fixture just like books, radio, music, and movies. Books become movies, which have soundtrack CDs, and movies, which also inspire books, are made into games. And now games are now spinning off movies and books. Though computer games are still a long way from having the cultural and economic impact of Hollywood, or even the penetration of music radio, they have undoubtedly become a major economic and cultural force.

With computer games touching so many lives, it's no wonder that more and more people are catching the bug and wanting to do more than just play. Any industry that deals in dreams attracts dreamers. Performing music, acting in movies, or writing books are considered 'cool' careers, and so is making computer games. Being a part of such a visible entertainment that is so widely accepted is always appealing.

From Indies to Blockbusters

In the very early days of computer games, nearly all game developers were loners, sneaking time away from their businesses or academic duties, turning astronomically expensive mainframe computers into toys. With the growth of the computer game industry into a mainstream market, however, this independent, individualistic approach changed. Games began to require teams of specialists, with budgets in the millions of dollars and schedules that stretched across one, two, or even more years. Having a publisher to provide funding for the development effort became all but mandatory.

As the huge game publishing conglomerates competed with each other, the budget per project rose. The profits of mass-market products that sold to millions of people also added to the budgets available. These bigger budgets led to more lavish, more polished products than were previously possible. But it also brought about a 'blockbuster' mentality; a project had to make money quickly or it was dropped. This led in turn to reduced risk-taking, because when that much money is on the line, risk

must be managed and preferably eliminated. The ultimate results have been the solidification of game genres, the number of sequels approaching or passing double-digits, and a focus on what has worked before based on the risk-reduction mantra, "proven successful."

Thus, like movies, books, and music before it, the computer game industry has consolidated and become dominated by a few, very large *gatekeeper* publishers who control distribution and retail channels. The term "gatekeeper" simply means that only games approved (and usually funded) by those publishers will be seen on store shelves. While this consolidation is inevitable in any profitable market segment, especially in any mass-market industry, it has the tendency to reduce the variety of what is being produced and released.

This does *not* spell the end of innovation, though, and the large publishers continue to develop and sell creative, fun games. However, the focus on reduced risk and increased profits does have a dampening effect on the trial-and-error process of coming up with new ideas.

Though at first glance this consolidation may seem to spell the end of independent developers, it actually provides the opportunity for them to appear and thrive. Time and time again, from *SimCity*, to *Doom*, to *Myth*, to *Roller Coaster Tycoon*, the game industry has been rocked by newcomers with innovative ideas and the dedication to see them through. Though these games often became the start of a new wave of expensive blockbusters, they started with a simple, often revolutionary new take on an old idea.

From Blockbusters to Indies

Ironically, it has been the blockbuster mentality of the large game publishers more than anything else that has been responsible for bringing the dream of making games back into the reach of lone developers or small teams. As publishers fund bigger and better special effects, many new techniques are discovered, and powerful tools are created to exploit those techniques. The moving target of the 'cutting edge,' however, leaves behind many viable and often inexpensive resources that can be readily and easily used by insightful developers.

This is much the same as it is in the movie industry. Expensive blockbusters like *Jurassic Park*, *Star Wars: Episode One*, and *Pearl Harbor* refined techniques of digital filmmaking, using computer-generated effects, creatures, and even actors. Once the pinnacle of high technology, these methods are now routinely used even in low-budget, made-for-TV movies and product commercials.

The computer game market is now measured in billions of dollars annually. This creates a lot of room for small developers to carve out a niche

and be moderately successful. The mass-market, retail-oriented publishers must pursue games that appeal to larger audiences in order to see continued growth from quarter to quarter; and this continued growth is sure to keep the shareholders happy.

Indies, on the other hand, don't need to crack the mass market. They can become amazingly profitable in a niche that would never even show up as a blip on a publisher's radar.

The huge budgets now spent creating retail games demand a correspondingly huge return. If a publisher spends $2 million to create a game, and then even more to promote it before and after its release, then sales of that game must be sufficiently large to repay the investment. Again, the indie doesn't have this problem. With very little overhead and no middleman, selling as few as 1,000 to 10,000 copies of a game directly to players can be enough to show a tidy profit.

As the mainstream market for computer games continues to grow and expand, it will permit a corresponding growth in the market for independent games. No matter how big the computer game industry gets, and no matter how consolidated it becomes, there will always be room for small, independent developers.

If the movie and music industries can be used as examples, the indie is essential to the future growth of the game industry. In many cases, it is the lone developer or small team who leads the way with innovative new ideas—the developer(s) with nothing to lose and the willingness to take risks.

Conclusion

Ultimately, being an independent game developer is as simple as doing your own thing and doing it your own way. Don't be intimidated by the huge teams and large budgets of modern computer game publishers. Take heart in the long tradition of independents in other industries, particularly music and film, and from the early roots of the computer game industry. After all, the current industry grew from the efforts of dedicated individuals and will continue to grow because of them.

WHY YOU SHOULD BE AN INDIE

IN THIS CHAPTER

- . . . But What I *Really* Want to do Is *Design*
- The Indie Alternative
- Shareware, the Internet, and Stable Platforms

S o now you know what an indie is. This chapter moves from defini-
tions and causes to reasons why you would want to be an indepen-
dent game developer.

First off, if you have a game idea that you think should be pursued,
you should be an indie. Why? Because only then can you realistically ex-
pect that your ideas will be made into games. Ideas are cheap. Everyone
has more ideas than they will ever have resources available to pursue, and
that definitely includes game development companies and publishers.

There is another reason you should consider becoming an indie game
developer. Doing so allows you to take control of your life. You are in
control of what you do and how you do it. You don't answer to your
boss, nor to any shareholders of the company. You only answer to your-
self. If you think the world needs more games about purple fuzz balls,
then you take the action to make sure the world gets those purple fuzz
ball games.

The ultimate goal for most new game developers is to work full time
on their own projects, and there are a number of developers who have
achieved just that. But even if you don't succeed at having your earnings
as an independent provide financial independence, there are other re-
wards to be had, personal as well as financial.

Finally, this chapter will show why now is the best time ever to be-
come an indie. If you're like most people (either inside or outside of the
computer game industry), you may find this hard to believe. After all,
most of the new games that you hear about required millions of dollars in
investment and scores or even hundreds of people working for as long as
three years on the project. How could one person or a small group of peo-
ple hope to produce a game that would even be noticed? It's all made
possible by three things: the growth of the shareware marketing strategy,
the Internet's ubiquitousness, and the availability of stable platforms.

First, though, let's talk about being a game designer.

. . . BUT WHAT I *REALLY* WANT TO DO IS DESIGN

If you want to be a game designer, or even just contribute significantly to
the design of a game, chances aren't good that you will ever get to do so,
even if you get a job in the game development industry. The title "game
designer" is easily the most sought-after position in the entire industry.
Everyone wants to be the person with the idea that the rest of the team is
working on.

Game development is an industry with many talented people, and
the design element (i.e., defining what makes a game fun) is arguably the
most creative part. It's probably what attracts most people to game devel-
opment in the first place. With this much competition, not everyone who

wants to be a game designer is going to achieve that goal. One way around this, though, is to go independent. One way *not* to do this is presented in the following cautionary tale.

The Parable of the Frustrated, Would-Be Designer

Joe Gameplayer is a computer game enthusiast. He has played just about every computer game that has hit the retail store shelves since his birth, and has played them on every game console and piece of computer hardware. Of *course* he has game ideas. Exciting game ideas. *Million-dollar* game ideas.

Joe figures he has to start somewhere, though; so he picks his best idea (a tough choice to pick only one, but he's dedicated and not afraid of a little work), and he begins his quest.

Right away, Joe hits his first obstacle. The publishers have their own opinions on what makes a good (i.e., 'profitable') game, and since they *might* already have a proposal on line that's similar to Joe Gameplayer's proposal, they won't even look at Joe's submission. So they send Joe a standard response, telling him they don't consider unsolicited ideas or pitches.

Joe is discouraged, but he's not giving up yet. Joe decides to submit his idea to his favorite game development company, Game Done Great Software (GDGS). GDGS, though, already has more ideas on hand than they can reasonably complete. Each one of their producers, programmers, artists, sound engineers, musicians, and janitors has a game idea. So, GDGS won't look at Joe's idea, either, no matter how big a fan Joe is of their hit game, no matter how much he begs or pleads.

Now Joe gets really frustrated. This was supposed to be easy. Who knew publishers and developers would be so uninterested? Fine. There are plenty of talented amateurs out there.

So Joe posts on an amateur game developer Web page, looking for someone to make his game. Of course, he's not going to actually post his game idea. He's not *that* naive. One of those amateurs might steal it!

```
Re: Hey, I have a game idea.
I have a game idea and it's really, really cool!
If you can make my game, I'll give you half.
Email me.
```

Most of the responses he gets aren't very positive or very nice. Some people ask him for details on the game idea—and then get snooty when he won't reveal them. Or they ask what he's able to contribute. Most respond, though, with mockery and call him a "noob" (newbie). Depressed and grumpy, Joe finally gives up.

The moral of this parable is simple: ideas are cheap. You must have more to bring to the table than just an idea.

The Myth of the Million-Dollar Idea

It really does seem that *everyone* has a game idea. Not just a *good* idea, of course, but a *great* idea! If they could only find a publisher who would make that game, they could be rich, *rich, RICH!*

This is a common misconception among fledgling game designers. They optimistically believe that ideas alone have some intrinsic value. The reality is a bit harsher.

Have no illusions about it. Ideas are cheap. It's a bitter truth, but one that must be faced. Millions of people have great ideas every day. They don't get paid for them, though, because ideas aren't worth much without expending the effort to make something concrete out of them.

Everyone, it seems, dreams of being paid big bucks to just hang out and think up great ideas. Other people then take the ideas and turn them into products that generate cash. Maybe this job exists somewhere, but the possibility of achieving it is doubtful.

Even Thomas Edison, who may have come pretty close to this ideal, worked harder and longer than just about anyone who ever worked for him. Invention isn't just thinking up something like 'light that comes from electricity' and then collecting royalties on the finished product. Edison and his team experimented for years, trying thousands of materials, before finally creating the first commercially viable light bulb.

Ideas without implementation have practically zero value. This is true whether it's a game idea, a book idea, a movie idea, a time-saving invention, or anything else. If you don't turn your idea into something valuable on your own, there is very little chance that anyone else will either.

The reason is simple: not only does everyone in the game development industry already have ideas of their own, but the resources to turn those ideas into a finished game are very limited.

The Odds of Getting Your Game Made

Let's go back to our parable one more time. This time, let's assume Joe Gameplayer actually *does* have a good idea and isn't just suggesting that his *EverQuest* clone have female characters with more cleavage. How could he see his game published?

Since Joe has little or no game industry experience, even if he navigates the non-disclosure agreement (NDA) and the submission process, swings a pitch meeting with a publisher, and then wows them with his idea, he'll still almost certain to get turned down. Why? Because without

a proven track record or a team of programmers, artists, and musicians ready to go, he's a huge risk. And, as we've already pointed out several times, publishers don't like unnecessary risks.

Publishers are all about selling games for a profit. They aren't going to allocate the significant resources required to complete a retail game to someone without a proven track record. At best, the publisher will tell Joe, "When you get a demo together, give us a call."

Joe won't get much further with a game development company. Most game development shops are strapped for cash, and they're behind on the projects they already have in progress. These developers have more game ideas that they want to pursue than they will ever have sufficient resources to tackle. Even if they like Joe's idea enough to hire him, Joe won't be working on *his* idea. Joe will be put to work helping the company get caught up on the projects they have going right now. At best, depending on the project, Joe may get to suggest ideas for different parts of the game in process. So Joe is on his own again, because ideas aren't what's in short supply.

Let's leave Joe for now and switch over to Jane Professional. Jane, who currently works for Game Done Great Software, also has a great game idea. How can she see her idea made into a game?

Jane enjoys her job at GDGS and doesn't want to leave it. She likes being involved in big retail projects. But what she *really* wants to do is design a game of her own. However, unless she's one of the principles of Game Done Great Software or in a lead designer position, chances are that Jane will never get to work on her own game idea at GDGS. At best, like Joe, she might be able to influence some elements of the design of GDGS's current and future projects. Why? Because there are always more ideas than resources to pursue them.

THE INDIE ALTERNATIVE

Here's where independent game development enters the picture. Whether you are an industry veteran or just someone with a game idea that you want to see made, as an independent game developer, you have the opportunity to do just that.

Personal Rewards

The indie game developer route is a challenging one for several reasons, not the least of which are the limited time and team resources. You will probably have no budget to speak of and will have to find other people to help you get your game done. Furthermore, when the game is completed, you will almost certainly have to market and publish it yourself.

On the bright side, just by reading this book, you will learn about game design, production planning, budgeting, management, marketing, and many other game industry topics. You will grow as programmer, artist, or musician, and also as a person. You will learn about yourself and your own capabilities.

As an indie, you not only have (near) complete control of your game design, you have a chance to take charge of your life. By making your own game, you have declared that you are responsible for how your life turns out. You aren't just relying on your full-time job to define who you are and what you do. You define yourself.

Financial Rewards

Your first independent game project could also become a first step toward financial independence. Numerous indies not only have enough income from their games to live on, they do very well at it. See Figure 2.1 for the results from the Indie Game Developer Survey conducted by the author in the fall of 2002.

While the majority of the respondents did not make most of their incomes from their projects, a very strong percentage (25%) did. And 8% of those who responded reported making $50,000 per year or more. While

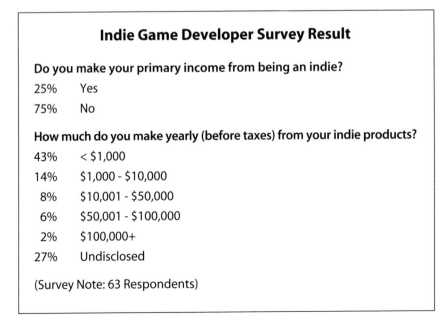

FIGURE 2.1 Survey of full-time indies.

this doesn't represent the top bracket of 'high earners,' this is still a very good income—and it's earned on *their* time, doing what *they* want to do.

Not many people have the opportunity to earn money directly from their own business efforts. Most people know exactly how much they are paid per hour, but they have no clue as to how their everyday efforts affect the bottom line. They do their job, earn their pay, and go home. As an indie, though, you don't just earn money, you *make* money. You create something new and valuable.

Indies also see something that most retail game publishers never see: royalties. It is common wisdom in the game development industry that only the top-selling games (probably only the top five games in a given year) ever earn enough money to generate royalties for their developers. A new retail game might have as much as $2.00 per unit earmarked for the developer's royalty. The game has to pay back development costs first, however, which can be millions of dollars. To do that at $2.00 per box would require 500,000 unit sales for a relatively small budget of $1,000,000. That's a lot of units. Not many games achieve this level of sales.

Contrast this with an indie game sold directly to players via the Internet; typically, only 10%–20% of the total sale is lost to overhead. The rest goes straight to the game developer. With this kind of profit margin, the independent can be profitable with sales that a retail publisher would consider worse than abysmal.

SHAREWARE, THE INTERNET, AND STABLE PLATFORMS

Right now is an exciting time to be an independent in nearly any industry, but especially an indie game developer! By now, you should agree that no matter how big the overall computer game industry becomes, there will always be a place for the independent game developer. Whether they self-publish their games, as described in this book, or a publisher decides to pick up their game and sell it retail, the indie remains an important part of the industry.

So how can you take advantage of these opportunities? The answer has three parts, all of which you probably use everyday: shareware, the Internet, and the operating system on your computer.

Shareware

The indie game market has always been intertwined with that stepchild of the software industry: *shareware*. Despite what many people think, shareware is not a type of software. Shareware is a marketing concept based on the simple principle of 'try it before you buy it.' Software (including games) is made available to the public, and anyone who wants to try it out

can do so. There is often some limitation placed on the use of the software, such as a limit to the number of days the software can be used, or some features might be disabled. If the person decides to buy the software, after payment, all limitations are removed. That's shareware. It's that simple.

Shareware has its roots in the emergence of the personal computer. As small, inexpensive computing power became available in the form of the Commodore 64, Apple II, and early IBM PC, a market for small, inexpensive software followed. Shareware, in true indie fashion, grew from the inability of the large software makers to fill all the possible needs of the new personal computer community. Instead, they focused their attention on supporting mainstream businesses. This left open a very large market of smaller, less common business and personal computing needs.

Shareware came into its own in the 1980s. Distribution channels sprang up via dial-up bulletin-board systems (BBSs), and software collections were sold at retail outlets. Certain utilities, like the archive program *PKZip*, became commonly used, even though they were sold only via shareware. It was the Internet, though, that really lifted shareware out of computer obscurity and into a position of prominence in the software industry.

The Internet

Just like in the other mass entertainment industries, the indie game developer does not have access to the 'normal' distribution channels. The large electronics stores, computer retail outlets, and software boutiques are as inaccessible to the small game developer as the megaplex theaters or chain record stores are to independent filmmakers and musicians. With the growth of the Internet, however, a new distribution channel has emerged, one that it is almost impossible to dominate. With some focused effort, just about anyone can carve out a niche on the Internet.

Soon, personal computers and Internet access became as common in households as refrigerators and microwave ovens. Suddenly, the number of potential customers for shareware skyrocketed. Shareware was ideally suited to the Internet, and the shift from dial-up BBSs to the direct Web access took almost no time at all. When people began looking to the Internet for their software needs, the shareware products were already there, waiting for them.

This shareware has not completely replaced software sold via the brick-and-mortar retail outlets, but it has become a force to be reckoned with. Shareware is now so common and has made such an impact on how people buy software that most commercial software (with origins as shareware or not) is available via download with a try-before-you-buy option. Even retail computer games now rely on a downloadable demo version to provide potential players with a free taste.

As recently as 1995, this was virtually unheard of. If you needed software for a particular task, you went to a store that sold software and hoped that what you bought would do the job. In the case of a game, you might have had a wider variety of places to purchase it from; but if you didn't like the game, there was very little recourse. Stores were reluctant to take returns for any kind of software, especially games. With shareware, you only buy the software when you know that it works for you—clearly an improvement.

The possibility that Internet sales of software will eventually render the current system of retail sales distribution obsolete is seen by many as not only inevitable but also desirable. Whether you agree or disagree, the impact of the Internet cannot be denied. Though the 'Internet Boom' has come and gone, the value of the Internet is still very evident. Online purchases of software, games, and other goods are increasing, and sales are predicted to rise even further.

The visionaries of the boom had the right idea, even if most of them couldn't figure out a way to profit from it. The Web is no longer the novelty it once was. People now use the Web as a matter of course and, in fact, is almost a necessity for millions, if not billions of people worldwide.

Beyond just sales and distribution, though, the Internet gives you access to resources and personnel like never before. In fact, the Web is probably the best thing that has happen to indies of every industry. More information is available than ever before, and a lot of it is free. Need to learn how to use a particular technique for 3D rendering? You can find it on the Web. Do you need to find someone to help you with your game project? You can find them via the Web. You can even use the Internet to manage your development team remotely.

With the Internet, developers have a powerful tool. It's a distribution medium. It's a coordination vehicle between team members. It's a communication device. As a small developer with big dreams, the Internet is your best friend.

Stable Platforms

Finally, modern developers, indie or otherwise, enjoy another advantage: a choice of (mostly) stable, highly viable platforms—Microsoft® Windows®, Mac® OS, and Linux each with millions of users worldwide; and most of these users are connected to the Internet. All of the platforms provide libraries for 2D graphics, 3D rendering, sound playback, high-speed networking, and powerful databases that use the most sophisticated development tools ever released. And you have access to all of this at incredibly low prices (or even free)!

Beyond personal computers, a couple of new platforms have emerged in the past few years: the personal digital assistant (PDA) and the cell phone. These small devices have amazing power for their compact size and have come into their own as platforms for software of all types, including games. Just like the larger platforms, the PDAs and cell phones have a growing collection of powerful development tools. Cell phones are a particularly attractive target platform because so many are already in use.

Whether you target a single platform or plan to release your games for a variety of platforms, this the best time ever to be a game developer. The possibilities open to you are nearly endless.

Granted, as a small developer, you cannot easily reach the ultimate mass-market platform: the game console. But even this tightly controlled market segment isn't impossible to broach. Case in point: the PS2 port of *Treadmarks,* by Longbow Digital Arts, the first winner of the Independent Game Festival in 2000. (Also, Microsoft has an Xbox 'incubator program.' You can read about it here: *http://www.xbox.com/dev/unsigned.htm.*)

The Microsoft Windows-based PC, Apple Macintosh, Linux, PDAs, and cell phones will remain the best platform choices for the aspiring game developer for the next few years, but more choices and even more opportunities are still to come. The future is bright!

CONCLUSION

If you dream of making games (a safe assumption, since you're reading this book), you should seriously consider becoming an independent game developer. Whether you are an industry veteran or an enthusiast with big plans, if you have a game that you want to make, you have the opportunity to make it as an indie.

Follow your dream. Never has the dream of making games been as attainable as it is today. The explosive growth of computer games has created a market for games beyond what the retail publishers can fulfill. New techniques, technologies, and markets are created every day. In addition, because retail games focus on the mainstream market, the indie is often free to exploit the smaller markets that would otherwise be ignored.

The Web provides resources, team members, and even distribution channels; and with standardized, stable platforms providing millions of potential customers, you can carve out a niche for yourself like never before.

If you have 'big' dreams, you may have to tone them down some to tackle them, especially at the start. But never forget that they are still *your* dreams. You're not working for someone else. You're working for *you!*

ON BEING AN INDIE

IN THIS CHAPTER

- Who Can Be an Indie?
- The Key Traits of the Indie
- The Indie Community
- "Indie" Is Not a Brand

S o far, we've covered what indies are, and why you should be one. This chapter discusses what it takes to be an independent game developer. The final section will cover the growing indie game development community and why the term "indie" is not a brand.

There is more than one path open to you. You don't have to go it alone, and you don't have to be in charge. You do, however, need the passion to create games, the ability to pace yourself for the long haul, and the perseverance to keep going until you reach the end. In short, you must be willing to do everything you can to see the project completed.

Regardless of your background—be it programming, art, or music—you have to contribute as much as you can muster and then be willing to do even more. If you can face this challenge, then you undoubtedly have what it takes.

WHO CAN BE AN INDIE?

The short answer to this question is: *anyone*. Anyone who wants to make their own games can be an indie. There are no membership fees, no contracts to sign, no obligations, and no code of conduct to agree to.

You don't even have to give up your 'day job' to be an indie game developer. In fact, it's recommended that you *don't* 'burn your bridges' by leaving your day job to complete your first project. Though you may certainly take that step in the future and become a full-time game developer, for the time being, your full-time job will provide the means for pursuing your indie dreams. This is discussed in more detail in Chapter 10, Creative Funding.

Doubtless, your job will also demand most of your available time, and you may have other responsibilities, as well, like a family. But with planning and dedication, you can see your project from design to completion on as little as one to two hours per day.

On the other hand, independent game development isn't for everyone. Being an indie requires guts. You will be operating without a safety net most of the time; there'll be no assurance that your efforts will ever be repaid. However, if fulfilling your own dreams is more important than helping someone else fulfill theirs, independence is the only possible road. If you can start with a vision—a dream of what could be—and have the dedication to see it through, as well as the perseverance to stay the course, you can be an indie.

Many Paths

There are many paths to becoming an independent game developer. Some of us have already worked as professional programmers and soft-

ware engineers before striking out on our own. Others have come back-grounds just as diverse and just as unrelated to the computer game in-dustry: the military, corporate America, Internet startups, and those of us who are straight out of college. Often, indie 'careers' begin as a hobby, making games mostly for one's own education and amusement. Some of these 'hobbies,' though, grow to the point where they earn a very com-fortable living for their developers.

Originally, most game developers were programmers, since program-mers were the first to extensively use personal computers. As the devel-opment tools have become more sophisticated, however, the level of expertise required to produce a game has shifted from the 'technical' dis-ciplines of hard-core programming to the 'softer' disciplines of design and art. Creativity now counts for as much as, if not more than, technical ex-pertise. For example, *Myst* and its sequel, *Riven*, two of the best-selling games of the 1990s, required very little complicated programming.

Whether you're a programmer, an artist, a musician, a writer, or a designer—whatever your talent, you can become an independent game developer. You may have to find other like-minded, independent souls to assist you; being an indie does not meant you have to go it *alone*.

Few people can master all the skills required to produce a modern computer game. If you're a programmer, you will almost certainly need to find at least an artist to create your artwork. And you might even look for someone to help you with the overall design of the game.

If you're an artist, you might be able to 'see' and even create the art-work you need, but you may find it hard to do all of the programming on your own. There are quite a few programmers who would be willing to swap their coding for your artwork.

Games are not the sole domain of programmers and artists, however. If you're a writer or a designer, or anyone else, so long as you are able to communicate a vision, and can coordinate the efforts of yourself and your team, you can get a game completed, too. Convincing programmers and artists to work with you might be a bit difficult; but if you do the nec-essary preproduction work and are willing to do what's necessary to make sure the project moves forward, then you can succeed.

If searching for these like-minded, skilled souls to help you create your game sounds daunting, don't be discouraged. Section IV (The Team) details the finding, recruiting, and managing of team members. Like many aspects of game development, it isn't as difficult as it might at first seem.

Indie, But Not in Charge

Even if you are not the visionary sort who wants to take charge, you can still be an indie. After all, not all business people or skilled professionals

want to be entrepreneurs or start their own businesses. Different people have different needs and different goals in life.

Maybe you just want to work on indie games but not be in charge or responsible for the entire project. If you want to work on indie projects, rest assured that there are project managers looking for someone exactly like you. This book can help you gauge such projects, so you can determine if you really want to be involved with and part of a small, dedicated team. And who knows? After you've helped complete a couple of projects, maybe you'll want to tackle your own.

THE KEY TRAITS OF THE INDIE

There are three key traits of the indie: passion, pace, and perseverance. Passion is an obvious prerequisite. If you were not passionate about games in general (and your own game in particular), you would not be reading this book. Passion alone, however, is not enough. Passion provides the initial spark. It is pace and perseverance, though, that fan that spark into a flame and then keep it burning until the game is completed.

Passion

The dream of making games is the beginning of a game developer's passion. More than the simple desire to be a game designer, however, you must have a driving need to create a game of your own. Whether you want to just express yourself artistically or make the computer game equivalent of the 'great American novel'—or if you just want to cash in on the growth of the computer game market—unless you believe in the game you're making, it's unlikely that you will finish it.

A normal job only requires clocking in and performing your assigned tasks until it is quitting time. No real interest or involvement in what you're doing is necessary. But creating games requires passion. There is no one forcing you to create your game except yourself; so if you don't want to do it, if you don't *need* to get the game finished, then you won't. It's that simple.

The basis for this passion is your purpose, your reason for beginning in the first place. "Why am I making this computer game?" Make sure you have a strong enough reason to carry you through to the finish.

Your passion is the fuel for your pace and perseverance. Without passion, your pace becomes an empty plodding, and your persistence becomes a grindstone that will wear you down. If you keep the passion alive, though, even after long months of work, you will muster the courage to keep going, even when there are more months of work still to come.

Pace

You may not have needed much convincing about the need for passion, but you may be wondering about the emphasis on pacing. Isn't the passion, the burning fire within that drives us to create new games, enough to see us through? If passion were all that was necessary, however, there would be a lot more indie games being completed and released.

Pacing is important because there is a significant investment in time and expenditure of energy between starting and finishing a game. Even simple games with full-time teams can take months of work. Most indie projects, though, won't have full-time team members. At best, your project is being worked on in between the demands of 'real' (i.e., paying) jobs, significant others or family, hobbies, and any of a myriad other facets of life. With so many other commitments, it can be difficult to allocate even 10–20 hours per week to work on the project. Thus, a project that might take a full-time team only three months could take from six to nine months for a part-time team, and possibly longer.

A good way to think of game development is as a marathon. Marathons can't be run all at once like a 100-meter dash; you wouldn't make it more than a fraction of the total distance. Instead, knowing that you have a long way to go, you set a pace that you can maintain for the entire race, possibly with something held in reserve to carry you those last few hundred steps. Marathon records aren't set at the beginning, they are set at the finish line. If you don't finish, starting was just so much wasted energy.

You must pace yourself to the task of completing your game. Keep your passion burning, but also keep it in check. You will need that passion to carry you all the way through, so don't spend it all at the beginning.

Many indies try to do the equivalent of sprinting a marathon and then wonder why they collapse, exhausted and dispirited, miles from the finish line. All the willpower in the world won't keep you moving forward if you exhaust yourself and your resources by trying to compress full-time effort into a part-time schedule. Accept it; to complete the game will require time (maybe more time than you had anticipated). Don't try to get it all done in the first weekend.

Pacing is management of your time and energy, as well as your team members'. Only by carefully managing your limited resources can you hope to make them last throughout the course of the project.

Perseverance

As an indie game developer, the odds are stacked against you. You have little or no money for the project and very limited time available to work on it. No one's job depends on the project being completed.

These odds *can* be overcome, though, so long as you don't give up. This is perseverance.

As in the marathon analogy discussed earlier, the way you finish a marathon is to keep taking one step and another step, and so on—one after the other, no matter how tempting it is to quit, until the race is completed. Conditioning your body to go the distance is as important as pacing yourself for that distance, and so is the strength of will to keep going, the belief that you *can* finish, and the courage to keep believing it until you cross the finish line. Perseverance keeps you putting one foot in front of the other, scratching off one completed task at a time, until the game is done.

You must commit to the game, promise yourself that you *will* see it completed, and renew that promise every day. It's up to you to keep the project moving forward. You must be willing to lead the team, even when the project seems stalled and the team is burned out. You provide the motivation and the enthusiasm. There is no place for a commander at the rear dictating orders to the troops up front. You must be a front-line officer and lead the charge. 'Take point' on the project and lead your team toward the goal.

If pacing is management, then perseverance is leadership—leadership through example and will power. The team derives its dedication from you. If you are not dedicated, you cannot expect your team to be (see Chapter 14, Team Management). Know that as an indie with a team, you will learn more about both teams and management skills than you ever expected.

Do All You Can—And Then Do More

Your level of dedication is reflected by your priorities. This is your project, and you must do whatever is necessary to make the project a success. You will be required to invest more time and energy than anyone else involved. Your background dictates your primary contribution to the project, whether it's programming, modeling, texturing, or composing. But you are also responsible for all the other areas of the project, such as design, implementation, testing, and marketing. You are responsible for *everything*.

The indie is an underfunded *producer* more than anything else. You are responsible for the project in a way that no one else is. Even if you put together a dedicated team to help you, the project remains *yours*, and it's up to you to see it through.

There is no way around this. The game industry press has penned the concepts of "game design by consensus" and "design by cabal," but the truth is that only projects with funding can afford the luxury of design by

committee. As an indie, you must accept the reality that your project is indeed *your* project. You may find dedicated team members who share your vision, but it remains *your* vision.

Thus, you will shoulder the lion's share of the work for the project. You will have to take care of the business aspects. You will have final say on the game design. You will have to manage the other team members. You will have to oversee the development process and the testing. And yes, it's a lot of work.

This book will do everything it can to help you handle all of these tasks—including finding team members to share your load. But you must be willing to shoulder that load yourself. Demonstrate the passion, set the pace, and provide the perseverance to do whatever it takes to see the project to completion. Only then will you be able to inspire others to sign up for the duration.

This cannot be stressed enough: as an indie game developer, you must do everything you can to get the project started. Until you have achieved even minor progress, it's unlikely you will find any volunteers to help.

THE INDIE COMMUNITY

Since the late 1990s, awareness and appreciation of indie games has grown considerably. Before then, most small indies had worked in relative solitude and obscurity. The computer game industry as a whole scarcely recognized that indies even existed, except for the highly successful ones, like Apogee Software, Ltd. and Id Software, Inc.

As the tools of game development became more sophisticated and less expensive, however, and as the publishing and distribution possibilities of the Internet exploded, the ranks of indie developers swelled. A sense of community developed.

The Indie Game Movement

As we've discussed before, independent game development is the natural result of the growth of the computer game industry as a whole. Without the success of the retail publishers, there would be no indies. The commercial publishers provided the initial capital and resources that created the wealth of development tools that are now available, and you can't be an 'independent' if there is nothing to be independent from. As such, indie games are a part of the whole game industry. Both sectors need to take this more to heart.

There is no single 'indie movement,' however. Everyone has a different take on what this means and even on what the definition of an "indie" is. The organizations and festivals listed in Appendix C reflect this

diversity. For example, the Indie Games Festival was the result of the game industry's notice of indies and their making room for them, while the Association of Shareware Professionals was created by independent software developers. Both are equally valid and important in their own ways.

Just because you're an independent doesn't mean you have to work alone or in isolation. There is a growing community of fellow visionaries on the Web, located at places like Garage Games (*http://www.garagegames.com*) and GameDev.net (*http://www.gamedev.net*). Reach out, make contact, and say, "Hello!"

"Indie" Is Not a Brand

Just as with independent film and music, there is sometimes the assumption that because indie games are not created by the big retail publishers, these games are 'better' than the retail games. This line of thought is an outgrowth of the observation that indie developers are free to try risky (or controversial) ideas that publishers wouldn't touch, or ideas that simply wouldn't be commercial enough. Neither controversy nor freedom from 'commercial concerns' immediately elevates a game to a higher plane. This fallacy might make some indies feel better about themselves, but it's not true (any more than the converse is true) and serves only to alienate and divide the industry as a whole.

There are also those who want to turn the term "indie" into a label for a brand of games. Proponents of this view want all independent game developers to come together, promote each other's games, and help educate the masses to the wonders of independent games. The problem with this indie branding approach, though, is that *anyone* can call themselves an indie. There is no 'Indie Certification Board,' nor is there ever likely to be one. Therefore, there is no guarantee that indie games meet minimum standards of production or game quality. In fact it's inevitable, if not lamentable, that many indie games *don't* meet any minimum standards.

Independent film and music face the same problem. Anyone can create a movie or a band; any development team can make a computer game. This great freedom means that noncommercial ideas and concepts can be explored, but it also means that the 'indie experience' is a very uneven one.

So don't let your independent status go to your head. Instead, do your best to make your game a worthy addition to the growing collection of games developed worldwide. In the same spirit, help other up-and-coming game developers to do likewise. When one of us does well, it helps us all.

And, of course, support your local indie music and movie scenes.

CONCLUSION

All independent game designers begin with passion. It's a prerequisite. But in addition to passion, the indie game developer also needs to pace themselves and have perseverance. Perseverance is the promise, made to yourself, to see the project completed and not give up halfway through.

Recognizing these needs will support you from the beginning to the end of your project.

With these three attributes—passion, pace, and perseverance—you demonstrate your commitment to your project and your willingness to do whatever it takes. It's up to you to get yourself and your team fired up, organized, and running at a steady pace; and it's up to you to see it all through to the end. Ultimately, it is the finishing of projects, whatever their size, that separates the indies from the wannabes.

4

GETTING STARTED

IN THIS CHAPTER

- Get Organized
- What Are Your Goals?
- Laying the Groundwork
- Using Professional Advisors

Befor you launch your exciting new career as an independent game developer, you should pause to consider some items that might seem a bit mundane—or even scary. First is the question, "What are your goals?"

In your initial excitement about making your own games, doing your own thing, and being your own boss, it's tempting to believe that you will *always* be this excited and motivated, and that the future will take care of itself. The future, though, is built upon what you do *today*, so you need to define and plan for your ultimate goal.

Next are corporate, legal, and accounting issues. These are seldom topics of pleasant conversation for programmers and artists, who tend to look on such matters with more than a little distrust and fear. Thus, the new indie often has no experience in these areas. But if you are serious about being an indie, you will need to consider them. It is possible that you will not need to make decisions on these matters right away, but you need to be aware of the options available.

Disclaimer

The information in this book is designed to educate and provide general information about the topics covered. However, laws/practices vary from state to state and nation to nation, and are subject to change. For this reason, readers are advised to consult with their own advisors regarding specific situations.

The author has taken reasonable precautions in the preparation of this material and believes the facts presented in this chapter are accurate as of the date it was written. However, neither the author nor the publisher assume any responsibility for any errors or omissions. The author and publisher specifically disclaim any liability resulting from the use or application of the information contained in this book. This information is not intended to serve as legal advice related to any individual situation.

GET ORGANIZED

One of the easiest steps you can take to help ensure the success of your project is to get organized. Don't make a high-risk project even riskier by being unprepared. You don't have to take this to the extreme, of course, and buy a whole new file cabinet with color-coded folders. You don't even have to straighten your desk. The point is that you should *plan* to *plan*.

Time management is part of planning. Being an independent game developer takes time, *lots* of time. If you're not prepared to *make* the time you need to do what needs to be done, then it's unlikely you will ever finish your project.

Plan to Plan

Approach your project seriously, and recognize that you must start well in order to finish well. Take the time to consider your project from beginning to end. What will you need? How will you keep your information up-to-date and available? If you have team members, how are they going to access that information? You might change the way you handle these issues as the project proceeds, but that's okay. It's better to have a plan (even a revised plan) than to have no plan at all.

Without a plan, your project might get started, but it is almost certain to grind to a halt as the team loses focus and unravels. The Web is littered with dead and dying amateur game projects. The only way to make sure that your new project doesn't suffer this fate is to be prepared at the beginning. Planning must accompany your passion.

In the same vein, without some kind of plan, it's nearly impossible to coordinate the team's efforts, no matter how small that team might be. Your progress will only reap a growing sense of uneasiness and impending failure without a plan or schedule to check it against. With no specific goals or milestones to work toward, energies and resources are easily misspent on efforts that don't bring the game any closer to completion.

With a plan, however, you always know where you are at any point in the development cycle. You can confirm that the artwork is ready, but the programmer has been slow to get it integrated. Places where no progress is happening at all might indicate that you need a new team member to fill that need. (And if all the team members have consented to a "team member contract," as discussed in Chapter 11, Team Basics, then replacing unproductive members becomes easier.)

Even if your project doesn't proceed exactly according to plan, the plan can be updated to reflect changes in priorities. Changing course is easier if you know where you are and where you want to go.

The following sections will not only help you create your game design, they will help you plan for turning that design into a game product.

Make the Time

To succeed at any project, you have to realize that there is no such thing as 'finding' the time. You must *make* the time. Otherwise, you will never

see your project completed. Even if it means devoting only one hour per day, that's a start. We all think we cannot possibly fit anything else into our daily schedules, but here are some tips on how you can find (make) additional time:

- **Get up earlier.** Set your alarm clock for an hour or so earlier than normal, and work on your project first thing in the morning. This has several benefits: first, by working on your project before you head off to your 'real' job, you create a definite deadline for yourself. You will find yourself more focused and more productive than if you'd been facing an open-ended time slot. In other words, this can help you 'pace' yourself. Second, you will probably start going to bed earlier, which could improve your productivity at both your own project and your full-time job.
- **Watch one hour less of TV.** Everyone has their favorite TV shows, and this book doesn't advocate giving up relaxation time. On the other hand, how much time do you spend watching *non-favorite* programming before or after your favorite show? This is time that you could put to use by doing something much more productive.
- **Play computer games one hour less.** Most game developers are also game enthusiasts. Many spend more hours each day gaming than they do watching TV. In the United States, at least, this adds up to a significant amount of time. You don't have to stop playing games altogether, and doing so is probably a bad idea. You need to stay on top of the current market and be aware of what other games and new technologies are available; but don't forget: if all you do is *play* games, then you won't have time to actually *make* games.

So, don't make excuses for why you can't *find* the time. Take control of your life, and *make* the time you need.

WHAT ARE YOUR GOALS?

How you answer this question has a huge impact on how you will proceed. There are many different kinds of independent game developers. Some developers just want to make games, regardless of whether those games will ever make money for them or for anyone else. Other developers consider the indie path only as a way to break into the retail game industry; their primary goal is to create a game that is noticed by a retail publisher, who might then hire the developer to work on the company's games. Still others want to both make games and make money from them, whether they publish the games themselves or work with a publisher. Finally, there are indies who are only interested in making games and selling them themselves.

None of these indies is any better or worse than any other. Different people have different goals and ambitions. But what *is* affected is the kind of business structure you should use (if any), and how ownership issues might affect you and your team.

The Hobbyist

If you just want to make games for the love of it, and you don't plan on selling the games, then making games is essentially just a hobby; you don't need a lot of preparation. As a hobbyist, you probably won't need any kind of corporate structure at all; although, if you plan to work with a team of people to create the games, you still need to be aware of ownership issues and take the necessary steps to protect the projects and yourself. This section can help you understand these issues, and it can help you plan for dealing with them.

Even a hobbyist shouldn't discount the more business-oriented approaches. Just because you're happy being a hobbyist now doesn't mean that you won't change your mind in the future. Many successful independent game developers started out as hobbyists. Once they had a couple of games completed, they realized they could turn their hobby into a full-time career. If you take the proper steps now, you can effect an easier transition in the future.

The Interim Indie

If your goal is to look for a job at a retail publisher or an established game development shop, rather than to start a career of your own, then you're an interim indie. Creating a company might be more trouble than it's worth, for example, but ownership issues can be even thornier. What happens to the project if you or some other team member get hired? Or, if a publisher buys the project, who is entitled to a share of the proceeds? No one wants to work long hours on a project and then have it seemingly 'stolen' from them.

If you plan to sell your project, keep in mind that a publisher isn't going to be interested in the project unless the ownership issues are very clearly resolved. Otherwise, there could be considerable legal problems, and the publisher will pass on the project. So, if your plan is to create an initial version of the game to serve as a demo for a publisher, you should take steps at the beginning of the project to keep the ownership of the project uncomplicated.

Again, even if this your main goal as an indie, keep in mind that the publisher might not be interested in your game; or you might change your mind as you see the game come together, decide to bypass the

publisher completely, and self-publish the game. In either case, you will be glad you took the time at the start to establish ownership of your project in order to protect and ensure a return on your investment in time and resources.

The Professional Indie

Finally, if your goal is to design, build, and market games yourself, then you are starting a business, and you should approach it as such. Don't panic, though. Running a business doesn't mean you have to wear a suit and tie, and start holding 'power lunches.' You only need to begin thinking like a business *owner*, rather than a business employee or contractor.

Like most new game developers, you probably come from a background of programming, art, or music; and thinking like a 'business owner' is probably foreign to you. You might not have any management or supervisory experience. But don't let this intimidate you. You've already conquered cutting-edge technologies. You've demonstrated your creative ability. Being a business owner and running that business professionally isn't hard. It only takes a willingness to learn.

The tasks and responsibilities of being a professional indie will take up some of your precious time, but it will be worth it. You will still get plenty of opportunities to ply the trade you love, and you'll be doing it with a greater awareness of the market you're plying it in.

LAYING THE GROUNDWORK

Now we will cover some of the more common issues that professional indies must address: company structure and ownership. Whether you feel you need a fully structured company is ultimately up to you. This section will endeavor to provide enough information to help you decide.

Ownership issues, as previously stated, are extremely important. If you take the time now to decide how ownership of the project will be handled, you'll minimize the likelihood of nasty surprises later on. We will also discuss the value of using lawyers and accountants to help keep your business legal and proper.

Company Structure

Even after our discussion on different types of indies, you may be still be wondering why you would need a company at all. Well, you may not need to form a company, at first.

During preproduction and early development, for instance, setting up a company might be overkill and more work than it's worth. Paper-

work must be filed, and fees must be paid when creating a legal corporate entity. Since you're on a tight budget, it makes sense to put off these extra costs and chores until they are necessary. Don't put them off too long, though. You may find yourself in a situation that could have been averted by simply acting sooner.

When you self-publish your game and begin seeing revenue, that revenue will have to be handled properly. And your team members (and players of your games) will want the assurance that you're handling the business side of the company properly. Here are some very good reasons for forming a legal entity:

- **A legal company is more professional.** Even if you use a simple sole proprietorship with a *Doing Business As (DBA)* filed with your state or local government, it makes your project look much more professional. This can be useful when recruiting team members, as well as when you begin selling the finished product.

- **A legal company provides better protection of intellectual property.** While ideas without implementation have little or no value, once you *have* implemented your idea and demonstrated how great it is, then your idea is at risk. As a legal business entity, you are a more intimidating target. Also, if you take the steps to get trademarks or patents, you can protect your ideas under the company's name.

- **A legal company provides better protection.** When properly set up and maintained, a legal corporation can ward off personal liability issues. As a sole proprietor, and even more so as a member of a general partnership (see descriptions of these later in this chapter), you are personally liable for everything your business does. This liability can sometimes have very unpleasant results.

- **A legal company is easier to sell.** If you use a structure like a *Limited Liability Corporation (LLC)* or an S or C corporation, you become more attractive to other companies (e.g., retail publishers) who might be interested in purchasing the rights to your game—or even your whole company.

- **A legal company is more financially responsible.** You need a legal company to get a bank account written on the name of that company, and in the United States you need a Federal Tax ID number, as well. Having a separate bank account adds to a professional appearance when it comes time to handle project expenses, profit-sharing payments, company taxes, and so on.

There are a number of company structures you could use. We will briefly discuss the most common structures used in the United States and cover both their advantages and disadvantages.

Sole Proprietorship

The simplest company structure is the *sole proprietorship*. The sole proprietorship is an individual who is 'doing business as' his or her company.

There's very little paperwork involved in creating a sole proprietorship. You may have to register the name of the company with your state or local government, but that's about it. Taxes are usually easy to handle, as well. In the U.S., sole proprietors simply file their company's yearly taxes along with their personal taxes.

There are significant disadvantages to a sole proprietorship, however. In particular, there is no asset protection and no liability protection, which means that you are personally liable for all losses incurred by your company. Also, it is difficult to sell a sole proprietorship.

As you can see in Figure 4.1, many indies begin with a sole proprietorship. As they grow, though, and especially if they partner with other indies, they move to one or more of the more involved company structures.

Indie Game Developer Survey Result

What kind of business structure do you use for your company, if you have one?

61% Sole proprietorship

15% LLC/Ltd.

12% None

7% Limited partnership

3% S-Corp

2% C-Corp

(Survey Note: 60 Respondents)

FIGURE 4.1 Indie company structures.

Limited Liability Corporation

One of the more popular company structures for indies is the *Limited Liability Corporation* (LLC). This stems from the LLC's flexibility and pass-through tax status, and the ease with which it can be created and maintained. Since an LLC is a legal corporate entity, it overcomes nearly

all of the shortcomings of the sole proprietorship, with only a little additional overhead.

Most people who form an LLC do so in the state where they live. In the U.S., though, some states are more LLC-friendly than others. You might be able to save some money and or get better protection and benefits if you 'shop around' at states other than your own. Check your local library or government information office for details on the laws governing corporations in specific states.

If you don't want to do everything yourself, there are lawyers, accountants, and consultants that make setting up and maintaining an LLC incredibly easy. For a yearly fee, they take care of most of the paperwork required. States like Nevada and Delaware, which are known for their 'export' of business filings, have quite a few such companies.

Corporations

At the top end of the U.S. company structure spectrum are the *C Corporation* (also called a *regular corporation*) and the *S Corporation* (or *subchapter S corporation*) company structures. These are formal corporate entities that require more effort to set up and maintain, but they offer options that LLCs don't: more-sophisticated tax handling, better legal protection, and the ability to sell stock in the company.

If you want to be a professional indie, you might consider starting with a C corporation. Even if you decide to start as an LLC, you might want to consider becoming an S or C corporation in the future. The long-term benefits can be well worth the initial cost and effort. One of the main benefits is in how taxes are handled, but there are others, as well. Check out the Bibliography at the end of this book for sources of information about forming and using corporations.

General Partnership

Before we leave our discussion on company structures, there is one other structure that must be mentioned so it can be avoided: the *general partnership*. In the United States, a general partnership is formed whenever two or more people agree to share the profits and losses of a venture. You don't even need a written agreement to form a general partnership—which makes it very easy to get into and very difficult to get out of.

There are severe disadvantages to general partnerships. In particular, you are now twice as exposed to personal liability than you are with a sole proprietorship, because now you are also liable for everything your partner does (and vice versa). And as you add more partners, this exposure to risk only increases.

Indie teams in the U.S. are in many cases general partnerships by default. This is almost never the best possible company structure. Without a written agreement specifying otherwise, each member is considered an equal partner with equal ownership. This can come as a nasty shock when problems arise later on, such as if there are difficulties between partners. It is best to avoid this situation by setting up a proper company structure at the start.

The company structure that is best for you, though, is a decision only you can make. You will want to discuss your business plans with a Certified Public Accountant (CPA) or even a lawyer. This consultation might even be free. Don't be shy about asking professionals for advice. That's what they're there for.

Ownership Issues: Who Owns What?

There is another very important consideration for any project, and one often overlooked by new indies. Who owns what? Who owns the game? Who owns the assets that have been contributed for the project? Unless these issues are worked out at the beginning of the project, you will be operating on assumptions—and your assumptions might be very, very wrong.

For example, you might assume that you own your game design, the documents, and whatever work you had created for the project. But do you? Had this been specified? And who owns what the rest of the team has contributed? What happens if a member of the team leaves? Do they take their contributions with them? What if they leave the project and then claim ownership after the project is finished?

All of these issues should be resolved before the first team member is added to the project. Attempting to resolve them later could be problematic at best and litigious at worst. A disgruntled team member who pulls out of the project and demands that all his contributions be removed is bad enough. Time and resources have been lost. But it could get worse. The disgruntled team member could bring legal action against you, the rest of the team, and/or the game project itself.

Similarly, if you are planning to make money from this project, who owns that money? How will bills be paid? Will the bills be paid first (as they should be), and which bills take precedence? Having a legal company to serve as the holding entity for monies can help keep some of these issues from becoming problems, or at least make handling them more organized.

How can you clear up nearly all of these issues at once and make sure every member of your team has the same interpretation? The answer is simple: you write it all down in the team member contract.

The team member contract is discussed in detail in Chapter 11, Team Basics. What follows is a quick overview. Your team member contract should cover at least the following items:

- The name and description of project.
- The stipulation that the member's work must be completed in order for them to participate in profit sharing.
- That the team members are not employees, and that possibly their contributions are 'work for hire.'
- That the team members must provide their own tools.
- Who owns the project and contributions to the project.
- How contributions to the project can be used.
- How team members are to be compensated.
- How profit sharing will work.
- The order in which the members will be paid back.

In short, the team member contract answers all of the questions that might arise. It has the advantage of providing those answers *before* you need them.

A lawyer should be consulted in order to make sure you are covering the necessary bases in your team member contract and also to verify the legality of it. Specifically, you should seek a lawyer with experience in the entertainment industry and intellectual property rights.

USING PROFESSIONAL ADVISORS

Company structures, ownership issues, and team contracts may seem like a lot to learn about and to think about. And you're right: they are. How you decide to handle these can play a major part in your success or failure as an indie. The good news, though, is that help is available, and it is often just a phone call away. Lawyers and accountants are professionals who know the law and how it impacts your business and financial concerns. That's their job. If you've never consulted one before, don't let that stop you now. Don't be afraid to ask them questions. That's what they're there for.

Using a Lawyer

A good lawyer can be a very useful resource. When you have a lawyer to help you choose and set up your company structure, and draft your contracts and team member agreements, there are several benefits: you know you're (at least) on sound legal footing and using proper of legal terms; and, in the event of litigation, you are already prepared with legal counsel.

A lawyer is, by definition, a legal consultant, so don't hesitate to consult with one if you have legal questions. Depending on his or her area of practice, you might even be able to get general business advice. What you do with that advice is up to you, of course. The important thing is to use every resource you have available in the most efficient, economical way. Learn everything you can *before* you make decisions.

There are three basic types of lawyer that you will find useful. The one you choose will depend on what you need done. The first type of lawyer is the basic, competent local attorney. They can handle day to day items, like reviewing your office lease contract, helping you form a company, checking your compliance with state employment laws, and so on. The next type of lawyer is one who specializes in intellectual properties, such as copyrights and trademarks. Finally, there are attorneys with experience in game development who can handle publisher/contract negotiations.

Obviously, not all lawyers are equal, so don't make your choice by simply scanning the local telephone directory. Consult small-business owners in your area; a great place to start is by asking for their recommendations.

Figure 4.2 shows how often the indies who responded to the Indie Game Developer Survey used lawyers.

Using an Accountant

Like a good lawyer, a good accountant can be a real asset to your budding enterprise. Perhaps you already use a CPA for your annual taxes; and if they aren't able to help you, chances are they know someone who could.

An accountant may be able to help you choose the proper company structure, and he can definitely help keep your new business's books proper and legal. Though it often becomes an issue *after* the game is completed, keeping track of all expenses and income is *very* important. You don't want to run afoul of the government by not properly reporting income and expenses for tax purposes.

Figure 4.3 shows how often the indies who responded to the Indie Game Developer Survey used accountants. Interestingly enough, the same percentage of indies used accountants as those who used lawyers (32%).

Like lawyers, accountants specialize in different areas, so put some effort into finding the right accountant to help you. Don't be shy about asking for recommendations and referrals.

Indie Game Developer Survey Result

Do you consult a lawyer for business purposes?

32% Yes

68% No

(Survey Note: 62 Respondents)

How often do you talk to a lawyer about your business?

34% Never

18% As Needed

 4% Monthly

10% Quarterly

 4% Annually

30% Other

(Survey Note: 50 Respondents)

FIGURE 4.2 Survey results on indies and their lawyers.

Indie Game Developer Survey Result

Do you consult an accountant for business purposes?

32% Yes

68% No

(Survey Note: 62 Respondents)

How often do you talk to an accountant about your business?

 9% Monthly

12% Quarterly

19% Annually

60% Other

(Survey Note: 43 Respondents)

FIGURE 4.3 Survey of indies on their accountants.

CONCLUSION

Whether you're a hobbyist, happy to gather a few players, or an ambitious professional who is planning to make it big by creating and selling your own games, there are plenty of reasons you should pause and consider future needs. Decide on your goals, and put some thought into the business side of making games. It is better to understand your options and make an informed decision, one way or the other, than to rush blindly forward, hoping for the best.

Finally, just because you're an indie doesn't mean you have to do everything on your own. Recognize what your strengths are, and recognize the strengths of others. You are a game developer, not a lawyer or an accountant. These professionals are used to being approached by new businesses of all sorts. Don't be afraid to contact them and ask for advice.

Next we will discuss how to choose a game concept based on your unique strengths and weaknesses, and how to choose one that fits within the boundaries most independent game developers face.

II

GAME DESIGN FOR SMALL- OR NO-BUDGET GAMES

The next step in the indie process is to choose a project. You can make any type game you choose. Realistically, though, you also have some very significant limitations.

Chapter 5 (Know Your Limitations) discusses the two biggest limitations faced by all independents: time and money. Then the chapter will go into the details of how retail publishers choose projects, and why you *shouldn't* use those same criteria—in particular, avoiding clones of existing games, and why you should stay out of the 'technology arms race.'

Chapter 6 (Choosing a Suitable Game Concept) shows how, even with the limitations discussed in Chapter 5, you can still create unique and exciting games. Many examples of creative indie games are given to show the range of what is possible.

Finally, Chapter 7 (The Game Design Document) will describe how to take your initial game concept and flesh it out into a full game design.

5

KNOW YOUR LIMITATIONS

IN THIS CHAPTER

- The Primary Limits: Time and Money
- Different Approaches
- The Technology Arms Race
- Work Within the Limits

"*K*now thyself," an ancient proverb, was carved in stone above the Oracle at Delphi. It is important to know yourself in order to be successful. You must know not only what you are capable of, but what you are *not* capable of. Realistically assess what you can do before you choose a project; and to do that, you must "know thyself."

The first step is to honestly assess your limitations. Your dreams are like no one else's, and they dazzle your mind's eye. But unless you've won the lottery or inherited a fortune, you're going to have tone down your dreams a bit, at least for now. Assess the time and money you have available, and learn to work within your means.

Next, recognize that how you choose your projects is very different from how retail publishers choose their projects. Besides having fewer resources available, you also have different goals and needs, so don't just follow the publishers' examples.

Finally, stay out of the 'technology arms race.' Retail games often try to outdo one other in the technologies they use—rendering technology, real-world physics, game world size, and so on. Again, the retailers have different goals, different needs, and different resources available. You must focus on doing more with less.

The future has no bounds, but you do. Unless you take your limitations and boundaries into account, you can't adjust for them. You cannot do more with less until you know what's available.

THE PRIMARY LIMITS: TIME AND MONEY

It is said that all art is created within constraints. You can either accept your constraints from the onset, or expect that they will be imposed on you later. If you accept them from the beginning, then your constraints don't control you; they only describe your operating environment. But when the constraints arise after the work has begun, your design might be thwarted. You might be forced to change your game plan.

Time and money are the two most significant limits (boundaries) that govern what you can accomplish. Even the most passionate, persevering developers still have only 24 hours a day to work with. Thus, time is always in short supply. And money (the more obvious boundary) might seem even scarcer than time.

The Time Boundary

If this is your first foray into creating an independent game, you probably have a full-time job. You plan to work on your project in your off hours, which is how many independents get their start. This is probably the best way to begin as an indie.

 Make sure that your employer hasn't made you sign an intellectual property agreement granting them all rights to anything you create, on or off premises, while you're employed by them. This could make things sticky. Consult a lawyer if you're unsure.

Even if you're a college student, there are still have considerable constraints on your time. There are classes to attend, papers to research, projects to complete, and so on. Your primary obligations, whether they be work or school, are going to eat up at least eight hours of your day. Throw in the eight hours you should be sleeping each night and a couple hours for 'life chores,' (e.g., eating, showering, dressing, etc.), and you're down to about six free hours per day. If you have a family, you should spend at least a couple hours each day with them, which drops your available time down to three to four hours.

Maybe you can add a few extra hours on the weekend, but don't count on it. Weekends have different priorities and demands, and there are still only 24 hours to work with in a single day.

Adding to your available time by sleeping less can be unhealthy. Missing a little sleep every so often isn't too bad, but losing significant amounts of sleep over period of weeks or months can put a drag on your overall productivity and have serious health consequences. Don't make your plan depend on sleep deprivation. Instead, cut something else out of your schedule, or change your schedule (see Chapter 4). Three to four hours of project time per day might not seem like a lot; but then, there's probably nothing worth watching on TV, anyway.

To put this in perspective, consider the results from the Indie Game Developer Survey shown in Figure 5.1. Forty-two percent of the projects took more than six months to complete, and some took as long as two years. *Artifact*, by Samu Games, took nearly three years to produce from the design stage to initial release, with four team members working on a part-time, volunteer basis.

Finding (or making) the time to work on your project can be hard to come by. The project might eventually have a production time that is much longer than originally planned. This further underscores the need for pacing yourself (see Chapter 3).

The Money Boundary

You might as well accept that your project is going to be funded by you, alone. Venture capital investors aren't going to be interested in providing funding, and angel investors can be as hard to find as angels with wings. So, the money that's spent on your project is going to be *your* money.

With planning and careful budgeting, though, your project shouldn't need more than a few hundred dollars (certainly no more than a few

Indie Game Developer Survey Results

What is the length of development time for projects you have completed?

15%	Less than three months
43%	Three to six months
19%	Seven to 12 months
10%	One to two years
13%	More than years

(Survey Note: 60 Respondents)

FIGURE 5.1 Indie project development times.

thousand dollars for most indie projects). If this seems high to you, take heart. Most expenses will be spread over the life of the project.

Figure 5.2 shows budget numbers that were collected in the Indie Game Developer Survey. More of than half (56%) of the projects reported had no budget to speak of. A very small percentage (7%) had budgets of $10,000 or more. Your first project will probably fall somewhere between the two.

The money boundary will most often arise when you attempt to overcome the time boundary, and you try to hire someone. Work-for-

Indie Game Developer Survey Results

What is the budget, or actual money spent toward the completion of your project (e.g., for components, contractors, servers, etc.)?

56%	Eh? Budget?
17%	$0–$1,000
20%	$1,001–$10,000
5%	$10,001–$100,000
2%	More than $100,000

(Survey Note: 60 Respondents)

FIGURE 5.2 Indie project budgets.

hire contractors usually do so as their full-time job, and they charge for their time appropriately. This makes contractors something of a luxury for your first project.

The money you spend on your project will mostly go for third-party products, such as libraries, components, or even content. Third-party solutions are generally more flexible and cheaper than contractors, making them the indie's best friend—and usually a very good investment. Vendors of third-party solutions can spread their costs over many buyers, like yourself (see Chapter 17), so the unit price is significantly lower than a contractor's custom solution. Plus, most tools, components, and libraries can be purchased once and then used over again. The cost for one project can then be 'amortized' over several projects.

DIFFERENT APPROACHES

Now that you have a basic understanding of your limits in terms of time and money, it is just as important to know what *not* to choose, and *why* not to choose it. Publishers and publisher-funded game development companies have very different goals than indies. Therefore, their approach toward choosing game projects is also quite different.

The Retail Approach

The retail approach to selling computer games boils down to two concepts. The first is obvious: sell as many copies of the game as possible. The second concept is a natural outgrowth of the first: avoiding risk by repeating successful formulas, which is the strategy of nearly all businesses hoping to make a profit.

The Need to Sell Through

Selling through is a retail term that means to sell the games to actual players (end users). Between the publisher and the players is at least one, and often two layers. The first layer is the distributor, which buys copies of the game from the publisher and sells them to the second layer, the actual retail outlet. Sometimes publishers bypass the distribution layer and deal directly with the retail outlet.

Selling through is very important for a game, because unless the game sells through to players (and isn't returned), the publisher is the one that assumes the loss in sales. This is because the distributor and retailer also put a strong emphasis on avoiding risk. If the retailer can't sell the game, the game goes back to the distributor. Likewise, if the distributor can't sell the game to retail outlets, the game gets packed up and sent back to the publisher.

Sales (selling units) is the basis for any business, and computer game sales are no different. This leads us to the next part of the retail approach to choosing game projects: avoiding risk.

Avoiding Risk

Avoiding risk is another business term, and it means exactly what it implies: do not take any unnecessary risks. The budgets for computer games have reached into the millions of dollars, and the time to create them has stretched into multiple years. Consequently, the risk of making computer games has grown to match these investments in time and money.

With millions of dollars on the line, publishers have to sell through hundreds of thousands of copies—and for console games, *millions* of copies—of a game title in order to 'break even' on the project. That kind of pressure makes publishers very adverse to risk. Even if they're counting on just one or two 'blockbusters to offset the losses on less-popular titles, they're still not going to stray too far from the established retail genres.

"Proven successful" is the retail publisher's mantra. They only want to back projects that can show track records in as many areas as possible, such as in the success of the development team and/or the project's genre.

"Proven Successful" or "How to Get a Publisher"

The Introduction to this book stated that advice on finding a publisher would not be included. Well, that's not *entirely* true. If you understand the retail value chain and can read between the lines, you can discover how to go about finding a publisher to fund your project. It all boils down to the phrase: "proven successful."

Show a publisher that you are 'proven successful' in as many areas as possible, and you greatly improve your chances of landing a contract. Here are a few ways to do just that, suggested by Randy Dersham in a presentation at the Indie Games Con in 2002 [Dersham02]:

- Have completed projects (the more successful, the better).
- Have team members with industry track records.
- Have experience in a specialty or genre that the publisher is interested in.

(continued)

There are a couple other ways to can get a publisher interested in you:

- Have intellectual property or a licensed property that the publisher wants.
- Be able to meet a deadline that the publisher is having difficulty meeting.

In summary, you can land a publishing deal if you show the publisher that you present very little risk and can, at the same time, help them meet their quarterly sales projections.

'Proven successful' applies to just about every aspect of making games: the team of developers, the subject matter of the game, the user interface, and so on. Anything that has been used to make a successful game can and will be used again. This is how 'genres' came into existence and why those genres see new titles appear every year.

By now you should have a better understanding of how retail publishers choose projects, so it is time to look at the indie side of the computer game universe.

The Indie Approach

Unlike a retail publisher, you can afford to take risks. This is one of the primary advantages of being an indie, and it's true in all industries, whether computer games, feature films, or music. You do not have to sell to the mass market to be successful, and you have many more options in terms of subject matter, interface, and gameplay.

Indie Economics

The independent game developer doesn't have to sell anywhere near as many units as the retail publisher has to in order to make a profit. As an indie, you can target smaller, vertical or niche markets that large retailers overlook. You can keep your overhead to a minimum and keep more of the purchase price than a developer hoping for a back-end royalty is ever likely to see.

Also, since you don't have an outside party holding your purse strings, you answer only to yourself and your team. Thus, you are free to work on projects that traditional publishers wouldn't be interested in, either because the subject matter doesn't appeal to them or because the potential market share is too small.

An independent game that sells over 1,000 units generates a healthy profit, even at a relatively low price point. For example: If the game is priced at $19.95, then its profit margin can easily be at least 75% (with 25% lost to payment processing, download bandwidth charges, etc.), or about $15. At 1,000 units, that represents a profit of $15,000—hardly enough to make you rich, especially when shared with three or four team members; but it's still not bad for a part-time, after-hours project with no up-front budget. It gets even better when you have several such games, all selling at (or about) the same rate, and all contributing their small part to a much larger whole. This will be discussed in more detail later.

Compare the previous scenario to a similarly priced retail game. At best, the developer's royalty *may* reach $2.00 per game copy sold. Therefore, the game has to sell many more copies at the retail level in order to generate the same amount of profit for the developer. To make matters even worse, since developer advances must be paid back to the publisher prior to the developer receiving royalties, sales would have to approach 100,000 units before the developer sees any back-end money at all. Even then, we're assuming that the developer's advance on royalties is only about $200,000, which is hardly sufficient for most retail games.

This comparison should clearly show that you do not have to follow the same decision-making processes as retail publishers. As an indie, you don't have to meet shareholders' expectations. You don't have to seek the 'proven successful' project. You can be—in a word—independent.

So what are you going to do with this newfound freedom?

The Usual Suspects

Many would-be indies make the mistake of trying to create a game that is similar in type or genre to a retail game. Classic examples are Role-Playing Games (RPGs), Massively Multiplayer online games (MMPs), First-Person Shooters (FPSs), and Real-Time Strategy games (RTSs). These are the games the developers enjoy playing—the games that are sold at retail outlets all across the U.S.; so these game types seem to be obvious candidates.

In our age of 'endless possibilities,' these types of games *can* be done by indies and have been. The downside, however, is that these games require significant programming, content, and infrastructures, requirements that are well outside the time and financial limitations faced by most independent developers, especially on their first project. And without the marketing clout of a retail publisher backing one of these new games, your contribution is unlikely to ever be noticed.

RPGs, for example (especially first-person, 3D RPGs), require strong story lines with good puzzles and a sense of mystery. They also usually require a significant amount of content creation in the way of artwork, sound effects, and music. On the flip side, though, the programming

(technical) side of an RPG might not be as involved, assuming you do an RPG like *Myst,* rather than like *Neverwinter Nights.*

MMPs have a very large infrastructure requirement. They also have enough content to make an RPG seem like a small-scale project. Such games require dedicated servers and a good connection to the Internet. Just the necessary 'server farm' is a big up-front expense; but this is insignificant compared to the initial cost and maintenance of a good Internet backbone. Furthermore, depending on the nature of the MMP, there could also be some complicated programming involved. MMPs are, for the short term at least, well outside the scope that most indies should tackle.

FPSs (shooters) have generally become less of a challenge to create, since the technology required to create them is increasingly available and inexpensive. However, a retail FPS is generally competitive only if it advances the genre in terms of photorealistic 3D rendering and special effects. FPSs have proliferated to the point that it is very hard to differentiate them. Unless it is one of the best sellers (e.g., *Doom*®, *Quake*®, or *Unreal*® *Tournament*), or it pushes the boundaries of acceptable content (e.g., extreme sex or violence), it's unlikely to be noticed. As a first indie project, the FPS offers a variety of readily available tools and content; but the expected market segment for an independently created FPS may not be very large.

RTSs have seen considerable retail presence over the past three to five years: sci-fi, medieval, fantasy, post-apocalyptic, conquer the world, build a railroad; they go on and on. Three-dimensional RTSs are the most recent innovation, though this doesn't seem to have changed the gameplay significantly. What it has done is add quite a lot to scheduling and budgets. RTSs also have significant art content requirements, and if they are also built to be MMPs, then those issues apply, as well.

Another (Very Small) Face in the Crowd

There is nothing inherently wrong with pursuing any of the types of games described above. If you can keep the scope small while also offering something new and unique, there's no reason not to make one and have it be successful. The problem is that these genres are all incredibly crowded; there is intense competition here, and most of your competitors are (much) better funded than you are.

In short, you cannot hope to have even moderate success with a game that is merely a clone of another game genre. When you compete with retail titles, you compete with not only their rendering technology and art content, but also with their marketing budgets. For example, you recognize a huge current market for RTSs, and you have created one that is innovative and a lot of fun. But the existence of this huge RTS market has hardly gone unnoticed by the retail publishers. They've funded projects of their own to capitalize on this sudden popularity. And, as their

projects approach completion, the publishers' marketing departments will be vying for the attention of players and leveraging large advertising budgets to garner positive coverage and reviews. With that kind of competition, the unfunded indie will not be noticed.

THE TECHNOLOGY ARMS RACE

You should also avoid joining the technology arms race that so often defines modern computer games. Retail games often try to stand out from the competition in the technology they use. Indie games, however, should seek to stand out based on their concept and/or gameplay, their creativity and innovation. But the main reason you should stay out of the technology arms race is because you simply can't afford to compete.

What are the weapons of the technology arms race? In short, they're the technical aspects that are designed into the game software usually at the expense of, and sometimes offered as a replacement for, designing a game that is unique and different. For example, there is a plethora of games that utilize real-time 3D rendering, whether the game needs it or not.

The technology arms race produces games that target 'hard-core' game players who buy the latest and greatest hardware for their computers. These players buy new 3D cards and chipsets as soon as they're released, and overclock their CPUs for a marginal increase in performance. And there's a really good chance that you're one of them, too.

The Old 'Mainstream'

It's easy to understand why the hard-core market segment is (or was) important. It formed nearly the *entire* market for the first couple decades of the computer game industry. It is also important to note that a large proportion of game developers came from, and still come from, that market segment.

However, with computer games becoming a more mainstream, mass-market entertainment, not only is that market segment incredibly over-serviced, it's also shrinking in significance as a whole. The market for computer games has expanded well beyond the hard-core sector.

Despite the overall growth of computer game market, there is still a disproportionate focus on the hard-core gamer. Even when the best-selling games target the *real* mainstream, big budgets still go to developers who make edge-cutting, dark games designed to impress the hard-core gamer. It's a hard habit to break.

The Technology Demo

One of several consequences of over-servicing the hard-core game players is that the games released each year try to out-do the others in terms of technical prowess—the fastest triangle rendering, the highest frames per second and most objects on screen, or the most photorealistic real-time display.

The success of developers like Id Software and Epic Games in licensing their 3D, multiplayer engines has prompted other developers to attempt the same thing. This has sometimes had the result of producing games with only minimal gameplay; the developers were focusing on their engines. These 'technology demos' end up being more about selling the engine or impressing other developers, rather than creating an exciting new game.

Not Built Here

Many game development companies also operate under the 'Not Built Here' syndrome. The Not Built Here syndrome, which is especially prevalent among programmers, results in developers recreating the engine and tools for every project from scratch. Perhaps they are convinced they can build it better than anyone else, or perhaps they're just itching to rewrite a tool that was hastily created for a previous project—either way, the developers throw out almost everything they have accumulated and start over.

In the early years of computer games, this all-encompassing slate-wiping was acceptable and possibly even necessary. The tools and methodologies for creating software were in flux for many industries, not just game development. Often, these tools evolved while still in use. There was little choice but to start over each time.

The tendency to rebuilding everything from scratch for each project is, fortunately, beginning to wane. Tools that currently exist, and which cover every aspect of game development, have become very sophisticated and inexpensive. However, as long as publishers are willing to fund the reinventing of even the most basic components, the practice will continue.

Drop Out of the Race

The simple truth is this: as an indie, you cannot cater to the hard-core gamer market. Until retail publishers abandon that market (and it doesn't look like that's going to happen any time soon), the cost of entry into this segment is just too high. It may be tempting to focus on the cutting edge of game development, but it is simply not feasible for an indie to try to keep up with the 'big guys.'

The retail publishers can devote resources and personnel toward achieving marginal improvements to specific areas of development. As an indie without funding and a very small team of volunteers, you cannot afford to focus on anything except getting the game completed. 'Gold plating' functional (if not optimal) code simply will not pay for itself in either the short or long term.

Focus on compelling gameplay and forego the 'high-gloss coating.' The game must be solid and fun to play, even if it's not a technological *tour de force*.

Use Existing Technology

Competent use of existing technology is the key to success. Anything you have to build for yourself makes the overall project that much more likely to fail. To be successful, you must know your limitations and accept them. With limited resources and a small team, it's important to leverage as much as you can.

If you absolutely must use cutting-edge techniques that target the latest and greatest hardware, then you should be looking for a job with a game development shop, rather than trying to go it on your own—that is, unless your designing is just a hobby, and you're happy making mods.

Chapter 17, Maximize Your Use of Third-Party Tools and Solutions, covers third-party solutions and tools in detail. The point here is that 'day-old' technology can be your best friend. In many respects, even though they're 'dated,' these techniques are still going to be useful for creating a lot more games than were created when they were 'the latest thing.'

Such technology also offers advantages in pricing and in stability. The cutting-edge technologies command the big bucks, while yesterday's technologies are almost given away. Another advantage is the stability of these tried and true technologies; titles have already been created using them, a large portion of the bugs have been fixed, and what they can and can't handle has been investigated.

Perhaps you think that 'day-old' technology isn't as attractive as cutting-edge 3D graphics with eye-popping visuals. But stop and ask yourself: How many times have you played a visually stunning game that was paper thin when it came to gameplay? And how many games have you enjoyed that were 'behind the curve' technologically? It's not an either-or situation, where games are either fun to play or look really good, and can never be both. Far from it. Some notable games have achieved both. The issue is that you, as an indie, can either focus your limited time and resources on getting a good game done, or you can spin your wheels in frustration, trying to out-perform the top of the food chain.

Indie games need to look good to be successful, but this doesn't require (bleeding-edge) state-of-the-art graphics, sound, and music. The

more reasonably priced technologies that have proven themselves will do quite nicely. Of course, it is important for the game to look 'modern.' But modern doesn't have to mean last week. It can mean last year.

With that in mind, if an indie game sees some success, however small, it's usually possible to very quickly upgrade the look and feel of the game. With some planning in the early stages of development, a game with 'dated' graphics can be updated after it's completed, thus keeping it current and extending its life indefinitely.

WORK WITHIN THE LIMITS

In order to complete an independent project, you are going to have to work within the constraints of your available time and limited funding. Unlike a retail project with its full-time staff, your project has only you and, at most, three to five other team members working an average of two hours a day, five days a week, and with only a minimal cash outlay. But even retail projects work within these constraints. Like you, they only have so much time available (the same 24-hour day) and operate on fixed budgets.

Focus on Gameplay

With the limitations imposed on indie developers, it would be folly to try and one-up a publisher-funded game. Your advantage, though, is that you and your team can be more focused and more efficient.

You can devote your time and energy almost exclusively to gameplay and avoid the need to invest heavily in cutting-edge technology. And, as our previous discussion on 'indie economics' taught us, we don't have to have a hit on our hands to see income from the project. To properly capitalize on this effort as it relates to your returns ratio, you must know what can and cannot be reasonably accomplished. Don't attempt to compete on the basis of technology; use whatever is good enough for the project. Photorealistic 3D rendering, for instance, is currently outside the reach of most independent projects; but high-quality 3D rendering is readily, and sometimes freely, available. Leave the technology demos to the publisher-funded shops.

Untapped Potential

It may seem that your limitations leave you very little room to operate; but if you take the time to consider what *can* be done rather than what *can't* be done, you will see that there is still a vast, untapped potential in computer games. Even such well-trod genres as first-person shooters and

real-time strategy games haven't explored all the possibilities. The nature of hit games is that they spawn other, similar hit games. Most games with a first-person element tend to be distant grandchildren of *Wolfenstein*, and most real-time strategy games tend to be resource-gathering, combat-oriented progeny of *Dune II*.

The technology for these types of games and others has become readily available, if not with the latest and greatest capabilities, then at least good enough to serve as the basis for a game that explores other avenues. While not an indie game, the original *Deer Hunter* illustrates this principle quite well. *Deer Hunter* was built in a matter of months with existing technology and then outsold most of the so-called cutting-edge games that were released the same year. Similarly, *Roller Coaster Tycoon,* which was created almost entirely by a single developer, is a real-time strategy/simulation game that became a huge hit.

Just because there are established game genres doesn't mean your game has to fit within them. You can create your own genre; and with some planning and 'sweat equity,' you can create games that don't require more than the few people and limited funds you have available.

There are always new games to be discovered and played, even within the tight constraints of time and money. Focus on what you can't do, and you'll never do anything. But if you embrace these limitations and are open to the endless new possibilities, you'll amaze even yourself with what you can accomplish.

CONCLUSION

As an indie, you have more constraints than the developer who is funded by a publisher, namely time (i.e., the demand of your other responsibilities) and money (i.e., no outside funding). On the other hand, publisher-funded developers have limitations that you don't have—they must convince the publisher that their game will sell enough money to earn back its development costs.

By accepting your time and money limitations at the start, you can better choose your project and design it to be as good as possible within those limitations. Exercise your freedom. Be willing to take a few risks in the design, content, or presentation. Ignore the security of what's already been done.

But don't venture onto the big retail sellers' turfs. Come up with a new angle, something fresh. Even in such well-worn genres as first-person shooters and real-time strategy games, there are new games waiting to be discovered.

CHOOSING A SUITABLE GAME CONCEPT

IN THIS CHAPTER

- The Usual Suspects, Again
- Some Unusual Suspects
- Simple Market Research
- Choose a Game You Care About

opefully, Chapter 5 enlightened you on the kinds of games you *shouldn't* plan to tackle as an independent game developer. At first, it may seem like all of the obvious choices have been eliminated, which may be true. These genres have already been done to death; so, avoiding the themes that have already saturated the market is a almost certainly good thing.

We've also scratched off our list anything that requires extensive staffing or a huge budget. Indies are not likely to have either of these at hand; it would be folly to begin a project that demanded a large team or huge initial investment. And when cutting-edge technology projects are added to our list of games to avoid, what does that leave?

There are many more options available than you might think, even within the genres that already receive a lot of attention. The trick is to look at computer games from a unique perspective. Don't look at what's been done. Instead, look at what is possible—which is, after all, what being an indie is all about: Do it *your* way, and that applies to game design, too.

THE USUAL SUSPECTS, AGAIN

In the previous chapter, we listed the reasons you should avoid the established, retail game genres. The reasons given centered on significant programming/technology, huge amounts of content and capital investment, or that they had simply been done over and over again. Now, though, we're going to tell you how you *could* approach creating a game in one of those genres.

In short, with a full understanding of your limitations as an indie game developer, you can focus on using the framework of each genre to create a new game concept or take an existing game concept in a new direction. Keep your eyes, ears, and mind open to the possibilities.

FPS Games

The 3D first-person shooter genre has been exploited to an incredible extent. But what about a paintball-themed FPS? In a sense, most FPSs are already very similar to paintball—'play' weapons, imaginary violence, and so forth. Despite the growing popularity of paintball as a weekend pastime, and even as a professional sport, only a few commercial paintball games have been made.

This is why Samu Games decided to resurrect its original *Paintball Net* as a 3D game based on the Torque Game Engine by Garage Games (*http://www.garagegames.com*). With both realistic and fantastic paintball equipment—everything from simple free markers to rocket-propelled

paint grenade launchers, from down-padded jackets to 'refracted-light cloaking suits'—*Paintball Net* would be unique enough to set it apart in the crowded marketplace. Persistent player statistics and multiple, dedicated 'paintball field' servers were also added. And rather than have a single, continuously running 'death match,' *Paintball Net* would feature fast-paced, single-hit elimination matches that last only a few minutes, with new matches starting every few minutes. Not exactly the most original plan, but perhaps different enough.

There are many more types of new, innovative FPSs waiting to be made. Ask yourself questions that might at first seem a bit 'off the wall,' such as: "Why do these games have to be 'shooters'?" The market for non-combat games within the mainstream market might be larger than the traditionally targeted combat segment. Not everyone wants a 'shoot-em-up.' Think of the possibilities of a game based on prehistoric tribes of hunter-gatherers, or a food-fight game that takes place in a school cafeteria. Don't be afraid to move outside the realm of what's already been done.

Clever examples of what can be done with FPS technology are *Orbz* by 21-6 (see Figure 6.1) and *Marble Blast* by Garage Games (see Figure 6.2). Both games use the Torque Game Engine, which was originally created for the sci-fi multiplayer game, *Tribes 2*. *Orbz* and *Marble Blast* are not traditional FPSs; they are almost 100% violence free.

FIGURE 6.1 *Orbz* © 21-6 Productions, Inc. Reprinted with permission.

FIGURE 6.2 *Marble Blast* © Garage Games. Reprinted with permission.

RTS Games

Real-time strategy games have also been done and done again. Despite this, the RTS genre has still not been fully exploited. As long as you stay away from the well-worn combat themes, and if you keep the amount of art, sound, and music requirements to a minimum, there's no reason why you couldn't do a real-time strategy game. Many possible gameplay variations still exist that would be ideal for real-time simulation.

In 1996, Samu Games decided to create a persistent-world RTS, *Artifact* (see Figure 6.3), which was released in 1999, about the same time many other retail RTS games (e.g., *Command&Conquer: Tiberian Sun* and *Age of Empires*) came on the market. *Artifact* was different from the other games due to its pure multiplayer status (no single-player version of the game was made), persistent world, and strong community emphasis; but, as might have been predicted, sales growth for the game was slow. The RTS market glut remains a challenge for all the new RTS games. However, *Artifact* is still online and growing in popularity, so the designers must have done something right.

Like the FPS, the RTS has historically been dominated by violent themes, but there's no reason to let that limit your thinking. How about flea markets? Or maybe auction houses? What about fortune tellers who

FIGURE 6.3 *Artifact* © Samu Games, LLC. Reprinted with permission.

compete to attract customers by using scented candles and understanding what fortunes the 'seekers' want to hear? Anywhere people are normally in competition could form the basis for a real-time strategy game. Your options are limited only by your imagination.

RPGs

A role-playing game is also be feasible for an indie if it has an adequate storyline, and the content is workable with a minimal amount of art and other resources. (Perhaps you can create them yourself.) Spiderweb Software, Inc. (*http://www.spiderwebsoftware.com/*) is an indie game developer that has successfully created RPGs that leverage some of the older, isometric styles, such as those popular in the late 1980s and the 1990s. One of these games is *Avernum 3* (see Figure 6.4), which has been ported to both the Windows and Apple Macintosh platforms.

These days, RPGs can sometimes be hard to distinguish from FPSs. Both use 3D rendering and first-person viewpoints. The RPGs can require a lot of graphical content, but they can be done as an independent game if you limit their scope. *Pierre's Nightmare* (Outhouse Software) is an example (see Figure 6.5) that uses a standard FPS 3D interface, but with a

FIGURE 6.4 *Avernum 3* © Spiderweb Software. Reprinted with permission.

FIGURE 6.5 *Pierre's Nightmare* © Outhouse Software. Reprinted with permission.

twist that is reminiscent of the retail RPG, *American McGee's Alice*, by Electronic Arts.

Flight Simulators

Flight simulators are a narrower niche than most of the established genres covered thus far. There are two main varieties of flight simulators. The first is the complex, detailed simulator that strives for complete realism. The second type is more game-like; it focuses less on realism and more on being easy and fun to play. Both types of simulators have their devotees.

Laminar Research, makers of *X-Plane* (*http://www.x-plane.com*), has focused on ultra-realistic flight controls and physics. At the other end of the spectrum is *Dog of Prey* by Darkhand Team, which features cartoon-like planes and landscapes (see Figure 6.6).

FIGURE 6.6 *Dog of Prey* © Darkhand Team. Reprinted with permission.

Multiplayer Games

Massively multiplayer online games, especially the multiplayer role-playing games, are very challenging projects for indie game developers, but they're

not impossible to handle. eGenesis has proven this with the release of *A Tale in the Desert* (see Figure 6.7). But the difficulties inherent in these massive projects make them unfavorable candidates.

FIGURE 6.7 *A Tale in the Desert* © eGenesis. Reprinted with permission.

Despite the challenges, though, multiplayer games represent a huge, open field for independent game developers. Along with the growing, overall market of computer owners has come increased Internet access; and there is more demand for multiplayer games. Since the retail publishers seem to be focusing on the *massively* multiplayer games, that leaves several large niches for small developers.

Not every game can (or should) be made into a multiplayer game, but many can; and quite a few can be designed from the beginning to be multiplayer. Tams11 Software (*http://www.tams11.com*) has carved a niche for itself by creating not only a collection of small, unique multiplayer games, but also by creating the Tams11 Lobby to host those games and provide matchmaking for players (see Figure 6.8).

FIGURE 6.8 Tams11 Lobby © Tams11 Software. Reprinted with permission.

Multiplayer games have a very significant advantage: these games come with a standing community of players. Your players meet as part of playing the game, so a community is automatically created, which can be very useful as you make and release other games, as will be discussed in Chapter 28, Leveraging Existing Products and Customers.

Some Unusual Suspects

In addition to previously discussed genres, there are many other possible game types that you may not have considered. Some of these, like card and puzzle games, have already become very popular with small game developers. But keep in mind that you should avoid overcrowded indie game niches just as you would overcrowded retail game niches.

Consider the examples presented in this book as inspiration for what you *can* do, rather than a lecture on what you *should* do. The important thing to learn from this chapter is to always be on the lookout for unique ideas. For example, *BaseGolf* (Alitius Games) combines baseball and golf with lighthearted artwork to create a different, but fun game experience that almost defies genre classification (see Figure 6.9).

FIGURE 6.9 *BaseGolf* © Alitius Games. Reprinted with permission.

Action Games

Action games cover a wide territory. Once dominated by the 2D side-scroller, action games have followed the other genres into 3D. FPSs were originally an offshoot of action games and have taken over the genre to an extent, but there are many types of action games. *Ploing 2*, published by Dexterity Software, is a 3D-action pinball game with an arcade style (see Figure 6.10).

Card Games

Card games have been popular with indies for years, and most of the standard card games have been done extensively. Solitaire and its many variations, for example, has proven very profitable for a few independent companies, like Silver Creek, whose *Hardwood Solitaire* is shown in Figure 6.11. But the card game niche as been pretty saturated. Still, there are hundreds, if not thousands of card games based on the standard 52-card deck that haven't been made into computer games yet; so there's room for growth.

FIGURE 6.10 *Ploing* © Dexterity Software. Reprinted with permission.

FIGURE 6.11 *Hardwood Solitaire* © Silver Creek. Reprinted with permission.

If you combine cards with other common game implements, like dice, you can create your own unique game. In addition, you are not limited to the 52-card deck that is standard in the United States. Other countries have their own traditional decks and card games. The Web can provide you with more information and inspiration, such as the National and Regional Card Games Web page at *http://www.pagat.com/national/index.html*.

There are also various types of Tarot decks, or you can even make up a deck of your own and base a game on it. Finally, don't forget games like *Magic: The Gathering*, published by Wizards of the Coast, which created a whole new genre of collectible card games.

One last word about card games: non-solitaire card games are multiplayer games, so these games can be useful in tapping the multiplayer game market.

Tile Games

Tile games, like dominoes, have more of an Oriental flavor than card games and have also been a popular choice for indie game developers. *Twilight Mahjongg*, by Twilight Games, is a prime example (see Figure 6.12).

FIGURE 6.12 *Twilight Mahjongg* © Twilight Games. Reprinted with permission.

With tile games, you aren't limited to any standard set of tiles or games based on those tiles. And like card games, they also have multi-player possibilities.

Dice Games

The reader is advised to avoid the more common dice games, since those have been done to a great extent. Take, for example, *Yahtzee*. Unless you come up with a variation that adds a new dimension to a common game, you should avoid these well-worn paths and create your own, novel games.

Even if you stick with the standard six-sided die, there are a lot of possibilities for both single-player and multiplayer dice games. The *Tams11 Lobby* features several unique dice games, such as *Trotter*, a horse race game, and *Dartzee* (see Figure 6.13), which combines barroom darts with a dice game similar to *Yahtzee*.

FIGURE 6.13 *Dartzee* © Tams11 Software. Reprinted with permission.

Dice come in all numbers of sides these days, made popular by pen-and-paper role-playing games like *Dungeons & Dragons,* by Wizards of the Coast. From the pyramid-shaped 4-sided die to the 6-, 8-, 10-, 12-, and 20-sided die, there are many varieties of modern dice. Of course, since you are making a computer game, there is no reason to limit yourself to dice that sport numbers, either. Your only limit is your imagination.

Word Games

Word games, especially multiplayer word games, have become very popular on the Web in the past few years. Word games come in many varieties and often incorporate the features of tile games, dice games, or both. Like tile and dice games, word games require fewer development resources. *Inkling*, by David Michael, is an example of a multiplayer crossword game (see Figure 6.14). Complex rendering and shading aren't required, and the graphics and sound resources of word games are usually simple.

FIGURE 6.14 *Inkling* © David Michael. Reprinted with permission.

Word games have fewer 'playing pieces,' though. If you're targeting English-speaking players, that means you're limited to the 26-letter Roman alphabet, with the possible addition of numbers (zero through nine) and punctuation (e.g., "Right!"). Despite this, there are still a lot of possibilities for word games. Your game could be based on letter combinations, for instance. It doesn't need to focus on creating actual words. For example, several popular word games are based on creating phrases to match randomly generated acronyms.

Puzzle Games

Like card games, puzzle games have been the launch pad for quite a few independent game developers, like Dexterity Software (*http://www.dexterity. com*). The popularity of their puzzle game, *Dweep* (see Figure 6.15), provided enough of a foundation to enable Dexterity Software to help other indies publish their games.

FIGURE 6.15 *Dweep* © Dexterity Software. Reprinted with permission.

Unlike card games, which tend to look similar, puzzle games have no bounds. Anything can be made into a puzzle game. *Dweep*, for example, is about a purple furry creature using common items like buckets of water and heating pads to defeat lasers and bombs in order to rescue its children. *Quaternion*, a puzzle game by Spin Studios, has falling colored balls that you match up to clear the accumulating piles.

The only downside to puzzle games is that they *have* been such a popular starting point for indie game developers over the years. Because of this, if you want to create puzzle games, you need to do a lot of research into the games already available. Learn what has worked for other game developers; but, more important, if you learn what's been done before, you won't inadvertently create an uninspired retread of an old idea. Your

possibilities for something new are endless; just be willing to look at the world in a slightly different way.

Strategy Games

There are a wide variety of strategy games. Many are based on combat and warfare, but there are also strategy games based on business, gardening, transportation, and other topics. Whether they are turn-based or real time, strategy games are usually competitive. Without opponents to play against, strategy games become puzzle games. A strategy game needs to be either multiplayer or provide strong AI-based computer opponents.

Many of the best strategy game examples are board games, like the *Settlers of Catan* and *Empire Builder* by Mayfair Games. If you want to make strategy games, but are unfamiliar with board games, take the time to check out the game shelves of your local board game shops.

There were a lot of new strategy board games released in the 1990s, many of them imported from Europe. While strategy games designed in the United States tend to have a war/combat theme, the games from Europe and Asia often cover a broader spectrum encompassing history and the human experience.

Regardless of their origin, some of these games have deceptively simple game mechanics that offer a depth of gameplay that is nothing short of incredible. You can learn a lot about game design by studying modern strategy board games; so don't be afraid to consider influences from outside of the computer game industry.

MARKET RESEARCH

Many game developers declare that they only create games they want to play. For them, games are a form of self-expression. Having a salable product is secondary to seeing their vision grow from an idea to a completed game.

If you plan to self-publish your game, though, you should make sure that there's a market waiting to buy it. Know who you're going to sell the game to from the beginning.

Steve Pavlina (Dexterity Software), in his aptly named Web article, "If You've Tried Everything Imaginable And Your Product Still Won't Sell, Here's What You're Missing," stresses the use of basic market research techniques for identifying a market for your game or other product *before* you begin developing it. And Brian Tinsman, in *The Game Inventor's Guidebook* [Tinsman02], repeatedly stresses that success in making games begins by identifying who you are making the game for.

Simple Market Research

Market research means exactly what it implies: researching the market. The basic goal of market research is to assess what people are currently buying and to discover what needs exist that are not being met. For the indie game developer, market research boils down to find out what games are available in both the retail outlets and from other indies.

You can easily handle your own market research. You don't need expensive consultants or agencies to conduct focus groups. All it takes is a few days of your time.

The first step is to decide what it is you're trying to find out. If you're like most developers, you already have a game idea. What you want to discover is:

1. How many other people have had the same idea, and how successful have they been?
2. Are there games already on the market that resemble what you have in mind?

But it is possible that you don't have a definite game idea. By conducting market research, you're looking for a 'hole' in the current market that you can fill.

Your next step is to search the Web for games. Look on the many shareware sites and sites created for or about your target genre. Download demos and see how well they work. Use the search engines and search on all the terms you can think of that might be related to your game concept.

Visit the big retail outlets, like Wal-Mart, CompUSA, and Electronic Boutique. Find out what games they have stocked. Note how many of each type of game they carry and what percentage that represents of the total games carried. While you're collecting information, go ahead and write down how much they're charging. It might prove useful later.

Finally, ask your friends and family which games they have purchased, which games they are looking forward to, and which games they didn't like. Until you know your target market, it's impossible to plan how to sell to them. Marketing and promotion are covered in more detail in Chapter 24, Marketing and Promotion. For right now, our need is to identify the different markets for various types of games. Then we will analyze the information collected.

Analyzing the Data

If you already have an idea in mind for a game, your research will generally reveal one of two things. Either you will find that your game idea is unique enough to have a chance of selling, or you will find that many

variations of your game idea have already been made. The latter case doesn't necessarily mean you should give up on your idea. It does, however, mean that you might want to consider ways to make your game idea more original, so it will stand out better in the crowded market.

Well-designed, well-executed software will nearly always find a market, even if that software is in a competitive genre, such as first-person shooters. The problem is that your share of the market may be very small. If you don't put some thought into how you are going to create a unique and compelling reason for someone to buy *your* FPS—something that sets it apart from the others—you probably won't see a return that justifies the effort put into creating the game.

Finding a new niche in the game market requires looking at what your collected data *doesn't* show. What genres are popular and which ones are unpopular? What games *could* be in that genre. What do you think could make a game in that genre stand out? New subject matter? New user interfaces? Extrapolating new ideas from existing data is a creative process all its own.

CHOOSE A GAME YOU CARE ABOUT

All of the issues previously discussed are important, such as the genre of the game, whether the niche for the game is already crowded, your market research results on real-life sales of similar games, and/or feedback on the popularity of these games. But the most important thing you can do is to choose a game you care about.

Plan for the Long Haul

Not only do games often take longer than estimated to finish, once the game *is* finished, your work as an independent game developer is far from over. There is marketing and promotion, handling payments, providing customer service, and updating the game to keep it current and marketable. Initial development of a game might only take a few months, but after the project is completed and the game is on the market, maintaining the salability of that game can last for years.

If you don't choose a game that you care about, you'll find that your passion for the game will fade, and you will either abandon the game before it's finished or come to hate it. But if you do care about your game and have the staying power to see it to completion and through its incarnations, whatever game you make is going to be around for a long time.

So, save yourself a lot of stress and wasted effort. Make sure that whatever type game you decide to make has at least one element that is uniquely yours. You should be proud and happy to make this game, es-

pecially if you think you're taking a step down in areas of your game design. Add something to the game that makes you want to play when it's completed.

One More Thing

Indie game development is an art form—one of learning to make do with what you have, of twisting and shaping a little to look like a lot. You are constantly making trade-offs and concessions in order to your manage limited budget and time. There has to be a line drawn somewhere, though, that defines what you *won't* trade off or concede, even if that line is only a circle drawn around one precious, valuable game concept.

You might not be satisfied with the 2D graphics engine you have to use, or that the TCP-based networking protocol that is all you can afford. Or maybe you're not happy about the time you expect the project will require. If you don't make the project something you *really* want to do, odds are that you will get discouraged, and you'll be looking for ways to get out of it. You have to choose at least one thing about the project, something under your control, that becomes your reason for completing it. Only you can determine what that one thing is.

It's probably best if you don't focus on the potential financial rewards as a motivating factor. How well the game eventually sells is not something under your direct control. Instead, concentrate on the game design: its milieu, characters, and so on. For example, Rainfall Studios chose to make their first game, *Katsu's Journey* (which is still in development), about samurai in medieval Japan. It was a game subject the developers cared about and would be interested in playing when project was finished.

CONCLUSION

There are a great many good game ideas out there have never seen the light of day. Even if you are planning a game within an established genre, don't be afraid to think up new and different ways to have fun or tell a story within that genre's framework.

You only have so much time in a day and limited resources, but some of the greatest innovations in history have sprung from the smallest seeds. So revel in your freedom as an independent game developer. Do the unexpected.

THE GAME DESIGN DOCUMENT

IN THIS CHAPTER

- A Different Approach and Audience
- The Game Design Document
- Size Matters
- Stability and Flexibility

Now that you have your game concept firmly in mind, the next step is to create a game design document that fully describes your idea and your plans for the completed project. A good game design document contains the following:

- Design Summary
- Design Details
- Designer's Notes
- Business Model
- Future Features
- Glossary
- Version History

As we discuss each of these items in detail, excerpts from the design document for *Paintball Net*, by Samu Games, will be presented as a reference. But first, let's examine the differences between publisher-funded and indie game design documents.

A DIFFERENT APPROACH AND AUDIENCE

Both retail game development and independent, self-published game development rely on game design documents. The primary purpose of the design document is to provide a description of the game that can be used to map out actual development. Retail and indie development do, however, have differences in their approach and audience.

The independent game developer's design document is more about laying down the specifics of the game mind; it is about describing the game in enough detail to serve as a blueprint for development. There's no need to describe how the finished game will fit into an SKU (Stock Keeping Unit) plan of games to ship in future quarters.

As an indie, your game design document is intended for you and your team, if you have one—not the board of directors, not the new product-acquisition manager. You still have to provide as much detail as possible, but you don't have to show that your game fits established genres and targets predefined player demographics in order to get approval to proceed. The design document serves *you*. You're creating it to preserve and flesh out the original game idea.

You might still need to convince potential team members that your game idea is worth pursuing. But even then, you're appealing more to their creative instincts than their pocketbooks. A well-written game design document can do much to persuade potential team members that you not only have a good idea, but that you have taken it beyond the initial "I had a cool idea!" stage.

THE GAME DESIGN DOCUMENT

Regardless of how simple or involved your game idea is, you will benefit from writing down the specifics. Your game takes its first step to becoming a reality when you do this. Also, your design document serves as your guide while you are working on the project; it describes where you started from and where you are going.

Design Summary

The first section of your game design document is the *design summary*. Sometimes called the *treatment*, the design summary describes what makes your game unique and fun. Focus on high-level features and gameplay elements, and resist the temptation to get too detailed or implementation-specific. You are trying to describe your game's *Unique Selling Point* (USP) in as few words as possible. The USP is what makes the game stand out—what makes it different from all the other available games.

What excites you about your game idea? Write it down! What do you think will excite the game's players? Write that down too! If you can't articulate in a few quick sentences why your game idea is unique and fun, your idea might not be as grand as you had originally thought. You might need to add a new 'twist' to give it more depth and originality.

Be sure to include a note on the target platform for the game. Will this game be for PC, Mac, consoles, or a handheld device, such as a cell phone or PDA? Will the game require Internet access? If it's a cell-phone game, can it be played solo, or does it need to connect with other players? What advantages does the target platform provide that you hope to exploit?

The answers to all these questions may seem obvious to you now; your new game idea is still fresh in your mind. But never assume that because you 'know it' right now that you'll be able to remember it in the future. After you've started production on the game, you might want to read your design summary to not only remind you of where you're going, but why you're going there.

Your design summary is also useful when and if you're trying to find team members or investors. If you can't quickly convince someone else that your idea has merit, then you won't be able to convince your target players, either.

Consider the design summary your *elevator pitch*. An elevator pitch is a quick presentation, made in 60–90 seconds (the time it takes an elevator to go from the lobby to the decision-maker's floor), that hits on all the merits of your project. If you can't spark someone's interest within that time limit, then you might want to reconsider your plans.

In the following sections you can read excerpts from *Paintball Net*'s design summary. It has several parts: an overview, an elevator pitch, a storyboard, and a list of what makes the game unique. The elevator pitch is deliberately written to sound like a marketing brochure, while the storyboard is a detailed, blow-by-blow description of the gamer's experience—what it will be like to join in the game and participate in a *Paintball Net* match. Finally, *Paintball Net*'s Unique Selling Proposition describes what makes *Paintball Net* different from other games. *Paintball Net,* based on the Torque Game Engine by Garage Games (*http://www.garagegames.com*), was originally planned for the PC platform with future expansion to Mac and Linux.

Paintball Net Design Summary

Paintball Net is a multiplayer paintball game. Players, competing individually or in teams, navigate through wide-open, outdoor landscapes and tight, indoor arenas, trying to splat their opponents before they, themselves get splatted. Each player begins with basic 'free' equipment and a small budget. By competing in paintball matches, players earn additional money that they can use to upgrade their equipment. Players can join established teams, create their own team, or remain solo.

Elevator Pitch

Paintball Net is paintball the way it *should* be! With a full arsenal of modern, sci-fi weapons and equipment—from pistols to grenades to rocket launchers to jetpacks to 'refracto' suits (think *Predator*)—*Paintball Net* gives you the thrill of paintball like you've never known it—and without the nasty welts and bruises!

- Play as part of a team, or go solo.
- Charge through the brush in outdoor environments, or lurk in the shadows of cramped indoor arenas. Hunt down your friends and make them eat paint!

Everyone begins with the same free equipment and a small budget of cash. As you play, you earn additional cash to upgrade your equipment. But everyone also has the same limit on what they can carry, forcing you to decide what you will use in the next match. Should you carry that heavy rocket launcher or just stuff a few extra grenades in your pouch and stay light on your feet? Or should you strap on the jetpack and pick off your opponents from the air? Decisions, decisions . . .

Storyboard in Text

When the new player first logs in to *Paintball Net*, he has to create an account. This involves submitting name, gender, and address, plus a few other characteristics, such as skin tone and hair color. The new player will be created with 'freebie' equipment: camouflage trousers, dark T-shirt, high-top shoes, protective face mask, and a free paintball gun. He will have a 'full load' of free paintballs (which, at the rate the free gun fires, should last for several matches).

Once the player has created his account, he must choose a paintball field to play on. The Field Manager lists all available *Paintball Net* fields and how many players are currently . . .

Paintball Net's Unique Selling Proposition

There are a lot of FPS games available, including some paintball-themed mods of those games, and some with better technology driving them. What makes us think that *Paintball Net* will find a place among them?

- **Player progression against competition.** Players learn the game while playing against each other in a well-balanced environment. All players have the same 'weight limit' for equipment carried, so even advanced players with better equipment must choose their weapons and equipment carefully.
- **Player persistence.** All player information is tracked and maintained. Whichever field a player plays on, his statistics and equipment are there waiting for him. Players can also customize their equipment to fit their own playing style.
- **Community emphasis.** *Paintball Net* is designed to support a real sense of community. With full-featured chat in the Ready Room, players can interact (or not) and get to know each other. Also, *Paintball Net* supports global teams of players that play together.
- **Unique paintball equipment with a 'real' paintball feel.** *Paintball Net* uses 3D technology to create unique and outlandish paintball equipment, such as 'refracto suits' and 'jetpacks,' while preserving the thrill of real paintball. And unlike a lot of paintball mods based on 'deathmatch' games, *Paintball Net* uses a single-hit match elimination model—no endless 'respawning' of players.

You might also want to include a storyboard subsection of your design summary. The storyboard is a Hollywood device for planning scene shots. Each shot in the scene is sketched in sequence, showing camera angles and scene composition. The director and cinematographer use the storyboard as a guide during production shooting.

Your storyboard for your game can be a collection of screenshot mock-ups that show the game as it might be played, with accompanying descriptions of what is happening in each screenshot. If you're an artist or have the necessary skills, you can use storyboarding to make your design summary look very impressive. If you're a programmer, though, you may have to make do with detailed descriptions and a few line-and-circle drawings that indicate what's going on, as shown in Figure 7.1.

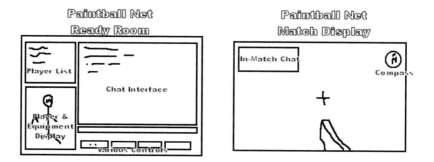

FIGURE 7.1 Storyboards for some of the main screens in *Paintball Net*.

Design Details

After the design summary has defined the overall experience your game will offer, it's time to go into more detail. The *design details* section describes the game in its entirety, from beginning to end. Cover all relevant topics in enough detail to be useful later on.

How much detail you need depends upon your project, but it should be sufficient enough so that in a week or two (or in a month or two), when you read through it again, you'll still know what you were trying to achieve. The more complicated the game, the more details that need to be written down. If you are planning to have a team help you build the game, then you will need as much detail as possible so that *they* will know what you're trying to achieve, as well.

For games based on cards, dice, tiles, or similar concepts, the design document might be simpler, but it should still include descriptions of all the components and be detailed enough to clearly define the designer's goals. You may not need more than a few pages of notes to adequately describe the game in full. It's still necessary, however, to indicate, for example, what kind of cards are to be used, how many players the game is for, how to deal out the starting hands, how players get new cards, how cards are played or discarded, and so on. The design document becomes minimal collection of rules, such as you would find in a board game.

More-complex games, like strategy or action games, will require more-detailed descriptions of how the various parts of the game interact with each other. If there is to be simulation, then the assumptions and 'laws' that govern the simulation need to be outlined. If the game is played in real time, the task-resolution period must be determined.

Major components of the game should each be given their own detailed subsection. As an example, the major components of a real-time strategy game could be as follows:

- Resources and how they are collected and used
- Races, nations, and their available units
- A technology tree, possibly subdivided by race or nation
- Economic and production model

Identifying these major components makes it easier to plan your development schedule in preproduction. For more information on development schedules, see Section III, Production Planning.

Paintball Net began with the Storyboard in Text described in the *Paintball Net* design document (see Appendix E). The document contained as much detail as possible, covering everything the player would see and experience, from creating his first account to buying equipment in the various stores to playing in a match. While this storyboard didn't go into detail about things like gun physics or match settings, it did provide a solid overview of the desired player experience.

The game was then divided into its major components: economy and cost of living; the ready room with its stores, player lockers, and inter-player communication options; equipment, including physics model and object properties; player information, like inventory and tracked statistics; teams and how they worked; matches, with payoffs and variation options; and the server structure. The following section is an example of some of *Paintball Net*'s 'economy' design details.

Paintball Net Design Details Summary

The economy of *Paintball Net* is based on how money is earned and spent. Every player begins with the same equipment: a fully loaded, free paintball gun, a face mask, camouflage trousers, a dark shirt, and boots. The player also begins with a small amount of cash.

The 'house' provides free compressed air/CO_2, but everything else must be purchased by the player, such as ammunition, guns, and equipment. 'Welfare,' in the form of free paintballs, is available to any player who has no available cash and a net worth of less than some specified amount.

Players earn money by scoring a hit in a match, by collecting 'tokens' that are scattered throughout the battlefield during a match, or by being on the winning side of a teams-based match.

Cost of Living Expenses

Ammunition is generally inexpensive, but cannot be sold back to the store. Also, once it's shot, it's gone. Guns and equipment can be sold back to the store for full price so long as they have . . .

Designer's Notes

In *Game Architecture and Design*, the authors advocate including all *designer notes* in the design document [Rollings00]. The designer's notes detail the reasons for design decisions. For example, why does this gameplay element function the way it does? Is it important for game balance, or is it a concession to hardware limitations? Two months later, you *might* remember why you designed the game the way you did, but if you *write it down*, you won't have to.

Keep notes on your design decisions as you make them. Record *why* you made the decisions you've made. Otherwise, when you review the decision later, you will be forced to reconstruct your thinking. Your might forget an important consideration that was obvious at the time but is no longer as obvious. Missing the point now could have impacts throughout the design, especially if you revise the earlier decision based on the incomplete review.

Keeping your designer's notes in a separate section may prove awkward and also make them difficult to find or reference. Instead, you might want to embed them within the design details section, wherever they seem appropriate.

Paintball Net's **Designer's Notes**

In the original *Paintball Net*, the economy tended toward inflation. There were several reasons for this. First, totally free guns and ammunition were offered, so players could invest $0 and make a profit with any shot that happened to hit, while not worrying about losing money with a 'spray-and-pray' strategy.

Second, by a strange fluke, it became popular to utilize the somewhat odd combination of a jetpack and can of spray paint. The can of spray paint would automatically fire at someone if it was targeted at them. So players would set their targets just to the front of them and zoom back and forth across the field.

Also, equipment never wore out. Whatever you paid for an item, you could get your money back just by selling the item back to the store. This was done on purpose to allow players to try out different combinations of equipment without losing money. The downside was that if a player spent $15,000 on a jetpack, he could get that $15,000 back two, or even three years later.

Some attempts to counter inflation were: reducing the payoff of a splat, using free ammunition, creating specialized, expensive ammunition, and a few other things. For the most part, though, money continued to pile up in the game.

If possible, a more balanced economy should be achieved this time around, or at least an economy that takes longer than a few years to spiral into inflation.

The previous section showed an example of designer notes in the economy design details. The new *Paintball Net* design notes reflect issues with the original version of the game. To help in referencing what those issues were, they were included in relevant section of the design document.

The Business Model

Depending on your plans for the completed game, you might include a *business model* section in your design document. The business model section describes how you expect to sell the game when it's finished. Pricing and promotion will be covered in later chapters of this book, but it won't hurt to plan how the project will pay for itself once it's completed. If it is a single-player game, do you plan to sell it as complete package, or will you sell add-ons? For multiplayer games, do you plan to charge monthly, quarterly, or annually?

Shareware—try-before-you-buy marketing approaches—mean that you should decide now how to handle the free trial. How many game levels will be granted? How long can the game can be played for free? Are there other variations of the game? These can be difficult decisions to make, since it depends on what you predict players will be willing to pay for in the game. Your market research (see Chapter 6, Choosing a Suitable Game Concept) can help you with this. If you consider these issues at the start, implementation decisions are easier later on.

Are you hoping to attract outside investors? If so, then the business model section is a must and should be completed in detail. It becomes a summary of your business plan. You should cover things like pricing, marketing, and promotion—in detail. You will also want to include sales projections and growth estimates, as well as how the investors will be able to 'cash out' and get their money back, and how soon.

Another useful piece of information for the business model section is a list of costs. What will it cost to sell the game once it has been completed? Is the game going to have a Web page/site of its own? If so, how much will the hosting and maintenance cost? What are the per-transaction fees for third-party payment processing services (a good choice for new indies)? And if the game is multiplayer and requires hosted servers, what are the projected hardware, software, and bandwidth costs?

These are just a few of the distribution costs you might encounter. Assessing them now is vital for establishing the final price for your game when it's released. Unless you know your costs, you can't project an accurate price.

As illustrated in the sections that follow, *Paintball Net* was planned as an online-only, multiplayer game with a subscription-based payment structure. A number of play options would also be available for free.

Paintball Net's Business Model

The business model for *Paintball Net* will be based on quarterly subscription fees paid by players. For $24.95, the player can play for three months (or $9.95 per month if monthly subscription payment processing can be acquired).

(continued)

Players will be able to create an account that has all the advantages of a paid account, but with a 30-day time limit. After the 30 days, unless the player pays for a subscription, the account is closed. After the first account created by a player, the free trial period of new accounts is reduced to 10 days.

When a player attempts to log into an account that has expired, he will be told that he needs to pay for the account. Clicking on a "Buy Now" button will take him to the payment Web page.

Free Game vs. For-Pay Game

The client software for *Paintball Net* will be given away for free. However, certain features of the game will be available only if the player first logs into the Field Manager with a paid (active) account.

Without an active account, player-hosted fields will not be listed on the Field Manager. Also, the guns and equipment available in the local stores will be limited to basic paintball gear. Matches will be limited to Survival and Random-Pick teams.

Future Features

As you design your game, you will come up with ideas that are worth remembering, but which aren't appropriate for the initial release of the game. They might add too much implementation overhead or require resources that are unfeasible in the first release. You might also decide to trim down a feature when it comes time to implement it, or even remove it. Instead of removing these ideas from the design document, just move them into the *future features* section. That way, you don't inadvertently forget a good idea.

It's possible that some of the future features will actually make it into the final game. As the game marches toward completion, something that once seemed impossible might become doable. In general, though, game projects usually benefit more from *removing* features than from adding them. So only employ an idea from the future features section if adding it to the game won't increase production time or demand significantly more resources.

As *Paintball Net's* future features show, there are always more good ideas for a game than can be reasonably implemented.

Paintball Net's **Future Features**

These features are good ideas, but implementing them should probably wait until after the initial release of the game.

- Ladder Matches
- Capture-the-Flag Matches
- Tournament Games
- Vehicles (four-wheelers)
- Simulated Weather
- Simulated Time of Day/Night
- Team Voice Chat

Glossary

A *glossary*? Yes, a glossary. Just because the designer knows what a particular game term or acronym means doesn't mean everybody else does. Any game-specific term should be given at least a short definition. One or two sentences are all that's necessary.

Like the designer's notes and future features, the glossary can help you remember what you meant weeks or months down the road. The meanings of all those *TLAs (Three-Letter Acronyms)* and made-up words can be lost forever if you don't write them down.

Team members who read the design document will also be grateful for the glossary. They might not have the same background as you, and the words you use for gameplay elements might not have the same meaning for them. By including a glossary, you can avoid any confusion. In addition, your glossary can also become part of your player's manual.

The following glossary for *Paintball Net* is collection of terms from both the old and new game design. Since several new team members had no experience with the original *Paintball Net*, the glossary helped them understand what certain terms meant within the context of the new game.

Paintball Net Glossary

- **Field:** A field is where players come together to play paintball. Only a single match happens at a time on a field. A field is a single Torque server, running on Linux (or possibly on a player's PC).
- **Field, Dedicated:** A dedicated field is a field server hosted by Samu Games. Only matches on a dedicated field affect the player's statistics.
- **Field Manager:** The field manager is the common entry point for all players. All dedicated fields are listed, as well as all public player-hosted fields. The field manager is separate server software, running on Linux.
- **Match:** A match is a single paintball 'battle.'
- **Newbie:** A player who has just started playing the game, who has fewer than 10 total splats.
- **Newbie Protection:** A match feature that prevents players with 10 or more total splats from being able to successfully hit newbies.
- **Padded:** Padded equipment, such as jackets or backpacks, create a softer impact surface that improves the chance of a paintball bouncing off rather than bursting.

Version History

Finally, as you make changes to the design document, it's useful to track them. When you first create the design document, you're adding more than you're changing, so it's probably not necessary to track changes at this point. But once the game design becomes relatively stable, you should start keeping track of what change are made.

Don't get caught up in details, like major or minor version numbers. All you really need is the date, the name of the person who made the change, and a short summary of what was changed. *Why* the change was made should be recorded in the Designer's Notes, as previously described. Here, you're just making a quick note, so you and your team members can know at a glance what is new and what has been changed since the latest version of the design document.

You might want to have the version history begin the design document so that it's immediately visible; you don't have to scroll to the end to find it.

Paintball Net's Version History Excerpt

1.0—Begun 19 Feb. 2002
2.0—Begun 21 Feb. 2002
3.0—Begun 22 Feb. 2002
4.0—Begun 25 Feb. 2002
4.1—7 April 2002
- Added 'maintenance factor' to gun physics model
- Minor editing for consistency
- Adjusted zoom factors for scopes and HUD zoom kits
- Adjusted maximum number of players per field to 64 (from 128)
- Moved Torque SDK questions to a separate document

4.2—12 April 2002
- Expanded Ready Room chat features description . . .

SIZE MATTERS

How long should your game design document be? The simple, if also circular answer is: "Long enough to be useful." If it is too short, you run the risk of losing your way or working toward uncertain goals that you might never reach. Also, with insufficient details, team members might have different interpretations and work in diverging directions, without meeting for a completed game.

On the other hand, if your design document is too long, it takes on a life of its own and overshadows the project. You will forget that the design document is only supposed to be the beginning of the project, not an end unto itself; the game that is 'supposedly' being designed might never built.

So don't get distracted by comparisons based on the number of pages in various design documents. You're not in competition with anyone to have either the shortest or the longest design document. You're simply getting organized and prepared for your own project.

When your design is completed to the point where *you* understand it and can see the completed game—and can describe it to others—declare the document done enough, and move on.

STABILITY *AND* FLEXIBILITY

The design of any game needs to be flexible. Inevitably, the design of your game will evolve throughout the project. Your design document

needs to reflect the current state of the game and provide a guide for how it will proceed. But it doesn't need to be adhered to like gospel.

As the game is built based on your design document, you will learn more about how this type of game *should* be developed. Testing, and especially *play* testing, will point out flaws in your design that need to be addressed and holes that need to be filled. When taking care of these issues, keep your design document up-to-date, and you'll always know where you are in the project. This is the type of design evolution that the designer's notes and future features sections were meant to accommodate.

Remember, you're an independent game developer. You started this project because *you* wanted to, not because you were told to. You have ultimate flexibility at your disposal. The design document is a tool to be used, not a writ that must be followed exactly.

CONCLUSION

One final word on design documents: they are never truly done until the game is also done. While the design document defines the game, and maybe even provides an overview of how to approach the game's implementation, nothing is set in stone. You created the design document to serve you, not vice versa.

It is possible to create a game without using a game design document. There are some indies who insist on this level of independence, as you can see in Figure 7.2. But the majority of indies (66%) rely on a game de-

Indie Game Developer Survey Results

How important is a completed design document to your projects?

10% Very important. It's all mapped out before I start.

35% Important. I create a detailed description before starting, but I'm flexible.

21% Sometimes I jot down a few notes before I start.

29% Varies with the scope of the project.

5% I'm an indie, so I can do what I want.

(Survey Note: 62 Respondents)

FIGURE 7.2 Indies and design documents.

sign document of some sort. So take the time to write down what your game is about, and what its final goals will be. Even a simple plan beats no plan at all.

In Section III, we will move from the design phase to the production planning phase. Production planning (preproduction) is all about planning the development of the game. You have your game design document, so you know where you want to go. In production planning, you plot the path to get there.

III

PRODUCTION PLANNING

Now that you have a game design document to work from, the next step is *production planning*, or *preproduction*. At its most basic, production planning involves deciding what tasks need to be done and in what order to complete the project. Your game design document describes the desired end product. Now you need to figure out how to get there.

Chapter 8 (Task Identification and Scheduling) describes how to break a project down into tasks and subtasks, and how to arrange these tasks into project milestones. Estimating task milestone times are also covered.

Chapter 9 (Budgeting and Risk Management) stresses the importance of identifying unavoidable project costs. It will also show us how to identify potential problems that need to be addressed. This chapter is about taking the time at the beginning of the project to think about what could go wrong and how you will deal with those problems if/when they occur.

Chapter 10 (Creative Funding) concludes this section by presenting a number of ways you can find, make, or negotiate funding to handle the inevitable costs of game development.

TASK IDENTIFICATION AND SCHEDULING

IN THIS CHAPTER

- Task Identification
- Scheduling Project Milestones

Only the simplest of projects can be completed by starting where your fancy chooses and then 'winging it' from there. But, even the simplest projects will benefit from proper planning from the beginning.

With indie projects, it is very important that you have a visible sense of progress at all stages of development. What this means is that each step of the project to have a demonstrable product of some sort. Thus, after each step is accomplished, you have evidence of your progress. This type of visible progress is vital for part-time projects where the team is potentially scattered across one or more states or continents. Without some visible measure of progress, the team members lose heart; their interest wanes, and the project grinds to a halt.

There is no one right way to plan a project, and you might not agree with the top-down project planning method that will be presented here. That's okay. Modify it to suit your needs, or choose your own methodology and go for it.

What's most important is that you actually take the time to make a plan; the type of plan you use is secondary. Whether you approach planning from the top-down or the bottom-up, as a logical process or an organic one, or as collection of objects—the end result should be the same: a series of steps that will lead to your goal, with each step providing the foundation for the next one.

TASK IDENTIFICATION

Production planning begins with knowing what needs to be done. If you don't know what needs to be done, then you cannot choose what to do. Just as important, though, is to know what order tasks should be done in. If Task B needs to be done before Task A, then working on Task A before Task B is almost certainly going to result in wasted time.

Production Planning Step 1: Identify Tasks

The first step in production planning is to make a list of everything that needs to be done. Your game design document contains all the features and gameplay elements you expect to be in the finished product. Each of these features and gameplay elements can be considered a single project task. Some of them will have dependencies that require other tasks to be completed first; but for now, try to group all of the features and elements into logical, 'macro' collections.

The top-level tasks for *Paintball Net* are shown in Figure 8.1. Short and simple, this list was created by deciding on the major components of the project as they were presented in the design document.

FIGURE 8.1 *Paintball Net* top-level tasks.

The next step is to make a list under each of these tasks, specifying what steps are needed to complete that feature, or what subfeatures compose that overall feature. In Figure 8.2, the Artwork task is expanded into groups of 3D objects.

FIGURE 8.2 *Paintball Net* artwork subtasks.

The subtasks listed in Figure 8.2, being groups of objects, need to be further expanded to list the individual objects needed, as shown in Figure 8.3. The Weapon Models subtask has been expanded to list each weapon required.

Paintball Net **Detailed Weapon Models List**

F. Artwork

 1. Players

 2. Weapon Models

 a. Free paintball gun

 b. Semi-automatic paintball gun

 c. RPG launcher

 d. Can of spray paint

FIGURE 8.3 *Paintball Net* detailed Weapon Models task list.

Do that for each of the top-level features. Get as detailed as you can with each task and subtask. For artwork (Figures 8.1–8.3), you can list out individual items; but for programming tasks, you might want to avoid getting so detailed in sublevels that you're specifying algorithms. Figure 8.4 shows how the high-level programming task from Figure 8.1, Dedicated Field Server, could be broken down.

Don't be afraid to reorganize your tasks as you go. One of the major tasks you started out with might be a subtask of something else. Or maybe a task or feature is too all-inclusive and needs to be divided into two or more separate tasks.

It's inevitable that your game design will change as you go through production planning, which is not necessarily a bad thing. Some ideas that may have seemed 'pretty cool' during the design process may prove to be infeasible once you begin thinking about how you're going make them happen. Production planning makes the game design 'tighter' by forcing you to decide whether or not features are essential and must be kept, or whether they're 'fluff' and should therefore be discarded.

Paintball Net Dedicated Field Server Task List

C. Dedicated Field Server

1. Define player send protocol to client software.

2. Implement interface to player database.

Player new account creation:

(1) Gender selection

(2) Model preferences

(3) . . .

FIGURE 8.4 *Paintball Net* Dedicated Field Server task list.

Reminder: Keep Your Design Document Updated!

Remember to keep your game design document up-to-date as you make changes to it (see Chapter 7). Record the reason for each change as a separate designer's note so you won't forget *why* you made the change. Also, if you remove a feature from the core design, put it in the future features section of the design document. You might want to resurrect the feature in later development.

When each task has been broken down as far as is reasonably possible, you should have a long list of tasks—possibly a *depressingly* long list tasks. But don't be discouraged; you now have a much better sense of the project's scope than you had before.

Production Planning Step 2: Identify Task Dependencies

Now you need to work out your *task dependencies*. A task dependency means that Task B can't be started or completed until Task A is completed. You *could* do Task B before Task A, but you run the risk of having to redo all or most of your work on Task B when you finally get around

to doing Task A. Better to realize that Task A needs to be done first—and do it first, so you don't waste time and energy.

As an example, in *Paintball Net*, work on certain inventory-affecting items, like backpacks, couldn't begin until the inventory system had been fully defined and scripted. Otherwise backpacks, which are mounted on the player model and increase the carrying capacity of the player, would be constantly under revision if created first. The same holds true for nearly every other in-game object that the player can interact with. How the player interacts with objects, how he carries them, and how he uses them are all dependent on the inventory system. Thus, the inventory system is a task dependency for many of the objects in the game.

There might also be resource dependencies, where the resource is a particular software tool or a team member with specific skills. If you are primarily an artist and a task requires programming, then completing that task is dependent on your learning how to program or (more likely) finding a programmer to do the work for you. The reverse is true for programmers, of course.

Once you have identified all dependencies, go back through the list and sort the tasks according to the order they must be completed. Unless you *really* enjoy planning things (and some people do), this will, without a doubt, be a bit tedious. Stick with it, though. Once you have your list of tasks, and you've figured out what tasks need to be done first, keep it all handy. You'll be using it soon. The next step is to create a schedule of milestones for your project.

SCHEDULING PROJECT MILESTONES

Now that you have a detailed task list and its corresponding list of dependencies, you can begin scheduling your game's development and project when each separate piece, or milestone, will be completed. The first part of scheduling is to get estimates for each task. Then you can schedule the milestones you'll need to see the project through from beginning to end.

Production Planning Step 3: Estimate Task Hours

The next step is to review your completed list of tasks and decide how long each task will take. Keep in mind that this is an estimate; it does not have to be precise. Your goal is to get a better grasp on how much time will be required to complete the overall project.

The easiest way to estimate tasks at this point is to consider how many hours each task will require. You shouldn't estimate less than a one-hour time slot for each task. If a task seems like it should take only a few minutes, then you may have divided things up too finely; bundle

some tasks together. On the other hand, if a task requires more than 40 hours to complete, you might want to break it down into smaller tasks. Figure 8.5 shows time estimates for the Dedicated Field Server tasks identified in Figure 8.4.

Paintball Net Dedicated Field Server Time Estimates

C. Dedicated Field Server

 1. Define player-send protocol to client software.

 Estimated Time: Four hours

 2. Implement interface to player database.

 Player new account creation.

 Estimated Time: 24 hours (includes subtasks)

 (1) Gender selection

 Estimated Time: Eight hours

 (2) Model preferences

 Estimated Time: Eight hours

 (3) . . .

FIGURE 8.5 *Paintball Net* Dedicated Field Server task time estimates.

Unless you are a 'renaissance' game developer with experience in every aspect of game development, there are going to be tasks on your list that you can't define a time estimate for. For example, a programmer might not have a clear idea of how long it will take to design, model, and animate a particular character. So how do you get estimates for these tasks? Simple. You ask someone who *does* know.

Most people don't mind giving estimates like this, especially if they already know you. If you don't have a direct contact for that specific task, then maybe someone else can give you a referral. Via networking, you can usually find who you're looking for after just a few inquiries. If not, there is always the public discussion forums.

Once you have estimated the time for each task, add them all together to get the total time estimated for the project. Then double that number, and you'll have a good idea of how long you're going to be working on this project.

You might wonder, why double the total estimate? There are a couple of reasons for this. First, because indie projects are nearly always unfunded, this means that work on the project will at times be set aside in favor of work that pays the bills. Doubling your original estimate pads the schedule to account for this. Second, doubling your original estimate also helps to compensate for the overwhelming optimism that is characteristic of most game developers.

A Real Game, A Real Example

Artifact (Samu Games) took three years of part-time work to go from initial design to 1.0 release. They originally estimated that closed alpha testing would take place in 10 months or less. In reality, it took a full 20 months to reach alpha stage. There were extenuating circumstances, of course (there always are). First, they were still building the project team through the first year, and it took most of that year before a committed artist joined the team. Both of the programmers were working full-time at 'real' jobs, as well, and the artist was a college student who didn't live in the United States. In addition, one of the programmers had a baby, and the other moved into a new house. All of this is no excuse for the slow turnaround, but it shows how hard it can be to plan for every contingency and possibility.

Granted, you have to be optimistic to be an indie. Just remember to temper that optimism when you're estimating how long your project will take.

Estimating for a Team

If there are several people working on the project, then some of the tasks can be worked on simultaneously. This will help trim down the overall schedule, and it can be finished faster—to an extent. An analogy tells of 60 post-hole diggers who can dig 60 post holes in 60 seconds. But the 60 post-hole diggers *cannot* dig one post hole in one second. *The Mythical Man Month*, by Frederick P. Brooks, published by Addison Wesley, makes a similar point. It explains why a project that is behind schedule will get even *more* behind schedule if more people are added to the project.

Therefore, getting your project done quickly isn't as simple as building a big team. Additional team members will see the game completed faster, but they also add to the administrative and managerial overhead required. Barring incredible productivity and shared vision at a supernatural level, two people will not finish a game in half the time, and three people will not finish the game in one-third of the time.

When scheduling multiple team members, try to keep the tasks assigned to each team member isolated. If one team member has to wait for another team member to complete his current task, then time is being wasted.

A Real Game, Another Real Example

Artifact had a team of four: two programmers, an artist, and a musician/sound engineer. The two programmers were the only team members that had cross-dependencies, which were minimized by having one programmer work exclusively on the server software and one exclusively on the client software. There were times when the two of them had to work in tandem, hammering out the implementation of certain features, but the majority of their development time was spent working independent of each other. For the new *Paintball Net*, though, there was a larger team with three programmers, three artists, and a sound engineer. The dividing lines for the various programming and art tasks were not as clear cut as they were in *Artifact*, so more organization and planning were needed.

Keep all team members as busy as possible throughout the project. If one team member finishes his tasks for the current development phase earlier than expected, put him to work helping one of the other team members. Or, if doing so doesn't disrupt dependencies, have him start on tasks for the next development phase.

Most team members on an indie project are only going to be putting in about 5–10 productive hours a week, *at most*. You, though, as the project leader, will probably put in two to three times that. Maybe more. So be as efficient as you can with your resources.

Production Planning Step 4: Create Milestones

The next step is to decide on the path you're going to take for the actual development. This path will be marked by *milestones*. Milestones, or development phases, are mini-projects within the overall project.

There are several benefits to milestones. First, milestones are significantly smaller than the whole project, so they're not as intimidating. Second, completing milestones provides a sense of accomplishment in small doses throughout the project, and at regular intervals. Without milestones, you have just one long period of anticipation until the end of the project. That much waiting can wear away enthusiasm for the project and bring progress to a halt. As you complete each milestone, though, you and your team can *see* that you are another step closer to completing the whole project.

For your first milestone, decide on where in your production schedule is the earliest point that you might have something that at least *resembles* the game. You're not trying to complete the full game in one step here. Instead, your first milestone should show the foundation on which the rest of the game will be built. It's unlikely that your first milestone will impress anyone outside of the project team; but milestones are for the team's benefit, not the target players.

Using your detailed task list and list of task dependencies, find all those items that must be done in order to complete the first milestone. If you find your task list for this first milestone comprises more than 20%–25% of your total list of tasks, then you might want to trim down your goals for the milestone. Maybe a couple of features can be implemented in later milestones.

For *Paintball Net*, Milestone One was called "Up and Running":

> At the end of Milestone One, we have a playable, if somewhat simple game. Players can join a player-hosted server and play in survival matches.

What was more important in *Paintball Net* was to have simple gameplay, rather than the central player database, working for the first milestone. The central player database would wait until the second milestone. *Paintball Net* used the Torque Game Engine, and so neither a 3D rendering engine nor a multiplayer networking layer had to be created; both of these critical pieces came with the engine.

Try to keep your first milestone doable within a very short time frame. If a milestone is going to take more than a few months, you should consider trimming it down. Move some of the features from this milestone to the next one, if you can. And unless you've had a lot of experience with estimating schedules, be conservative with your time estimates.

Paintball Net's Milestone One was intended for completion within three to four months. It ended up taking more than six months. So even with advantages of the Torque Game Engine and the designers' experi-

ences with previous projects, they were still overly optimistic with estimates of the work required.

When you are satisfied with your first milestone, take your game to the next level and create your second milestone. Choose the features you will implement in milestone two based on what was accomplished in milestone one. Unless your game is very simple, try not to pull more than 20%–25% of the full task list into the second milestone. Continue this process until the last milestone is the completed game. Generally, you'll have from three to five milestones.

Try to schedule your milestones for as often as possible, but not too close together, or you run the risk of feeling like you're always behind and trying to catch up. Don't schedule them too far apart, either, because then interest in the project might wane, and you might lose team members who feel the project will never get done.

Paintball Net was planned with five milestones, as shown in Figure 8.6. Starting with Milestone Two, each milestone had its own round of player testing and feedback. Don't think that should wait until the last

Paintball Net **Milestone List**

Milestone One, Up and Running: At the end of Milestone One, we have a playable, if somewhat simple game. Players can join a player-hosted server and play in Survival matches.

Milestone Two, Player Persistence: At the end of Milestone Two, players have individual accounts that track their game statistics as well as their equipment. No new players models or equipment have been added, but the player can now buy new ammunition when it runs out.

Milestone Three, It's Getting Interesting: New stores selling new equipment are added to the game, as well as global teams. And players can finally choose a gender-based model.

Milestone Four, Are We Done Yet?: Players can now vote on the map used in matches, and they can modify their equipment with kits from the new Chop Shop.

Milestone Five, Final Testing and Tweaking: Final testing and tweaking, along with integration of the remaining artwork.

FIGURE 8.6 *Paintball Net*'s planned milestones.

milestone. Far from it. Testing is vital throughout the development process, as will be discussed in Chapter 20, Project Testing.

CONCLUSION

Ultimately, how you plan your project is up to you. You're the indie, and you have the freedom to do what you want. It's your project, and you are best aware of your capabilities, your strengths and weaknesses. Whether you use the method presented here or one of your own, it's important that you have some kind of plan.

There is such a thing as too much planning, of course. But most people err to the other extreme, launching into a grand endeavor with little more than a vague destination in mind. Even if you take only a few hours to consider where you're going with your project and how you want to get there, then you'll be ahead of the curve.

BUDGETING AND RISK MANAGEMENT

IN THIS CHAPTER

- Budgeting
- Risk Management

There's a chapter on *budgeting?* Aren't most indie projects unfunded? Well, yes, they are.

While you will probably be getting labor, your biggest project cost, free from volunteer team members who hope for back-end royalties, there may be other project costs that are unavoidable. You won't know what these costs are, though, until you consider the entire project and see what's needed. Once identified, these costs can be covered, and you won't be blind-sided by them.

This chapter will also provide an overview of risk management as it pertains to independent game development. Just as with costs, you won't know what risks exist until you examine the project in detail.

BUDGETING

The first part of making a budget is to list your costs. If you're unfamiliar with the normal costs of game development, we will provide a quick course in game development cost accounting that will help you understand the basics. After that, we will discuss some of the more common costs encountered by indie game developers.

Don't let the concept of budgeting overwhelm you. It's not as difficult as it might seem at first, and you don't need to learn how to use a commercially available accounting software package to create a budget. Spreadsheets are ideal for compiling a budget and for tracking costs as you go along. You can even track when those costs are due and when they were paid. Spreadsheets also make it easy to see what charges are due within a few days or weeks of each other, making planning and budgeting simple.

Game Development Cost Accounting: A Primer

If you've never managed a corporate or game development project before, you've probably been insulated from the budgeting process. As an employee, the closest you've probably been to budgeting was when your manager or project leader showed you a task and asked you to estimate how long would take (see Chapter 8, Task Identification and Scheduling). Sometimes they come back and have you actually live up to that estimate, and sometimes you never hear about that project or task again.

All business is based on the dreary-sounding subject of *cost accounting*. Cost accounting means simply knowing what everything costs. Whether it is the per-seat licensing fee of development software, the cost per

square foot of office space, or the cost of consumable office supplies—cost accounting tells the business owner what his expenses are, and how much revenue he needs to have come in to make a profit. The most common costs of a game project are as follows:

- Labor (e.g., Joe Developer)
- Development Hardware (e.g., PC)
- Development Workspace (e.g., office space with lights, heat, electricity, etc.)
- Development Tools (e.g., VC++, 3DS Max)
- Consumables (e.g., CDs, paper, toner)
- Project-Specific Third-Party Components (e.g., 3D engine, motion capture)
- Project Management (e.g., project communication equipment, software)
- Legal (e.g., contracts)
- Accounting (e.g., bookkeeping, taxes)
- Marketing (e.g., Web presence)

This list might seem formidable at first glance, but a number of these items may already be taken care of. For instance, as an indie, you are probably going to rely on team members who provide their own development hardware, workspace, tools, and consumables. And they will be contributing their labor for a piece of the back-end profit-sharing. You, as the indie in charge, will be handling the project management tasks, yourself. If retail game projects could eliminate these costs, it would cut their budgets by 85%–90%. Employees—including a place for them to work, tools for them to work with, and other people to oversee their work—are expensive.

You may have some up-front legal costs to deal with, such as to cover company formation and team member contract reviews. But your accounting and marketing costs will probably not kick in until the game nears completion.

That leaves only the short-term, project-specific third-party component costs to be dealt with. Since this is *your* project, assume that you will have to cover these costs yourself. Some of your team members might be willing to pay for some of these costs, but it's likely that you're going to have to provide most of these components.

As you identify each expense item, assign a cost to that item. This may take a bit of research, but that's part of the process, too. *Real* cost accounting goes into much more detail. Here, we're just trying to identify basic costs and quantify them.

Identify Your Project Costs

Now that you are familiar with the basics of cost accounting, go through your game design document and production planning documents, and identify all the tasks that need to be paid for. What costs do you already anticipate? When are they going to come due? Are there other costs that could come up?

Where possible, think in terms of packages and subsystems. For example, you might consider buying a package of precreated button icons rather than have your primary artist divert his attention from the more important task of creating model textures or level layouts. Or you might decide that it would be more efficient to purchase a sound/music playback API rather than tackle the job of building it yourself. For *Artifact*, Samu Games chose to use the Miles Sound System by Rad Game Tools (*http://www.radgametools.com*). An excellent sound and music API, the Miles Sound System came with a per-project price tag of $3,000 (1998). Since this was a project cost and obviously not something that the sound engineer should be expected to pay, Samu Games bit the bullet and paid for the API as an expense against later revenue.

Before you worry about how much your own project is going to cost you, understand that the Miles Sound System was the largest single development cost for the Samu Games *Artifact* project, more than the rest of their costs, combined. Most indie project costs are not going to be that large. Even Samu Games wouldn't have considered such an expensive component if another of their previously released games hadn't provided the capital to fund it. In all likelihood, most of your costs will be no more than a few hundred dollars per item, if that much.

Once you've identified your irreducible costs—the components or infrastructure elements that the project must have—use your production schedule to see when those costs will need to be paid. Examine your schedule closely to see if any will need to be paid at or near the same time, or within the same project milestone period. You may be able to juggle your schedule sufficiently so that the costs are spread over a longer period, or at least don't all come due at once.

How you pay for these irreducible costs will be covered in Chapter 10, Creative Funding. For now, though, let's cover risk management.

RISK MANAGEMENT

Budgeting, as it is discussed in this chapter, is part of your project's *risk management*. In simple terms, risk management is about identifying as many risks to the project as possible *before* beginning the project, and then deciding how those risks will be handled when or if they occur.

Identifying possible risks, is very important. You cannot adequately prepare for something unless you know what it is.

Identify Risks, Then Plan for Them

Because you are an independent game developer with little or no funding for your game, budgeting is more of a risk management task for you. Instead of projecting how much it will cost to create your game, you are identifying the costs that you cannot avoid, which are some of your more significant risks. You must then come up with a way to manage those risks, either by paying the cost out of pocket or some other way.

For example, if your project is a multiplayer game, there will come a time when you'll have to deal with the issue of bandwidth. Bandwidth is the single largest expense for multiplayer games (followed closely by customer service). If you plan to host the game yourself, then you will have to be prepared to pay for that bandwidth on top of the cost of the physical hardware (servers) to host the games. If you know that the expense is coming, you can take steps to have funding available; or you can choose to redesign your game or its networking infrastructure to offload some of the bandwidth costs to your players. Or you might decide to provide only simple match-making services. Whichever route you choose, you will have identified the risk—and the cost—and you can take steps to manage it.

When you created your budget, you identified everything with an 'obvious' price tag. But what about those things that don't have obvious costs? Go through your entire game design and your production plan again. And this time, ask yourself, "What could go wrong?" What features might prove more difficult than predicted, and what other features will be affected by not getting these done on time? What if the feature turns out to be impossible, or at best infeasible? And how will the game need to change in order to compensate for it?

Get paranoid and pessimistic during this step, but also be creative. When identifying your risks, assume that the worst not only *can* happen, but *will* happen. Start with the far out, catastrophic risks, like the death of an artist from a meteor shower over the Thanksgiving Day holidays—and then focus in more realistically: what happens if a team member leaves the project? To manage this situation, you might establish legal contracts and Nondisclosure Agreements (NDAs) to protect you, the project, and the team members (see Chapter 4, Getting Started and Chapter 13, Finding Team Members). What if you find a great artist, but he doesn't own the modeling tools needed by your project? Before you prepare to buy the tools for him, decide if the team members must own legal copies of all the tools necessary when they come into the project, and/or who will own the tools if you buy them, yourself.

These examples should illustrate the basic idea. Risk management isn't a complex topic. Look at the project, see what could go wrong, and then take steps to either prevent the problem or establish a course of action to take if/when it happens. Keep the list of risks, and descriptions of how these risks will be managed, in a companion document to your production plan.

Finally, risk management should also include keeping backups of all project resources, such as source code, art, sound, music, and documentation. Don't trust the fate of your project to a single piece of hardware (see Chapter 18, Resource Management During Development).

Keep Records

Another important part of risk management is keeping records. As a taxpayer, you've no doubt already learned the importance of keeping records and receipts, especially if you use an accountant to prepare your taxes. This is also important for independent game projects, and not just for tax reasons.

Whether you plan to offer your project for sale through a publisher, by self-publishing it, or even not all, you should keep records of all expenses incurred by and for the project. Even if you consider your project little more than a hobby, keep track of everything that is money-related. The project could possibly become profitable, which is much more likely if you prepare for it.

Whenever you pay project costs out of your own pocket, keep track of them in detail. Wherever possible, keep the receipt for the transaction, too, even if it's just your credit card statement with the charge listed. Besides being able to claim these as business costs on your annual taxes (consult an accountant to be sure about this; laws vary), they are also expenses that should be recouped prior to profit-sharing when the game begins making money. If there are other team members investing project-specific monies, you should record these, too, and allow them to recoup those expenses before profit-sharing, as well. You will need to decide who gets paid back first, of course. This will be covered in more detail in Chapter 12, Team Member Compensation Options.

Detailed recordkeeping is also useful for reviewing your budgeted costs versus actual costs after the project is completed. It can tell you where you overestimated, where you underestimated, and how you can more accurately estimate in the future. It's hard to do an informative post-mortem without adequate documentation.

There's no reason to get too complicated with your recordkeeping, and it's not necessary to have a fully functional accounting system. Keep it simple for now. A spreadsheet with a line per transaction and a sepa-

rate file folder for keeping track of receipts are all you really need. As pointed out in Chapter 4, an accountant (especially a CPA) can help you with this.

CONCLUSION

Budgeting and risk management are as important for indies as they are for the big retail publishers, possibly even more important. Limited time and money, which define the independent game development experience, make it that much more important for you to consider and be aware of all sorts of possibilities—good and bad, cheap and expensive.

As an indie, you have no time you can spare, no resources you can waste. With forethought and planning, though, you can maximize what you do have and reduce any chance that you will be surprised or caught off guard—and possibly have your project completely derailed—by sudden changes.

When it comes to budgeting and risk management, assume nothing. Until you have examined your project in detail, you don't really know what the costs or risks will be. You don't need all the answers before you begin, but you should try to have a good idea of what questions are going to come up.

Be prepared!

CREATIVE FUNDING

IN THIS CHAPTER

- Your Money
- Other People's Money
- Target Market Money

Chapter 9 taught us that even a volunteer project with 'free' labor will have some expenses. You will, no doubt, do what you can to make sure that as few as possible irreducible expenses stand between you and your completed project. It's inevitable, though, that something will need to be purchased, replaced, upgraded, or otherwise demand money. Whether it's third-party components/libraries or necessary pieces of infrastructure, or even contract work that can't be acquired any other way, there is going to be at least some cash needed.

Some of these expenses should have been anticipated. Chapter 9 stressed that all irreducible costs should be identified as part of production planning. There might be more of these costs, or (in very unusual cases) there might be fewer. By identifying all possible costs, though, you can take the first step toward managing the risk. When you acknowledge the costs and schedule when they must be paid, then you can estimate how much money you will need to allocate, find, or borrow as the project progresses.

But where will this money come from? There are three primary sources of cash you can use for your project: your money, other people's money, and target market money.

YOUR MONEY

The most obvious source of funds for your project is *your* money. This may involve some sacrifices on your part, but if you're committed to seeing the project through, whatever it takes, then you should be prepared for sacrifices. Rather, look at it as an investment in yourself and your future. You are taking your money and using it to build something the world has never seen before! Sounds exciting, doesn't it? But don't get too excited. Keep your day job.

Keep Your Day Job

One of the most useful financial resources the new indie has is their full-time job. The day job covers living expenses, such as a place to stay and food to eat, so you can focus on your project and not worry about survival. Regardless of how well received you expect the game to be when it's completed, your full-time job allows you to face your project without with the worries that come with house payments and feeding yourself or your family. You have peace of mind.

Granted, a full-time job will take about 40 productive hours out of your week, significantly reducing the amount of time you have to work on the project—more if you have to commute. That's the price of security, though, however tenuous it is.

You might find it interesting to look at how you spend your time at work. Most of us are not operating at full capacity for more than three to five hours during the work day, six at the most. The rest of the time is soaked up by 'administrative overhead,' such as attending meetings, handling paperwork, returning phone calls, and other necessary but trivial tasks that chip away at your productivity. Imagine how productive you will be on your game project, since you won't have to deal with these distractions.

In the beginning, you may find switching gears between your project and your day job a bit jarring. As you get used to the routine, though, you will find that the two co-exist (at least somewhat) peacefully. You can even use your full-time job as your daily break from your project, knowing that your project will move forward each day, steadily becoming more and more complete. Your after-hours project can actually keep you happy and productive at the day job that keeps you comfortable and well-fed, so you are free to work on your game project with 100% productivity in the few hours available.

There is a caveat to keeping your day job, though. Some employers insist that they own anything you create, whether on their time or on your own. Be aware of your employer's policies in this regard. If you're in doubt, ask a lawyer.

After you have a couple of projects completed, and if they are providing income for you and your team, the day may come when you decide to quit your day job and become a full-time indie. Every indie dreams of this day; and in many cases, this their ultimate goal. But if you're one of those indies who just wants to 'quit and go home' *today*, you might want to reconsider such a drastic approach. It can be a dangerous one.

Should You "Burn the Ships"?

A popular contention among some indies is that the best way to get your project done is to *burn the ships*. Burning the ships refers to the Spanish conquistador, Cortez, who motivated his crew toward success by burning the ships that brought them to the New World. The only way to get home again was to win, and win big. People who espouse this approach quit their jobs and focus solely on their projects. The idea is to work as hard and fast as possible to get the game finished—and turning a profit—before the they collapse from exposure and lack of food. If you are single and have no dependents, this drastic approach may work for you. Imminent starvation can be a powerful motivator.

Before you decide to follow Cortez's example, however, there are a few things you should consider. First, how certain are you that you have the reserves on hand to cover the entire development process

from preproduction to sales? Software development in general, and computer game development in particular, is notorious for taking significantly longer than originally estimated. What happens if your project takes twice as long you had anticipated?

Second, do you expect your entire team to quit their jobs, schooling, or other commitments, as well? Not everyone is willing to gamble with the spectre of poverty. And, if not, what then? Do you boot them from the team? Or just hope that you and the rest of the full-time team can make up the difference?

Third, in addition to the time required to get the game finished, there is also the time required to build the game's revenue stream. How long are you prepared to wait for your gamble to pay off? Independently produced software can be profitable for years, but it can take months or even years to build up to that point. What will you and your team do during the interim?

Finally, Abraham Maslow's famous 'hierarchy of needs' refutes the most basic premise of the burn-the-ships approach. When you remove the security of your full-time job and its support for your basic needs, like housing and food, you create distractions on a whole new level. On the one hand, a full-time job eats up a lot of time and can be very distracting. But on the other hand, the distractions caused by a full-time job are seldom life threatening.

Doom and gloom notwithstanding, the burn-the-ships approach to becoming a full-time indie can be successful. There are people who have quit their jobs to pursue their dreams and have done just that. The point is one of caution, and to bring to light some of the risks involved. If you want to go this route, don't make the decision rashly. Consider all the possibilities, and come up with a few contingency plans to cover any difficulties that might arise.

As a compromise, you might consider reducing your full-time employment to part-time hours. Perhaps your employer will agree to a change your schedule and/or the number of hours you are expected to work. This will reduce the income from your job and possibly affect your benefits, like health insurance, but it could provide you with sufficient money to meet your obligations while simultaneously devoting an additional 10–20 hours per week to your project. Keep your mind open to all the possibilities.

In the same vein and depending on your background, you might be able to pick up part-time, contract work. The emphasis here is on "part-time"; if you're clocked in for 40 or more hours a week, you haven't freed up any additional time. You've just swapped one full-time job for another.

Avoid Debt

Avoid project-related debt. And if you can't avoid it, then think long and hard before you actually incur it. This can't be stressed enough.

It's okay if the project owes *you* money, but it's a completely different issue if you take on debt of your own to pay project expenses. If you, yourself, spend the money for a component that the project needs, counting the outlay of cash as an expense against the project to be repaid later, this is much the same as using your disposable income for a hobby or other pastime—better, in fact, because there's a chance you will get the money back. The expense becomes an investment of sorts.

If, however, you put that same expense on a credit card or some other form of consumer debt, you aren't helping yourself or the project. You're adding a financial burden to both yourself and the project, if only indirectly. Debt accrues interest, making the total cost much higher over time, and it's not reasonable to assume that the project will repay the interest in addition to the initial expense.

Indie filmmaking is replete with anecdotes of filmmakers charging the costs of production to their credit cards. There is even a story about an indie who had a traffic accident and was relieved when the insurance payment would be enough to cover finishing his film. Now, that's definitely 'creative funding,' but it's not recommended. Some of these films did pay back the charges over time, but it's a long shot—a gamble with bad odds. Invest in your future, but don't gamble on it.

Disposable income (money you have left over after you've covered basic expenses) can be reasonably invested in an independent game project. Even if the project fails or never produces sufficient revenue to pay you back, at least it was money you could 'afford' to lose. Call it a hobby, and no one can fault you. Hobbies always soak up inordinate amounts of money, giving satisfaction and enjoyment as their primary (and often only) return. If you have to go into debt, then you're already past what you can afford. Remember: whether or not the project ever makes any money, you will still have to pay back the debt. So, when it comes to using personal debt to fund your game project, just say, "No."

Spreading Costs

Spreading costs won't generate funds, but it may help keep your expenses from ganging up on you. Many small expenses that are due at or around the same time can add up quickly. So while you're putting your projected budget together (see Chapter 9, Budgeting and Risk Management), keep an eye out for ways you can spread your costs over a longer periods of time.

In addition to spreading costs, you should look for opportunities to break large costs into smaller costs that come due weeks or months apart. (Negotiating your payment terms with vendors is discussed later on in this chapter.) And there are other avenues for spreading costs.

If you are purchasing a bundle of services or products from a single contractor or vendor, you may be tempted to pay for all of them at once. However, if you only need one piece of the bundle right now, consider buying only that piece. When the time comes later on in the project that you need the rest, buy them then. You may lose out on some savings by breaking up the bundle, but in the short term, it could be worth it.

For example, if you are contracting out the artwork for your game, you could elect to have all the artwork delivered as a package. Do you really need all of your artwork at once, though? If you know what artwork you need for each milestone (see Chapter 8, Task Identification and Scheduling), then have the artist only do the artwork for the current milestone. That way, you get the artwork you need, as you need it, and only pay for the work done so far. This approach can convert a single contractor cost that might otherwise be thousands of dollars into a number of payments of only a few hundred dollars each.

Negotiating with Vendors

Negotiating with vendors doesn't generate funds; rather, it reduces expenses, at least in the short term. Everything is open to negotiation. Exploit that by asking vendors for a discount. Or ask if you can defer payments until the project is completed and/or producing revenue. Even if you're not a very good negotiator, you could reap some serious benefits just by asking. You never know until you ask.

In addition to discounts, ask if there is any flexibility in *how* you pay. You may be able to get your payment broken into several smaller payments that span a period of weeks or months.

Think long term. Think trade. Think partnership. Think shared risk and shared reward. Do you have something of value to offer the vendor, such as exposure or even a percentage of future profits? With that kind of leverage, you may be able to create a partnership that pays dividends to you both for years to come. Be creative, but also be prompt with payments and worthy of their trust. If you make a deal with a vendor, always hold up your end of the bargain.

OTHER PEOPLE'S MONEY

There is a chance, however small, that you might be able to use other people's money to help your project—either from team members or in-

vestors. Neither of these options is a given nor should be treated lightly. Both could also have repercussions on not only the game, but beyond, as well.

Other Team Members

If you have a team working on your project, you might consider asking them for contributions to cover necessary project expenses. But just as you expect to be repaid for a back-end expense, so do other team members. You should only request money from your team members if you are willing to, and have already, put in money of your own.

Another alternative is keeping expense contributions balanced among all team members. When the project needs cash for something, everyone contributes an equal amount. That way, all team members have put in an equal amount, and no one has a greater investment in the game than anyone else.

Consider the situation carefully, though, before you ask team members to contribute. As project leader, you are expected to do what you can to see the project through to completion. If you put in out-of-pocket money, it's not a big deal. It's expected. But if a team member puts in money, in addition to his normal time and effort, he may expect more than simple reimbursement. Team member contributions must be handled very carefully, with repayment and other issues spelled out in advance. And never make assumptions. Be explicit.

Investors

Investors aren't really a 'creative' funding approach. Most developers think of them at some point in the process. Investors don't give free money, though. Just as with using a credit card, investors expect to be paid back— soon, rather than later—or else, which adds a burden to the project.

In the investor's mind, your project is *their* project. As such, the project *must* make money so that they can 'cash out.' When it comes to their money, "hobby" is not in their vocabulary. They're in this to make a profit, period. That attitude will add pressure to everyone involved in the project.

In addition, some investors may want to exert control over the project, such as in design issues or staffing. They've provided funding, and they want a say in how those funds are used. Keep in mind that if you had wanted *other* people exerting control over *your* game, you wouldn't have become an indie. So if you do accept money from people outside the team, be very clear on what their contribution entitles them to do. If

possible, restrict their involvement in the project to, at most, an advisory role.

A detailed discussion on investors—how to attract them and keep them involved until they can cash out, and do so legally—is far beyond the scope of this book. The simplest approach may be to decide on a dollar value for percentage points of profit sharing. This assumes, of course, that you have unallocated percentage points in a sufficient quantity to make offering them this way feasible (see Chapter 12, Team Member Compensation Options). In summary, if you want to pursue investors, you should talk to a lawyer or accountant, and probably both.

Target Market Money

Finally, the your target market, the players, might be a source of funding for your game. How can you can get players to pay you *before* your game is completed? It's not always easy, but there are ways.

Merchandising

The most obvious way to get money from players before your game is finished is through *merchandising*. Merchandising is a marketing tool that combines products, like clothing and accessories, with promotion.

If your game has characters or other features that lend themselves to logos and images on t-shirts, sports caps, or other paraphernalia, you might be able to generate some funding that way. There are a number of Web-based companies who can handle the printing of these items. Some, like CafePress (*http://www.cafepress.com*), will even provide a virtual 'store' where you can sell your items.

But before you get excited and decide to fund your game with preprinted novelties, realize this: players probably have a different opinion of merchandising than you do. They tend to view this kind of merchandising as 'free advertising'; so they should get the items free of charge. After all, they wear the shirt, and other people see the shirt, and maybe those other people play the game. It's an honest trade, especially for a game that isn't finished yet. And even after the game is finished, and you have raving fans that think your game is the best thing since *Doom 2*, it's unlikely that you will sell enough units your outlay for the merchandise worthwhile. Do a survey of your own closet and count how many logo-bearing t-shirts you paid for versus those that were given away at trade shows, launch parties, and similar events.

Nonetheless, if you can put together a merchandising item with enough 'cool' that people will want them, then go for it. The important thing to keep in mind, though, is that you're not trying to get rich off of your merchandising sales. You're just trying to scrape together enough money to buy what you need in order to keep the project moving forward.

Pre-Release Tactic

Here is another slight advantage that indie games have over retail games: the indie game developer can, in certain circumstances, begin selling a game *before* it's done, thanks to Internet-based distribution. With proper planning of development phases, you can begin selling the game while it's being finished. This may not provide a huge amount of cash, but if you've managed the project to this point, it's unlikely you need too much.

Not all players will pay for a 'beta version' of your game, of course. Some will even be indignant if asked. So you might have to modify your planned payment structure to accommodate making the game available for pre-release sales. You could offer extra benefits for players who buy the game while it is still in the final testing period. Or you might offer the game for a reduced price, with a free upgrade when the full version is released. These are only a few of many options.

For example, when *Artifact* went into public beta testing, Samu Games also began selling the game. There was no doubt the game wasn't finished yet. There were features (like player clans and optional chat channels) that were incomplete or not yet implemented. The game mechanics were still being fine-tuned. Despite this, the game had reached the point where it was complete enough to support full-time players, and the game needed to start paying off some of its development costs. To sweeten the deal for the players, a 'Charter Citizenship' was offered with enhanced benefits over the normal payment levels. A special award icon would also be displayed next to the Charter Citizen's name while they played. Sales during beta testing were slow, but they did help create a foundation of paying players and helped fund the infrastructure build-out when the game was finally released seven months later.

The intention here is not to sell 'vaporware' to potential players. You are not selling just the promise of a game (that's *fraud*, which is illegal). Instead, you are selling a game that has reached a point where it *will* be completed, and it is complete enough to be fun to play.

CONCLUSION

Except in rare cases, your projects will be self-funded. This is true among indies of most industries. Still, it's possible with some creative thinking to generate extra cash and keep the project alive as it moves toward completion.

Always be on the lookout for ways to make your project pay for itself, even before its finished. If you've never been a bargain hunter, learn how now. Stretch your limited funds as far as you can. Ask for discounts, negotiate extended payments, and be open to partnership opportunities. In short, be creative!

THE TEAM

Independent game developers don't have to work alone. In fact, in the modern computer game industry, it's much more difficult to work alone than as part of a team. Many specialized skills are needed to create a computer game, from programming to pixel-pushing and from composing to scripting. A game that is designed, developed, and marketed by a single person is rare.

Chapter 11 (Team Basics) takes you through the initial steps of deciding whether your project requires a team. Different projects have different needs. No one 'team solution' will fit all projects. This chapter also discusses your long-term goals for your team and some potential issues that should be considered *before* you build your team.

Chapter 12 (Team Member Compensation) discusses the many different ways of compensating your team. Profit sharing is discussed in detail, and several ways of handling it are presented. Other compensation options are presented, as well, such as deferred payment.

In Chapter 13 (Finding Team Members), you will learn how to find people to help you with your project via personal and professional contacts, as well as on the Web. This chapter also covers how to screen candidates before adding them to your team.

Chapter 14 (Remote Team Management) focuses on those aspects of team management that apply to indie projects, such as team structure, communication, and motivation. There are also tips for dealing with unproductive team members.

Finally, Chapter 15 (Team Leadership) moves beyond talk of managing your team to discuss *leading* your team.

TEAM BASICS

IN THIS CHAPTER

- Do You Need a Team?
- What Are Your Goals for the Team?
- Team Issues
- The Team Member Contract

Τ he team of independent game developers coming together to create a fun new game has been a part of the lore of the computer game industry for years. Some of these teams, like Id Software in the early 1990s, have risen to the status of legend. Their success stories inspire even the most jaded industry veterans.

This chapter takes you through the initial steps of deciding whether or not your project requires a team, how big a team it might need, and what your goals are for that team. Different developers and different projects (even by the same developer) have different needs. No one 'team solution' will fit all projects. Also discussed are some potential issues that should be considered *before* you build your team, such as the all-important team member contract.

DO YOU NEED A TEAM?

Does your project require a team? Chances are that it does; but like all aspects of independent game development, building a team benefits from careful planning *before* you get started. For example, how many team members do you need? What if you *want* to be a lone indie? The 'minimal team' concept will also be covered. You might be surprised at how much can be accomplished when just two or three people work together.

How Big a Team Do You Need?

Before you start combing the Internet for potential team members, you need to decide whether you actually need a team. If you've created a full game design document (see Chapter 7) and a production plan and schedule (see Chapter 8), you probably already know (or at least should have a very good idea) if you do or don't need a team. If you haven't done these things, then you're just guessing. Go back and do your homework.

Consider your project in detail. Your game design document, along with your detailed task list, should provide enough information for you to make an educated guess about how many team members you need and which specialties of game development they need to handle, be it art, sound, or coding.

Begin by identifying the parts of the project *you* want to work on. Out of all the tasks and subtasks you've identified, pick the ones you plan to handle. If possible, don't just stick to the tasks you know you can do. Be willing to push your boundaries a little. Don't push too much, though; recognize your weaknesses so that the project won't suffer from them.

Next, based on the time estimates gathered for each task, add up everything you want to work on and see if it is too big a load to attempt in a reasonable time frame. If it is, then you'll want to narrow your focus.

Is your workload spread more or less evenly across your milestones (see Chapter 8, Task Identification and Scheduling)? If not, you may want to choose tasks that are more evenly distributed.

Finally, calculate how many more of 'you' would be needed (assuming you had all the necessary skills) to take care of the rest of the project's tasks. This number will serve as a base. You probably won't need *fewer* than this number, but it's quite possible that you will as many as twice this number. (If you end up needing more than twice this number of team members, chalk it up to experience and make better estimates on your next project.)

Keep in mind that your team members will likely have full-time jobs, families, and other commitments, just like you do. This might have an impact on how many team members you need to meet your target completion date.

Try to group tasks according to their primary required skill set. If possible, keep programming tasks separate from the art tasks, art tasks separate from sound tasks, and so on. You may be lucky enough to find a team member who can wear multiple development hats, but don't count on it. Assume that most team members are specialists, and plan accordingly.

Then again, you might be more interested in going it alone. No law says you have to have a team, regardless of the estimated workload. You might be able to do it all by yourself.

All by Yourself

Maybe you don't need a team. Perhaps the project is simple and you've calculated how long it will take, even if you're the only one working on it, and you're happy with the resulting schedule. If you have no team members, then obviously you're responsible for everything: design, programming, artwork, sound, music, documentation—*everything*.

Doing it all by yourself is not necessarily a bad thing. You have fewer legal issues to deal with, you can work at your own pace from start to finish, and when the project is complete, you don't have to share the profits.

The downside of staying solo, however, can be pretty steep. Even if you have the necessary skills to perform all of the project's tasks (which is quite impressive), there's still only one of you, and you can only work on one thing at a time. The time between starting the project and completing the project could stretch into months, possibly years, for all but the simplest projects.

It can also be hard to motivate and inspire yourself over time. As the project stretches on, if you're all by yourself, keeping your passion burning can be a challenge. Nobody likes to work alone for very long.

Even if you have skills in several different areas, you probably do only one of them well enough and/or fast enough to be really productive. Therefore, attempting the whole project by yourself isn't likely to work well. There are going to be parts of the project that you simply cannot satisfactorily complete by yourself. Contracting parts of the project out to freelance professionals can help keep your project doable by yourself. Freelance professionals, though, will add considerably to your out-of-pocket costs.

Figure 11.1 shows the Indie Game Developer Survey results on projects with teams. Just over half (53%) of the indies who responded had worked alone on their projects.

Indie Game Developer Survey Results

Have you ever completed a project that required more than just one team member (yourself)?

47% Yes

53% No

(Survey Note: 62 Respondents)

FIGURE 11.1 Indie solo project survey results.

There is another alternative to working alone that, at the same time, keeps your team as small as possible. Find a partner who complements your skill set, and the two of you could form a 'minimal team.'

The Minimal Team

For most indie game projects, the minimal team is comprised of one programmer and one artist. You will also probably need sound effects, but for a project small enough to be tackled by two people, most of the audio you need can probably be purchased as a bundle, and you can contract out the rest. If you're not a programmer or an artist (e.g., an audio specialist), unfortunately, you're going to have to find the other two, making yours a minimal team of three members: you, the programmer, and the artist.

A project that requires only a minimal team is a good beginning for an up-and-coming developer. There are a lot of viable game ideas that re-

quire a team no larger than this. Figure 11.2 shows that more than a quarter of the teams (27%) had only two to three members. Many projects require a much larger team, of course, but these probably shouldn't be tackled by an indie—at least, not as first project.

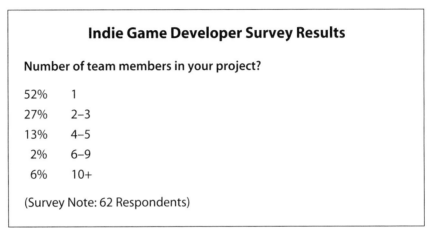

FIGURE 11.2 Indie project team sizes.

If you decide to use the minimal team approach, you might have to go back through your production plan and schedule, and adjust your milestones. If the project could easily use a team of four or five, using the minimal approach, it will take longer to complete. You might even want to redesign the project and reduce its scope down to fit the minimal team specification.

Now that you have a good idea of the size team you will need, ask yourself, what is your goal for the team for this project. And what are your goals for your team for future projects?

WHAT ARE YOUR GOALS FOR THE TEAM?

You've decided how big a team you need and what specialties you need to staff it. Before you start looking for team members, though, you should consider one more question: what are your goals for the team?

The obvious goal for your new team is to complete the current project. But what about after this project is finished? Do you envision a future of more such projects? Do you hope to create a new game development shop based on this team? Your goals affect how you approach building the team. If you are only interested in the current project, then the long-term compatibility of team members may not be as

important as simple competence and a willingness to do the work required. If, however, your goal is to create a team that can form the core of a new game development company, then the people you select for the team must integrate and 'play well' together.

Ad-Hoc Team

An *ad-hoc team* is brought together specifically for the current project. Once the project is completed, the team is disbanded. Royalties and deferred payment are paid as agreed upon, but the team, itself, no longer exists.

Ad-hoc teams are a great choice for indies who want to get their games done as quickly as possible. Also, if you prefer to think of yourself as a one-man company, the ad-hoc team offers several advantages.

Since there's no need for long-term compatibility between team members, the screening process for team members can focus less on interpersonal issues. You are primarily interested in whether the potential team member can do what you need done. In this way, ad-hoc team members are very similar to freelance contractors.

Over time, as you complete more projects, you may find that you are working with the same people over and over. Some of them will be indies, and you may be helping them with their projects. In this way, you end up with an interconnected network of independent game developers, each with their own games and specialties.

The ad-hoc team structure is less formal and has minimal long-term commitments, which may make it an ideal choice. In addition, the networking advantages can extend beyond the present project and provide you with future resources as you build a *career* as an indie.

Long-Term Team

On the other end of the team-building spectrum is the *long-term team*. A long-term team is formed with the intent of working together on many projects, not just the current one.

If you build a team that can create one game, perhaps that team could create another—and another. The relationships that form as the team works on the present game could provide a solid foundation for future projects.

Long-term teams take more time and effort to pull together. Not only do you need to consider the prospect's technical skills, you must also be aware of how they fit into the team. Long-term teams don't require homogenous personality types, with everyone always in agreement about

everything. They do, however, require that everyone be compatible to a significant degree. You are going to be together for a long time, so you have to be able to stand each other.

Long-term teams can more easily form the core of a new game development company than ad-hoc teams. So if that's your ultimate goal, you should definitely consider forming a long-term team.

TEAM ISSUES

Even though indie teams are formed from passion, lead by a vision, and motivated by dreams of the future, they are not without their problems. Indie teams face many of the same issues as retail publishers' teams, such as team member compensation, project ownership, and dealing with team members that leave the project.

How Are You Going to Pay Them?

So you know how many team members you need, and you know what their responsibilities are. The next issue you need to handle is how you're going to reimburse them for their help. Cash payment for services rendered is going to be outside the range of options for most indies. Fortunately, independent game projects have a long history of people working together to create a game and then splitting the proceeds. So there is plenty of precedent to draw from.

The simplest approach is for all team members to share equally. If the game sees a profit, this profit is split up among all of the team members.

Taking this 'shares' concept a step further, you could offer multiple shares to some team members, or even fractions of a share. Your share may be double or triple the others, if you are doing most of the work on the project. You might offer a particularly valuable team member a double share as a bonus, or half a share to a team member who has contributed a lot, but has to leave the project before it's completed. That way he gets reimbursed for his work, and the project still benefits from his contributions. There are many options for reimbursing team members. Be creative.

Who Owns What?

The following lesson presented in Chapter 4, Getting Started, deserves re-iterating: if you are going to have multiple people, all contributing to the same project, it's important that ownership of those contributions and the project as a whole be clearly stated beforehand. You will probably want to

talk to a lawyer who has experience with intellectual property rights to make sure that your team member contract (which is covered later in this chapter) properly handles all ownership and use issues.

What Happens When Someone Leaves?

Not all relationships, personal or professional, go as planned, and it would be foolish to ignore the possible consequences. Some questions that need to be answered include:

- Who decides whether a team member will be added to the project or asked to leave?
- What criteria are used to determine whether a team member is eligible for profit sharing?
- Who owns the assets contributed by the team member?
- Do the team member's contributions revert back to him when he leaves? Or do they stay with the project?
- Is the team member able to participate in profit sharing after he leaves the project?

These are very important questions. You should consider discussing them with a lawyer.

THE TEAM MEMBER CONTRACT

The *team member contract* is a legal contract between the indie (or the indie's company) and each member of the team. A valid team member contract can prevent most of the problems that plague independent game projects.

Whichever style of team you plan to form, your team member contract should be ready before you start. What should the team member contract include? At the least, it should include all of the following issues, and they should be addressed in universally accepted legal form:

- **Project description.** This is short description of what the contract is about (creating a computer game), including the working title of the game. This section will also specify the locality whose laws apply to the contract.
- **Compensation requirement.** Here is where you stipulate that the people who contribute to the project will *not* receive any payment unless they complete the work they were brought in to do.
- **Work-for-hire.** This section the contract specifies that the team members are not employees of you or your company, and that all

work for the project is 'work-for-hire' in exchange for profit sharing or other remuneration, as agreed to by both parties, on the completed project.

- **Tools.** Contributors to the project are expected to provide their own tools, unless other arrangements are made.
- **Ownership.** The contract should also specify who owns the project, and possibly as a separate item, who owns work contributed to the project.
- **Use.** Similar to ownership, the team member contract should describe how contributions to the project can be used. For instance, if a team member leaves, is the project still allowed to use his contributions? And is a team member allowed to use his contributions in another project, or is the contribution considered the 'intellectual property' of this project?
- **Compensation.** The contract should also specify how the team member is to be reimbursed (e.g., profit sharing) and the conditions required for that reimbursement (e.g., work completed to the satisfaction of the developer).
- **Profit sharing.** The contract needs to specify how profit sharing will work. For example, is profit sharing based on gross revenue (all money that comes in) or net revenue (gross revenue minus expenses)?
- **Order of payback.** If there are team members who are not receiving profit-sharing payments, or are receiving payments in addition to profit sharing, how will these payments be made and in what order? This needs to be specified here.
- **Project cancellation.** The contract needs to specify what happens if the project is canceled. For example, should ownership of contributions to the project revert back to the team members who contributed them?
- **Sale of the project.** The contract should explain how profits will be divided in case the project is sold to a third party, such as a publisher.

The advantage of the team member contract is that you and the other team members have all these answers *before* they're needed. To make sure you are covering the necessary bases in your team member contract and to verify the legality of it, a lawyer should be consulted. In this case, you want a lawyer with experience in the entertainment industry and intellectual property rights.

You now have your team goals in mind, and your team member contract is ready. The time has come to start staffing your indie team.

CONCLUSION

The indie team has a long tradition that stretches back to the earliest days of the computer game industry. Over these years, teams of independent game developers have achieved great things.

There is no single team configuration that works for everyone, of course. You might not need a team at all. Consider your project's requirements before building a team to handle them.

Finally, make sure you consider all the implications of having one or more people help you with your project. Don't operate on faulty assumptions. Have as much written down beforehand as you can.

CHAPTER

12

TEAM MEMBER COMPENSATION

IN THIS CHAPTER

- Profit Sharing
- Other Compensation Options
- Compensation Issues

Y ou shouldn't consider building a team unless you're willing to do everything you can, financially or otherwise, to see your game completed and share generously in the profits of that game. Of course, you value your own time and contributions. But you must value the time and contributions of your team members just as highly.

It's part of the indie tradition to work and contribute to a project prior to any reimbursement. And just as big a part of that tradition, though, is the profit that comes from the back end when the project is complete and money (sometimes a lot of money) begins coming in. Chapter 11, Team Basics, discussed how large a team your project needs. This chapter will present different ways to handle profit sharing.

PROFIT SHARING

Independently developed games are risky ventures. They are long-odds projects with many obstacles standing in the way of success. Therefore, anyone who is involved in the considerable effort required to go from game design to finished product should be entitled to a share of the proceeds. Whether the game becomes a cash bonanza, allowing you and your team members to retire comfortably in the tropics, or makes just enough to cover expenses, each team member deserves to receive a share of what he has worked for.

Profit sharing means just that—sharing in the profits. There are many forms of profit sharing. In the indie game development arena, the most common form of profit sharing is essentially a royalty payment based on net revenue (gross revenue minus expenses).

There are a number of ways to divvy up the profits. Figure 12.1 shows how some indies have handled profit sharing.

There are various ways that profits can be distributed. But first, let's discuss the difference between profit sharing and ownership.

Profit Sharing vs. Ownership

When you offer a team member a percentage or share of the game in return for their assistance in completing the game, you need to be explicit about what it is that you are offering a percentage or share of. Are you offering ownership in the game itself or a split of the profit sharing?

In some cases, the difference between profit sharing and ownership won't be immediately obvious. To make matters worse, you might understand the arrangement as profit sharing, whereas the team member thinks that it's ownership, or vice versa. This miscommunication could lead to disagreements and even legal action later on.

Indie Game Developer Survey Results

What kind of payment arrangements do you typically use with your noncontractor/non-work-for-hire team members (assuming net profits)?

30% Pure profit sharing, everyone gets an equal share.

19% Profit sharing, with variations for contribution or seniority.

16% I (my) company take(s) a significant slice of the pie; team members divvy up the rest.

 6% Some team members are paid as an expense prior to general profit sharing.

16% Some combination of the above.

13% Other.

(Survey Note: 32 Respondents)

FIGURE 12.1 Indie responses on team member compensation.

A share of ownership means that the team member is now a co-owner of the game. This could affect your control of the game's growth and development, and will affect how you handle the licensing and/or sale of the game, should the opportunity arise. If you own less than 51% of the game, you'll discover that in order to arrange some business deals, you will have to get some of the other owners to cosign.

A share of the profits, on the other hand, entitles the team member to a piece of the revenue from the project if/when revenue resulting from the project exceeds the expenses that have accrued. You must decide how the profits are determined, using terms like *gross* and *net*. A percent of gross revenue comes out of the total revenue received. A percent of net revenue, on the other hand, would apply only after specified expenses and costs have been subtracted from the gross revenue.

Never offer percentage ownership, except in rare instances. Offer a percentage of shares in the net profit of the game from unit sales to players, licenses to third-parties, or even the sale of the game to a publisher or another company. This way, the team members participate in the profits, if there are any, but you retain full control and ownership of the game itself.

If you do exchange ownership of the game for services, remember the 51% rule. You may find it hard to do business if you constantly have to get permission from your 'equal' partners.

Percentage Points

Percentage points (based on net profits) are probably the easiest way to divide up your profits. If you have a net profit, it is simple to calculate a percentage of the net profits. There is, of course, a limit to how many percentage points are available. Unlike shares (which will be discussed next), where you can add more shares as you need them (within reason), you can't have more than 100% total percentage points.

Since your team is probably going to be small, with only three to five members, you should be able to offer generous percentages while retaining a good percentage for yourself. One approach for dividing up your percentages could be as is shown in Table 12.1. Twenty-five percent is kept as your own, 45% is divided among team members, according to their agreements with you, 10% goes for reinvestment, and 20% is unassigned. That way you don't give away everything or leave yourself with a pittance. You can, of course, decide to keep less for yourself, though you probably won't want to give yourself less than 20%.

TABLE 12.1 Indie Percentages

RECIPIENT	PERCENT
Indie	25%
Team	45% (divided equally)
Reinvestment	10%
Unassigned	20%

The reinvestment money is set aside to provide funding for the marketing, advertising, development, and other things that the game might require. You might look at these as simply expenses against revenue, but this can limit your options. By having the game accumulate money to spend on itself, you help the game grow.

For example, assume that the game has had a gross revenue of $10,000 in the past quarter. Out of that, you had to pay for Web hosting, bandwidth, payment processing, and other expenses, for a total of $2,000 in expenses. That leaves $8,000 as net profit to be divided. You, with 25%, would take $2,000. Forty-five percent ($3,600) would be divided among the four other team members, or $900 each. Eight hundred dollars ($800) would be earmarked for reinvestment, and the remaining $1,600 is unassigned.

The unassigned 20% is kept for unforeseen expenses, such as attracting project team members late in the game, or maybe for courting an in-

vestor who is interested in providing funding (well, it *could* happen). If you get to the end of the project and still have some of this 20% unassigned, you could use it as accumulated 'bonuses' for the other team members, divide it up evenly among the team members, or add it to your own percentage block.

Accumulated bonuses for the team members means that the share of the net profits that would go to the unassigned percentage are held back, or accumulated. When the amount reaches some designated number (e.g., $1,000), it is split evenly among the team and added to their normal profit-sharing payments. This does have one advantage over simply dividing the unassigned percentage among team members. By only disbursing the payment at periodic intervals, there is the impression of greater reward. After all, would you rather get an extra $50 every three months or an extra $200 a year? Many companies use this same principle to calculate annual Christmas bonuses. People tend to appreciate large amounts received less frequently than small amounts parceled out over shorter intervals.

Shares

An alternative to the percentage method is to offer shares of the net profits. Shares are more flexible than percentages, and you can add (within limits) as many as you need. When it comes time to divide the profits, a share is much like a percentage, but the exact amount depends on the number of shares that are outstanding. Note that our use of the term "shares" here means shares of the profits, not shares of game ownership.

Even if you use shares for team member compensation and give yourself an equal share, keep back some percentage of the total profits, say, 20%. This serves the same purpose as the unassigned 20% mentioned in the discussion on percentages. It gives you a 'cushion' if something unexpected happens. You could also give the game a share in itself, which is much like the reinvestment percentage. If you do either of these, make sure that it's clearly specified in your team member contract to prevent confusion.

Shares are inherently flexible. You could give team members multiples of a share, or even fractions of a share should the circumstances warrant. For example, if you have a team member who has been with you since the project began, and you want to keep him happy as you add new team members, you could offer him a double, or even a triple share. Similarly, if a team member contributed a good portion of what he was brought on board to do, but now he has to withdraw from the project for some reason, you could offer him a half share. That way, he still gets paid for his contribution.

Using the same $10,000 gross quarterly revenue example given above, with its $2,000 in expenses, there is $8,000 in net profit. Twenty percent of the net profits ($1,600) has been flagged as 'unassigned' and will be used for bonuses at the end of the year. That leaves $6,400 to be divided among the outstanding shares. Besides you, there are three team members, each with an equal share. The game also has a share for reinvestment purposes. That means there are five shares outstanding, so everyone gets $1,280 this quarter.

Don't get too enthusiastic about giving out shares or otherwise adding to the pool of shares. To your team members, the perceived share value might be diluted as you add more members to a team. After all, each new member means another share that must be paid out. However, if you keep the team small, the members could have a larger share of the profits with the shares method than they might have with the straight percentages method.

OTHER COMPENSATION OPTIONS

There are other ways to compensate team members. Not everyone is interested in getting royalties, but they still might be willing to wait until the project makes money before getting paid. If you are willing to be flexible and consider different approaches to payment, you can offer some unique and creative payment options to your team members.

Deferred Payment

It's possible that you will have a team member who wants to charge you for the hours he worked on your project, but is willing to wait until the project begins to see revenue before he is paid. This way, he gets his normal (high) hourly rate, and you get to defer payment until you have something to pay him with. With this arrangement, you may be able to attract higher caliber professionals than you could with simple profit sharing.

This type of arrangement can also be used to pay a contractor a lower rate during development, but a higher rate would kick in when revenue begins to arrive. For instance, an artist who normally works at $50 per hour might be willing to initially work for $10 per hour. Then, when the project begins to have income, he would be paid his normal rate for the work he had done. That is, if he did 100 hours of work, he will be paid another $40 per hour for those 100 hours; you only have to pay him $1,000 for his part during development, with the balance of $4,000 paid to him when the game becomes profitable.

Deferred payment can also be useful to the developer who doesn't want to have to pay out percentages every quarter and write many small checks—perhaps some to people living in other countries. By using deferred payment, you can pay off each team member with either a single check or a short series of checks. And then you're done. It has all the benefits of contract work for hire with the advantage of not having to pay for it up front.

If you have multiple team members with this arrangement, you will have to set the order of who gets paid when. The simplest approach may be to pay them off in the order they came into the project, but that could cause problems with team members who join the project later on. Fortunately, there are still more options.

Variations

By now, you should appreciate that there is no one correct way to divide up the ownership and/or profits of a project. You can mix and match, based on your own preferences, and on what your team members expect and/or negotiate with you. You could offer a particularly valuable team member both a straight percentage and a regular share. Or you could give a member a share in addition to deferred payment. For example, for *Artifact 2*, Samu Games paid their artist a completion fee for the artwork he contributed, as well as a percentage of the net profits after the game was released.

If you have multiple team members who are owed flat payments, you could arrange to pay them an equal percentage of the net profits each quarter until they have been fully repaid. This gets money to everyone at the same time, though they might have to wait a bit longer to see full payment.

Finally, a royalty payment might be considered that stops after some maximum is reached. You could pay your artist 50% of net profits until his total compensation reaches $10,000. After that, he is considered fully paid. Not everyone will agree to such an arrangement, but it's an option.

Whatever arrangement you work out should always be put in writing and signed by all parties. You might also want to have the contract reviewed by a lawyer. This eliminates confusion and helps head off legal problems.

COMPENSATION ISSUES

Before we close this chapter on team member compensation, there are a few issues that must be covered. The most obvious of these is: when do team members start getting paid?

When Do I Get Paid?

It's important that your agreements with your team members explicitly state what they are to do in order to get paid. The team members must understand that if they do not complete the agreed-upon work, they will not share in the profits.

Dealing with unproductive (or counterproductive) team members will be covered in Chapter 14, Remote Team Management, but the situation is made easier if the team member knows they won't get a share of the profits if they don't contribute. You state this condition up front, before they've joined the team, and insist that they agree to it. This might be enough to head off potential problems.

Transferring Ownership or Profit Sharing

As remote as the possibility might be, you should consider how to handle the sale or transfer of a team member's share of ownership/profits to someone else. Do you want to expressly disallow that? Or, if you want to allow it, what is the proper procedure? There's also the possibility that the game will be licensed or purchased by another company. How will team members be reimbursed in these situations? Will they get a cut of the purchase price based on their percentage or shares? Or will it be calculated some other way entirely?

What happens if the project is canceled? Do people who contributed money, for whatever reason, get paid back in any way? Who owns the project and any contributed resources? Do the contributions revert back to the contributors?

Whatever you decide should be stated explicitly in your agreement with your team members, as discussed in Chapter 11, Team Basics. Again, to make sure you're doing things all legal and proper, you may need to consult a lawyer.

Buying Out Your Team Members

One last issue to discuss is the option of *buying out* team members. When you buy out a team member, you offer them a single payment in exchange for their ownership rights, or profit-sharing percentage, or share(s). This issue isn't likely to come up until long after your game has been released, but it's still something you will want to think about.

There are several situations in which you might want to buy back profit sharing from your team members. For example, your game has been out a couple years now, with steady, if unimpressive sales. You'd rather not continue cutting small royalty checks every quarter, so decide to make an offer to your team members. You come up with an amount

that you think is fair and offer it to the team members. If they accept, you pay them as agreed, and your life has one less administrative task.

Coming up with a buy-out offer is more art than science. You might ask an accountant for their opinion on how much you should offer. However you calculate it, the amount is surely going to be based on current and projected sales across the next two to the three years, multiplied by their profit-sharing percentage.

Samu Games has bought out team members a couple of times over the years. The team members were paid well for the work they had contributed, and Samu Games was able to reclaim profits and reduce administrative overhead. Some team members didn't accept buy-out offers. These members were willing to gamble that the games would do well enough to make it more advantageous to hang on to their shares over the long term.

The important thing is that your dealings with your team members be above board and completely honest. If you're not offering a deal that is as good for the team member as it is for you, then you shouldn't be making the offer.

CONCLUSION

Just as there is no one team structure that fits every indie project, there is no one best way to handle team member compensation. Use some of the methods presented in this chapter, or come up with some of your own. Only you and your team can decide what is best for your project.

FINDING AND SCREENING TEAM MEMBERS

IN THIS CHAPTER

- Finding Team Members
- Screening Potential Team Members

B y now you've decided how many team members you need, and you've worked out how you're going to pay them for helping you. The next step is find these talented, helpful people.

FINDING TEAM MEMBERS

Finding team members is both easier than it seems and harder than it looks. With the entire world as a recruiting ground, via the Internet, there are hundreds if not thousands of potential team members who would be a perfect fit for your game's team. This abundance is both a help and a hindrance. Figure 13.1 shows how respondents to the Indie Game Developer Survey handled finding team members. Most of them reported using more than one venue, and you should expect that you will need to do the same. Don't expect to find all of the people you need with a single posting on the Web.

The easiest way to begin is by asking people you already know. After that, there are plenty of places on the World Wide Web where you can find potential team members. We will discuss how to use both of these resources. Finally, once you have a selection of potential team members to choose from, you have to decide which ones to bring aboard.

Indie Game Developer Survey Results

How do you usually find new team members? (Check all that apply.)

69%	Worked with them on past projects
51%	Posting on game development 'help wanted' Web pages
40%	Via professional contacts
11%	Posting on Usenet newsgroups
9%	Friends/Family
6%	Colleges

(Survey Note: 65 Responses, 35 Respondents)

FIGURE 13.1 Where do indies find team members?

Who Needs You, and Who do You Need?

Who you will need for your project is, of course, dependent on what your skills are. If you are a programmer, then you probably know many other programmers, and maybe half of these are looking for the same thing you are: an artist. On the contrary, if you are an artist, the hole you have to fill is probably a programmer-shaped one.

What is somewhat amusing is that neither *really* trusts the other. Programmers who ask artists for help take the full brunt of that artist's past disappointments with failed projects. And artists who approach programmers get the same harsh treatment. Hopefully, by taking a more professional approach to developing games, both sides can benefit from each other's skills.

You will also be concerned with the experience level of the prospective team member. As shown in Figure 13.2, most developers want at least *some* experience, but enthusiasm and talent were often given more weight.

Indie Game Developer Survey Results

What kind of team members do you look for?

39% Enthusiastic amateurs who display talent and potential.

25% Enthusiastic hobbyists with some professional experience.

14% Professionals with a good track record and at least one completed project.

14% Seasoned professionals with multiple projects under their belts.

 8% I'll take anybody.

(Survey Note: 36 Respondents)

FIGURE 13.2 Team member experience preferences.

Talent and enthusiasm are a powerful mix, even if the potential team member is inexperienced. These team members might require more hands-on direction, and possibly even instruction, but they learn quickly and grow to become important members of the team. On a more

practical note, they are also often much less demanding (less expensive) than seasoned professionals.

Here is a good rule of thumb: do not have someone in your team that has significantly more experience than you do. If you're confident in your role as project leader, though, this may not be an issue. Also, this doesn't apply to contractors. With contractors, you want the most experienced professional you can afford.

Networking

Your best source of leads for potential team members is from people you already know. Whether they are within or outside of the indie/retail computer game industry, you probably know quite a few people who would be willing and able to help you with your project. If you are new to the industry, your network of professional contacts might be smaller, but you should still start there.

When you approach someone you know to discuss your project, make it clear that you are only wondering if they would be interested. Be professional. Don't assume that they will (or won't) be either interested or available. If they aren't interested, or otherwise can't participate in your project, don't take it personally.

Even if no one you know is available to work on your project, there's a good chance they will know someone you can ask. Most people are more than happy to put in you touch with someone they think might be able to help you.

When you contact a referral, make sure you let them know how you got their name. Also, strive to be even *more* professional than you were with your direct contact. After all, now you are representing not only yourself, but also the person who referred you to them.

Once you've exhausted your personal network, then it's time take more active measures. Welcome to the World Wide Web.

Using the Web

The Internet connects you to the world, which can be good and bad: good because there are so many possible candidates to choose from, and bad for the same reason. The Web complicates your hunt, because it has what a lot of programmers/engineers like to call, a "low signal-to-noise ratio." In other words, there is a lot more *useless* information (noise) on the Web than there is *useful* information (signal). Despite this, the Web is still a powerful tool for finding team members.

Resist the temptation to post your team member search on public Web site forums right away. This should be your last avenue, not your first.

So, how do you winnow through the chaff and find the most valuable people? Begin by surfing the Web for examples of work you like—such as artwork, programming, or music. Check the archives of e-mail lists and scour the message forums, especially those related to game development. Look at posted examples of artwork and music. When you find something that seems ideal for your game, find out who the author is. This information might not be publicly posted, but it can usually be found with just a bit of digging.

E-mail the prospects you've found, compliment their work, and explain that you're looking for someone who does work like theirs for a project you're leading. Keep your explanation short and to the point. Busy people hate long, rambling missives. They might be looking for a project like yours to participate in. And if not, they may know someone else you can contact. In either case, you won't know if you don't ask.

Posting on the Web

Only after you've tried everything else should you consider posting on public Internet forums. Keep in mind, though, that not all public forums are equal. If you post in the wrong place, you could get completely shunned by the people you're trying to find. Even worse, you could come to the attention of exactly the last people you want to find (e.g., the 'nuts'). Either way, it's bad.

To begin with, see if any of your prior contacts can recommend a good place to post for the type of position you're trying to fill. In general, programmers know where to find other programmers, and artists know where to find other artists. If this is the first time you've tried to find a professional of this type (e.g., programmer, artist, musician, etc.), you might also ask for advice on how to word your posting. This way you can maximize your appeal and minimize any wording that might annoy your prospects. There are also game development-oriented UseNet newsgroups you can post to. Here are some good game development Web forums to begin your search:

- GameDev.Net's "Help Wanted" forum: *http://www.gamedev.net*
- Garage Games' "Marketplace" forum (in their "Make Games" section): *http://www.garagegames.com*
- Gamasutra's "Projects" listings: *http://www.gamasutra.com/projects/*

When you post in forums, how you word your post is very important. You want to appear professional, while also being clear that yours is an independent project with back-end payments.

Begin with introducing yourself, and *briefly* describe what you are looking for. You don't have to disclose all the details about your project,

and probably best if you don't. You're not looking for feedback on your game design. You're looking for assistance in a specific capacity.

Include a brief explanation of how you intent to reimburse project participants. Profit-sharing agreements are pretty common, so you don't have to explain it in detail—for example: "All project participants will receive an equal share of profits." If you are willing to consider alternative reimbursement options, you should mention that, as well.

If you are looking for contractors, it is even more important that your posting is professional. Contractors are professionals, and they're only interested in working for someone who displays the same level of professionalism.

Here is the *Request for Proposal (RFP)* that Samu Games used in their initial search for an art contractor for *Artifact* in 1997:

> *I am in charge of a computer game development project that requires contract artwork.*
>
> *The style of the graphics should be comparable to* WarCraft 2 *and* Civilization 2. *The pieces I require include terrains (grassland, hills, forest, etc.), buildings (lumber mill, farm, quarry, etc.), and military units (infantry, cavalry, etc.). Most are in the 48x48-pixel range and will involve simple animation.*
>
> *If you have the time to pick up this project in the next four to six weeks, e-mail me at* davidrm@.... *Please include your availability and your rates.*
>
> *Thank you for your time. I look forward to hearing from you.*
> [Michael99]

Did the RFP work? Well, yes and no. Samu Games was contacted by a number of professionals who responded to the posting. Some were very talented artists with price tags to match. Ultimately, they selected an artist who had responded to a similar posting, and who was willing to work under a back-end, profit-sharing arrangement.

SCREENING POTENTIAL TEAM MEMBERS

When you're posting on the Web, there's really no telling who might show up. So be prepared to thoroughly check out every respondent.

As you receive responses to your post, don't be shy about requesting the person's resume or portfolio (i.e., examples of their past work). You need to be confident that their skills mesh with your needs.

Do not 'settle' for someone just because they responded. You are not under any obligation to include them in your project. Of course, you

should keep your expectations in check, but don't settle for someone below your standards. If no one suitable responds, bide your time. If necessary, find new places to post your request, and do whatever else you can on the project while you wait.

Once you are satisfied that the person has the necessary skills, the next step is to interview them. How you handle the interview is up to you, and depends on your particular circumstances. If the respondent is local to you, you could meet for a face-to-face interview, but you'll probably want to handle the interview by phone, e-mail and/or IM/IRC chat. A phone interview will be more revealing than either e-mail or chat, so you should include at least one phone call in your screening process.

Figure 13.3 shows how indies screen team members. Again, multiple methods are often used. If you haven't considered some of the listed options, you might do so.

Indie Game Developer Survey Results

How do you screen prospective team members? (Check all that apply.)

76%	E-mail interview
56%	Resume/Curriculum Vitae (CV)/Portfolio
50%	Testing for skills
26%	Face-to-face interview
21%	Phone interview
21%	Checking references
6%	IRC/IM chat interview
6%	Checking for team compatibility
3%	Logic problems

(Survey Note: 90 Responses, 34 Respondents)

FIGURE 13.3 Team member screening.

There are plenty of books and articles on handling job interviews. Keep in mind, however, that while this *is* a job interview of sorts, it's still an interview for an independent project; neither of you will, in all probability, see any money in the near future. So don't be *too* demanding. *Do*

know what you are looking for, though, and search for someone who will fit the project and mesh well with the rest of your team.

Another point to consider is that if you successfully complete this project, you will probably do another. The team members from this project, if you selected them carefully, are likely to be just as useful on future projects. Or you might work with them on *their* projects, helping them build *their* dream game. So keep the future in mind throughout the screening and selection process.

For *Artifact*, Samu Games went through two rounds of searching for an artist. The first round of artists were all contractors. Several of them were very good, but outside of Samu Games' budget. After six months, they posted the RFP again and were quite lucky to find a young, talented artist who was willing to work for an ownership share of the completed game. Since then, this same artist has worked with the company on several other projects.

Conclusion

Finding team members begins with who you know and who *they* know. If you have to use the Web, don't naively post on a public message forum and expect to get a host of qualified applicants. Instead, focus your search by contacting people who do good work—and work that fits your project's needs. Only post in public forums when you have exhausted the more direct means.

Finally, just because you don't have a human-resources budget doesn't mean you can't use tried and true hiring techniques. Your project is important, if only to you, so be professional in how you recruit team members. If you find ones, your project has a much improved chance of success.

CHAPTER

14

REMOTE TEAM MANAGEMENT

IN THIS CHAPTER

- Team Structure
- Communication
- Team Management

F ew indie-led development teams are completely local. It's not un-common for members of a remote (virtual) team to be scattered across the United States and/or Canada, or even between continents, such as Europe, Asia, Africa, or South America. In many cases, team members never meet face to face.

Even if the team members live in the same geographic region, there is a good chance they do not see each other very often. This stems from the nature of independent projects: a team of people creating a game on their own time. Different people can have wildly diverging schedules, and getting everyone together at the same time can be a challenge. So even a local team could be considered a remote, or virtual team.

Managing any project's team can be a challenge, whether local or virtual. It's important for you, as *de facto* producer and project manager, to assign tasks and keep track of how these tasks are progressing. It's your job to be aware of what everyone is working on (including yourself), and keep the whole the team informed of the project's status.

This chapter focuses on those aspects of team management that directly apply to indie projects: team structure, communication, and motivation. We will also discuss the unproductive team member and how to handle him.

TEAM STRUCTURE

Team structure refers to how your group of programmers and artists is organized. There are many different types of team structures—from flat, essentially structureless teams to multitiered, hierarchical teams. The best type of structure is based on the size and purpose of the team.

As an indie, your team will probably be small, consisting of no more than five or six members with specific roles. You have a definite purpose for your team: create a game. So what type of team is a good fit for these types of projects?

Types of Teams

In his book, *Rapid Development*, Steve McConnell [McConnell96] identifies three different kinds of teams: the problem-resolution team, the creativity team, and the tactical execution team. The problem-resolution and creativity teams are useful in some circumstances, but it is the tactical execution team most closely resembles what the indie needs. The tactical execution team, as defined by McConnell, is formed to carry out a specific, defined plan. Team members are chosen to perform specific tasks.

Why not consider a problem-resolution team? The reason is because you aren't looking for the solution to a problem. Your team is creating something new.

So why not a creativity team? After all, making games is a creative task, perhaps even an art form. However, a creativity team is explores 'possibilities and alternatives' [McConnell96], which is to say that a creativity team is about research. Maybe the team will come up with something useful, maybe it won't.

A game design, whether for the indie- or retail-oriented team, should be flexible enough to accommodate new ideas as the project moves toward completion. But it shouldn't be so flexible that the project stops progressing toward a set goal and begins to meander, with research replacing implementation. Your game project may be innovative and packed with new ideas, but these are *specific* innovations and new ideas. Presumably, you did your brainstorming and free associating *before* you started working on the implementation.

Thus, the purpose of your team is to implement a plan. In this case, the plan is your game design. Your limited time and resources don't allow you the privilege of research for the sake of research. If you're going to get your game done, you have to focus on exactly that.

Team Structure

Now that your type of team is identified, it's time to decide how to organize the members within the team. Perhaps the best team structure for independent game projects is what McConnell calls the *theater team*. [McConnell96] Loosely modeled after theater and film crews, the theater team is organized around the director who keeps the vision for the project and assigns individual areas of responsibility to the other team members. The theater team also implies a certain amount of negotiation between the director and the team members. This negotiation is about issues like roles and how things are to be done.

To take the analogy further, as the indie, you play the role of the writer (game designer), producer, and probably the director (project manager), as well, in addition to being one of the actors (developers). Also, you negotiate with potential team members to find their best fit within the production, based on their current skills and what they want to do. Your duties as director also include providing them with the information and motivation needed to perform their assigned tasks.

If you follow the model of the theater team, you end up with a simple team structure. As director, you are the person the other team members report to.

Keep in mind, though, that the goal isn't to lord over the team. Your team members aren't just cogs in a gear assembly, churning out your vision. Rather, the goal is to have a singleness of vision, with all of the members working toward a common purpose while accepting the specialized contribution of each team member.

As the team works together, *your* game evolves into *our* game. You remain the keeper of the vision, but that vision must be shared by the entire team. In the end, you are only as good as your team.

COMMUNICATION

Communication is the key to project management, and not just in game development. Any task that involves more than one participant succeeds or fails based on the quality of the communication between the team members.

Quality of communication in this context has little to do with how well you speak or how proper your grammar is. Instead, it refers to how well information moves through the team, and how well that information is presented and interpreted. If ideas and information are not clearly communicated, then both the sender and receiver might as well be speaking different languages.

Communication is especially important for independent game projects; the team members might be scattered across several continents. Without communication between the members of the team, the project will stall or splinter apart. The project manager must communicate with the team members, and vice versa, and the team members must communicate with each other.

Types of Communication

Communication takes several forms. First, you, as project manager, must clearly communicate what is required of each team member. Unless the team members know what they need to do and when it needs to be done, the chances of getting anything done are slim. The game design document and detailed task list must be made available to all team members. If something is unclear in either document, then it should be clarified and the changes made known to everyone on the team.

It is also important that all team members be kept aware of what all the other team members are doing, and how they are progressing with their tasks. This serves a motivational purpose, as will be discussed later on in this chapter. It also lets everyone know where the project stands in relation to the overall schedule.

Finally, team members must feel free to communicate with each other, whether to see if a necessary component has been completed, ask for help, offer assistance, or even just to shoot the breeze. Team members should be encouraged to talk to each other without worrying about formal procedures or over-stepping their bounds. The team members take their cues from the team leader, so it's important for the team leader to set a good example of being open as well as encouraging team members to talk back and forth.

Methods of Communication

In our modern age, there are many ways to communicate. Only 10 years ago, a phone call, fax, or letter were about the only ways for scattered team members to coordinate their efforts. Some services provided e-mail, but they were few and generally expensive.

Now the Internet is everywhere, bringing with it a host of new ways to communicate. The once-simple telephone network has also changed, with ubiquitous cell-phone and long-distance rates less expensive than ever before. E-mail is cheap and readily available. It has almost become more work to *not* communicate.

The Internet provides a number of inexpensive, and possibly free communication alternatives. Take advantage of them. A centralized Web site and *FTP (File Transfer Protocol)* server are excellent vehicles for delivering design documents, tasks lists, and other materials to all team members. A Web site can also host a message forum for the project members. E-mail can be used to provide project status updates and for status reports from team members. Instant messaging and phone calls are useful when coordinating a particular task, and they can be used for 'staff meetings,' as well.

Voice chat via telephone or an Internet-based service is probably the best 'instant messaging' option. Text chat and e-mail are great, but some things are best discussed in a way that doesn't require typing. Speaking aloud can convey more information quicker than almost any other medium of communication. Use it.

And don't forget the possibilities offered by the non-virtual world. If you live less than an hour or so away from your team members, consider face-to-face meetings, either individually or as a group. Even if you don't handle official team business at these meetings, they can help bond everyone together and keep morale up.

Figure 14.1 shows the most popular ways that indie teams stay in touch. Everyone uses e-mail, it seems, and instant messaging is also seeing a lot of use. Phone calls and face-to-face meetings happen a lot, though less frequently than the other methods. At Samu Games, e-mail

Indie Game Developer Survey Results

How do you stay in contact with your team members? (Check all that apply.)

100% E-mail/Web

66% Instant Messaging

43% Phone

43% Face-to-face Meetings

(Survey Note: 88 Responses, 35 Respondents)

FIGURE 14.1 How indies stay in contact with their team members.

was used as the primary means of communication, augmented by instant messaging software and the occasional phone conversation. Team members for a couple of projects were distributed across continents, so meeting in person just hadn't been feasible.

Frequency of Communication

How often should you be in contact with your team? The short answer is: as often as possible.

Everyone needs time to themselves for personal responsibilities that are unrelated to the project. But no team member should be left alone too long. Figure 14.2 shows how often some indies contacted their team members.

The distributed nature of most independent teams makes it easy for team members to become isolated. Whether it's because the team member hasn't checked in with you, or because you haven't checked in with them, extended periods without contact are detrimental to the project. As will be discussed Chapter 15, Team Leadership, communication is a vital part of motivating your team. Isolation saps motivation.

Weekly team meetings can do a lot to keep a team inspired and productive. Everyone is kept up to day when they see what's been accomplished by the rest of the team over the past week. Similarly, coming together once a week promotes communication between team members. If one team member is waiting for a task or resource to be completed by another, they can keep each other apprised and better coordinate their efforts.

<div style="border: 1px solid black; padding: 1em;">

Indie Game Developer Survey Results

How often do you keep in contact with all your team members?

46% Two to three times per week

28% Weekly/Semi-weekly

26% Daily

(Survey Note: 35 Respondents)

</div>

FIGURE 14.2 How often indies contact their team members.

Ultimately, how you communicate with your team and how often is up to you and your preferred management style. Your team members will also have preferences. Listen to them and work together. You may have started the project alone, but you will finish it together or not at all.

TEAM MANAGEMENT

Two of the key concepts of team management have already been discussed: structure and communication. In this last section, we will discuss motivating your team. Maintaining team member motivation across the whole project can be a real challenge.

We examine ways to deal with unproductive team members. A lack of productivity isn't always the fault of the team member. It's quite possible that you, as team leader, need to adjust either your approach or your expectations.

Motivating Your Team

All teams start off motivated. Everyone is psyched up and productivity is high, both from the expectation of seeing the completed game and from the promise of eventual reward through profit sharing. This enthusiasm will inevitably fade, however, and productivity will drop down to normal levels.

The danger, though, is that productivity will *continue* to drop until the project dies. This especially a concern with more complex and involved projects whose production schedules can stretch into months, and maybe years. How can you keep your team motivated throughout the development of the game?

Frequent communication, as described above, is one way to keep the team motivated. As team members get their pieces of the project done, and this is communicated to the rest of the team, everyone gets to share in the feeling of accomplishment. The game *is* getting done, and progress *is* being made. A sense of forward progress is important to maintaining motivation.

In the same vein, good communication keeps the players in touch with each other. Especially with remote teams, it's easy for team members to become isolated, and with isolation comes reduced interest and motivation. Eventually the project dies. Don't let any team member become isolated.

Have Regular Team Meetings

To help your team stay in touch with you and each other, consider having a weekly or semiweekly team meeting. The venue you choose should allow all team members to attend. An *IRC (Internet Relay Chat)* channel or a group chat through an instant messaging program are Web-based choices. And don't forget the Internet's predecessor: the telephone. Conference calls are much easier to set up and handle these days than they were in the past. A caveat to conference calls is that the number of participants is limited by the phone hardware of the person setting up the conference; perhaps only four or five people can participate. Moreover, the conversation becomes awkward if people talk over each other inadvertently.

What happens at the team meeting depends on the team. The content is less important than the event itself. Bringing the team members together is the real goal. For the new version of *Paintball Net*, Samu Games decided to host the weekly team meetings on the game itself. The game's 'Ready Room' provided an adequate chat channel where progress and tasks could be discussed with everyone. And after the status reports were finished, everyone geared up and had fun painting each other in paintball matches.

Leadership is big part of keeping your team motivated. If you provide direction for the project as well as a good example by doing everything you can to keep the project moving forward, the other team members will follow your lead. You must lead by example, not try to direct from the rear, as we will see detailed in Chapter 15, Team Leadership.

Have Fun as a Team

Find ways to get your team together that are unrelated to the project. The purpose of these gatherings, whether virtual or face to face, is to have fun. Play online games together as a team, or even in competition with each

other. If you live relatively close to each other, arrange to meet once a month to have fun. Have a LAN party, play minigolf, go camping—do anything that appeals to you and your team.

Keep the Project Visible

Another way to motivate your team is to keep the project visible to the world at large. Talk about the project in public forums, and encourage your team members to do the same.

Keep the message positive, focusing on what is going well. Even if the project begins to slip behind schedule, maintain a positive attitude and point out how much is going as planned.

This also provides additional fuel for your later marketing efforts as potential players hear about and discuss the game. You can also use this type of exposure to find beta testers later on in the project.

Dealing with Unproductive Team Members

Regardless of how carefully you screened all potential team members, and no matter how clear you were in communicating your expectations and instructions—and even if you perform miracles of team management and motivation—it's almost inevitable that you will have someone on the team who is not contributing their share, or is performing at a level below what you're willing to accept.

Before you assume that it's the team member's fault, though, verify that you *have* been doing all of these things: being selective, communicating well, and staying in touch with your team. If you haven't, then you already know part of what needs to be done. Accept responsibility and move to correct the problem.

As with all other aspects of management, communication is important when dealing with unproductive team members. If you have been actively communicating with your team, there's a good chance you already know why a particular member isn't producing. Maybe he's getting married in the next month or two, or maybe his 'regular' employer is now requiring that he work mandatory overtime to meet a deadline—or maybe he picked up a new project or contract that pays more up front, and this is taking up time that he used to allocate to your project.

All of these reasons are understandable, and if you talk it over with him, you can probably work out a solution. Maybe there's a date after which he'll be able to put more time into the project. Or maybe he can juggle some of his other priorities to make time for the project again. There are all sorts of options if you keep an open mind and discuss the issue with the team member(s) involved.

If you *haven't* been keeping tabs on the team member, get in contact with him right away and see what's up. You should've done this already, so don't blame *him* for your lapse.

Parting Ways

It's possible that even with the best of goodwill on both sides of the issue, the team member is going to have to leave the team. A big part of how easy or difficult his leaving will be depends on how you handled building the team.

If you carefully screened all potential team members and had them agree to and sign a team member contract, then you have already prepared for this contingency. Just follow the steps you laid out, and both you and the former team member can amicably go your separate ways. If not, however, then the situation could get sticky. The resulting mess and possible legal ramifications could set the project into a destructive tailspin or even kill it outright.

If you handle the situation properly, and there is no ill will on either side, it's possible that you and the departing team member can and will work together on another project in the future. So try to stay positive.

Avoid burning any bridges by being overly negative about team members who leave. Regardless of how someone leaves your project, you should never be anything but professional. The game development industry is a small one, even if you include all of the indies and amateurs. Bad blood can come around much sooner than you might think. So it's in your best interests to keep the parting as amicable as possible, even if circumstances surrounding the departure are strained.

CONCLUSION

If you are like many programmers and artists, you have probably never considered what it takes to actually manage a development team. However, if you decide to become an independent game developer working on a project that requires a team of two or more people, then you have also elected to become a manager.

Team management is not as easy as it looks, but it's not too hard to learn. No special college courses are necessary, just a willingness to try. And the experience will do you good.

At the very least, remember this: *Communication is the key.* Stay in constant contact with your team, do what you can, and you'll find that the rest takes care of itself.

TEAM LEADERSHIP

IN THIS CHAPTER

- Leadership vs. Management
- Leading the Way

Asan indie, you don't just manage your team. You must also lead your team. You are both the visionary and the one to implement that vision.

As a manager, you oversee your project's journey from birth to completion, keeping yourself and the team on course and moving toward the goal that you, as the leader, have chosen. Your game design is the basis for the project, and it's up to you to see it through all the way to the end. You are the torch bearer, the keeper of the vision.

Chapter 14 covered team management and emphasized preparation and communication. In this chapter, we will discuss the leadership qualities you need to develop.

LEADERSHIP VS. MANAGEMENT

Leadership and management are two sides of the same coin. Leadership provides the direction that the team will travel, while management handles the day-to-day logistics of getting from the starting point to the destination. Some team management books favor leadership as the more positive of the two. However, the truth is that no project will succeed without both.

Know yourself, and know what you want to accomplish; these are fundamental to leadership. If you've come this far, you've already demonstrated leadership. You've visualized a dream and have come up with a way to turn that dream into reality. The challenge now is to *continue* leading the project. You can't lose faith in the project or get so caught up in the day-to-day minutia that you lose sight of the vision that brought you here.

Don't Forget the Passion

As you manage the project according to your design document and task lists, and you oversee the contributions of your team members as well as your own, remember that there is a reason behind it all. You're not working on a project just to have a project to work on. This project belongs to both you and your team. It is a shared dream. Don't turn it into a nightmare.

Every so often, step away from your work and take the time to remind yourself of why you started. Remember the passion that got you started. Don't let the day-to-day effort to keep up the pace kill your motivation.

Don't Forget the Point

Another thing you should remember is that the work you and your team members are doing is part of something larger. There is a point to it all: completing the project.

This may seem obvious, but many indie projects stall because team members (and team leaders, as well) stop thinking of the project as a game to be finished and get bogged down 'perfecting' a single feature. This obsession is called 'gold-plating' or 'gilding lilies,' and it makes you lose sight of your goal—completing the game. You focus on one feature as if it were the reason for project, instead of the other way around.

Any feature or design element that starts to require two to three times its original time estimate should seriously be reconsidered. As the manager, you will have to look for these roadblocks. How to handle them, though, is a leadership decision.

LEADING THE WAY

There are a number of leadership styles, just like there are a number of management styles. The nature of independent game development, though, limits the number of leadership styles that are useful to you. For example, in most instances, you cannot afford to be a pure strategist who leads from behind.

To be a successful leader, you must be closely involved with your project and your team at all stages of development. You must lead by example, by doing everything in your power to see the project completed. Drawing from the ideas of Warren Bennis in *Leader to Leader* [Bennis97], you, as the team leader, must provide the purpose, trust, confidence, and hope that the team needs. Your team and the project move forward or falter based on how well you fulfill these needs.

Purpose

You started the project, you brought the team together. This is your baby. The team looks to you as the leader.

If possible, move beyond the simple purpose of getting the game done and getting royalties. Look at how your game could affect the culture of the world. For example, games like *Mahjongg* are almost common today; but only a decade ago, many Westerners had never even heard of the game or had seen it only in foreign films. Does your game promote a recognized cause, either directly or indirectly? If so, look at your game as helping the world in its own way, and encourage your team members to think the same way.

Your team feeds on your passion for the project, your belief in the ultimate destination. If you lose sight of your original vision, don't expect your team to remember it for you.

Trust

When you give the team a purpose and lead them forward, you begin to earn their trust. Trust is never a given. Trust must be earned and should never be taken for granted. Despite your leadership role, you must realize that your team is just as important to the project as you are. Without your team, the project is unlikely to be completed. Or if it does get completed, it won't have the same overall value. Therefore, to lead your team, you must also be a *part* of the team. You aren't just the person with the idea.

The team must trust you. They must trust that you know where the team is headed and that you can carry your own weight. The team must trust that you are not only committed to seeing the project through, but that you bring your own unique talents and abilities to bear on the project—that you lead by example. If the team does not trust you to lead or contribute, then the project is doomed.

Confidence

As trust grows, it forms the basis for instilling confidence in your team. Your team members must have confidence in your ability to lead, and indecision and apathy do not inspire confidence. However, by starting the project in an organized manner, you've already demonstrated that you can take decisive action; and by committing to see the project all the way through, you've shown that you are not at all apathetic about your goal. So you're off to a good start.

No doubt, you could be working profitably for someone else or even spending your time on a hobby, which is much easier to finance. Your team members have the same options. If they lose confidence in you, they will exercise those options.

Confidence comes from the knowledge that whatever happens, you are willing and able to deal with it and keep going. Build your team members' confidence, and your own, by never giving in to doubt. Having doubts, of course, is not the issue; you can have doubts and still be confident. Just as you manage risks by first identifying them, you manage doubts by first acknowledging them and then facing those doubts. Once you know what your doubts are, you can then plan how to overcome them and take action.

Hope

Finally, just as trust brings confidence, confidence brings hope. As team leader, you must keep hope alive and keep the project moving toward completion. Never lose faith in your project, and you must keep hope

alive in the rest of the team, as well, by constantly showing them how far the team has come, and how well the game is coming together as planned.

You need to rekindle your passion from time to time, and you must rekindle your team's passion. Remind them of how fun the game will be when it's completed and how great the rewards will be. But don't focus on only the monetary rewards; there are many possible rewards: peer/player recognition and respect, experience building a game, the 'rush' of shared accomplishment, and so on.

Take the initiative. Give your team purpose, trust, confidence, and hope.

CONCLUSION

Your most important, and possibly most challenging, task as an indie team leader is to *lead*. Your team will help you get to your destination—finishing the game—but you have to convince them that this destination is a good place to be, that the end result is worth the effort expended. A team can run on momentum, but only for a short time. Take charge of your team before it stalls out and becomes another of the hundreds of abandoned projects that litter the indie universe.

Lead the way!

V

BUILDING THE GAME

You've designed your game in detail (Section II), taken that design and created milestones and a schedule (Section III), and you've found other people to help you make the game (Section IV). Up to this point, you've been laying the foundation on which to build your game. Now it's time to build the game itself. This section will cover the development process, it and highlights ways to manage and reduce the time required for building, documenting, and testing your game.

Chapter 16 (The Development Process) provides an overview of the entire development process. The iterative development process is briefly covered, as well as managing the development process.

Chapter 17 (Maximize Your Use of Third-Party Tools and Solutions) discusses how the underfunded, minimally staffed indie team can leverage tools and resources that already exist in order to save both time and money. Resist the temptation to build everything you need for your project. Look for ways to use third-party tools and solutions to significantly reduce the time required to finish your game.

Chapter 18 (Resource Management During Development) covers the necessary development task of managing your project's resources, such as source code, art, sound, and music. The importance of regularly scheduled backups is also discussed.

Chapter 19 (Creating Quality Documentation) will discuss the many benefits of keeping your project documentation current and complete throughout the development process.

Chapter 20 (Project Testing) explains how to find and manage testers for your game, from early testing of the incomplete game, all the way to pre-release and open beta testing.

Finally, Chapter 21 (Completing the Game) will guide you through the last stages of development. When you've been working on the same project for a long time, it can be hard to stop and just call it finished.

THE DEVELOPMENT PROCESS

IN THIS CHAPTER

- The Iterative Development Process
- Managing the Development Process

When your game design document and production plan are complete, building your game becomes as simple as picking the top item on your list, doing what needs to be done, crossing that item off, and then moving on to the next item. Repeat this process until you have implemented the last feature, completed the last image, and processed the last sound effect in the final milestone. Then you're done. What could be simpler?

This chapter provides a brief overview of the software development process. Specifically, we will discuss the iterative development approach and use the production plan/milestones created in Chapter 8, Task Identification and Scheduling, as the road map for getting from the beginning of the project all the way to its completion.

ITERATIVE DEVELOPMENT

It can be daunting to look at the entire development process for your game. There are probably hundreds of tasks listed in the production plan—enough work to keep you and your team busy for months, which is why you shouldn't look at the whole development process all at once.

Instead, focus on the milestones you set for the project. You will create the entire game in time; but for now, work to complete this smaller subproject that is the milestone. This is the core of *iterative development*.

Iterative development means to create the game one step at a time, and then test each step to verify that it works as expected before starting on the next step. Rather than tackling the whole project as a single, massive item on your 'to-do' list, you establish a cycle of build, test, and improve, and repeat that cycle until the project is completed.

The advantage of iterative development is that you have *something* almost immediately. It's not the whole game, but it's a *piece* of the game, and you can *see* that it works or doesn't work. If it works, you go on to the next cycle. If not, then you fix it and test it again.

As you build, test, and improve small pieces of the game, your project grows more closely resemble the game you'd planned. This visible progress is a powerful motivating factor.

What Is a Build?

If you do not have a background in programming, the concept of a *build* may be new. A build is a full compilation of your source code, art, sound, and other resources into an executable package that can be run on the target platform.

How you create a build of your project depends on the tools you're using, especially the programming environment, and the resources your project requires. Managing the resources of your project and bringing them together to create the build is covered in more detail in Chapter 18, Resource Management During Development.

If you are not a programmer, you may want to hand the task of creating the build to one of the programmers on your team. On the other hand, learning how to create the build for your game can help you better understand how computer games come together.

Your build doesn't have to be a playable version of the game. The build can be a 'test run' of what you've done so far—those parts of the game that have been completed and/or need testing.

Quality Assurance as an Ongoing Process

Once you have a build, you can begin *quality assurance* testing. Quality assurance verifies that the feature just implemented or the resource just added works as expected. You also get to see how the recent changes interact with previous builds, and you can spot potential conflicts.

In iterative development, testing isn't just the final step in the development process. It doesn't come at the end of the project when everything has been supposedly been completed. Testing should be integral to the process from the beginning and happen at regular intervals, usually with each new build.

By testing as you go, unpleasant surprises don't arise when a feature that was previously implemented causes problems. If you identify problems immediately, while the details of the implementation are still fresh, it can take much less time to correct them. Another benefit is that the list of bugs is kept short. As they are identified, these bugs can be fixed, often before the next build is scheduled.

Also, like many other tasks, quality assurance is much easier to handle in small portions. A list of 5–10 bugs from the most recent build are much easier to correct and manage than a list of 100 or more bugs accumulated over a period of months. The longer you put off testing, the bigger the list of bugs and potential problems becomes. Such an unmanageable list might kill the team's motivation and stop the whole project. (See Chapter 20, Project Testing, for more details on managing testing and testers.)

The Importance of Milestones

Chapter 8 discussed milestones, phases that mark the development path and provide a series of shorter destinations, or 'mini-projects,' within the overall project. An old proverb states, "The journey of 1,000 miles begins

with a single step." This is still true. Milestones make that first step even easier by defining a series of much shorter journeys.

Milestones and builds work together to move your project closer to completion. As you create each build of your game, you can compare it to the current milestone target. When the build matches the milestone, that milestone is complete, and you can move on to the next milestone.

Subsequent milestones give you the foundation for those that follow—your second milestone is built on the first completed milestone, and your third milestone is built on your second one. So when you begin a new milestone, you are not starting over; you are starting *again* and continuing to move forward.

MANAGING THE DEVELOPMENT PROCESS

If you've never managed a software development project before, it might seem like a lot to learn. You could feel a bit overwhelmed at times. The trick, though, is to take the process one step at a time and stay aware of what everyone is doing.

Take It One Step at a Time

You cannot complete the entire project all at once. To try and do so is to court frustration and burnout. This is where pacing comes in (see Chapter 3, On Being an Indie). Remember, don't worry about how quickly you will finish the race. Just focus on taking each step, one after the other, and run each lap, one lap at a time, until you reach the finish line. The goal is to finish.

Pace yourself and help your teammates pace themselves, as well. Use the frequent, ever-improving build of your game to show how far you've come as a team, and how much you've all accomplished.

Have faith that your game design and production plan will get you where you want to go. Let the constant addition of new features, however small, motivate you to keep going.

Everyone Doing Their Part

As was stressed in Chapter 14, Remote Team Management, the key to managing your team is communication, communication, and more communication! Stay in touch with your team members, and stay aware of what each of them is working on. Status reports and weekly team meetings (see Chapter 14 and Chapter 19, Creating Quality Documentation) are very important for keeping track of how the project is progressing and how the team members are doing.

Encourage everyone on the team to talk to the each other, as well. That way, all parties are kept up-to-date, and everyone feels their contribution is valuable to the project as a whole. With everyone doing their part, items on the production plan will be checked off one-by-one until each subsequent milestone is completed; and before you know it, the game will be finished.

Build Often

To get the most benefit from the iterative development process, it is important that you create a new build of your game on a frequent, regular schedule. Frequent builds serve several useful purposes. First, each build provides a new round of testing for the features and resources that have been added thus far. The sooner programming bugs and other problems are identified, the sooner they can be traced down and eliminated.

Second, each new build is great candidate for a completed milestone. You cannot attain a milestone without a build to prove you got there.

Third, frequent builds help to show how the gameplay is coming together. Just as with finding and fixing bugs, spotting and addressing design flaws and gameplay issues is much easier if done as early in development soon as possible.

Finally, frequent builds provide visible progress to you and your team. It's easy to be motivated about a game that's incomplete but still works as expected, and which is getting ever closer to the ideal that you all got excited about when the project started.

How often should you create a build? Some software professionals advocate daily builds of the project. Independent game projects, though, might not have enough progress on a daily basis to warrant such a frequent build schedule. Creating a new build once a week on a specific day is a good target. In a week, most team members should have something new to contribute to the project that they will want to show and test.

If, for example, you schedule your weekly build to occur on Wednesday, then your team members can organize their additions and testing around that day. Team members will know that to have their changes and additions in the next build, they will have to get their source code and resources submitted before Wednesday. On Thursday, they can test what they added, and maybe check out what the other team members added, as well.

If there were problems in the Wednesday build that prevent the game from running, you might schedule a second build on Friday. For this build, a team member would either fix the contribution that has problems or remove it. The team member should then try to have their contribution working by the next Wednesday build. In the meantime,

the rest of the team isn't being held up by one person's temporary set-back.

Design Impact

Iterative development is almost certain to have an impact on the design of the game. The game *will* evolve as development proceeds. Exactly how it evolves will be hard to predict. Just expect a metamorphosis and be prepared for change.

Be flexible enough to let the game evolve. Change is good, but keep in mind that you don't want a *revolution*. Stay as true to the original game design as you can. Let the evolution make the game *better*, not change it completely.

Also, as the game evolves, remember to keep your game design document up to date (see Chapter 7, The Game Design Document). Make sure that the game you're building and the design/production plan for it stay in sync.

When you update the game design document, record the reason for each change as a separate designer's note. That way you won't forget why the change was made. In addition, if you remove a feature from the core design, put it in the future features section of the design document. You might want to resurrect it later on in development.

CONCLUSION

Your game design and production plan were created to help you develop your game from beginning to end, using the source code, art, music, and other resources created and contributed by yourself and your team. Now is when you take your plan and act on it.

Rather than try to build your game all at once, build it one piece at a time, with milestones to help you along the way. Focus on constant, small improvements, rather than trying to 'jump' from one milestone to the next. The iterative development process presented in this chapter 'grows' your game one step at a time with a continuing cycle of build, test, and improve. The bibliography at the end of this book contains resources for more information on the software development process and alternative development methodologies.

17

MAXIMIZE YOUR USE OF THIRD-PARTY TOOLS AND SOLUTIONS

IN THIS CHAPTER

- Third-Party Tools and Solutions
- Third-Party Pricing Options

In *Game Architecture and Design* [Rollings00], Andrew Rollings and Dave Morris stress that with the increased complexity of computer games, it is no longer reasonable to assume that a project team can develop all of the software systems required. Rollings and Morris were referring to well-funded, retail-oriented game development. For you, an indie with minimal or no funding, this is even more true.

Too often, the would-be independent game developer lets himself get bogged down in creating everything from 'scratch,' needlessly reinventing the strap and harness when making his own version of the horse-drawn buggy. He gets lost in creating each successive layer of software along with its requisite tools, and eventually the designer despairs of ever finishing. Or he forgets why he began working on this particular tool, and progress on the game ceases while he spends all of his energy making the best possible tool he can.

In this chapter, we will discuss how to leverage pre-existing tools and components to create your game. Far from limiting your options, this use of third-party code and resources frees up your time and makes it possible for you to do what you had intended to do: create a game.

THIRD-PARTY TOOLS AND SOLUTIONS

As development tools have matured and the use of object-oriented coding techniques, rapid application development, and other methods of reusing resources have spread through software development—and even into game development—there has been an explosion in the availability of ready-made, third-party solutions for common tasks. The World Wide Web has made these ready-made solutions, in all their schedule-shrinking glory, only a couple of mouse clicks away.

The Black Box

A *black box* is an engineering term that refers to a component that is 'plug and play.' You just use it. You don't have to worry about how the component works. In fact, it's called a black box because you *can't* tell how it works. It just does what you want it to do.

Black boxes are important because by eliminating your need to understand how they work, you can just plug them in where necessary, and you are free to focus on creating your game. You don't have to become an expert on what the black box does. You only have to understand how to use it, not how to create it. That's been done for you.

Third-party components and libraries are the black boxes of independent game development. With ready-made components to take care of

the common tasks, you can apply your time and energy to building your game—which is what you wanted to do, anyway.

Third-Party Paradise

Third-party components are the best friend of the time-strapped, resource-poor, cash-broke indie. Well-chosen third-party components can shave months or even years from your project's schedule. By leveraging ready-made libraries and resources, you can focus on what you need to do most: create unique and interesting gameplay, and oversee your project to completion.

Arguably, some of the greatest costs incurred by big-budget retail game projects stem from the 'not-built-here' syndrome, which disdains anything not created in-house. "I can do it better" are the programmer's famous (last) words, often leading to months spent creating a new, improved hammer and chisel.

Recent years have seen a growth in the licensing of core technologies like 3D rendering, user interfaces, networking, sound playback, physics, and more. Once exclusively created in-house and often recreated for each new project, more developers are turning to off-the-shelf solutions.

Technology-only companies like RAD Game Tools, Inc. (*http://www.radgametools.com*), Numerical Design, Ltd. (*http://www.ndl.com*), and Criterion Software, Ltd. (*http://www.renderware.com/*) have become increasingly popular. Their products are being used (and reused) in increasing numbers for commercial titles destined for the latest consoles as well as PCs/Macs. While the independent developer will probably not be able to afford these top-of-the-line products, there are plenty of options that, while not as technologically advanced, are still amazingly capable.

In almost all cases, it is less expensive in both time and money to purchase a third-party solution than it is to develop a solution of your own. This is true even when there is a 'learning curve' involved with using the third-party option. The third-party solution has been designed for generic use, and it has already been through at least one cycle of development and debugging—development and debugging *you* don't have to do.

Licensed third-party components and libraries usually offer source code, documentation, and at least some form of support. Examples are often available to help get up to speed as quickly as possible. That's a lot of resources at your disposal for a small outlay of cash.

The companies who provide these third-party tools have a vested interest in their products being used in successful games. If you use their products in a game that gets noticed and sells well, then other developers will take notice and use the company's products. So don't hesitate to

ask for help on how to properly use the libraries and components you purchase.

Another advantage of third-party components is easy reuse. If you choose them carefully, with an eye toward the future, you can often spread the cost of the components across several projects.

Some components and libraries must be licensed on a per-project basis, but these are not in the majority. Most smaller components, once purchased, can be used in any number of projects. Even if there are upgrade fees over time, these fees are usually significantly less than the initial purchase. So if you plan to do a game with needs that are similar to your current game, you can reuse the component, and the effective cost is cut in half.

Be Lazy! Within Limits . . .

Obviously, there are certain project-specific components and features that can only be created by you or your team. And there are probably enough of these that you can't really afford to be working on something like learning OpenGL when someone else has that covered for you. A few weeks or months spent reviewing your options and choosing which one to use is a *lot* less time than it would take to create your own OpenGL-based 3D engine from scratch.

Code that you don't have to write, even if you do have to occasionally debug it, means more time is available to you, and less time is required for the project's completion. So be 'efficiently lazy' and refuse to do anything you don't absolutely have to. Use the time to create a new and unique gaming experience.

Figure 17.1 shows how prevalent the use of third-party solutions is among indies. More than two-thirds of the survey respondents indicated they used at least one to three third-party libraries and components.

What types of third-party solutions do these indies use? Check out Figure 17.2. Just about the entire range of software solutions is represented. Predictably, the most common third-party products used are sound/audio and 2D/3D graphics components.

Picking on 3D

If it seems third-party 3D engines are popular, then you're right. More than for any other cause, would-be indie projects get stuck—and eventually die—because the design, development, and debugging of yet another 3D-engine *never ended*.

It is estimated that as much as 70% of the development costs for a new 3D game are spent on the game engine and tools. Even assuming

Indie Game Developer Survey Results

How many third-party development libraries/components do you use?

68% 1–3 significant libraries/components.

13% 4–10 significant libraries/components.

 2% 11–100 significant libraries/components.

17% I build everything myself.

(Survey Note: 60 Respondents)

FIGURE 17.1 Indies and third-party solutions.

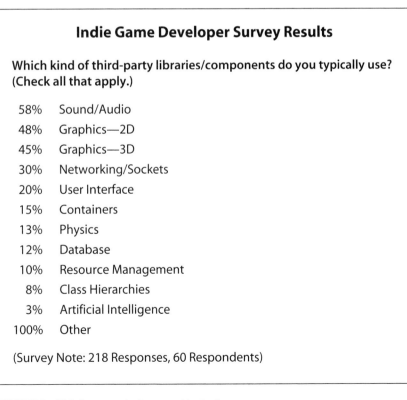

Indie Game Developer Survey Results

Which kind of third-party libraries/components do you typically use? (Check all that apply.)

58% Sound/Audio

48% Graphics—2D

45% Graphics—3D

30% Networking/Sockets

20% User Interface

15% Containers

13% Physics

12% Database

10% Resource Management

 8% Class Hierarchies

 3% Artificial Intelligence

100% Other

(Survey Note: 218 Responses, 60 Respondents)

FIGURE 17.2 Third-party solutions used by indies.

that those percentages carry over into the independent game development arena (without getting even *larger*), it should be obvious that you are best served by using what's available and tweaking it where necessary. A little bit of retooling to fit your needs requires significantly less time than creating the tool from scratch.

But an engine is seldom useful without its companion tools for content development. So in addition to the engine, you inherit all of the art, sound, level, and other content-creation tools that complement the engine. Again, even if you have to modify the content-creation tools to support the exact data you need, you have saved the time and resources that would have been required to build the tools on your own.

In the final analysis, most 3D engines do exactly the same thing: they produce a two-dimensional rendering of a three-dimensional scene. When the game is completed, the 'look' of the game will owe more to the content created for the game, especially the models and texturing, than to the engine. So don't get caught up in engine feature lists that have little or no impact on the final game. Find an engine that does what you need for your game, and plug it in.

THIRD-PARTY PRICING OPTIONS

As you can see in Figure 17.3, indies are interested in all kinds of third-party components. Whether the third-party solution is free or comes with a price tag, successful developers try to make the best use of what's available.

Up till now, this chapter has referred to commercial third-party components and libraries that must be purchased before they can be used. There are many high-quality components and libraries for sale. But there are also many options for the cash-poor indie.

Indie Game Developer Survey Results

Do you use mostly:

66% Freeware components/libraries

23% Commercial components/libraries

11% Shareware components/libraries

(Survey Note: 56 Respondents)

FIGURE 17.3 How much indies pay for third-party tools.

Freeware

The growth of *freeware* third-party solutions have been in step with the growth of their commercial counterparts. While often not on the same technical level, the array of available freeware components, such as 3D engines or sound APIs, is nonetheless impressive. And the price is right. They're free.

Many good, free third-party solutions exist. Crystal Space (*http://crystal.sourceforge.net/*) and Genesis3D (*http://www.genesis3d.com/*) are free 3D engines, and Ogg Vorbis (*http://www.vorbis.com*) is a patent-free, open source audio streaming format.

When dealing with freeware, you have to keep in mind the old axiom, "You get what you pay for." A lot of freeware engines and libraries are incomplete, at best, and have spotty support from their developers.

It's also important that you keep an eye on the licensing agreement that accompanies the freeware. Some licenses, especially variations of the GNU public license, make it very difficult to use the software in projects that are intended for sale.

Some free libraries carry the burden of requiring applications that use these libraries to also be free. In some cases, the application's source code and content must be made freely available, as well. So be certain to read the licensing agreement that accompanies free libraries and components. If you're uncertain about some of the terms for use, don't hesitate to e-mail the author of the library/component and ask for a clarification. It's better to find out now than later on.

Even with their limitations, freeware third-party solutions often have devoted users who are happy to answer questions about using them. And even if you can't find an online community of users to tap, freeware components nearly always include full source code. So with a bit of concentration and step-through debugging, you can usually figure out what's going on.

In Between Freeware and Price Tags

In the past few years, there has been an increase in the number of libraries that are offered to independent developers for either free or, at most, a small licensing fee. Companies like Garage Games (*http://www.garagegames.com*), in an effort to support independent game developers, are offering technologically advanced software (sometimes even with source code) for only nominal licensing fees.

There are caveats, of course. For instance, Garage Games offers their advanced multiplayer 3D Torque Game Engine for only $100. If, however, the developer or their publisher has a yearly revenue exceeding $500,000, the licensing fee becomes a flat, royalty-free $10,000. Other

restrictions to look out for are things like limited publishing requirements and/or exclusivity.

Some freeware components and libraries have similar approaches. They are free to use in noncommercial products; but if the developer wants to sell the project, he must get special permission from the author and perhaps pay a licensing fee.

Creative Pricing

Don't be afraid to ask a third-party vendor for a discount or deferred payment (see Chapter 10, Creative Funding). You could also suggest a partnership deal with shared profits for both of you on the back end.

Almost everything is open to negotiation. Asking is free and could have a real impact on how much you pay. But if you don't ask, you won't know.

CONCLUSION

Assembling a game from pre-existing parts may seem, at first glance, to be a recipe for churning out repetitive, look-alike, boring games; but this isn't the case, at all. You use the pre-existing parts as building blocks to economize your time and create a game that would have been impossible to finish on your own; that is, you get to create your game by 'standing on the shoulders of giants.' You no longer have to be a 3D expert or a whiz at multidimensional math to create a good 3D game.

Use the solutions that have been provided for you. Take advantage of ready-made resources. If you want to make an engine, do so. But if you want to make a game, recognize that the engine doesn't make the game. *You make the game!*

RESOURCE MANAGEMENT DURING DEVELOPMENT

IN THIS CHAPTER

- Basic Resource Management
- Resource Management: Source Code and Binary Files

Computer games are multimedia software applications, which means they are built with multimedia resources. Not only is there source code, but there is a collection of text files and art, sound, and music resources. All of these must be organized and readily available when needed. They must also be easily updated.

Resource management is the act of organizing the many resources of your game project. It encompasses many tasks, some of them quite tedious such as:

- Establishing a folder/directory structure for source files and other file-based resources.
- Deciding on naming conventions for those files.
- Keeping track of different versions of the resources.
- Building the resources into a deliverable package, and more.

Establishing how to manage your project's resources will require a bit of thought and planning. When you're champing at the bit to get started, it might seem boring to take the time for such a mundane task. Implementing any system, though, is easier *before* crises occur than *after;* so take the time. Even if you create a less-than-ideal system, you'll still be ahead of the game, and you can apply what you learn to your next project.

BASIC RESOURCE MANAGEMENT

Just like with budgeting and scheduling, resource management doesn't have to be complicated. Nor does it require expensive software. All you really need is a bit of organization and the discipline to keep it up.

We will begin by discussing the simplest case: an indie working alone. Then, resource management for small projects will be covered, and a short case study will be presented that illustrates Samu Games' experience with *Artifact*.

The Simplest Case

Here's the simplest case: you're working on your project alone. You're doing everything. As long as you can find what you need when you need it, you think you're 'organized enough.' And you might be right. However, most of us can always benefit from being a little more organization.

The trick to being organized is to create a system that works for you and then sticking to it. It's better to have a simple system that you use consistently than a brilliantly constructed set of rules and procedures that you ignore.

Furthermore, no system should be static. How you do things will evolve over time, and how you organize your projects should evolve to match. So feel free to experiment as you go. It's the only way to find out what works and what doesn't.

At the very least, you need to organize your many different resources on your computer's hard drive—from source code to compressed audio. A simple, hierarchical structure of folders, like the one shown in Figure 18.1, might be all you need.

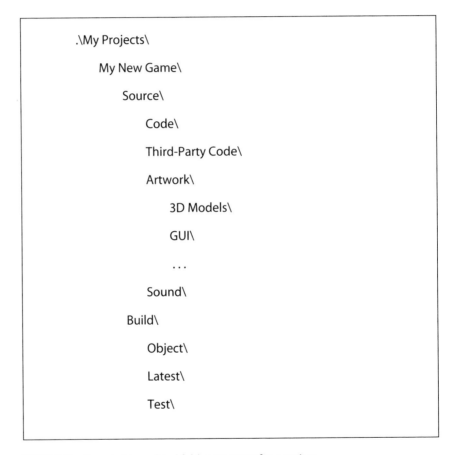

```
.\My Projects\
    My New Game\
        Source\
            Code\
                Third-Party Code\
            Artwork\
                3D Models\
                GUI\
                    . . .
            Sound\
        Build\
            Object\
            Latest\
            Test\
```

FIGURE 18.1 Sample hierarchical folder structure for a project.

There are two primary goals for any resource management system. First, you need to know where new resources should be placed. Second, you need to be able to quickly access any particular resource. Both of these goals are supported in folder structure shown in Figure 18.1.

The "Source" folder tree shown in Figure 18.1 contains all the files needed to create a build. The "Code" and "Third-Party Code" folders are for your own project-specific source code and the source code of third-party libraries/components that you have acquired. Resist the temptation to combine these two. If you combine them, there could be problems separating out what you have done on your own from what was outsourced. Also, by separating them, you always know when you're modifying your own project's code and when you're making changes to a third-party library.

When there is a project build, the resulting files (e.g., object files, compressed audio, processed images, etc.) are accumulated into the "Build" folder tree. This folder tree should be organized as closely as possible to match how the final game will be organized when installed on the player's computer.

Another advantage of having an hierarchical folder structure is that it makes backing up your project files very easy. Since the "Build" tree is created from the "Source" tree, you might not need to back it up. Even if you decide to back up everything, it's still just the recursive archiving of a single folder.

A Word About Backups

Let's take a moment and talk about *backups*. A backup is, at its most basic, a copy of your work (e.g., resources, documents, etc.) that is kept out of harm's way.

Backups are *incredibly* important. Whether you backup to floppy disks, read-write CD-ROMs, Zip disks, tape drives, or clay tablets—the important thing is to *backup regularly*. Don't lose your project to hardware/software failure.

As an added precaution, store your backups 'off site.' Keep your backup media stored somewhere outside of your (hardware) working environment. Buy a small lock box to store your backups in a friend's or family member's home. Or get an inexpensive safety deposit box at your local bank and store them there.

There are several advantages to off-site backups. First, you separate the fate of your backups from the fate of your computer. If you store your backups in the same desk, room, or house where you have your computer, then whatever happens to your computer (e.g., theft, fire, flood, etc.) will most likely happen to your backups, as well.

Second, if you store your backups with a friend/family member, you have someone who knows you're supposed to be making regular backups and can remind you. This will help you do what you should be doing: backing up your project files.

Finally, by storing your backups off site, you'll end up with several different versions of your project, backed up at different points in time. Even if you simply rotate between your current backup and the backup in storage, you now have twice as much protection.

The Almost-as-Simple Case

A small team of two or three people working on a project increases the need for organization. Unless the team members are working on totally unrelated parts of the game, how you manage the resources of the project will have to become more sophisticated. At the least, you'll have to decide how the team members get access to the project build (for testing) and to the raw resource files to add and update their contributions.

If all parts of the project are isolated from each other, then each team member can manage their own resources to an extent. They can keep track of the different versions they are working on, sending only their actual 'finished' submissions to the project leader. Someone will need to keep the original 'raw' source files so that there can be a build at regular intervals.

With the project divided up like this, and with the project team spread across a large geographical region, communication becomes key to resource management, just as it is to many other parts of game development. The team members need to know where to send updates of their resources and how to see or test those updates in a build of the game. A central repository using a package like the *Concurrent Versions System* (CVS, *http://www.cvshome.org/*) could provide all that you need with minimal overhead and cost.

Project builds should be made available regularly. A vehicle for importing new resources into an existing build will also be appreciated by the nonprogrammers in the team or anyone who doesn't want to do a full build of their own.

An Almost-as-Simple Case Study: *Artifact*

What follows is a short case study on how Samu Games managed resources for *Artifact*. *Artifact* is a multiplayer, real-time strategy game originally released in 1999. Nearly all of the game's content was updated in 2000.

Artifact had four team members: two programmers, an artist, and a sound engineer. Each had completely separate areas of responsibility. The two programmers were divided between the client software and the server software. The artist's and the sound engineer's disciplines did not overlap with each other, or with the two programmers' disciplines, either. With this kind of separation, all of them could work on their own

pieces of the project, safe in the knowledge that they wouldn't be affecting the other team members. The client-side programmer, also served as the resource manager for the project and pulled together the various pieces needed to create each new build.

In practice, it was a bit more complicated than it seemed at the beginning of the project. For communication between the client software and server, the two programmers created a lengthy document that described the interface that both programmers were implementing. The server-side programmer would assume that the client was sending information as described in the interface document, and vice versa for the client-side programmer. Sometimes, one programmer would run into a snag in his implementation that would require a change to the document and possibly a change to the other side's implementation. But even with that kind of evolution happening, all of the team members could work independently most of the time.

For the artwork and sound resources, though, the artist or sound engineer had to send their new versions to the resource manager. It was then necessary to get their new and updated resources into the next build so that they could test/see what they had just done. This was where the process broke down a bit. The resource manager occasionally got behind on integrating new resources. On top of that, they would have to download entirely new versions of the game to see/hear their newest additions and updates, which was hardly ideal. The latest versions of the resources also had to be kept track of—such as which were finished and which were merely placeholders.

All in all, it *mostly* worked, and the team managed to never lose a final version of a resource. A few interim versions were lost, though, that would have been useful at certain times.

Figure 18.2 shows some of the folder structure used for the *Artifact* client software. In this example, the "Source" folder is only for the software source code. As *Artifact* went from alpha to beta testing and then to release, full copies of the client source code were kept in separate folders. This wasn't entirely necessary, but it provided a record of what the game looked like in each of those stages.

Artwork and sound both had "PreProd" and "Cooked" subfolders. "PreProd" (i.e., preproduction) was for the 'raw' resource files. These were the 24-bit color images and uncompressed wave (.wav) files. The "Cooked" subfolder was where the art and sound images were placed when they had been processed. The images were considered cooked when they had been used to create a single, 256-color palette, and then had been converted to that palette. For the audio files, the processing was up- or down-sampling to match the required sample rate and bit size, followed by compression. When *Artifact* had a build, art and sound resources would be pulled from the "Cooked" subfolders.

```
.\My Projects\

    Artifact\

        Source\

            Alpha\

            Beta\

            Release\

        Artwork\

            PreProd\

            Cooked\

        Sound\

            PreProd\

            Cooked\

        Help\

        EXE\

            Data\
```

FIGURE 18.2 Client software folder structure for *Artifact*.

The structure shown in Figure 18.2 evolved from production work done in 1996–1999 for the first version of *Artifact*. The folder structure has continued to evolve since then; but with the release of *Artifact 2*, it reverted to more closely resemble the structure shown in Figure 18.1. No doubt, the folder structure and other aspects of *Artifact's* resource management will continue to evolve as the team continues to learn and improve.

This case study isn't presented to show how well (or poorly) Samu Games did. Rather, it's to show that even when the project has only four team members, each with clearly delineated areas of responsibility, and less than 20MB of total art, sound, and music resources (hardly a large game by modern standards), there can still be problems with resource management.

Resource Management: Source Code and Binary Files

As mentioned at the beginning of this chapter, there's more to project resource management than organizing source files in folders and creating builds. Source code management will now be examined in more detail, and we will discuss managing nontext files, such as image and audio files.

Managing Source Code

Managing a project's source code encompasses several tasks: source file organization within the project build process, coordinating updates to those files, tracking changes made to the source files, and making backups. Most of these tasks can be handled by using a version control system, like Microsoft® Visual SourceSafe™ or the GNU-licensed CVS (*http://www.cvshome.org*). There are many software packages and many ways to handle the different tasks of resource management. So whether you pay big bucks or go for the freeware approach, you have a number of options.

You or one of the programmers on your team will need to be the 'Source Code Manager.' There's no need to become overbearing in this role, but someone needs to provide a consistent approach to file management. This person's first responsibility is to create the project's source folder structure and decide on the file-naming convention.

Once the folder structure and file-naming convention have been decided on, the software package you use for version control will handle most of the rest. When a standard is established and accepted, most people tend to follow it automatically. Some programmers may get stubborn, but they will come around if they see that the system and conventions make sense, at least for this project.

Another responsibility of the Source Code Manager is to build the executable for the game. This 'official build' will be created according to your regular daily, weekly, or semiweekly schedule. It will be bundled with the resources, if they aren't part of the executable, and made available to all of the team members for testing, and it will also show that the game does, in fact, build.

Once a project gets underway, it is easy for the source code control procedures to erode. Every system tends toward entropy. So the Source Code Manager will need to keep an eye on the programmers to make sure they are checking these files in and out properly, and making good notes about what's new and different with each change they make. Any good version control software can compare two or more versions of a particular source file and show exactly what's different between them. But it won't tell you (or anyone else) *why* a change was made, and the reason can sometimes be just as important as the change itself.

Managing Artwork, Sound, and Other Binary Files

Binary files, like 3D-model meshes and sound .wav files, can be managed in most source code-versioning software. The software will usually provide *basic versioning* for nontext files. Basic versioning means that it keeps the old version(s) of an updated binary file. You would therefore be able to review a previous version of a graphic resource. What the exact differences between the two versions are, though, is your task to spot. Good version log comments are invaluable for tracking down these differences, but it's still far from the ideal way to version binary files.

The need for more-sophisticated versioning of binary files is fueling the creation of ever more-powerful software. At the high end of the scale, products like *Alienbrain* by NXN (*http://www.alienbrain.com*) can assist with both text and binary resource files. If you're like most indies, though, it's unlikely you'll be able to afford the steep price tag that comes with such products.

If you are archiving binary resources by hand, adopt a simple, easy-to-use convention for marking the resource version, such as adding a date tag to the resource file name. For example, the resource file *Race0 FacilityQuarry.BMP*, if archived as *Race0FacilityQuarry-2003-03-04.BMP*, would identify that the file archived on March 4, 2003.

Whichever method or software you use to manage your binary resources, you will need to have it integrated with your *content pipeline* from the beginning. Your content pipeline is the path a resource takes from initial concept, through to placeholder and interim versions, and to the project build(s) for testing.

Will your noncode resources be built into the executable file, or will you use separate resource files that are loaded when the game runs? How will one image or sound effect be updated? Will the artist or sound engineer be able to easily test their tweaks and changes in working build? Is there any processing (e.g., compression) that must be performed on the resource file before it's useable in the game? All of these questions must be answered and the resulting steps added to the content pipeline.

CONCLUSION

Most people who have worked for larger companies and development houses are already familiar with resource management. They may not, however, have ever considered that even smaller projects can benefit from it, even without the large-scale, high-price-tag solutions that are on the market. No project is so small that it won't benefit from being more organized and protected from catastrophic data loss. Which system you choose for organizing your project's resources is not as important as your sticking to that system throughout the project's development cycle.

CREATING QUALITY DOCUMENTATION

IN THIS CHAPTER

- Types of Documentation
- Keeping Your Project Documentation Updated
- Uses for Your Project Documentation

Documentation is often the last priority for many software developers. They dive into development immediately, with little more than a short description of the 'cool' features they want to implement. If, by some miracle, they actually finish the project, these brief notes are usually all the documentation they *still* have. They then struggle to create a meaningful help file to accompany the game; but they don't struggle too hard, rationalizing that no one reads the documentation, anyway. This is not the best way to approach an important topic like project documentation.

Creating useful documentation for your project from start to finish provides many benefits beyond resulting in a more polished players manual. There are other advantages. Your all-important game design and production plan documents provide the road map for your project. They hold the instructions for where you're going, the path you're taking, and how you'll know when you get there. So it's important that this documentation be kept up to date and portray an accurate picture of where the project is.

In addition, detailed documentation can be invaluable in creating test plans for the last stages of the project. And even after the project is over, you will be able to look back at your notes and accumulated documentation, and do an intensive post-mortem of your project.

Types of Documentation

The players manual is the most obvious form of documentation, but it's not the only form; and it's not the one that should be tackled first. First there is the game design document, which serves as the blueprint for the project (see Chapter 7, The Game Design Document). Documentation will be created throughout the course of the project. There is the detailed task list—with dependencies and time-to-completion estimates—the list of milestones, and the schedule will be updated and annotated throughout the project with actual completion dates and implementation notes. Then there is the testing documentation, which encompasses test plans for the project and the results of those test plans. Finally, there is the actual player documentation, or players manual. This last piece of documentation is often the hardest to write. Unlike the other documentation, the players manual must be written with the end user in mind.

As daunting as all of that paperwork may seem, keep in mind that you will not be creating it all at once. You will create the documents you need in a logical sequence. Often, the next piece of necessary documentation is built from parts of previous pieces. For example, the game design document is the basis for the task list. The task list leads to the milestones; and when you create test plans, you refer to the game design document,

task list, and milestones to define what needs to be tested. All of this eventually leads to the players manual.

Documenting your project doesn't have to be a chore, and it *won't* be a chore if you don't put it off until the last stages of production. Do your documentation as you need it, and keep everything up to date along the way.

Since this is your project, you will probably be doing most of the documentation and related tasks. If you have a team, though, bring them into this part of the project, as well. Encourage them to contribute to keeping all of the many documents current.

KEEPING YOUR PROJECT DOCUMENTATION UPDATED

The design and preproduction documents were discussed in detail in Chapters 7, The Game Design Document, and 8, Task Identification and Scheduling. Your game design document describes where you want to go, while your production plan maps out how you're going to get there. Now we will find out how to keep those documents up to date.

Design Documentation

All projects, no matter how well planned, will begin to evolve once they're underway. It's inevitable. Implementation issues arise and force minor changes, redefinitions, or rescheduling of tasks. Play testing might show that gameplay elements need to be better defined, shifted from one part of play to another, or discarded entirely. Change can be good. And as changes to the game design occur, they must be recorded immediately.

Even after development of your project begins, the game design document remains your best guide. Therefore, your design document must be routinely updated to reflect the new, clearer vision for the game. As part of the update, make a note about the circumstances that brought about the change. That way, if you need to remember why some feature was changed or removed, you have it written down.

If you delay updates to your game design document, the document will become less and less relevant, until finally the project is adrift. After all, if the design document no longer describes where you're going, where *are* you going?

After updating the design document, you will have to review your task list and milestones. See if the design change adds new tasks to be completed (avoid these types of changes if you can), changes the priority or scheduling for a task, or eliminates a task altogether (almost always a good thing).

Keep in mind that the changes discussed here refer primarily to the tweaking and adjusting that become necessary when implementing and

play testing the game. The important phrase here is "tweaking and adjusting"; major changes in gameplay or direction should be avoided. Have faith in both your original vision for the game and in your production plan. You may be tempted to branch off from your current project to pursue a tangent; but if you do, it's unlikely that you will finish either.

Project Documentation

Project documentation encompasses the day-to-day, week-to-week, and month-to-month status of the project. *Status reports* are created to keep the whole team apprised of what each member is doing: their current task, how far along they are on that task, and where they're headed next.

Daily project status reports would drive your team to distraction, and such frequent reports would be so much work to compile and post that you would find all of your time spent generating reports. A weekly or semi-weekly report, however, gives everyone a quick overview of how the project is doing without upsetting their personal production schedules, and it won't add too much to your already impressive workload.

When you are creating the status reports, check in with all of the team members so that you have the most current information. Then post the report for the whole team to read and review. Even if you have weekly team meetings, where everyone tells everyone else what they're doing, a posted report is valuable

Whether you send out project status reports via e-mail or post them to a Web page, keep all of the reports available in an archive. When you review the project during development or afterward during a post-mortem, the collection of status reports will show you when progress was fastest, when progress was slowest, and when progress was stalled. This information can tell you who is contributing and who is dead weight.

Your status reports can also be used as a marketing tool, assuming that there are players interested in the game's progress. For *Paintball Net*, Samu Games' semiweekly status reports were echoed in a publicly available .plan file so that future players could keep updated as the game came together. Sometimes screenshots were included with the posted status reports to show the progress in a more easily visualized way. Most of these posts proved popular with the players.

If you have regular team meetings, posting a summary of what was discussed at each meeting can be very useful down the road. These meeting reports don't have to be a lot of work. A straight text chat log of the meeting, with important points highlighted, can be useful. If action items were discussed and assigned during the meeting, list those in the meeting summary, as well.

Throughout the project, encourage your team members to also talk to each other about what they're working on. If possible, keep a record of all project-related discussions. E-mail and instant messaging are easily logged; but for phone conversations, someone should be assigned to agree to keep notes. These logs and notes can provide much-needed explanations for design and scheduling changes, as well as provide additional documentation of the project's progress over time.

Testing Documentation

There are two forms of testing documentation that you will want to track: test plans and the results of those test plans. Even simple games represent complex software systems with a number of interrelated subsystems, such as the user interface, the graphics engine, the resource manager, and the game logic. Testing all of these systems and their interactions can be just as complex, so it's important to approach testing in a systematic manner.

Test Plans

A *test plan* is a list of all the features that need to be tested. Each item of the test plan describes how to perform the test and also reports the result of the test. In general, all tests are pass-fail tests; the test was either successful or it wasn't. When all of the tests have passed, then it can be safely assumed that the game 'works.' Now, whether the game is *fun* or not is more of a play-testing issue, which is a separate matter.

Don't wait until your project is nearly completed to create your test plan. Instead, build your test plan at the very beginning, and continue testing the project grows.

Create a new test plan for your game at the beginning of each milestone, and keep it updated as new features are added. This way, the burden of creating the plan is spread across the whole milestone. In addition, an up-to-date test plan is then constantly available during the entire project, providing a quick and systematic way to verify what you have so far.

When you create the test plan, each new task for the current milestone easily becomes a new test item. The first new build of the milestone will probably fail nearly every test item, but the point is that you will clearly see what is and isn't working.

Extreme Programming (XP) is a software development philosophy that encourages the creation of 'test suites' *prior* to beginning development. As the software grows, the collection of test suites is expanded so that the software is kept as correct as possible. (For more information about XP, see "Extreme Programming: A gentle introduction." Available online at *http://www.extremeprogramming.org/*.)

The Test Plan Results

Your test plan will show what is working in the current build of the project, what is not working, and to what extent nonworking items are failing. There are no vague bug reports that only state, "It doesn't work." You and your team will know as exactly as possible what needs to be fixed.

Finding and managing play testers will be covered in Chapter 20, Project Testing, but it is just as important to have a test plan for play testing. It's exciting to see players actually *playing* your game, but don't forget that the game isn't done yet. You have play testers for one reason: *testing*. With that in mind, create a test plan that outlines how your early play testers can test certain features.

Player Documentation

Finally, there is documentation that is intended for the player. While life would be nice if all games were intuitive enough that anyone could download them and immediately begin playing, this hope is far from realistic. Many players do try to learn how to play new games by jumping in and giving them a go. The more familiar they are with the game's genre and/or milieu, the more likely they are to do this. But not all game players have racked up 1,000 or more hours playing similar games, and these players are going to go straight for the game manual.

Your design document is the obvious foundation for the players manual. A document that describes how the game *works*, however, is not the same as a help file explaining how to *play* the game. The game design document and the players manual have very different audiences and very different purposes.

The game design document is created for a development team; it describes the game and all of its myriad elements in detail. The audience for the players manual, on the other hand, is either someone who is new to the game or who is looking for more information about a particular feature in the game. Thus, the purpose of the players manual is to quickly and clearly impart that information in a way that makes sense to the player.

The foremost goal of the player documentation is to get a new player into the game and having fun as quickly as possible. Even if you have reservations about how many people read the help files or manuals of games, you can't afford to shirk on this effort. Even the most hard-core players eventually end up at least skimming the manual, looking for new information and less-obvious tips and tricks to give them a competitive edge.

If possible, have a professional writer create the players manual. At the very least, have a professional writer review the manual for correct use of language, grammar, and punctuation. Also, have someone who was not a part of the development team read through the manual. This will help reveal those areas that don't provide enough detail, use unfamiliar jargon without explanation, or are in other ways unclear.

Some parts of the game design document may work well in the players manual with little change. The glossary, for instance, can probably be cut and pasted into the players manual to provide a summary of game-specific terms that new players need to know.

For *Artifact* (Samu Games), the online help page grew from a short list of features and a quick explanation of how to build a city that was included in the alpha test installation package. As the game became more complete and certain questions became common, the 'quick and easy' guide got longer and included more-detailed information. In the end, the online help was divided into two primary sections: a 'how to play' guide, which provided a 'Quick Start Tutorial' and overviews of important concepts, like alliances; and a detailed 'Reference Guide,' which had some information that was imported verbatim from the design document.

OTHER USES FOR YOUR PROJECT DOCUMENTATION

When your project is completed, there are more ways you can use the documentation you've accumulated. One of the most useful of these is for a project post-mortem. Beyond that, there is always the potential for using this information in promotional materials, such as for game development articles.

The Project Post-Mortem

A *project post-mortem* is a review of the project from beginning to end, assessing its strengths and weaknesses. Post-mortems of game development projects have been popularized in recent years by *Game Developer* magazine. These reviews serve as a learning tool for everyone involved in the industry.

The goal of a project post-mortem is to learn from the project that you just completed and, hopefully, correct mistakes and reinforce successes in future projects. The extensive documentation you've created for the project, from inception to completion, will provide the data you need to perform a detailed post-mortem.

A project post-mortem should be done after every project, and the whole team should be included. Each team member of a project will have

a different opinion on how the various tasks and resources were managed. Get feedback from each of them, both individually and as a group.

Begin with a review of your game design. How much did it change? Was there any common thread to the changes and revisions? What brought about the changes? The version history section and designers notes in the game design document should show most of the changes and provide at least a thumbnail sketch of the purpose behind the changes. What changes *weren't* made that, in hindsight, might have been obvious or useful?

Next, document what went right with the project. List as many things as you can that went as planned or expected. Also list pleasant surprises—those fortuitous or useful events that weren't planned, but that helped the project along. Include as many details of each successful aspect of the project as you and your team can remember.

Now create a list of what went wrong with the project. Again, list as many details as possible. The idea here isn't to assign blame, so resist the temptation to do so. Everyone makes mistakes, even indies. The point is to spot what went wrong so you can prevent it from happening on the next project.

The post-mortem format used in *Game Developer* lists the top five things that went right and the top five things that went wrong. Your post mortem will probably have more than five items in each list, and all of them should be considered.

The conclusions you draw from your project post-mortem will vary with each project. Perhaps more risk management was needed, or maybe project costs should have been more accuracy assessed. Applaud your successes and learn from your failures.

Game Development Articles

Never underestimate the value of the written word. Anything written down or otherwise recorded can be leveraged for other purposes, such as for creating game development articles destined for the Web, print magazines, or even books. Every project teaches its own unique lessons. By writing articles about what you and your team learned, you can help other independent game developers build on your successes and learn from your mistakes. And you, in turn, can learn from theirs.

For example, during work on *Artifact*, Samu Games created a detailed document describing the interplayer communication options that were going to be offered, such as chat, private messages, and notes. Besides serving as the basis for implementing those features in the game, that document became an article for GameDev.net, entitled "Designing for Online Communities," (*http://www.gamedev.net/reference/design/features/dfoc/*). It also served as a chap-

ter in *Game Design Perspectives,* published by Charles River Media, Inc. Similarly, Samu Games' experiences with contracting artwork, designing data structures for real-time strategy games, and displaying maps with terrain transitions have all become articles published on the Web. None of this would have been possible if they hadn't kept detailed notes (including well-commented source code) over the production life of their project.

You might get paid for these articles, or you might not. But getting paid isn't the point. These articles are used to promote yourself and/or your game (see Chapter 24, Marketing and Promotion). You will also benefit by sharing your experiences and adding to the growing game design/development knowledge bank. This benefits everyone.

CONCLUSION

Documenting your project is simple: write down everything that happens, as it happens. Begin with your game design document. That's the foundation of everything to follow. Don't be too concerned about doing it right or wrong. Do what you can right now, and improve as you go.

What you write down throughout your project can be useful even after the project is completed, especially when it comes time to do a postmortem. It's easier to learn from your successes and mistakes if you keep track of them along the way.

20

PROJECT TESTING

IN THIS CHAPTER

- Team Testing
- Play Testing

Testing, or quality assurance, is not something you tack on at the end of the project. After it's been planned in preproduction, testing should be run throughout the development of the project. If you following your test plans (see Chapter 19, Creating Quality Documentation) and keep them current as the project grows, you will limit the risk of wasting valuable development time in building subsystems that don't work, fixing parts that weren't broken, and optimizing features that aren't critical.

Retail-oriented developers can budget in the use of professional testers, or their publisher might provide a *Quality Assurance (QA)* team. As an indie, though, you and your team are the primary group of testers for your project. You are the front line of quality assurance. In the early stages of development, you will be the only group of testers. But as the game moves toward completion, you will be able to leverage the Internet and build a team of volunteer testers. Granted, they might not be as polished as a publisher's QA department, but these volunteers will more than make up for it in enthusiasm.

TEAM TESTING

You and your team are your first and best testers. You will each be responsible for testing your own parts of the project. When necessary, two or more team members can work together on testing new features.

This early team testing is less about whether the game is fun or not; rather, it's more about whether the game works or not. Is the server hosting players properly? Are the chat channels working? Is the player model rendering correctly with weapons mounted?

Before the game reaches a certain level of completion (e.g., before the first milestone is finished), it's doubtful anyone would be able to judge the game's fun factor. Because of this, you should limit access to the game to the team members. You don't want future players to form poor opinions about the game before it's complete enough to impress them.

PLAY TESTING

Play testing is to game development as proofreading is to books/articles and test screening is to movies. The goal of play testing is make sure that an unbiased person—someone other than a team member or their loved ones—likes the game. Just as parents tend to dote on their children, game development teams have a hard time being objective about their games— Of *course* it's a great game!

Obviously, play testing can't begin until the game is in a playable state. Until then, your project is little more than a curiosity—an experiment in concepts and rendering techniques—something you can impress your friends with before going out for a movie and a hamburger. It's not real entertainment. It's not even a demo. Once you have even the minimum gameplay in place, though, then you have a *game*. And a game can be play tested.

Early Play Testing

Early play testing, sometimes called *alpha testing*, is when you first allow players to try out your game. Your first non-team play testers must be people you can trust, and who can be relied on to provide feedback. You need to be confident that they won't make the test package available to other, nonauthorized people in any way. It's also helpful if they agree not to discuss the game with anyone except you, your team, and the other testers. A full nondisclosure agreement might be overkill in some circumstances, but there has to be some level of trust between you and your testers; they should have your teams' best interests at heart.

A tester's ability to give detailed feedback is also essential. The game they are trying out is far from complete, and there will be problems—probably be *lots* of problems, in fact. When these problems occur, the testers must be able to describe exactly what they were doing at the time the problem occurred, as well as report the error message and/or other information, if possible. Without details, it's hard to pinpoint a problem and fix it.

Make it easy for your testers to report errors. Make the software as robust as possible, so that if there are access violations or exceptions, these are caught and reported to the player in a meaningful way. You might take the step of having the game e-mail error messages directly to you, or to some central, team-accessible location.

Feedback is important for judging how the game plays. Could the player easily figure out what he was supposed to be doing, or was he lost once the intro screen had faded? Early testing will go through several phases that follow the development stages of the game itself. As the game becomes more complete, you can add more testers.

Finding Early Testers

For early testers, you should consider keeping your search close to home. Family members and friends who are interested in the project make good initial choices. Not all of them are going to be good testers; but for early testing, you want as small a group as possible, and you want them to use a variety of hardware configurations.

Recruiting people for early play testing is sometimes simply a matter of asking them if you can install your game on their computer to make sure it runs. Most people will be happy to help out.

In Figure 20.1, indies respond on where they've found testers. For *Artifact*, Samu Games started testing with fewer than 10 people. Most of these were players of their first game, the original *Paintball Net*, but a few were from a different game that one of the programmers had worked on. Over the next few months, more and more testers were added, until there were about 50 testers. After that point, they were no longer able to control access to the test; people invited themselves to join. But by then, Samu Games didn't really mind.

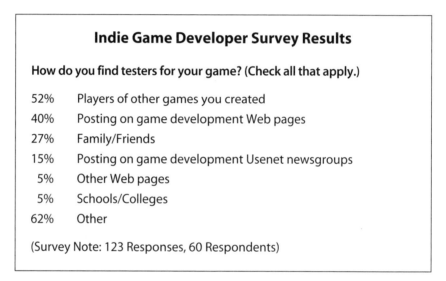

Indie Game Developer Survey Results

How do you find testers for your game? (Check all that apply.)

52%	Players of other games you created
40%	Posting on game development Web pages
27%	Family/Friends
15%	Posting on game development Usenet newsgroups
5%	Other Web pages
5%	Schools/Colleges
62%	Other

(Survey Note: 123 Responses, 60 Respondents)

FIGURE 20.1 Where indies find testers.

Managing Early Testers

Don't be afraid to give your early testers a test plan to follow. With the game still so incomplete and the user interface a long way from being done, your testers will probably appreciate detailed instructions. So include the test plan and a brief description of how to play the game with the game's installation package.

As you add testers, get as much information about their personal computer as you can. Have them tell you their hardware configuration (e.g., CPU, RAM, graphics card, RAM on graphics card, sound card, etc.) as well as what operating system they're using, including version, and

any other software they may be running on their computer at the same time they are running your game. This information will prove handy when you need to test a particular hardware configuration, or if you need to find out why tester A has a problem that testers B, C, and D don't have.

Don't be shy about asking your testers for feedback. That's what they're there for. Encourage the testers to tell you what they like and don't like. If possible, create a private forum on a Web page where the testers can talk to the team and each other.

Some testers are not going to like the game. This is inevitable. So neither you nor your team should take unfavorable feedback personally or as a sign that your project is doomed. Of course, if *all* of yours testers hate the game and tell you so in no uncertain terms, you may want to seriously reconsider the project. But that's highly unlikely.

Most testers, whether they like the game or not, will have plenty of advice to share about how the game can be improved. All these suggestions should be valued as the valuable feedback they are. A few will be great ideas, obvious refinements or extensions of the game. Some of them so obvious that you'll wonder why you didn't think of them yourself. The rest, however, will be features that are planned but not implemented yet; or great ideas for a game that's similar to yours but not quite right in this context; or some players might just be excited about being able to provide feedback. Regardless of whether you act on their suggestions or not, always thank each tester for assistance.

Beta Testing

Beta testing usually occurs when the game is nearly complete. The goal of beta testing is not as much feature testing as it is load testing. Up until now, the game software works in all the cases you've been able to test, and the gameplay has been implemented and refined. What you are looking for in beta testing is access to a wider variety of hardware configurations and levels of player expertise.

There are so many possible hardware configurations, especially in the Windows PC arena, that it is virtually impossible to test every combination of CPU, operating system, graphics card, sound card, available RAM, and so on. Also, as indie developers, you and your team probably know either more indie developers or other people who share your interests. Your own friends and acquaintances are likely to have your same level of computer skills and a similar approach to testing software and/or playing games. You will need to cover of a multitude of player situations, and the only way to get test this kind of coverage is by opening the game up to (nearly) all comers.

Managing Beta Testing

You are unlikely to get people who participate in an open beta to follow a test plan. You can still try, though. Provide the test plan with the installation package. You may be pleasantly surprised by how many players actually give it a go and send you their results.

Even though you are nearly finished testing your game, don't shirk in making it easy for all players to submit bug reports and other feedback. Set up a special forum for players to discuss the game, report the bugs they find, and offer suggestions for improvements. The discussion of the game and the bug reports are the most useful results of such a forum; but even at this late stage, there can be good suggestions forthcoming. The discussion in these forums is good for another reason: it creates a community of players.

Keep an eye out for hints of bugs and exploits that you're *not* being told about. Players are competitive, and a bug they find that works in their favor may not get reported. This isn't going to be much of a problem in the early play testing, but it could become an issue during beta testing. You may only hear about the exploit from someone that it was used against. Again, don't be shy about asking players for information about these kind of bugs. Explain that the game will be improved (and fixed) for everyone.

CONCLUSION

You need to test your game throughout the project. The more often you test, the better you can manage issues as you go along; you will have fewer nasty surprises as the game nears completion.

Play testing your game as the project progresses also helps get you a base of devoted players. Public testing can also bring your game to the attention of the computer game press, who are always interested in hearing about fun new games.

COMPLETING THE GAME

IN THIS CHAPTER

- Knowing When to Stop
- Pulling Everything Together

The final part of building your game is to declare it *finished*. As obvious as this may sound, it can be scarier to *stop* working on a game than it was to start in the first place. After months of effort and keeping your team's passion burning bright—after putting one foot in front of the other day after day, week after week—your project has become a part of you, a part of that you now have to release to face the world on its own.

This chapter will help you know when to declare your game done. By sticking to your game design and following the milestones established in preproduction, you can avoid game development problems like feature creep and unending testing. A final checklist will then be presented for getting your game ready to be released. Just as with every other part of indie game development, completing the game is most efficiently done by approaching it in a systematic, organized fashion.

KNOWING WHEN TO STOP

Knowing when your game is 'done enough,' can be harder than it seems. As was discussed in Chapter 15, Team Leadership, it's easy to get so caught up in the process of making the game that you and your team forget that the project has an end goal—completing the game. By all means, enjoy the journey that is game development. But in your excitement, don't forget that there is a destination that marks the end of that journey.

If you give in to the urge to keeping adding more features, or never muster the courage to move out of final testing, then your game will never be finished. You won't really be enjoying the journey; you'll only be avoiding the destination.

Follow Your Design to Avoid Feature Creep

Feature creep is the obsession to add feature after feature to a computer game (or other software program) so that development never ends. Whether the features come from the development team or are suggested by the players, there is always 'just one more thing' to add. Besides extending the schedule and putting off the completion date indefinitely, feature creep most often results in a bloated, incoherent collection of 'good ideas' with no clear intent.

To be sure, the evolution of the game is good; it is a sign of life. There will be suggestions made by play testers and even by team members that are obviously worthwhile additions to the game. Feature creep, though, if left unchecked, can turn useful evolution into a series of harmful mutations. The original game design can become lost, obscured by 'good ideas.' One change leads to another, and another, and still another.

Your project might continue in spite of feature creep, moving forward one addition at a time. However, it will eventually collapse under the weight of these extra features.

The way to avoid feature creep is to have faith in your game design. Just as important, have faith your team's ability to see the game finished—as designed. Every new feature must be seriously considered before being implemented. Some questions you should ask yourself before adding to your game design include:

- **Is the feature consistent with the rest of the game design?** If not, you're better off without it. Special cases and exceptions to the established design rules dilute the purity of that design and set a precedent for more special cases.
- **Does the feature fill a gap in the game design?** That is, does the feature satisfy a need by introducing a new facet to the game? If not, and the feature is just another way to handle an existing gameplay element, you may want to pass on it.
- **Can the feature be implemented with the current infrastructure?** If you can easily add the feature using the source code and resources you already have available, then it might be a good idea (or at least not a bad idea). On the other hand, if the feature requires a whole-new infrastructure of its own, you're better off leaving it for a future release.
- **How much effort/time will the feature add to the project?** This is the most important question of all. Too often, features are added to a game without any consideration for that feature's impact on the overall schedule. If the feature is going to add another three to six months to the project's schedule, is it really worth it?

Don't forget the future features section of the game design document (see Chapter 7, The Game Design Document). If a new feature is a good idea, and you want to implement it, consider scheduling it for a future release of the game. That way, you still have the feature available, and you don't impact the schedule for the current release. Look at the future features section as your plans for the future, your list of features that might make a good game even better.

Follow Your Schedule to Avoid Infinite Beta

Another stumbling block to completing games is the *infinite beta,* or when the game is never finished. This can be brought on by a variety of reasons, either because feature creep has taken over, or because the development team is continually refining the game. The result is the same: the game never ships.

Using test plans (see Chapter 19, Creating Quality Documents and Chapter 20, Project Testing) can help keep your beta-testing phase from

running on indefinitely. Once all the test plans have been completed satisfactorily, and once all (or most) of the player-reported bugs have been addressed, you should set your release date.

The same applies to every milestone in your development schedule. Don't let the testing for a particular milestone drag on. Once the requirements for the milestone have been met, move on to the next one. Use forward momentum to keep the pace going.

Face the Fear

It's alright to be nervous about releasing your game. It's natural. This is your creation, your handiwork, your baby. It can be hard to let go of something so close to you. What if no one likes your game? What if it bombs and embarrasses you and your whole team? The "what ifs" can continue *ad infinitum*, fueled by fear and doubt—if you let them. If you've done your work well (and of course you have), then you shouldn't worry about these or any of a million other questions. You will, though. Get used to it. Just try not to let it stop you.

Don't let fear cause you to hesitate at releasing your game. Recognize it for what it is, and just face the fear. Remind yourself of all the ways you've prepared for this day, from the team testing to the system configurations tests that passed with flying colors—remind yourself of all the risks you identified early on and took steps to manage. Be confident in your abilities and those of your team. Then, release the game.

Samu Games faced both feature creep and the infinite beta when working on *Artifact*. Public beta had begun in March 1999. Five months later, the game was still getting frequent updates and new features. Five months may not seem that long, but there had been 11 months of closed testing that preceded it. The testing seemed never ending. The team was getting tired. They needed the game finished. And, more important, they needed to make some money from the game so that the team could begin to be reimbursed for nearly three years of effort. At the end of August, Samu Games declared *Artifact* was "pre-release" (anything but beta!). Six weeks later, *Artifact 1.0* was finally released on October 15, 1999.

PULLING EVERYTHING TOGETHER

The following high-level checklist can serve as a roadmap for completing your game. Each of these steps will be discussed in detail.

- Freeze all features
- Get all final resources
- Create the final build
- Complete the players manual

- Backup everything
- Build the installation package
- Create the Web page for the game

Freeze All Features

The first step to releasing your game is stop adding anything new to it. This is called *freezing the feature set*. Once the feature set has been frozen, the only changes allowed are bug fixes. You might even decree that only critical bugs be fixed. Bugs that have workarounds or don't cause crashes for most players might be safely ignored until later.

Another aspect of freezing the feature set involves reviewing the game design. Any features that have not yet been implemented are eliminated or moved to the future features section of the design document. In other words, you are reviewing everything that stands between you and a completed game. Get it done or get rid of it. Those are the only two options.

Get All of the Final Resources

With the features of the game frozen, get the final version of every resource your game requires: artwork, source code, sound effects, music, *everything*. If you have any 'placeholder' resources, identify them and get the real resource that's supposed to be there. Every team member should review the resources they have submitted and make sure that they are the most current ones.

Depending on the size of your project, this step could take from a few hours to a few weeks. Fortunately, this step easily coincides with freezing the feature set.

Create the Final Build

Once you have collected all of the final resources for the game, you can create the final build.

Something you might consider is to have a 'pre-release' testing period. During pre-release, the game is as complete as possible. You make sure that the final build still works as expected, and you look for only very minor (easily fixable) or very major (critical) bugs. No new features should be added during the pre-release period. After all, you've already frozen the feature set.

Complete the Players Manual

If you've been working on the players manual throughout the development process, then finishing it mostly involves proofreading and spell

checking. Go through all of the topics and tutorials. Verify that the information given reflects how the game really is, as opposed to how it was originally designed. This is especially necessary if the design has recently been pruned to meet the release date.

Backup Everything

Backup *everything*. Do it twice. Then send both backups to separate, safe locations. You've come too far to lose everything because your hard drive decides to call it quits and never spin again. Backup *now*.

Build the Installation Package

Build the installation package for your game. You may have been using a simple archive format up to this point, like the popular .zip file format. Although .zip files are adequate for testing purposes, it's just not good enough for a real game environment.

Your players will be downloading your installation package via the Web. It's one of the first things they see about your game, so it's important that your game installs as professionally as possible. Just as important, your game should easily *un*install itself.

Fortunately, there are a number of free installers available. *Inno Setup*, by Jordan Russell (*http://www.innosetup.com*), is one of the most popular. It provides many features, including a built-in uninstaller, and it is both flexible and easy to use. If you've never used installer software before, Inno Setup is a great, freeware place to start. If you prefer, of course, there are also installer programs that come with a price tag.

However you build your installation package, the goal is to make it *easy* to install your game. Additional steps, like putting your setup program in a .zip file or requiring command line parameters, only make installation more of a headache. Most players don't want to work too hard. After all, that why games are called 'entertainment.' If they can't install your game instantly, they'll probably just delete it and move on to some other amusement.

How Big Should Your Download Be?

When it comes to download sizes, there is no one-size-fits-all answer. Different games require different amounts of resources. On top of that, players have their own perspectives on download file sizes, either from personal preference or due to their individual hardware setups.

A game that requires a lot of resources will have to include all of those resources in the installation package. If you don't mind having a

separate download file for the demo version and the full version, you could make the demo version slightly smaller by leaving out resources that aren't required by the demo. However, not everyone wants the smallest file possible. In the mid-1990s, when most people on the Web were still using dial-up connections, smaller was better. Anything over 10MB was just too large and took too long to download. Even a 5MB download was too large for some people.

As broadband connectivity to the Internet has become more prevalent, the smaller-is-better logic is being subverted. In some cases, people are beginning to view the *larger* download file as the 'better' of two options. With broadband, there is almost no such thing as 'too big.' Even files as large as 50MB to 100MB can be downloaded in a matter of minutes.

Broadband users are still a minority, but their constantly growing numbers may make them comprise the majority of Internet users in the next few years. When that happens, and assuming that bandwidth is still readily available, the whole issue of how big your download file should be will be all but irrelevant. In the meantime, if you want to sell to dial-up players, you should stay within the 10MB size range.

Create the Web Page

As with the players manual, if you've been updating a Web page throughout the project, then there's not too much you need to do now. Mostly, you are putting the last bit of polish on your description of the game, creating new screen shots that display the final artwork, and maybe improving your community support.

For many independent game developers, the Web page is going to be their main salesperson. It will likely be your players' first contact with your game. Therefore, put a lot of thought into how you build your Web page and how you present your game. Keep in mind that your Web page is also going to be your primary distribution point for your game. This is where you upload the installation package, and where you place download links.

CONCLUSION

Completing your project can be almost as much work as getting the gameplay done right. However, if you believe in your game design and stick to your scheduled milestones, you can bring the project to a satisfactory finish.

Once you have everything ready to go, all that's left is to announce your game to the world. Section VI, Selling the Game, will help do just that: market, promote, and sell your game over the World Wide Web.

SELLING THE GAME

Take heart—you're almost done. The next, and possibly most crucial step, is to sell your game.

If you are like many programmers, artists, and musicians, you might find marketing, promotion, and sales topics intimidating and/or foreign. This section will help you understand these concepts and teach you how to apply them.

Chapter 22 (Self-Publishing on the Internet) provides a detailed overview of the self-publishing process. Three simple rules are used: have something to sell, be obvious, and be easy.

Chapter 23 (Pricing) discusses the very important topic of setting a price tag for your completed project. How much should you charge for your game? This chapter answers the question from two directions—first, from the viewpoint of the developer; and second, from the viewpoint of the customer.

Chapter 24 (Marketing and Promotion) will describe how to create a marketing plan for your game. A number of ways that you can put your plan into action will be provided.

Chapter 25 (Payment Processing) covers the details of handling payments from players and discusses the advantages and disadvantages of using third-party payment processing companies and merchant accounts.

Finally, Chapter 26 (Customer Support) will focus on how to handle customer questions and support issues in the most professional manner possible.

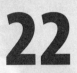
SELF-PUBLISHING ON THE INTERNET

IN THIS CHAPTER

- Step 1: Have Something to Sell
- Step 2: Make It Obvious
- Step 3: Make It Easy

So many developers focus only on retail publishing, they miss seeing another alternative. It may come as a surprise, but the methodology of selling software over the Internet has become well-established and a force to be reckoned with in the software marketplace: shareware.

The basic tenet of shareware is "try it before you buy it." The potential purchaser is invited to download the software, install it, and give it a test drive for a limited period of time or number of uses. If the user likes the software, he pays for it and continues to use it. If not, he un-installs the software.

The strength of the shareware marketing model has spilled over into the commercial software market. Just about all software, including many retail computer games, can be evaluated this way prior to purchasing them.

Whether you decide to market your game as shareware or not, there is more to learn from successful shareware developers than just 'try it before you buy it.' There are three steps you can use to sell your game software over the Internet. First, have something to sell. Second, be obvious about what's for sale. And third, make it easy to purchase the software.

STEP 1: HAVE SOMETHING TO SELL

The first step of self-publishing via the Internet is to have something to sell. But we're not just referring to a completed game, here. "Something to sell" also implies "something worth buying." Your design decisions and market research (see Chapter 5, Know Your Limitations and Chapter 6, Choosing a Suitable Game Concept) will guide you in avoiding clones and games that are already in over-served niches. If you want to sell a game, it's important that you create one that people will want to buy.

Also, if you have something to sell, you have to protect that something. The old adage, "why buy the cow if the milk is free," is applicable to marketing game software: if you want players to pay you for playing your game, you have to hold something back. Limit their experience of the game in some way. And this is where copy protection comes in.

Copy Protection

Copy protection is a mechanism for ensuring that players pay you for your game. For most indie games, copy protection usually takes the form of limiting the player's experience in the game, either by allowing the player a set number of playable days, or by providing a small subset of the available features or playable game levels.

Copy protection products have become increasingly popular as more software shifts to Internet-based distribution. Hacking and pirating of

software has been a problem since the earliest days of the industry, and isn't going to go away anytime soon. You would be remiss if you did not consider the piracy problem and take steps to either thwart pirating or at least reduce its impact.

The bad news is: you won't be able to stop everyone. No protection scheme is immune from reverse engineering. All it takes is patience and a bit of ingenuity, and hackers have an abundance of both.

The good news is: not everyone is a thief. Most people, in fact, are more than happy to pay for the games and other software that they find are fun and useful. In many cases, even if they did know there was a cracked version of your game out there somewhere, they wouldn't bother to find it. Most people are basically honest.

The goal of copy protection, then, is to keep honest people honest. You don't have to make your software uncrackable, which is an impossibility; you just need to make the copy protection tough enough to thwart casual attempts to bypass it. But don't go overboard and let your copy protection ruin the gaming experience for people who might have otherwise bought it.

An Alternative: *Almost* Have Something to Sell

As was mentioned Chapter 10, Creative Funding, you can, in certain circumstances, begin selling a game *before* it's done. You still need to have a game worth paying for; but if you planned its development properly, you can begin selling the game while you're finishing it. This can generate funding, even if only a small amount, to help complete the game. It also provides an additional incentive to a tired team of developers.

If you take this step and bend the "have something to sell" rule, it's very important that the players see definite benefits for paying early. Maybe the pre-release version is cheaper and includes a free upgrade when the final version is made available. Or maybe you provide more features in the pre-release version if they pay early.

Whichever method you choose to market your new release, you must let the players know in the clearest way possible exactly what they are purchasing and what your terms are. Also, the players must be able to make their payment as quickly and easily as possible.

STEP 2: MAKE IT OBVIOUS

The next step in selling your game over the Internet is to broadcast it and make the game's features obvious. Some new indies are timid when it comes to selling their games, and timidity is a horrible marketing strategy.

Make *everything* as obvious as possible. Make it obvious that the game is for sale. Make it obvious that players are expected to pay for the game. And make it *very* obvious what the players get when they do pay for it.

Making it obvious that the game is for sale means prominently posting the game's nonfree status. Put the price of the game where it can't be missed, such as in the game itself and on the game's Web page. If the game is free to try, then emphasize that fact, but don't be shy about the game itself not being free.

Keep in mind that you shouldn't be *rude* while you're being obvious. Be positive and friendly, not negative and aggressive. For example, don't state: "This game is NOT FREE. You must pay $29.95 to play this game." That's just obnoxious and annoying. Instead, say something like: "This game is free to try, and can be yours to play forever for the low price of $29.95!" That states the price prominently and also presents the price in a favorable context for the player.

Using Shareware Locking to Make It Obvious

Promoting your game as free to try is a good marketing approach; but, as was previously discussed, a game that can be played free forever isn't going to generate significant revenue. This is where your copy protection comes into play and does its job at *shareware locking*.

You have to enforce the expectation of a sale. You are expecting an exchange of their funds for your creation. There are a number of options for facilitating this, from evaluation period time limits to limited game feature/level access.

An *evaluation period limit* means the game can only be played for a certain number of days or a certain number of turns within the game. After the evaluation period is up, the game stops working. The player must buy the game to continue playing. The evaluation period is probably the most popular mechanism for nongame software, and some games have used it with success.

When you use the *limited access to game features* approach, the player is allowed to play for free for as long as desired; the catch, though, is that certain features are disabled. Samu Games used this approach in the original *Paintball Net*. Players could play for free as long as they liked, but with limited in-game capabilities. Similarly, many 'free' online gaming sites have a paid-player tier that provides more goodies, such as additional games, rankings, or sponsored tournaments.

One of the more popular limitation models for games is the *limited number of free levels* that come with the game. The free version of the game includes only a small set of levels. This gives the player enough levels so that they can see what the game is about, and hopefully become

'hooked.' When the player finishes the last free level, he has to buy the game to get more play time. The value of this approach has been proven for nearly two decades.

The mechanism you use for your game depends on the game itself and on what game upgrades (e.g., more features, more levels, etc.) you think players are willing to pay for. During play testing, pay attention to the feedback you get from your testers. Note what they liked, and what kept them playing the game. This information will enable you to make a good decision on where to put the game's limitation.

Once you know what you're selling, promote it to the players. For example, if you limit the number of levels available in the shareware version, your pitch could be: "Buy now and get 100 more levels!"

Make It Obvious What They Will Receive

Beyond explicitly stating that your game is not free, you have to make it obvious to the player what he will gain by paying for the game. Rule number one in Steve Pavlina's "How to Permanently Increase Your Sales by 50% or More in Only One Day" article is: "What you are selling is merely the difference between the shareware and the registered versions, not the registered version itself" [Pavlina00]. What matters to the player is not what he is getting during the free trial period, but what he can get if he pays for the game. Make sure, then, that what you're offering is sufficiently enticing to make them want to pay.

When you put together your promotional material, focus on the benefits for the player, for example, more levels or more in-game options. If you were a player, what would you be looking for? Think like a player, not like a developer, and then sell them what they want.

Stay Visible

The last part of making it obvious is to stay in the player's field of vision. Don't wait for the player to act on his own. Prompt him to act *now*.

'Nag screens,' as they are known, have a deservedly poor reputation, but they work. With some thought and planning, though, you can use nag screens to get your point across, and even help the player get the most out of their free evaluation of the game. For instance, you can have your nag screens provide tips about how to play the game in addition to reminding the players of all the great stuff they'll get when they pay for the game.

You must walk a thin line between reminding the player to buy the game and annoying them to the point of leaving. A good guide is your own experience with shareware products, games or otherwise. What did

you hate about this marketing method, and what convinced you to buy? Avoid the former and emphasize the latter.

STEP 3: MAKE IT EASY

The final step to self-publishing your game is to make it easy for the player to buy your game. The easier and simpler, the better.

Make it obvious *how* the player can pay for the game. Too often, shareware developers hide the "Buy Now" button beneath layers of menus or in out-of-the-way areas of the software. Granted, a really determined purchaser will always figure out how to pay for the game, but it's foolish to insert unnecessary roadblocks between a buyer and what they wish to buy—at least at this moment.

Make It *Really* Easy

Making it easy extends beyond helping the player find the "Buy Now!" button. Common wisdom among successful shareware authors includes:

- **Don't use jargon.** Call it "Buy Now!" Don't use the word "register" when you mean "buy." "Register" is confusing, at best.
- **Don't be shy.** Prominently place a big "Buy Now!" button on all of your main screens, and put a "Buy Now!" command on every menu. There are few, if any, points awarded for subtlety.

Whether the "Buy Now!" button takes the player to a special order form within your game or to a separate Web page, the make-it-easy mantra still applies. The fewer steps that exist between "Buy Now!" and "Thank you for buying the game!", the more likely it will be that players will complete those steps.

Your goal is to have the smoothest, most streamlined payment process possible. If there is an order form that must be printed, include a "Print Order Form" command that prints it for the player with a single click. If you are using a third-party payment processing company (see Chapter 25, Payment Processing), link directly to their Web page. In short, avoid *all* unnecessary steps.

How Easy Is It? Conversion Rates

The *conversion rate* is the number of players who pay for your game versus those who downloaded the game, checked it out, and didn't pay. Your conversion rate is probably the quickest, easiest way to calculate and measure how compelling your game is to players.

The conversion rate reflects the overall quality of the game, its documentation and customer support, and what's currently popular with its community of players. Sheer volume of downloads will net you some payments (it's a big Internet world out there), but downloads alone aren't enough. You have to put proper incentives in place and make it worthwhile for people to pay you for your product.

Shareware lore has it that the average conversion rate is one percent. That is, for every 100 people who download and try the software, one person pays for it. Real life, however, is seldom as simple. A one-percent conversion rate should not be assumed. There is no 'shareware welfare.' Some software never sees a conversion rate of more than 0.01% (1 in 10,000), while others may have a rate as high as 20% (1 in 5). There are no guarantees.

How well your game converts downloads into payments is within your control. Do whatever you can to make your game a fun and compelling experience, and you will be successful.

CONCLUSION

There is no way to guarantee that your game will sell even that first unit. You cannot force people to buy your game. You can, however, do a lot to make it more likely that they will.

Design the entire sales process, from beginning to end, to be both pleasant and irresistible. Start with a game that players enjoy. Then, once you have their attention, let them know how much *more* fun they could be have by buying the full game. Finally, bring it all together by presenting them with a streamlined, easy-to-use way to make the purchase.

PRICING

IN THIS CHAPTER

- The Spectrum of Computer Game Prices
- Pricing Considerations
- Choosing a Price for Your Game
- Other Pricing Options
- Price Maintenance

How much should you charge for your game? This question is debated endlessly in online forums. On the one hand, some people think that retail games are overpriced, and therefore independent games should cost very little. Others recognize that price is based on what people are willing to pay, but they are uncertain whether or not they can get what they're planning to charge. Where do you stand?

This chapter discusses the various pricing models that are common in the computer game industry. It will also show you how to research pricing so that you can confidently charge a competitive price that includes a healthy profit margin. Of course, if you believe that all software should be free, you can skip this chapter.

 Estimated prices quoted in this chapter are in constant U.S. dollars, based on average retailer game prices as of the time of this writing in 2003.

THE SPECTRUM OF COMPUTER GAME PRICES

There is more than one way to price a computer game. If you visit your local software retailer, game prices will range from only a few dollars to as much as $60. In general, these prices fit into one of the following categories: retail new game pricing, value pricing, and bargain bin pricing. Another pricing model, which isn't often seen it at mass-market retail outlets, is vertical pricing. This chapter will cover each of these pricing models.

Retail New Game Pricing

Retail new game pricing is usually the highest possible price for a computer game. This pricing is most often used by newly released retail games from the major publishers, with price tags ranging from $55–$65.

Another way to think of retail new game pricing is as the *luxury price point* of computer games. Rolls Royce and Ferrari are examples of car manufacturers that have very successfully focused all their energies on creating only the best possible automobiles, and they price them accordingly—as luxuries. When you position yourself at the high end of the price spectrum, you're saying that your game is the best available, and you're charging premium rates because it's the best.

New retail games can easily be referred to as 'luxury items' because of they make use of the latest and greatest hardware in both personal computers and consoles. Most new retail games target the top of the field.

Pulling back from the cutting edge is more often the domain of value pricing.

Few games stay at the new game pricing level for very long. There's always a new title being released that targets the cutting edge. The older games inevitably make way for the newcomers and are pushed into the value pricing area, with the new titles taking over the premium price point.

Value Pricing

Value pricing encompasses a wide range of prices, generally from $20–$50. The economic force behind value pricing is that the buyer will pay a good price for a good game. Not everyone has the latest and greatest hardware. They want games that will run well and be fun to play on the computer or console hardware that they already have.

At retail, games that had formerly occupied the retail new game price point generally slip into value pricing after 6–12 months, sometimes sooner. These games will hover at various positions within the value pricing range for the next 6–12 months, and then slowly slip down toward bargain bin pricing.

Not all games in the value price range are older games. Many games released each year take advantage of the broader market appeal of value pricing—educational games, for instance, and games that have a more mass-market appeal.

The value pricing range is popular among independent games. You could do much worse than staying within the value price range. Keep in mind that, unlike retail games, your games do not have to see a steady decrease in price. In fact, it's not uncommon for independent games, even those that started near the bottom of the value pricing range (or even below it), to steadily *rise* in price over time.

Bargain Bin Pricing

At the low end of the pricing spectrum is bargain bin pricing. The bargain bin is often the final resting place of formerly high-priced retail games. They've had their share of shelf space and no longer sell, so the retailer piles them in an ignominious heap, mixed with other games that also failed to make the conversion from shelf to cart to checkout.

Prices in the bargain bin vary from as low as $1.95 to sometimes as high as $19.95. How games in the bargain bin are priced is discussed in detail later in this chapter.

Somewhere between the bargain bin and value pricing is *Low Cost Retail (LCR)*. Low-cost retail exploits the very low price points, from $1.95–$9.95, offering bundles of small, inexpensive games.

While the bargain bin offers little in the way of opportunity for indies, LCR deals can prove to be profitable, even if only in a one-shot manner. Many LCR deals involve a single licensing payment for a production run of a certain size. The LCR market comes and goes, as do the companies that offer these deals, so you will have to keep your eyes open to capitalize on this pricing option. You will most likely use LCR to supplement your normal sales, and not as your primary price point.

Vertical Pricing

Vertical pricing refers to pricing that is possible within a *niche*, or *vertical market*. A vertical market is considered 'perpendicular' to the mass market, which can be considered the 'horizontal market.' To succeed in a vertical market you don't try to appeal a little to everyone. Instead, you try to maximize your appeal to a select few.

This tight focus on a single market segment can pay off really well if the niche truly does have sufficient demand and money. The range of vertical pricing can begin at or even above retail new game pricing and extend *upward*. This high price range is possible because the game that is created for a vertical market does not have to adhere to mass-market pricing. Members of the niche know what they want, and they are willing to pay for it.

Vertical markets are the prime hunting ground of independents. Unless a niche represents millions of dollars in annual revenue, the big software publishers generally aren't interested. This leaves the field open for the savvy indie.

PRICING CONSIDERATIONS

Before we move on to choosing the price for your game, there are some pricing issues that must be covered. These are your cost of goods and the perceived value of your game.

Cost of Goods

Cost of goods refers to how much it costs to produce each individual unit of your game. In the retail arena, cost of goods includes the following expenses:

- **The CD-ROM.** This is the cost of the blank CD-ROM disk, plus the cost of burning the game onto the CD-ROM. Also included is the cost of the plastic jewel case and/or the paper sleeve.
- **Printed materials.** This covers the insert and label for the CD-ROM, as well as the players manual and any other printed material included with the game.
- **The box.** This is the cardboard or plastic case that the game is sold in, and includes the cost of printing the game information on the outside faces of the box.

All of these cost of goods add together to create a minimal price for a physical copy of the game. There are other costs, however, which are less tangible, but must still be covered in the price of the game:

- **Shipping and handling.** This is the cost of shipping the units to the retail outlet, and also the cost of warehousing the units.
- **Advertising.** All of those full-color ads running in print magazines have to be paid for, of course.
- **Retail shelf space.** Many of the larger retail outlets charge publishers and distributors a fee to cover the cost of their product's shelf space.
- **Customer support.** Someone has to man the phones to answer the inevitable questions, and that someone must be paid.
- **Royalties.** Once the publisher recoups the cost of developing the game, this money is paid to the developer.

The good news is that as an independent game developer selling primarily over the Internet, you don't have to account for all of these costs. If you only sell via download, for instance, you have no physical cost of goods or shipping charges above the cost of maintaining your download site. There's no CD-ROM, no label to affix, and no box or sleeve to ship it in.

Of course, you will have to pay for your own advertising and customer support, so you're not avoiding all the costs listed above. And you will have to pay your team their profit sharing, as well as other costs you must consider. Here are a few:

- **Payment processing fees.** If you are using a third-party payment processor to handle player purchases (see Chapter 25, Payment Processing), you will lose 10%–20% of the total price to their fees. And many of these processing companies have minimum fees of $3 or more. For example, at the time this book was published, RegSoft (*http://www.regsoft.com*) only charged a 10% processing fee, but their minimum fee was $3. Most other payment processing companies have similar arrangements, though some have special 'micropayment' rates for payments below $10. Even if you use your own merchant account

for credit cards, you still lose a percentage of all credit card sales, though it may be a much smaller percentage.

- **Web hosting and bandwidth.** This is your overhead for maintaining your Web presence. Your Web page has to be hosted somewhere, as does your downloadable installation package; and bandwidth is necessary for people to access your Web page and/or download your game. In addition, if your game is multiplayer, you may have other bandwidth charges.

So do a bit of cost accounting and see what's the minimum you can charge while still covering costs. This is your 'break-even' price. If you don't think you can charge more than that (a profit will be necessary for future endeavors), then you might want to reconsider your project.

Affiliate Sales

Another pricing consideration is *affiliate sales*. Affiliate sales are marketing partnerships you make with third parties to sell your game. The affiliate markets your game and generates sales. In return, you offer them a percentage of the sales total.

If you plan to use affiliates or other resellers to promote and sell your game, then it's important that you budget in a sufficient profit margin. If you price your game at $10, and your costs soak up four dollars of that, that leaves only six dollars profit per unit sold. Affiliates typically take a percentage of the profit, from 20%–40%. Twenty to forty percent of $6.00 is only $1.20–$2.40—hardly enough to make this arrangement worthwhile, except in large volumes. In general, the larger the payoff for the affiliate, the more affiliates you can attract, and the more enthusiastically they will promote your game.

Perceived Value

Perceived value bases the cost of an item on what the customer thinks it is worth, which may have no relation to the real cost of goods mentioned above. The customer's perceived value may even be contrary to your perceived value.

For example, some independent game developers argue that computer games are much too expensive, and they want to start a revolution in game sales by setting lower prices. Their logic stems from the knowledge of all those games piled in the bargain bin at the local retail outlet. However, you should ignore this bargain-bin philosophy. You are in a different economic situation, and you are not competing with games in the bargain bin.

Also, before you settle on a low price point for your game, consider this bit of human psychology: prices below $10–$15, unless they are for a subscription, fall below customer expectations. At this low price range, customers will feel that 'you get what you pay for,' and are likely to by-pass the cheap game for one that's priced more within their expectations. Like it or not, in the marketplace, perception is reality. Be careful of how your game is perceived. Conversely, if the customer perceives the value of your game is greater than the price you're asking for it, then you have probably selected an adequate price.

You can improve the perceived value of your game in a number of ways. One popular method is to offer a huge number of additional levels or play options as an incentive to buyers. For instance, *Pretty Good Solitaire,* by GoodSol, offers 500 solitaire card game variations. In the same manner, *Dweep Gold,* by Dexterity Software, offers over 150 levels. Other ways to improve perceived value include bundling your game with other games for a reduced price, including free tools (such as level-building software), and offering free bonuses.

If you keep an open mind and look at your game through your players' eyes, you can find all sorts of ways to add value. Many of these might not cost you much at all, while allowing you to set a higher asking price than you would be able to without them.

CHOOSING A PRICE FOR YOUR GAME

By now, you should have at least a 'feel' for the minimum price you should charge for your game. If you are like many new indies, you might feel uncomfortable charging much more than that price. If you settle, though, you are probably missing out on a lot of revenue.

The first step, then, in setting the best price for your game is to over-come your timidity and accept that the player's perceived value of your game is the most important consideration. Next, research the prices of games that are similar to yours, both in retail stores and on the Web. Finally, refine your price over time, using simple testing techniques.

Don't Be Timid

The first hurdle most independent game developers face when they try to price their games is their own timidity. They aren't sure whether they should charge *anything*, much less a decent price. Whoever said that indies shouldn't be 'in it for the money'? This justification for timidity is hardly reasonable. Indies aren't any more or less noble than any other professional, and they have to eat just as often.

More common is the following rationale: "This is my first project. It's not that good. It was just a learning experience, anyway." This kind of modest, self-effacing logic is also self-defeating. First, an indie's time is just as valuable as a 'professional's' time, possibly more so, because it's *your* time, and you are creating something new, rather than just doing what you are told. You chose to work on this project, so it represents a greater investment of energy than simply hours clocked at a full-time job. Don't sell yourself short.

Second, everyone has to start somewhere. Just because this might be your first completed project, it doesn't mean that the game isn't worth paying for. Look at the software you've purchased over the years. Compare what you've done with your game to what would likely have been required for any of the software *you* paid for. How different is it, really? And what do you think that software looked like in the earliest versions? This isn't to say that you shouldn't put together as professional a package as you can. But you *have* accomplished something significant (or will have when the game is finished), even if there is room for improvement. You *deserve* to be paid for your work, and so does your team.

The first time you put a price tag on your game and present it to the world at large, it is a lot like speaking in public the first time. It's natural to feel insecure, and happens to everyone. The trick is to not let your insecurity dominate you or stop you from doing what you need to do.

"Fortune favors the bold," so the saying goes. And that's as true in game development as it is in life, love, and business. It was a bold step to tackle independent game development, to begin the long task of seeing your own vision brought to pass. Don't get bashful now.

Using Retail Pricing as a Guide

The easiest way to judge what is a good price would be for a game like yours is to review the games that are already available. Visit the retail outlets in your area that sell computer games. Focus your research on games like yours that have been released in the past year or two. They will give you an idea of the most you can reasonably charge.

As you do this, note an interesting fact. All new games are priced within $5–$10 of each other, regardless of how long they were in development, how big the team of programmers and artists were, how much original content is shipped in the box, or how big the overall budget was.

At the time of this writing, the average new game costs $55–$65, and even games that have been out for two to three years are still selling above $40. Obviously, there is a lot of maneuvering room in the 'acceptable' price of games, even in retail. Also, price is less a function of how

much it costs to make the game, and more about how much the retailer can reasonably charge. That is the power of perceived value.

If your game genre is one that doesn't have a retail presence (e.g., certain types of puzzle games), you can conduct your research on the Web. Visit software Web sites and review their game sections. Find the games that most resemble yours and see what their charging. Focus on games that have some been out a while and have a proven track record of selling well. Those are the ones that have had the time to settle into their perfect price, or *sweet spot*. The sweet spot is the price that provides the most perceived value as well as a favorable profit margin. The closer you can land to your game's sweet spot, the better you will do over time.

Ignore the Bargain Bin

As was previously mentioned, some people look at the bargain bins with their piles of old, out-of-date games, and they mistakenly use the prices on those games as their basis for acceptable pricing. This is a mistake.

The economics of the bargain bin are different from those of regular retail. Like summer fashions in September, the retailer wants to sell old inventory and make way for new products. The retailer is not trying to sell the games in the bargain bin for an acceptable price. Instead, he is trying to sell them for *any price he can get*.

In many cases, games in the bargain bin are returns and overstocks. The publisher and the distributor have already eaten the cost of creating the box, documentation, and CD-ROM, and do not want to store the product anymore. So the games are given any price that will cause them to move out of the store.

Choosing Your Price

Many new indies go for the 'easy' price of $19.95. It's comfortable. It's on the border of the value pricing range, and players have a demonstrated track record of purchasing games for $19.95. However, while $19.95 *may* be exactly the right price for your game, don't settle on that price just because it's easy. Put some thought into it.

Again, be bold. Have the wherewithal to push past your comfort zone. Don't just go with the low end of the range of prices you found because it feels comfortable. There is a strong possibility that you are being either timid, modest, or are underselling yourself. If you push the price just a bit higher than you think it should be, you may hit exactly the right price.

With your research in hand, you should able to come up with a price range that would provide both a good profit margin and good value for

the player. All that's left is to make your choice. Even after you choose your price, though, you're not 'stuck' with it. After you release your game, you can (and should) test your pricing to see if you need to change it. Price maintenance will be discussed later on in this chapter, and will present some ways to test your pricing.

OTHER PRICING OPTIONS

The most common type of game pricing is: one sale, one game. That is not the only option, though, especially for multiplayer games. There's also tiered pricing and subscriptions. In addition, you might consider charging for upgrades.

Tiered Pricing

It's always good to offer your players a choice. With a *tiered*, or multi-level pricing structure, you can do just that.

By offering your player a choice, you allow them to pay for only as much of the game as they want. This can reduce the pressure to buy, since the player is in control of which version he is buying. Plus, it gives you the opportunity to 'up sell' the player by showing him how much *more* fun he could be having if he purchased one of the more expensive options.

The easiest type of tiers are a 'basic edition' of the game, which is value-priced, and a 'gold edition,' which is more expensive. The gold edition of the game has more of everything—more levels, more puzzles, more features, and more equipment. With the gold edition offering so much additional value, it can be priced significantly higher than the basic edition. Depending on your particular game, you might price your gold edition at twice or even three times the cost of the basic edition.

The original version of *Paintball Net* used a tiered payment structure. There were 14 different levels, and a player's level determined how much weight in equipment he could carry. More available weight translated to more equipment variations (to cover different game situations) that the player could have handy. Each payment level was a $10 upgrade from the previous one. That is, the first level cost $10, the second level cost $20, the third level cost $30, and so on. As you might expect, most players started at the first level. Having paid for the first level, though, they were 50% likely to buy the upgrade to the next level. That 50% upgrade probability continued through all of the available levels.

Subscriptions

The subscription model for games is still relatively new. Most games that require a subscription are multiplayer online games, but that doesn't mean that you couldn't use subscriptions for a different genre.

Games like *Ultima Online* and *EverQuest* pioneered the current pricing schemes for online games, but many more casual game Web sites, like *Yahoo! Games,* are charging subscriptions, as well. Recurring subscriptions for games has become acceptable, even if it's not yet very widespread.

The first subscription prices ran about $9.95 per month. Recently, however, games have been setting higher monthly fees, some as high as $14.95. This opens up some much needed room in the lower price ranges.

One consideration for subscription pricing is how long a period is covered by the subscription. Common periods are one month, three months (quarterly), and a year. There are advantages to bundling multiple months together. First is that you might take less of a payment-processing hit. If you are using a third-party payment processing service, they charge you a percentage of each transaction. So, if your service has a three dollar per-transaction fee, three monthly payments of $9.95 nets to three monthly payments of $6.95. Thirty percent is a lot of overhead.

If you bundled the three months together, however, and sold them for $28.95, you only pay the three dollar transaction fee once. With only the single transaction fee, even if you lowered your three-month price to $24.95, you'd still be making more money than with $9.95 per month. Keep this kind of 'new math' in mind when you're setting your prices.

A second advantage of offering a multimonth subscription is that is gives you more up-front revenue. More money, faster, is usually preferable to the alternatives.

Finally, by bundling multiple months together, you create a greater perceived value for the player. This is especially true if you show how much money the player can save by buying the longer subscription period, much like the tiered pricing structure with its basic and gold editions.

So, if you decide to offer a variety of payment periods, begin at the one-month level. Figure out your monthly costs per player, and then calculate how much you want to make per paying player per month. Add those two together, and add the payment processing fee. Now you have your price. Multiply that number by three, and you have a quarterly subscription price. Alternatively, you could multiply your base monthly price by three, then add the expected processing fee at that level. That gives you the same amount of money each month, while giving the player a very real discount.

Here's an example. Let's say you have a small online gaming community and you want to charge quarterly. You do some simple cost accounting and figure out you need to clear three dollars per player per month to be profitable. Your payment processing is 10%, or three dollars, whichever is greater. So you set your quarterly subscription fee at $12.95. At that price, the three dollar processing fee leaves you $9.95, which more than covers your three dollar per player per month requirement.

Now, you decide you would also like to offer a yearly subscription. You still need to clear three dollars per player per month, which means you need to take in $36 for the year. Ten percent of $36.00 is $3.60. Add that to your base, and you can charge $39.95 per year. One very real advantage of this pricing option is that your players save nearly 25% by paying for the entire year at once, rather than in four quarterly subscriptions. That is significant bargain, and it costs you nothing to offer it to them.

Charging for Upgrades

There may come a point after your game has been out for a while that you have to face a new question: will you (or won't you) charge for an upgrade? In general software market (excluding games), the common practice is that they *do* charge for upgrades. Your time and resources are valuable; and you, too, should not be afraid to charge an upgrade fee when the circumstances warrant it.

Also, by charging for an upgrade, you have the opportunity to turn your existing customers into a steady income stream. It's nearly always easier to sell to someone who has purchased from you before. *Paintball Net* demonstrated this for Samu Games. If a player paid for one level upgrade, he was 50% likely to pay for another one. This percentage held true all the way up the tiered payment structure, from the lowest to the highest level.

With games, though, the situation is not so clear cut. Computer games often have sequels, and the only 'upgrades' to a particular version are *patches*. A patch is usually a simple bug fix. It might have some minor improvements, but the game is basically the same as it was before the patch. So patches are usually free (or should be).

Upgrades also are hard to apply to games that have a monthly fee. A very reasonable assumption is that the monthly subscription fee pays for enhancements to the software. Games like *EverQuest*, however, have had some success releasing upgrades as expansion packs. Players paid for the upgrade in addition to their monthly fee.

So what is a good price to charge for an upgrade? Most often, the upgrade price is from one-half to two-thirds the original price. Testing different upgrade prices will show you what works.

PRICE MAINTENANCE

No pricing decision is ever final. Just because you set the price today doesn't mean you can't change the price tomorrow. It is possible to change your price too often, of course. But if you never check to make sure the current price is still the best price, it's very possible that you are losing sales because your price is too high, or you're missing out on revenue because your price is too low.

The only way to know if your price is ideal is to test it. You don't need to spend a lot of money on market research or focus groups to do this. Here are a couple of simple and inexpensive ways to test the price of your game, followed by a short discussion on how to change your price.

Offer Different Prices

The simplest way to test the price of your game is to offer different prices and then track the response to each offer. If a particular price shows a significant improvement in sales, then that should be your new price. Then you begin the process again.

The key to price testing is tracking. You have to know what kind of results your current price is getting. That becomes your test *control group*, or the group you compare against.

Then you have to be able to present a different test price to a subset of your players, and track their response, as well. For best results, you should have at least two price alternatives that you are testing in addition to your current price.

This kind of testing and tracking can require some significant planning, and even the creation of support software within your game and your Web page, but the results can pay off very well. At the worst, you verify that your current price is the one you should be using.

Eighty/Twenty Split Testing

Another very simple way to test different possible prices for your game is the *80/20 split*. The 80/20 split method works this way. Say you have a new game that you're about to release, and you want to test a couple of price variations before settling on the one to use for the public at large. You also have a list of subscribers to a newsletter that you put out once a month.

The first thing you do is create separate Web pages for each price variation. Then you send an announcement for the game to 10% of your newsletter subscribers pointing to one price, and 10% pointing to the other price. After gauging the response to each price, you choose the one

that had the best performance, and you announce that price to the remaining 80% of your subscribers.

You can use this same method to test upgrade pricing, bundle prices, and more. Be creative!

Changing Your Price

The goal of all this research and analysis is to help you arrive at the 'sweet spot,' the price that best fits your game. It's possible, though, that no matter how perfect a price may seem when first chosen, there will come a time when you want to either raise or lower that price. When you decide that your price needs to change, don't hesitate. Do what needs to be done as quickly as you can.

If you are raising your price, you can use this opportunity to generate more sales in the short term. For example, if you announce that the price will rise a certain date, you can prompt players to save money by paying *now*.

Lowering your price is much more difficult. Be prepared for customer support issues. Players who paid the higher price might demand either a partial or full refund. If at all possible, avoid lowering your price.

CONCLUSION

The price you choose for your game is very important. Don't just pick a number out of the air and run with it. Do research at your local retail software outlet and on the Web. Consider your game from the player's viewpoint. Try to maximize the value they perceive in order to maximize the price you can set.

After you choose your price and ship your game, don't hesitate to try out new prices. Nothing can replace testing and tracking your results.

MARKETING AND PROMOTION

IN THIS CHAPTER

- Marketing Is Not Advertising
- Your Marketing Plan
- Promotional Venues

Your game is complete. It's a solid game, even if a bit plain in presentation, with good gameplay and a lot of depth. Your play testers are telling you that this is the best game they've ever played, bar none. You're champing at the bit, straining to burst out of the starting gate and straight to the winner's circle. But first you have to tell the world about this wonderful new game. How do you do that?

It's a big Internet out there. With over *three billion* Web pages out there, getting noticed is going to take more than just putting up yet another Web page. Yet, many would-be independent game developers do exactly that. They create their game's Web page and post the URL on a few game development-oriented sites. And then they wonder why no one notices.

Marketing and promotion are linked. Marketing is your strategy, embodied in your marketing plan, while promotion is your tactics, how you implement your marketing plan.

Promotion is hard, and often very tedious work. But without a marketing plan and active promotion of your game and its Web site, you're relying on blind luck. And blind luck is not a sound basis for building a market for your game. You are your own best promoter. Thus, it's in your best interests to learn the basics of marketing and promotion, and put them to work at announcing your wonderful new game.

MARKETING IS NOT ADVERTISING

The first thing you have to learn about marketing and promotion is: *marketing is not advertising*. If you're like most small-business novices (and even a few successful veterans), when you think of marketing, your first thought is of advertising. You'll dig deep into your pocket, strain your small budget, and pay for ads on Web pages. And you'll be wasting your money. You may see some results, but hardly enough to pay for the cost of the ad campaigns.

Getting a small return from your advertising is almost worse than getting none at all. If you were to get nothing back from your advertising investment, at least it would be an immediate clue that this was a bad choice; time to try other approaches.

If you get a little something back, though, you start thinking that just a bit more money spent on advertising will bring you more sales. Except it almost never works that way. Instead, you end up on a treadmill, running faster and faster, spending more and more money, getting tired, burned out, and broke.

The big, colorful magazine and Web page ads you see, as well as the ones shown on TV, are a luxuries no indie can afford. Your limited (or non-existent) budget cannot compete in the national advertising arena.

You have to be more creative and more focused. You must be willing to do whatever you can, just like in all other areas of independent game development. Fortunately, there are plenty of free promotional opportunities that you can pursue, and we'll be discussing a number of those.

Marketing is more than just advertising. Marketing is strategy, a plan of attack for not only letting people know about your game, but for targeting those people most likely to be interested in your game and convincing to play it—and pay for it!

YOUR MARKETING PLAN

You might think that marketing plans are only created and used by big businesses, but that is not the case. Successful businesses of all types and sizes, including game development shops, have benefited from marketing plans.

A marketing plan is simply a list of people you want to hear about your game and a series of steps that describe how you will reach them. You set down the vision of the game that you want to present to prospective players, and then you create a list of tasks that will ensure that those prospective players see and/or hear about your game.

Your marketing plan gives you a concrete description of what you're trying to accomplish. Without a written marketing plan, you are promoting 'at random.' While you may have some success with whim-based marketing initiatives, attributing success to any particular effort you undertake will be difficult. Even worse, repeating that success is once again consigned to luck.

With a marketing plan, though, you can see what's working and what's not working, and spend your time on what works. You can even adjust how the game is promoted to different target markets in order to account for variations in player interest.

Figure 24.1 shows that a good portion of indies (37%) already use marketing plans. This chapter will show you how to create your own marketing plan.

Marketing Plan Step 1: Know Your Target Market

The first step in creating your marketing plan is deceptively simple. Ask yourself: "Who are my players?" Who are you making this game for (besides yourself)? Be specific. Answers like "players who liked *Grand Theft Auto*" or "players who like real-time strategy games" are not specific enough. Explain *why* these players will like your game, and why they will want to pay for it. Also, ask yourself: "Who *won't* like this game?" Why

Indie Game Developer Survey Results

Do you have a marketing plan?

37% Yes

63% No

(Survey Note: 59 Respondents)

FIGURE 24.1 Percentage of indies that use marketing plans.

won't they like it? How does that help you better define the people who *will* like it?

By knowing the players you're targeting, you can decide how to position the game to appeal to those players. *Positioning* is a marketing term that means you define the unique spot where your game fits in the overall game market. Your game's position is created through active comparison to other games. For example, when Samu Games first launched *Artifact*, the designers chose the position, "*Civilization* meets *WarCraft* meets *SimCity*." This was much shorter and clearer than saying, "*Artifact* is a game of city management, empire building, and real-time battles."

It's possible that you won't be 100% correct when you predict who will like your game. Or you might be caught off guard by a group of players you didn't foresee.

When Samu Games was working on the original *Paintball Net*, the anticipated players were mostly college students or post-graduate working professionals. Their logic was based on what they knew about the people who played the text-based *Multiplayer Dungeon (MUD)* games that were popular in the mid-1990s, and these MUDs were a readily available example of a similar kind of game.

They were then caught by surprise when most of their players turned out to be junior high and high school students, averaging 14 years old, and 99% male. A community of 14-year-old males is vastly different from a more 'co-educational' community of college students and young professionals. Samu Games had to adjust not only their promotional efforts, but their in-game administrative functions. So do your best to make a good guess, but be flexible enough to adjust your plans if it turns out that you missed the mark.

Marketing Plan Step 2: Know Your Strengths and Weaknesses

When you figure out who your players are, you will also know at least some of the reasons why these players will like your game. These are the strengths of your game, your *unique selling points* that will provide the core of your promotional efforts. Take the time to expand on your strengths, focusing on what makes your game unique and interesting. Go back to your game design document and review your design summary. What you wrote in the design summary, particularly in the elevator pitch and unique selling points subsections, can help you get started.

In addition to your strengths, determine what your weaknesses are. Weaknesses aren't necessarily a bad thing. Perhaps your game is very team-oriented, which you consider a strength. The corresponding weakness then would be that the game is not going to be very interesting to solo players who don't want to join a team.

When you consider your strengths and weaknesses, don't assess them solely from your own point of view. Think like a player. Do the *players* consider the team-oriented nature of the game as a benefit or a problem? Why or why not? Maybe the team-orientation is useful to them, but what they *really* like are the options to play by themselves *or* with a team.

Don't be shy about asking your play testers what they most like about the game and what they like least. How do their lists compare with yours?

By assessing both your strengths and your weaknesses, you can better define a message to promote your game. Play up your strengths and your unique selling points. Show how your strengths more than make up for any perceived weaknesses. For example:

> "With *Fragmaster 2K3* you can be a lone agent, or you can join your friends to become the terror of the neighborhood! Fully integrated team support features like coordinated HUDs and streaming voice chat take the experience to a whole new level!"

Marketing Plan Step 3: Action Items

The last step in creating your marketing plan is to decide how you will communicate your game's marketing message to all those waiting players. As an indie with very limited resources, you must maximize what you do have and focus on promotional activities that are low-cost and high-yield.

Jay Conrad Levinson coined the phrase "guerrilla marketing" with the release of his book, *Guerrilla Marketing*, published by Houghton Mifflin Company in 1983. While the book is a bit dated in some of the

specifics, the concept of highly focused, innovative, and above all *cheap* methods of getting the word out about your business or product is still very applicable.

What you want are methods that cost very little (preferably free) and that build the momentum for your game. Each campaign should build on the previous ones to create a steadily increasing level of interest and an increasing number of visitors to your Web page. While you might get the occasional spike in interest as you follow your plan, you should focus on long-term growth rather than short-term peaks.

Implementing Your Marketing Plan

With your marketing plan complete, you know who you're trying to reach, and you have something to tell them. All that's left is to get started. Implement your marketing plan in much the same way you implemented your production plan: start with the first item, measure the results, and move on to the next item.

Be Consistently Persistent

How much time should you spend on marketing each week? Figure 24.2 shows how much time respondents to the Indie Game Developer Survey spent. Also shown is how much time indies thought they *should* be spending each week.

More important than how much time you spend on marketing each week is that you are 'consistently persistent.' It's more important that you are *consistently* working on your marketing and promotion than only for some fixed number of hours each week. If possible, do at least some marketing every day.

Measure Your Marketing

As you implement the steps of your marketing plan, include a mechanism for measuring the success of each step. By measuring your results, you can find out what is working well, what is working occasionally, and what isn't working at all. Once you know which marketing ideas work well, you can focus on those and improve or discard the rest.

If your marketing efforts are primarily Web based, then tracking your marketing is simple. Try to get access to your Web site's access and referral logs. Through them, you can quickly learn where your traffic is coming from and even how people navigated through the various pages of your Web site.

Indie Game Developer Survey Results

How much time do you spend on marketing each week?

52% Less than 1 hour

33% 1–3 hours

7% 4–5 hours

4% 6–10 hours

4% More than 10 hours

How much time do you think you *should* spend on marketing each week?

17% Less than 1 hour

30% 1–3 hours

18% 4–5 hours

5% 6–10 hours

30% More than 10 hours

(Survey Note: 57 Respondents)

FIGURE 24.2 How much time do indies spend on marketing?

Don't put a marketing plan or any part of a plan into effect without having some way to know if it's working. Without some form of tracking, you might think you're cruising down the highway, when in reality you're stuck in the mud with your wheels spinning. Only by tracking your results can you optimize your marketing. When you find something that works, keep doing it. If something isn't working, stop doing it.

PROMOTIONAL VENUES

A number of promotional opportunities exist, like Web search engines and Web pages that list software. All of these have been used with success by many independent game companies. Every game's different, of course, and every indie has different goals. The marketing plans to support these goals, as well as how these promotional venues are utilized, will be unique.

Your Game Site

The Web site you create for your game should be an important part of your overall marketing plan. Preparing your game's Web site is probably the first marketing task you should tackle on your list.

Besides serving as the primary 'sales brochure' for your game, you can make your game's Web site a true resource. With tutorials, tips, and tricks, and maybe even a player community, your Web site can be a part of the whole game experience.

Promote the Web site from within your game. Since a good number of your players may have learned about the game from other venues, it makes sense to steer them to your Web site to learn more.

Also, when you develop and release new games, you will be able to tie their various Web sites together. You may even be able to offer cross-promotional deals and 'up sells' via bundling.

The minimum you should have on your game's Web site is:

- **Summary information.** Usually at the top level of the Web site, the summary information needs to provide an overview of the game. You should include at least one well-chosen screen shot that shows off the game in a fun and exciting way. The summary should also include the price of the game and provide a way to buy the game *now*.
- **Detailed information.** For those players who are interested, include as much detail as might be useful. Describe the player's goal(s) when playing the game, and liberally use screen shots to add color and show off the game in action.
- **Payment information.** Include a page that describes what the player gets for buying the game. Focus on benefits, not on features. For example, point out how much fun the player will have solving the many puzzles, rather than brag about how many more polygons rendered per second they'll get by paying.

Some other information you might want to include:

- **Community information.** Help your players form a community. Include a message forum, if it seems appropriate. Hosting a newsletter can also be useful.
- **Tutorials and help.** Include tutorials to help your players get the most from your game. Encourage players to submit tutorials, tips, and tricks that they have developed.

Your game is only the beginning. Combined with your Web site, your game can become an impressive network of information, tutorials, community, and more!

Web Search Engines

Web search engines, like Google (*http://www.google.com*) or Alta Vista (*http://www.altavista.com*), are the easiest places to get your game listed. And they're free. There are only a few major search engines, so finding them and getting listed on them requires minimal effort. The downside of these general-purpose search engines is that they list *everything*, and you have little control over how your Web site is listed.

The content of your game's Web site is important to how it gets *ranked* by the search engine. A high ranking on a search engine means that your Web site is listed at the top of the list in those searches that find it. Different search engines use different ranking algorithms, so there's no one-size-fits-all recommendation for improving your site's search ranking. In the past, HTML <META> tags could be used to describe the content of a Web page, but the actual content of the page is now the primary consideration. Some search engines will include the number of other Web pages that link to the game's page as part of their ranking.

You can tailor the content of your Web site to target specific search words and phrases. Do some research to find out what the more-useful words and phrases are for games like yours. Once you do, that you will get much more targeted, or *qualified* visitors from the search engines.

Relying on search engines alone to drive significant traffic to your game's Web site may not be the best choice for you. Some games, like those based on popular outdoor sports or activities, might see a lot of Web traffic driven their way by search engines. For example, with *Paintball Net*, Samu Games had a lot of traffic from people doing searches for "paintball games."

Not all games have such an enthusiastic, built-in search engine audience. When Samu Games released *Artifact*, for instance, it received almost no search engine traffic. Not many people search for "multiplayer real-time strategy game based on medieval warfare with some fantasy elements." At best, they will search for "online strategy games," or even simply "online games." And even if they did type in the longer, more specific search terms, there are so many medieval/fantasy RTS games out there that *Artifact* would still possibly be overlooked. The market segment is just too crowded to expect a high ranking in a search engine result set.

Software/Shareware Sites

The next step in getting noticed on the World Wide Web is to take advantage of the multitude of software/shareware Web sites that have sprung up over the past five years. These sites generally provide at least high-level listing categories (e.g., business, home, games, etc.) and simple search facilities.

The downside of these software sites is that most of them will list any software at all. There is no, or at best very little, editorial review. The Web site operators will check to make sure your links work, and that you specified an appropriate category for your software; but that's about it. Some such sites, though, do go the extra mile and review the software they list, offering awards and improved listings for the software they think is well done.

There are literally hundreds of these Web sites, and they are not all equal in terms of either attracting attention or driving traffic. But with the submission process takes only about 5–10 minutes each, so there's no reason not to submit to as many as you can. The simplest way to do this is to find a consolidated listing, like the MantaDB Big List of shareware sites at *http://www.mantadb.com/shareware_site.htm*, and go through the list from top to bottom.

Visit every site in the list and submit your game. To make the job easier, choose to do only about 10 sites a day. That should take 30 minutes or less, leaving you free to work on other things. Once you've gone through the entire list (which should take about three to four weeks at 10 sites per day) go through the list again. This time, verify that the information displayed about your game is correct, and resubmit it if it's not. After that, find another list and go through it the same way. Come back to each list periodically.

Resubmitting your game to software Web sites each time you make a significant update or new release is a strategy that can pay off. Many of these software Web sites have a "What's New" feature, which lists all new and updated software on the site. This can provide your game with a temporary boost in exposure. With the more popular Web sites, like CNet's Download.com (*http://www.download.com*), this boost in exposure can be significant.

The *Association of Shareware Professionals (ASP)* has worked hard over the past few years to streamline the software submission process for both authors and Web site operators. Their .PAD™ file format has reduced the software submission process to mere seconds, and in some cases has made keeping software listings up-to-date all but automatic. You can learn more about the ASP online at *http://www.asp-shareware.org/*. To learn more about the .PAD format, log on to *http://www.asp-shareware.org/pad/*. Also, software like Shareware Tracker (AccuSolve, *http://www.accusolve.biz/*) can greatly simplify the process of submitting your game to software Web sites.

In the past couple years, some of the better known software sites have begun to charge for listing new software (e.g., Download.com). They might also charge you to update an existing listing. If you're not sure about spending money on a software listing, postpone doing so, or try their least expensive listing package, if they have options. If your re-

search shows that the exposure of being listed at such a site more than makes up the costs associated, then you should definitely take the plunge.

Game Sites

Web sites that focus exclusively on computer games are your next promotional action item. More specific than the general-purpose software listing sites, the right game Web site can drive a lot of interested players your way.

Some of these Web sites focus only on game industry news. Even these sites are useful, though. You can send them press releases about your game, and they will often post them.

What you're *really* looking for, though, are Web sites like MPOGD (*http://www.mpogd.com*) or Multiplayer.com (*http://www.multiplayer.com*). These sites provide listings of games by category. Some also have community forums where people mingle and chat about the games they play. So if you're still itching to spend money on advertising your game, these Web sites, and the many others like them, are the ones to target. Since their visitors are game players, you can at least be sure you're not wasting your valuable advertising dollars on someone looking for a new checkbook-balancing program. If the Web site's advertising is handled by the owner/operator, you can probably get a very good deal on your ad campaign just by asking. Unfortunately, a lot of game Web sites have become part of 'ad networks' that jack up the prices and dilute the targeting you need. So be careful.

There are other ways, though, to get coverage on game Web sites that don't involve spending money. And these are what you want. Reviews, contests, and giveaways can all be excellent sources of exposure for your game. If the Web site does reviews of the games it lists, find out who you need to contact about getting your game reviewed. Send them a free review copy of the game, or set up a free review account on your main server. You're not trying to 'buy' a good review, you're just trying to get exposure. If you get a poor review, don't worry too much about it. As the old public relations adage states: "There is no such thing as bad press." Whether the review is favorable or unfavorable, you now have a list of things you can (and likely should) fix and/or improve on. Depending on the reviewer, you may then be able to solicit another review to verify that you've fixed the problems that the reviewer had spotted in your first submission.

Another possibility is to offer free copies of your game that the Web site can give away as part of a contest. The Web site operator benefits by having something to bring in more visitors, and you benefit

from increased coverage. Granted, you're giving away copies that you might have been able to sell; but in the long run, a few generous give-aways can do a lot when it comes to getting your game known and played.

Get to know the operators of your favorite game Web sites. Tell them how much you appreciate their efforts. Participate in the message forums if they have them. Be a 'real person' to them and their visitors. Work with them not only to promote your game, but to build their Web sites into something bigger and better.

It was when Samu Games started listing their game *Artifact* on game Web pages that it finally began to be noticed. Besides being a new release at the time, *Artifact* had one rather unexpected advantage over other games in the same genre: its name begins with an "A." Not all game sites have alphabetical listings, but a lot do. This doesn't mean you should adopt the telephone directory tactic and name your game "AAA Frag-master." Aside from being silly, it would almost certainly fail. If you do have a game with a name that starts with the first few letters of the English alphabet, though, you may be able to take advantage of it.

Host/Beneficiary Relationships

Host/beneficiary relationships are a way you (the beneficiary) can leverage someone else's (the host's) Web traffic or player database in a way that benefits both of you. Affiliate sales programs are a form of host/beneficiary relationship, as are software and game Web sites. In the case of software and game sites, the Web site lists your game, giving your game exposure to their visitors while, at the same time, your game provides them with the content they need to attract visitors. There are many host/beneficiary relationship opportunities like this.

The key to host/beneficiary relationships is to find someone who has attracted an audience that you think would also be interested in hearing about your game. For example, you have a new puzzle game you want to promote. Your game's theme is on the era of steam locomotives, with historically accurate images and sound effects. Searching the Web, you find an e-mail newsletter with subscribers who are steam era railroad enthusiasts. You contact the host of the newsletter and ask him to present your game to his subscribers. In return, you offer him a percentage of the sales that result.

Use your imagination. Not everyone out there is your competitor, even if they market to the same people.

Game Development Articles

Chapter 19, Creating Quality Documentation, discussed a topic that bears repeating here. By writing game development articles, you can share the experience and knowledge you've accumulated with other game developers, both new and professional.

Give back to the game development community. You can help other up-and-coming developers while simultaneously promoting your game. Web pages like GameDev.Net (*http://www.gamedev.net*) and Flipcode (*http://www.flipcode.com*) are always looking for both news and content. If your game involves some interesting twist of logic, innovative programming, or new content creation technique, write a short article about it. You might find a receptive audience.

The important thing to keep in mind when doing articles, however, is that the content of the article should not be overpowered by hype for your game. Yes, you are writing an article to promote yourself, your team, and your game, but what you're describing in the article must stand on its own. If the article is just a 'puff piece,' your audience will quickly see through you, and you'll have done neither your readers nor yourself any favors.

If you question the wisdom of promoting your game to other game developers, stop a moment and think about it. *You* are a game developer. *You* play games, don't you? *You* buy games, don't you? That sums it up.

Game developers, whether they are programmers, artists, musicians, or testers, are the easiest audiences to sell new games to. They're probably the most avid game players you're likely to meet.

Press Releases

Press releases are short news articles, written by you, promoting the launch of your game or its latest update. Press releases are sent to various news outlets, both online and offline: game Web sites, game news Web sites, game magazines, local newspapers, and so forth. You goal is to have an editor notice your press release and decide to run a story about you and your game—either run the release as written or have someone do a write-up specifically for his outlet. With that goal in mind, target only those publications that write about games and game development.

Writing press releases is easy. Writing *good* press releases, though, can require thought and time.

Figure 24.3 shows a press release template. A quick search on the Web will provide you with other formats, Web sites that provide 'cookie cutter' press release templates. As always, make full use of the resources that are available, but don't just slap together a cookie cutter press release

Press Release Template

<div align="center">

PRESS RELEASE

</div>

FOR IMMEDIATE RELEASE:

(or **RELEASE DATE: <date>**)

CONTACT:

Contact Person

Company Name

Telephone Number

Fax Number

E-mail Address

Web site address

HEADLINE

City, State, Date—Your opening paragraph should contain the most basic information about your game: who designed it, what is it, when was it released, where can it be found, and why it's the greatest game ever.

The remainder of body text: Include any relevant information about your game or team. Describe what makes your game unique. If possible, include quotes from team members or excited players.

<div align="center">

-more-

(if there is more than one page)

</div>

(the top of the next page):

Abbreviated Headline (page 2)

Remainder of text, should you still have more to say.

For additional information or a sample copy of the game, contact:

(all contact information)

Summarize the game's description one last time, possibly adding the system requirements required to play it.

Company (or Team) History: Give a quick history of your team. Don't be longwinded.

<div align="center">

###

-30-

(Indicates the press release is finished.)

</div>

FIGURE 24.3 Press release template.

and send it out. If you do, you'll end up with a dry, boring, obviously self-promoting piece that will be ignored.

The standard press release template in Figure 24.3 provides the basic structure. For the content, however, prepare to create several drafts until you have your press release condensed down to a useful and newsworthy article.

Start with a headline that not only gets the reader's attention, but gets to the point immediately. After the headline, open with a strong paragraph. Give the who, what, when, where, and why of your news story. Write the press release as much like a real article as possible. This isn't a sales pitch, so don't use words or phrases that make the press release sound like an announcer's pitch on a direct-response TV spot.

Your opening paragraph needs to be strong enough to stand on its own. This way, it can be easily copied into a news item on a Web page.

In the same vein, make your press release newsworthy—as defined by the news outlet and their readers. If it's not news that the outlet cares about, then they aren't going to bore their readers by running the press release. If you or a member of your team has a noteworthy experience that applies to the press release, mention that, as well.

The last couple paragraphs of the press release should contain your company/contact information. This information is useful in case the editor needs to get in touch with you about the article. For an additional example press release, see Appendix D, Example Press Release.

Public Relations

Public Relations (PR) is another of those big business concepts/tools that can be successfully used by the indie, though maybe not right away. The basis of PR is simple: a continuing story about your game provides exposure for your game—often for free!

PR encompasses all forms of promotion. It's not just restricted to word of mouth or newspaper/magazines articles. Anytime your game (or information about your game) comes in contact with other people, this is a public relations opportunity.

PR for the indie begins with getting out of your own head and into the heads of your players. Don't think like the game's developer. Think like a player. And as with your press release, you also need to get into the minds and agendas of the media for whom you are creating the story. What do they want to see in a story? What will interest their readers?

Your PR story needs to be about more than just your game. Concentrate on the people who play your game. How does the game impact the players, or even the lives of the players? Look for a surprise, an interesting twist that makes your game and your story about your game stand out.

If possible, give your PR story a human interest angle. Human interest angles are many and varied. What are your players doing when they play your game? Has a community of players developed with a unique flavor all its own? Can physically disabled players enjoy your game as well as the able-bodied? All of these, and more, could be included in your continuing PR story.

Word of mouth is extraordinarily important for indies, but it generates slowly and requires time to build up. Thus, your public relations campaign should be persistent and constant. Don't stray too far from the public's eye. Don't let too much time pass between updates to your PR story.

CONCLUSION

There is no silver bullet. There is no one thing that will guarantee that a game will be successful, or that your game will be seen and admired by everyone. Rather, you must continually work on promoting your game. From submitting your game to search engines, all the way to creating and sustaining an extended public relations effort, it's important that you do everything you can whenever you can.

No matter how good your game is, if no one hears about it, no one will play it—and no one will pay for it. Thousands of new games are released each year at retail and on the Internet. It's easy to get lost in the crowd.

Beat the odds. Create a marketing plan, and devote time and energy to carrying it out. Get noticed.

PAYMENT PROCESSING

IN THIS CHAPTER

- Payment Processing
- Handling Payments

It's a great feeling the first time someone gives you money for the game you've been funneling so much of your life into. You sweated and agonized over the design and the production planning. You learned the ropes of remote team management and leadership as you spearheaded the effort to see this project to completion. You created a marketing plan and performed amazingly tedious promotional tasks. And now a player—a living, breathing *player*—has deemed *your game* a worthy exchange for *his money*. Life is good.

You finally understand why many small business owners have their 'first dollar' framed and hung on the wall. It's not just a piece of paper currency. This is *money you earned*. And unlike your first paycheck from your first job in the work-a-day world, you didn't get this for working for someone else. This is the fruit of your own labors. It's a heady feeling. Congratulations!

Now, what do you do with it?

This chapter will describe the steps to take when handling payments. First, though, the various payment processing options that are available when offering your game for sale will be discussed.

PAYMENT PROCESSING

Your *payment processing* system is how players send you their payments. What you do with their payments is discussed later in this chapter, under "Handling Payments." In this section, the different types of payment and how you go about receiving them from players will be covered.

Types of Payment

There are three primary types of payment: cash, check, and credit card. Each type has its advantages and disadvantages.

Cash

Cash—cold, hard currency—is the easiest type of payment to understand. Processing cash payments is as simple as opening the envelope, counting the money sent, and then handling the payment as will be described later. There is no waiting period and no potential for 'bouncing' like there is for checks. Barring collapse of the government, cash is always worth exactly what it says it's worth.

Cash has several disadvantages, though. First, cash sent through the mail cannot be verified. This can be a serious problem for the player. If the envelope is lost, or the letter is delivered to the wrong address, the money is almost certainly gone. Also, cash payments cannot be canceled

or stopped. For the indie, cash sent by mail slows down the payment process for the player, especially when compared to credit card payments.

Checks and Money Orders

Checks and money orders, solve some of the problems of cash payments, at least for the player. If a check gets lost in the mail, then the check never clears the bank, and the player doesn't lose their money. The same is true for a money order. By keeping the receipt for a money order, the player has the possibility of recovering (at least some of) his money if the payment is lost.

This additional security for the player, though, does create certain risks for you—in particular, 'bounced' checks. If you process your check payments immediately, just like you do cash payments, then you run the risk of the check being returned by the bank for insufficient funds. You can avoid this risk by waiting for check payments to clear before handling the payments. The downside of this is that it can take as long as 5-10 business days for a check to clear.

There is a very real risk of checks bouncing; but on the other hand, it may not be *that* much of a risk. Since you are dealing in a relatively low-cost product that has little or no resale value (for example, at a pawn shop), there isn't much incentive for people to send you bad checks. In seven years of processing hundreds of checks, Samu Games received fewer than five bad checks. So just be aware of the risk, and take precautions where they seem necessary.

Money orders, however, are almost the same thing as cash. Unless the bank that issued the money order folds overnight, it will clear. The only caveat is with international money orders. Depending on the issuing bank in the other country, there may be fees for collecting the money order. This happens if the money order must be mailed back to its country of origin and the money mailed back. This will become less of a problem, though, as more banks connect electronically across international borders.

Credit Cards

The last type of payment, credit cards, is the most popular. The reason for their popularity is obvious: credit card transactions are quick and easy. The player puts in his credit card information, and the payment is processed. Usually, it takes only a few minutes, at most.

While credit cards are the easiest way for players to pay, they are the most complex and delayed option for you. First, you have to be set up to accept credit cards. This can involve upfront costs for you, and

even development costs as you build or modify your payment Web pages or order forms.

Second, while you can trust that a credit card bank *will* clear all approved payments, it can be as long as four to six *weeks* before you receive the actual funds if you use a third-party payment processing company. As will be discussed later, though, if you have a merchant account of your own, you obviate this delay, receiving the money in two to three business days.

Despite these issues, credit card payments will easily represent 80% *or more* of your total payments. So it's almost imperative for you to support them, despite the hassles that might be involved. For 2002, Samu Game's payments for *Artifact* included all three types of payment. Three percent of the payments were in cash, 8% were checks or money orders, and 89% were credit card payments.

Third-Party Payment Processing

This processing of payments might seem like a somewhat complex undertaking. In some respects, it is. Fortunately, you don't have to learn everything all at once. With a *third-party payment processing* company, you can start accepting any type of payment almost immediately.

A third-party payment processing company accepts payments from customers on your behalf. The payment processing company handles the various issues associated with product payments—such as collecting the customer's name, address, credit card number, and expiration date—and verifies that all of this information is accurate.

Third-party payment processing companies can accept payments from Web pages, e-mail, postal mail, phone, fax, and other ways. They can handle credit card payments for you, opening up probably the single most profitable payment venue in the modern age. And they do all of this for a simple percentage of the total price. All you have to do is handle the payment notifications you receive, and cash the check they send you each month. What could be simpler?

Advantages of Third-Party Payment Processing

Here is a more detailed list of what a third-party payment processing company offers you:

- **A wide variety of payment options for your players.** Credit cards of all varieties (e.g., Visa, MasterCard, American Express, Novus/Discover) can be processed via e-mail, Web page, phone, or fax. Some companies even handle purchase orders; but unless you plan to sell your game to corporations, this probably won't help you

much. Cash, check, and money order payments can be mailed in to their central payment address, and they will handle them, as well.

- **International payment possibilities.** When you accept credit cards, many international markets could open up for you. But even if mailed-in checks or money orders are in international currencies, the company will often handle the conversion to your local currency.
- **Easy refund processing.** Regardless of how the payment was made, the payment processing company will handle refunds. All you have to do is tell them which payment to refund. Refunds usually have some small additional fee, but that's negligible compared to the effort saved. Some refunds are free, though, like those for unintentional duplicate payments by the player.
- **No need to ever handle the payments.** You can use the payment processing company for *everything* payment related, thus automating your payment processing in a single step. And since no payment processing company ever notifies you of a payment before they have the money in their bank account, you don't have to worry about bouncing checks.
- **Built-in security.** Your payment Web page will be hosted by their secure server. In this way, you get the benefit of offering your players a secure online payment option, without the overhead of obtaining an *SSL (Secure Socket Layer)* certificate for setting up your own secure Web pages.

Some payment processing companies will handle additional tasks for you, such as generate registration/unlocking keys, host downloads of the full version of your game, and even burn and ship CD-ROMs with your game. How much these additional features cost varies with each company.

Another feature that a third-party payment processing company might offer is the handling of *affiliates*. Affiliates are Web sites or companies that sell software created by other people (such as your game). Recruiting affiliates to help you promote and sell your game is a way to share the effort of marketing and promoting your game. You give up from 20%–40% of the total sale to the affiliate, but a good affiliate can be worth every penny by finding players and generating sales that you would otherwise never have.

Since the affiliate program works through the payment processing company, the affiliates are paid automatically. You don't have to keep track of who referred the sale and mail them their percentage. The payment processing company handles all of this for you.

As a new indie, you should definitely consider using a third-party payment processing company, at least for now. Not all of these companies are equal, though. You should compare services offered versus the fees charged. If you don't need a particular service or feature, don't pay

for it. On the brighter side, most payment processing companies do not charge set-up fees, so getting them started at selling your game could be free. Multiple payment options can be useful in the long run, and even if you only sell a few copies through that company, you'll be glad you took the time to do it.

Disadvantages of Third-Party Payment Processing

While there are very significant advantages to third-party payment processing companies, they are not without some disadvantages. The most significant disadvantages are the minimum processing fee and the fixed payment percentage that is deducted.

Most payment processing companies have a minimum processing fee that overrides the normal percentage that is taken. An example is *DigiBuy* (*http://www.digibuy.com*), which at the time of this writing charged either 13.9% of the transaction or three dollars, whichever is greater. Therefore, any incoming payment that is less than about $22 has a fee that is greater than the normal 13.9%.

This minimum processing fee is important to keep in mind, because it could have an impact on how you price your game. Some companies support so-called 'micropayments' with reduced minimum fees for prices below a set amount (usually from $5–$10). If you plan to sell your game with a price below $20, be aware of what the minimum fee is going to be.

On top of that, it can take you from 30–60 days to receive your money from a particular payment. Many third-party payment processing companies batch all payments on a monthly basis and send your payment 15–30 days *after* the end of that month. So, for example, it would be mid- to late-February, maybe even early March, before you received the money from your payments in January.

Another disadvantage is the payment percentage that is taken. As was previously mentioned, most processing companies have a single, fixed percentage that they take, regardless of the total ticket price. There is no maximum. If you managed a single order exceeding $1,000, they would still take their full percentage. In the example above, this comes to a $139 fee (13.9%) for the order. Is this fee unreasonable? Only you can really decide, because it depends on a number of factors: did the payment processing actually help you make the sale, or did it only provide the payment mechanism? Are you making sales like this on a regular basis? Most games will sell only one or two units at a time, with total tickets coming to $100 or less, so this fee percentage may not affect you adversely.

Another disadvantage is tied to the payment percentage you give up. This one stems from payments made via normal mail. If you're willing to give out a mailing address for players to post check or money order payments to instead of using the payment processing company, and you

choose to handle these mail-in payments yourself, you keep almost all of the payment—no fees, no minimum payments. All that's invested is just a few minutes of your time. To provide some hard data: in 2002, 11% of all payments for *Artifact* were mailed directly to Samu Games. If they hadn't supported mailed-in payments, hundreds of dollars of possible income would have been given up to third-party processing fees.

Finally, there is the very real possibility of confusing your players when they have to leave your Web site to make a payment. Most payment processing companies host the payment Web pages on their own sites. There are very good security reasons for this. The downside is that the player can see that they are no longer at your Web site. This may or may not be an issue for your players, and you can reduce the impact by customizing the payment page to look like your Web site, if possible.

Even with these disadvantages, though, your best bet is still to use a payment processing company, at least to get started. Once you have an established income stream, you have another option.

Your Own Merchant Account

Once you have a somewhat steady stream of payments coming that exceeds about $1,000 per month in credit card payments alone, you might want to consider getting your own merchant account. As recently as a few years ago, getting your own merchant account was a chore, involving a significant amount of pain and paperwork. But this is no longer the case. With a only a bit of paperwork and some small upfront fees, you can be set up to process credit cards within a few days.

This route isn't for everyone. You do have to take responsibility for certain tasks that would have been handled for you by the payment processing company. The difference in fees and percentages, though, can more than make up for it.

In general, at the time of this writing, you will give up only $0.30 plus 2.35% of the payment total (different merchant accounts may have slightly different fees). That's a significant savings over the third-party payment processors. If you charge $35.00 for your game, that means $1.12 in fees and discounts with your own merchant account versus $4.87 at 13.9% with a third-party processing company. That's a 77% savings! You do have new monthly fees to contend with, such as gateway fees and minimum purchase fees, but the money you're saving on each transaction will more than offset these.

One of the more significant responsibilities that you have to assume with your own merchant account is the handling of credit card owners who phone with questions about the charges on their account. For example, the card owner might not recognize your company name on their

statement, or might not connect it with the game they purchased 30–60 days ago. The card owner may have let their child use their credit card, and they're curious what it is that 'little Mary' actually purchased. Their card may have been stolen (in which case you'll be issuing a refund), or they may have other questions and concerns. You will need to supply a phone number and field the calls that come in.

Another merchant account responsibility you might have to take on is to set up a secure online purchasing Web page. The company you get your merchant account through might provide this for you, or you may be able to use your Web host's security certificate. If not, you'll need to get a security certificate and have your Web server set up to handle SSL. You can get an SSL certificate from companies like Thawte (*http://www.thawte.com/*) and VeriSign (*http://www.verisign.com*).

Your SSL certificate will cost you a few hundred dollars up front the first year you buy it, depending on the service you buy it from. Renewal fees, though, are generally much cheaper, so future years won't cost you as much.

HANDLING PAYMENTS

Whether you are handling all payments yourself or are receiving only notifications of payments from a payment processing company, the necessary steps are essentially the same:

- Record the payer's name and information in your *customer database*.
- Record the payment amount (minus any fees or charges) for *reconciliation*.
- *Deliver* the product to the payer.

Document Everything

Document *everything* that has to do with payments. Keep records of everyone who paid, what they paid for, and when their payment was processed and delivered. This is not only useful for building a database of customers who might buy future games, it also keeps everything organized and above board, and eliminates any hints of mis-management (people are always extra-sensitive when money is involved). So be proactive, and don't let suspicion get a foot in the door.

A good way to keep your team happy, and to make sure that you document everything properly, is to use a separate bank account. Have all payments made out to the name on this account, and do all business in that name, as well. Keep all the monthly statements for the account, and make them available to the team members if they ask for them.

Honest business is always the best kind of business. Your team is expecting you to do right by them. Don't give them any reason to think that you're anything but completely honest and open with them.

Keeping a Customer Database

Your customer database doesn't need to be anything fancy. There are accounting and customer management software packages available, some even specifically targeted at shareware authors. In this early stage of your indie career, however, these are probably overkill. A simple spreadsheet will suffice and provide a lot of flexibility for tracking new information when you decide you need it.

Your customer database should track every piece of information you collect from your customers: name, e-mail address, mailing address, date paid, and amount paid. If you have affiliates who sell your game for you, you'll want to include the source of the sale, as well.

In a spreadsheet, each of the listed data items works well as a column. Whether you use a spreadsheet or specialized software, you'll be doing spreadsheet searches primarily on the customer's name and e-mail address. You may also want the capability to search mailing addresses or dates paid. Some software programs include simple reporting capabilities that can focus on sales for a particular date or range of dates.

There are some significant advantages to using a more complicated customer database. For example, you can collect a larger amount of data if you use an automated system, and you can then 'mine,' or extract more information out of the data. You could also automate certain customer service tasks, such as handling refunds, allowing existing players to redownload games they've purchased, and so on. As your business grows, you can put tools in place to take advantage of these capabilities. For now, though, keep it simple.

Reconciling Payments

Your customer database, with its records of who paid and how much they paid, is also useful for *reconciliation*. Reconciliation is an accounting term that means "checking for accuracy."

Reconciliation is very similar to balancing your checkbook. If you have a payment processing company, the company will send you a list of orders you are being paid for. You then reconcile the statement and/or report with your records by comparing the details in the report to what you have recorded. This reconciliation is also used for reporting total payments and profit-sharing amounts to your team members.

Reconciliation of all payments helps you make sure that you are actually paid for all copies of your game that you think have been sold. It doesn't happen often, but it's possible that you will be sent a payment notification, yet never receive the money for that payment. It's also possible for a check to bounce or be cleared by the bank for a different amount. The only way to be certain, and to keep your books balanced, is to reconcile all accounts periodically.

It's possible, and maybe even advisable, that you hire a bookkeeper to handle this for you. For a relatively small fee, they can check and reconcile your books in just a few hours.

Delivery

The final step in payment handling is to send the player the product (your game!) by furnishing him with the information he needs to download or otherwise acquire the full version of the game. The exact details of this step depend on how you set up the trial version of your game. These are the two primary variations on handling deliverable electronic media:

- Registered/full version of the game via download or CD-ROM
- Registration/unlocking keys via e-mail

Both variations have their advantages and disadvantages. Sending the full version of the game only after a payment has been processed guarantees that the player can't somehow 'crack' the demo version of the game and play it without paying. On the downside, though, once one player gets the full version, he can freely (if illegally) share it with anyone he wants.

If the game demo is the full game with limitations that are removed when the player enters unlocking keys, there are similar trade-offs. Automating delivery of unlocking keys is simple: it takes only a single e-mail with the keys included. This also saves the player from the process of uninstalling the demo version of the game, and then downloading and installing the full version. The downside is that unlocking keys are easier to share with friends than full installation packages.

Sophisticated mechanisms have been created to support and enhance both of these types of deliverables, and there are third-party solutions available to help you. Keep in mind, though, the goal of copy protection is to keep honest people honest, not to defeat all attempts at hacking your game (see Chapter 22, Self-Publishing on the Internet).

Technically, either way you approach this issue, you can deliver your game on CD-ROM if the player wants it and is willing to pay for it. Make

sure that if you do offer your game on CD-ROM, that you charge for the cost of the blank CD-ROM disk, the jewel case or wallet/sleeve, and shipping and handling. Otherwise, each sale of your game on a CD-ROM will end up costing you money.

Handling Refunds

Refunds are a part of doing business—not a fun part, to be sure, but definitely part and parcel of the whole experience. It's a truism that "you can't please everyone." So just accept it, and when it inevitably happens that a customer wants their money back, refund the customer quickly and professionally.

Create and post your refund policy on your Web page and in your game's documentation. If you have a credit card merchant account, you are *required* to post your refund policy prominently on your main payment Web page. So don't put this off.

Having a refund policy where your players can see it makes them more comfortable when purchasing the game. They know that if they don't like the game or have a problem with the game, they can always change their mind and get their money back. To maximize their sense of security, you should set your refund period for as long as you're comfortable having it. Thirty days should be considered a minimum refund period. There is no real maximum refund period. For Samu Games, the refund policy was kept simple and obvious:

> "Samu Games 30-Day Risk-Free Refund Policy: If you are unsatisfied for any reason, Samu Games will promptly refund your payment, no questions asked, for up to 30 days."

In addition to normal refunds, credit card payments are subject to being charged back for up to six months. The credit card companies are on the side of the card owner, so there's usually very little you can do to refute a chargeback. You just update your records, eat the loss, and move on.

If you are easy to contact, though (with your e-mail address or other contact information prominently displayed on your Web page), most people will get in touch with you before challenging a charge and initiating a chargeback. Take advantage of this; a normal refund is a much more amicable (and often cheaper) way to return money to a customer. Chargebacks are unfriendly all the way around.

The Benefits of Automation

Automate your sales process as much as you can. Don't worry about being fully automated when you launch your first game. Do what you can when you can do it. The more automated your sales process is, the less effort is expended by you and your team in keeping up with your payments.

Automation is also extremely useful as you move on to develop new games or if you want to take a weekend off every so often. You'll be able to relax, knowing that your paying players are being taken care of.

How you automate your payments is going to vary according to your type of game, how you're handling the trial period, the particulars of your shareware-locking mechanism, and how you accept and process payments. In general, though, you will probably need the ability to create server-side scripts and processes with Perl, PHP, ASP, or a similar CGI setup.

Automating your payment processing doesn't have to be all hardware and software, however. There are other options. Just like there are payment processing companies, there are payment handling companies. These companies receive your payment notifications and process them for you. They send back any registration keys or download instructions to the buyer and update your customer database with the information from the payment. Some payment handling companies will also handle minor support issues for you via e-mail.

How these companies are paid varies. Some companies take a percentage of the total payment, others charge a set fee per payment handled. Yes, this type of arrangement does add to your overhead and reduces your profit per sale, but you get the benefits of having a payment system that takes care of itself, and you have a lighter load to bear, overall.

Handling Expenses

If your game project incurs expenses, these must be paid as promptly as possible. In most cases, profit sharing is based on net income (income minus expenses) instead of gross income (total income), so expenses take precedence over profit sharing. Bills are paid first, and then profits are distributed according to the team member agreement(s).

Don't let your bills catch you by surprise. Keep track of all of your expenses for the game, both during development and after release. If you know that a bill is coming due, you can budget the funds to be available beforehand. Example expenses for a game that has already been released include advertising fees, Web page/server maintenance, Web domain maintenance, bandwidth fees (from downloads), and listing fees for software Web sites.

In some cases, expenses might show up before the game has generated any income. These expenses are generally for licensing third-party libraries, paying for contractors (e.g., artwork or programming), and the like. How these expenses are paid depends on the project. You, as the team leader, may pick up the tab to keep the project moving forward. When this happens, record all details of the expense so that you can be reimbursed later.

Again, if you don't like to keep the books and have never fancied yourself as an accountant, then you should consider finding a bookkeeper or Certified Public Accountant (CPA) to keep them for you (see Chapter 4, Getting Started). A CPA can also help you track which expenses can be used to offset earnings for tax purposes. Just like there are payment processing companies, there are companies and individuals who will assist you in managing the nitty-gritty details of business life.

Handling Profit Sharing

Profit sharing shouldn't be an issue unless and until the game sees a positive cash flow, with income exceeding expenses. Beginning profit-sharing payouts before the game has established a steady stream of income can make it difficult for the game to grow. If all money is disbursed immediately, then there are no readily available funds for buying exposure or expanding the services offered by the game.

Most profit-sharing payments are reported and made quarterly. Each person who participates in profit sharing receives a report showing the total income for the quarter versus total expenses, with his percentage of the resulting profit indicated.

Sending out profit-sharing reports and payments quarterly has a couple of advantages. First, the three-month period provides a good window for handling most bills that come in. The game can accumulate sufficient funds to pay all expenses. The reverse also holds true in that a three-month payment is going to be more impressive.

Second, you might not want to do the work of the whole process every month. Even if you use a bookkeeper, the job of collecting records and calculating the shares and percentages for profit sharing can be a chore. By doing it only once per quarter, you cut down on your monthly task list.

Before dispersing any payments, get up-to-date and accurate tax information from each team member who is to receive payments. In the United States, this information includes their full name plus middle initial, their mailing address, and their Social Security number. At the end of the calendar year, all payments made must be reported to the Internal Revenue Service. To be absolutely certain you are keeping adequate

records for tax filing purposes, you should have an accountant look over your books at least once per year.

For the original *Paintball Net*, profit sharing was very simple: it was split two ways, 50/50, by the two programmers who created the game. For *Artifact*, though, since there were four on the team, and two of these were not part of Samu Games, LLC, handling profit sharing was a bit more involved. E-mails were sent out each month to all of the team members, showing total payments for the month and for the year to date. The report also included a list of all expenses that were incurred and what everyone was being paid for their profit sharing. Profit-sharing checks were then cut and sent via postal mail. In retrospect, Samu Games concluded they'd rather send out the reports and checks once every quarter, as once a month became a bit tedious.

CONCLUSION

Processing payments for your game boils down to three steps: recording the player's information in your customer database, tracking the payment amount for reconciliation, and sending the player what he paid for. Though there are details to each step, handling payments is really quite simple.

As your game grows, you can become more sophisticated in how you handle payments and manage your business. While you're getting started, though, don't make things more complicated than they have to be.

CUSTOMER SUPPORT

IN THIS CHAPTER

- Customer Service Essentials
- Tracking Customer Service Issues

No business can exist without customers. This is true no matter how big or small the business is. As an independent game developer who is self-publishing games and selling directly to players via the Internet, this still holds true. You may not consider your game as a business; you may even be giving it away. You are still doing business, however.

Your players are, or could be your customers, and you must be prepared to hear from them on issues—both favorable and unfavorable—and deal with them as professionally as any other business owner.

As indies, you and your team *are* part of the game—more than the graphics, sound, or programming. And you are not separated from your players by a publisher and/or retailer.

Therefore, how you respond to your players—whether they are offering praise, asking questions, or reporting problems—becomes part of their overall experience of your game. Were your rude? Not helpful? Unresponsive? Or did you quickly, pleasantly, and professionally help them take care of their problem? Your players will remember your response, and they will judge the game accordingly.

CUSTOMER SERVICE ESSENTIALS

A business exists for the sake of its customers, not the other way around, and your game is no exception. You, as the game developer, need players. The reverse is not true. So never take your players for granted. No matter how great you think your game is, it has little or no value without players.

Your players, both those who have paid and those who have yet to pay, are your most valuable asset, and you should treat them as such. Look for every opportunity to help your players enjoy your game even more.

The Indie Advantage

A common complaint of customers who deal with large companies in the game industry (and in every other industry for that matter) is that the service they received (if they actually received any) was impersonal and uncaring. For centuries, small business owners have exploited this weakness of oversized, impersonal corporations. They lavish attention on grateful customers, keep them coming back for more, and run profitable businesses, even in the face of monolithic competition.

As an independent game developer, you too can capitalize on customer service combined with intimacy. Players seldom get to interact with the people who designed and created the games they enjoy. They buy the

games at major chain stores, which were shipped to the stores by distributors, who got them from the publishers, who got them from the developers. That's a lot of layers between the game developer and the player. The reverse also holds true: game developers don't often meet the people who play their games (unless the players are other game developers).

Indies, though, get to be accessible. They get to meet their players, at least online, and the players get to meet them.

Players can send comments, bug reports, and even suggestions directly to the people who made the game. This provides a real sense of intimacy, a feeling that they didn't just purchase a piece of software, but that they became part of a community. This can greatly improve the player's perception of the game.

Take advantage of this intimacy to create loyal customers. When you create new games, your existing players will already know and trust you, and will be first in line to try (and buy) the new games. Even players who e-mail you to complain about certain issues will be impressed if you treat them professionally and help them with their problems.

Types of Players

In general, you will hear from two types of players. The first, and usually most pleasant, is the player who really enjoyed the game and wanted to let you know. They might even have suggestions for how you could improve the game.

The second type of player has a problem; and since they took the time to contact you, it's probably a serious problem. Their problem could be with the game, or with other players playing the game, or with the price of the game, or with paying for the game, or just about anything else that went wrong with their gaming experience.

Handling the first type of player is pure joy. Even if they think the game could be better, they liked the game enough to let you know. We could all use more of these.

The second type of player requires much more effort on your part, and unfortunately you hear from more of them. It seems there are a limited number of compliments in the world, but there are an endless number of complaints.

Be Professional

Regardless of which type of player you are dealing with, you must maintain a professional attitude: pleasant, informative, and helpful. Here are four steps for dealing with all types of customers:

Step 1: Think first, then speak.

First, think carefully and consider every word before you respond to a customer. Don't just react. Even if the customer is abusive, see past the abuse to discern the problem. Then, help them solve the problem as if they had asked you in the nicest way possible.

Never go 'on record' with a negative or emotionally caustic response. You never know how far something you say will travel, or how long it will be around. With e-mail especially, there is no 'statute of limitations.' Everything you say in an e-mail is recorded somewhere on the Internet, and a poorly worded or insensitive comment can haunt you for years.

Step 2: Don't take anything personally.

When dealing with customers of any sort remember: don't take anything personally. Regardless of how uncivil a player is, no matter how personal they get with their caustic remarks and criticism, don't take it personally.

This is easier to do via e-mail than it is to do over the phone or face-to-face. So in this respect, since you are located somewhere in cyberspace behind a Web site and an e-mail address, you have an advantage over a brick-and-mortar business owner. You at least don't have to deal with customers screaming at you. Of course, you will still get some verbal abuse, but you can always turn off your monitor for a few minutes while you cool down.

When people buy something and it doesn't work as they expected it to, and they're upset enough to let you know about it, they don't tend to filter what they have to say. Quite the opposite, in fact. Most of the time, though, they aren't mad at you, personally. You're just the most convenient target. Something isn't working for them, and they're frustrated. Ignore the ranting and help them get resolution.

You may be tempted to scream back (via e-mail) and run them through the ringer, too, but that won't help. In fact, giving in to that urge will only make the problem worse and cause it to spread as the player expresses his displeasure with you and your game to other players and potential players. So, no matter how vitriolic someone is with their word choice and personal references, ignore it.

Step 3: Don't assume you know what's going on. *Ask.*

Focus on the problem the player is having. Don't make assumptions about the problem or the player. If you're not certain what problem they're experiencing, based on what they've told you, ask for more information.

A simple, direct question will help the player refocus, and show them that you are trying to help. This applies whether the player has already paid for the game or is still giving the game a test drive.

If the problem they're reporting has a simple solution, don't make them feel stupid, intentionally or unintentionally. Just tell them what they need to know to solve the problem. Be helpful, not snide.

Step 4: Do your best.

Ultimately, being professional means always striving to do the best you can. Don't shirk your responsibilities or try to cut corners. Do your very best, all the time. If you're actively providing the best customer service you can and are constantly trying to improve it, you will be perceived as professional.

If the player is not reporting a problem, but merely a giving a very negative review, you should still be civil. Respond simply and directly to the issues they bring up, when such responses seem warranted. You can't please everyone, and you're unlikely to convince them to like your game by arguing. You can still be pleasant. If there's nothing else you can say, just respond with: "Thank you for the feedback."

TRACKING CUSTOMER SERVICE ISSUES

An important part of handling customer service issues is keeping track of them. If you take the time to track the customer service issues and complaints that you receive, you can spot problem areas in the game and even take advantage of creative suggestions from your players.

Problem Tracking

How you track the problems your players report will impact how you respond to those problems. Is the problem one you've seen before? Is it a critical error, or just a display issue? Is it actually a problem with a hardware driver or some other software that is running at the same time? How often is this problem reported? These questions can't be answered unless you take time to track the problems that are reported.

Tracking bug reports isn't something you'll only do during development and testing. It remains an ongoing process. Even small software programs seldom reach a state of bug-free nirvana, and computer games are no different. After your game has been released, you will still need to keep track of reported problems.

Whether you fix the problems as they happen or wait and handle them every three to six months with a patch, tracking reported problems begins with keeping a log of what the bugs are and who's experiencing them.

When someone reports a problem, get as many details as you can, such as their OS version, hardware specifications, add-on cards, and other hardware they might be using. Not all problems are bugs per se. Some problems might result from a misunderstanding of the 'intuitive' user interface you designed or attempts by the player to do something unexpected in the game. When these types of problems are reported, give them as much consideration as those reported by players who *did* read and understand the manual. Just because you don't see these issues as problems with the game doesn't mean they aren't problems. Record them. Whether you need to improve the documentation, streamline the user interface, or put in better edge-case checking, take care of the issue.

Treat every problem report seriously. Every problem you solve is one that you no longer have to deal with. So be diligent about finding and fixing bugs in the game.

Realize that no matter how many bug reports you get, you are only seeing the tip of the iceberg. You will never hear from *every* player who has a problem. If one player reports a problem, the odds are good that there are plenty of other players having the same problem. Rather than report it to you, though, they'll decide the game is just 'messed up' and leave unhappy. And unhappy players who leave your game won't pay for it.

How you track reported problems doesn't have to be complicated. There is freeware and software you can buy that will handle this task for you. Some will allow you to track problems with full descriptions, and even assign individual problems to team members to be fixed. Tracking software will do reports for you and possibly even link into your resource management software. Don't get caught up in the technology, though. You can have good results with a simple text file, copying and pasting e-mail contents as problems are reported. The important thing is that you actually do the tracking and fix the problems. The information you need to track is:

- **Who reported the problem?** Keep the contact information of the person reporting the bug. You might need more details about the problem, or even want them to help you test the fix. You also might want to inform them when the problem has been addressed. If more than one person is reporting the problem, you can easily accumulate contact information for all of them.
- **When was the problem reported?** Again, if more than one player is reporting the problem, you could keep track of when the problem was last reported, and even see how frequently it's being reported.

- **Details, details, details!** When trying to find the source of a problem, every detail could be important. What was the player doing when the problem occurred? What level were they on? Were they running any other software at the same time as the game? Anything and everything you can dig out of the player goes here.
- **System configuration.** The player's system configuration could be considered yet another detail, but it's important enough to deserve its own heading. Find out everything you can about their computer. Which operating system are they running, and which version of that operating system? What kind of video and sound cards do they have? How much system memory (RAM) are they running? Maybe even ask for the company that built the computer originally. Get this for everyone who reports the problem. It's very possible, for instance, that the reason they all have this problem is that they are all using the same outdated device driver.
- **Is this problem being worked on currently?** If so, by whom? When did they start? When do they expect to be finished? If you or another team member is trying to find the source of the problem, track that and bring it up at your regular team meeting, if you're still having them. And if a team member is not currently busy, perhaps you can assign them some problem-solving duties.

Of course, you can track even more information if you want to. For example, how many hours of effort does it take to solve each problem? This could be valuable to know in case you run into similar problems in the future. Also, some problems are going to have a higher priority than others: a typo reported in the "About" box can probably wait until after you've fixed the game's apparent allergic reaction to the latest graphics card driver.

Frequently Asked Questions

A list of *Frequently Asked Questions (FAQ)* is an excellent way to reduce your customer service issues. By posting a FAQ section where it can be easily found and reviewed, you can answer many questions *before* they're asked. FAQ lists make life easier for both the player and you. The player gets a quick, useful answer, and no additional time or bandwidth is used up in swapping e-mails back and forth.

A FAQ page is a natural outgrowth of tracking reported problems. Not all problems are within your power to solve or address. With FAQ, though, you can provide a quick workaround to players, or at least inform them that you know about the problem.

Once a question or issue becomes a FAQ item, you shouldn't settle for just answering the question or providing a workaround. Ask yourself

why it became a FAQ item. See if you can prevent the question or issue from coming up in the first place. Maybe you can tweak the game's user interface, or make it more tolerant of different hardware configurations. Maybe you should update the in-game documentation.

Just because you've answered a question doesn't mean you're finished with that question. Imagine how much better your game will be for players if they don't have to ask *any* questions.

Suggestions Tracking

Just like bug reports, player suggestions should be encouraged, responded to, and tracked. If they are really good suggestions, you *should* add them to the game.

No matter how much thought you put into the game and its implementation, or how much play testing you do, there are ways your game can be improved. Some suggestions will seem so obvious that, in retrospect, you'll wonder why you didn't think of them in the first place.

Implementing player suggestions is almost always good business. Not only do you make the player(s) who made the suggestion feel good, you also improve the game for future players. Thus, you add value for your current players and even more incentive for future players to experience and buy your game. All it costs you is a few minutes of listening time. For more detail, see Chapter 27, After Shipping: Game Evolution via Player Feedback, for a discussion on the value of implementing player suggestions.

If a player submits a suggestion that seems to have potential, but you're unsure about it, respond and ask for more details. The player will be flattered that you want to discuss a game design topic with him, as well as be impressed with your openness to new ideas. The player will probably be more than happy to give you more information. And between the two of you, you might be able to hammer out a really good extension to the game. The information you should track is:

- **Who made the suggestion?** Players like their contributions to be acknowledged; so if they make a suggestion that seems worthwhile, keep their name with the suggestion. Some suggestions will be sent in by multiple players. If it seems you have a groundswell of support for a suggestion, you might want to give it priority over other suggestions.
- **When did they make the suggestion?** Tracking when you first got the suggestion can be useful for scheduling work on it. It can also be useful for resolving player squabbles about who suggested a particular feature first. (Yes, it happens.)
- **Details and more details.** Some suggestions can be summed up in a single sentence (e.g., from *Artifact*'s list of suggestion: "a way to download all available game maps"), but others require elaboration

and examples. Get as many details as you can. The more clear your description of the suggestion, the easier it is to implement.

As with problem tracking, you can track suggestions with nothing more complicated than a text file. The important thing is to keep a record of suggestions. Then, let your players help you improve your game.

Of course, some suggestions you receive are going to be completely out of sync with the game. Not everyone who thinks they have a great idea really does. It's possible that the suggestion really is a good idea, but it's not something that fits in the game. Regardless, respond to the player, and thank them for their suggestion.

CONCLUSION

Customer support begins when players first hear about your game, and it continues until they finally stop playing the game. Without players, your game is nothing more than a collection of bits with an installer. Customer support is, therefore, a very important part of marketing and selling your game.

You don't need your own letterhead and call center to deal with your players in a professional manner. Being professional is a state of mind. Think before you speak, don't take anything personally, don't make assumptions, and always do your best. You will impress your players with your attention and responsiveness.

Take advantage of your small size. As an independent game developer, you get to have direct contact with your players in a way that retail game developers can't.

THE FUTURE

Congratulations! You had a vision of a game, and you've grown that vision from idea to design to plan to completed game. That's quite an accomplishment. You and your team should be proud. Take a few days off and really enjoy yourself. You've earned it!

This section wraps up *The Indie Game Development Survival Guide* and provides a couple of suggestions on where you can go from here, and how you can build on what you've already created.

Chapter 27 (After Shipping: Game Evolution via Player Feedback) will discuss how you can continually improve your game, even after it's shipped. This type of continual improvement can keep your game attracting players and making sales for years to come.

Chapter 28 (Leveraging Existing Products and Customers) will show you how you can maximize what you've built thus far to build even further. Focus on re-using everything, and leverage your past accomplishments for future achievements.

AFTER SHIPPING: GAME EVOLUTION VIA PLAYER FEEDBACK

IN THIS CHAPTER

- Accessibility to Players
- Game Evolution Through Player Feedback
- Balancing Improvements with New Development

The first step into your future as an independent game developer is to recognize that the development process doesn't end with the release of the game. The release of your first game becomes the foundation on which you build your next game, and the next.

As an independent game developer, you have at your disposal an incredibly powerful marketing tool: accessibility. There are more advantages to being accessible than just providing great customer service, as was discussed in Chapter 26, Customer Support, and we will expand on that chapter's suggestions for tracking players' suggestions. This chapter will show you how to leverage the bridge between indie and player even further.

First, *encourage* your players to send you suggestions for improving the game. Then *implement* those suggestions. We'll also discuss the advantages of a rapid turnaround on patches and updates via the Internet.

ACCESSIBILITY TO PLAYERS

As an indie, you are not insulated from your players. There is no publisher, distributor, or retailer to sell your game. Your are the player's primary contact. You are in the thick of it and part of the process from beginning to end. The first step to leverage this unprecedented access to your players, the part that makes the information in this chapter useful, is humility.

Humility

Humility is simply accepting your own limitations, knowing that you don't know everything, and not pretending otherwise. You need players. Your players don't need you. In this chapter, we take that concept beyond just customer service and your efforts to keep your players happy. We will show you how your players can help to make your game better than you or your team, working alone, could ever have dreamed of. This is humility.

You will never have as much contact with your game as your players do. You may have chalked up hundreds of hours playing the game during testing, but your players will put in *thousands* of hours. Less than six months after you release your game, it's almost guaranteed that your players will know more about your game than you ever did—or will.

If you resist the temptation to view your game as being the perfect embodiment of your own amazing vision and insight, you will be able to accept the criticism of your players and incorporate their suggestions. Be proud of what you have accomplished, of course, but don't let that pride prevent you from listening to good advice. Ultimately, it is still your game

and your (or your team's) vision, but with the help of your players, you will be able to take the game to the next level.

Soliciting Player Feedback

Some players will send you feedback and suggestions whether you ask for them or not. These players are a vocal minority, however. You won't hear from everyone who might have an idea or suggestion.

Some players need encouragement before they will offer feedback. Talking to game designers is still a novel concept, and after decades of dealing with large, impersonal corporations, your players might think that you don't *want* to hear from them. So make it as easy and obvious as possible for them to contact you. Don't be subtle. Ask them outright: "Do you have a suggestion to improve this game?" You might even create a special e-mail address for this type of feedback.

However, requesting feedback and suggestions from players will only work if you are really interested. If you don't *really* want to hear from your players, and you have no intention of implementing their suggestions, then don't ask. Asking for suggestions and then ignoring them is rude and arrogant. It's better to not ask at all.

As players submit suggestions, you should respond to them and track them (see Chapter 26 on Tracking Customer Service Issues). Don't worry about accumulating more suggestions than you'll ever be able to implement. It's possible that a suggestion that seems wrong for the game now will become very appropriate in the future, or something that once seemed infeasible might suddenly become very simple. So keep track of every suggestion and let serendipity work for you.

Implementing even a single player-submitted improvement will result in a greater sense of ownership and loyalty among *all* your players. Many players dream of making their own games. Being able to make a contribution to a game that they enjoy playing is nearly as good. The players will see that you do listen and are working to keep the game current.

Rapid Turnaround on Patches and Updates

As a self-publishing indie, you have a lot of flexibility that retail publishers only dream of. The first of these is that since your game is mainly available via download, you are not stuck with out-of-date versions burned onto CD-ROMs, copies that you'd have to sell or destroy. You can quickly and easily update your game's package on your Web site. So anyone who downloads the game is always getting the most recent release.

This ability to rapidly roll out a new version of your game is an integral part of evolving your game over time. You don't want to update too

often, unless the update fixes a critical error, but there are advantages to updating every two to three months. Many software Web sites, for instance, have a "What's New" listing that announces recently updated software. This can be useful (albeit short-lived) exposure, keeping your game in the public eye.

Also, having periodic updates makes it easy to incorporate refinements in the game, a few at a time. You're not making a lot of changes all at once. Instead, you're adding a few here and a few there, intermingled with necessary bug fixes.

Staying in close contact with your players, combined with periodic updates, means that improvements to your game can be suggested, refined, and incorporated into the game in a matter of weeks or months. At the end of a year, your game will probably be significantly changed from what it was at the beginning of the year, one small step at a time.

It's this process of incremental improvement and evolution over time that allows independent games to successfully compete with retail games. Retail games typically must show a profit very quickly, or they are cleared off of the store shelves and dropped un-ceremoniously into the bargain bin. This means the effective lifetime of a retail game is, on average, three to six months. Indie games, on the other hand, can last for years, accumulate more players, and make more money.

GAME EVOLUTION

As you implement players' suggestions, your game begins to change. It is no longer just your and your team's game. Instead, the game becomes something new—a better, more refined version of itself.

Keep in mind, though, that *evolution* is not the same as *revolution*. You're not trying to create a whole new game. Be selective in your choice of improvements; don't just implement everything the players suggest.

Evolution, Not Revolution

You're not trying to create a whole new game by soliciting players' suggestions for improvements. Rather, you're trying to fine tune the game you already have and make it better, easier to play, and more fun. Your goal is incremental improvement, or evolution, and not radical change.

With that in mind, don't try to incorporate every good idea that comes your way. Stay true to the original vision of the game. For instance, if the game is a puzzle game based on cars in a parking lot, resist the temptation to add a car-driving simulation. Sure, it might be fun to go careening around the parking lot with a first-person perspective, but what does it add to the game you already have? It's a truism in art and

design that "anything that does not add, takes away." So before you add something new to your game, make sure it fits the game's vision.

Refining and polishing your game is the goal. Adding new layers of complexity is not always the best choice. Just because a railroad game is fun with eight types of loads doesn't mean it will be even more fun with 32 types of loads (and certainly not four times as much fun). Streamlining the game, making it easier to learn and more intuitive to play, is the better decision. For instance, make the current eight loads more easily distinguishable on the display.

Give Players What They Want . . . Within Limits

This chapter is based on the assumption that players not only like change, they expect it. Without change, whether it means new puzzles in a puzzle game or new battlefield display options in a combat game, your players will get bored. Keep in mind, though, too much change too quickly will also cost you players. If the game changes too much, then the player's experience and progress is lost. The same goes for 'improvements' that change the fundamental strategies of the game.

Players enjoy learning how to play new games, but learning how to play the same game over and over stops being fun very quickly. Change can keep the game fresh, but players also need stability. Without stability in the game's basic mechanics or gameplay, the players cannot create a body of knowledge and useful experience.

At some point, improvements and refinements to the game will hit a point of diminishing returns. That is, the effort to make a change will begin to outweigh any benefit derived from it. There will also come a point at which the game has been extended about as far as it can reasonably go. Further changes would result in a different game. This doesn't mean the game is dead, however, merely that it has reached its peak of maturity.

A mature game is much easier to market than a new game for several reasons. By the time a game reaches this point, you know exactly who your players are, demographically, and why they play. Remember: chess has been virtually the same game for centuries, and it's still a bestseller.

You Can't Please Everyone

If you stick to improvements that streamline the game without changing its fundamentals, your players will usually be happy. These type of refinements are also useful for giving the game broader appeal.

It's almost inevitable, though, that a given change to the game is going to upset some players. The more significant changes, especially

those that affect how the game is played, will nearly always result in complaints from the ranks.

It's impossible to please everyone. Some people hate change—period—and not just changes to the game. Even some bug fixes you do will generate ill will, especially if the bug was useful to the player or integral to his strategy.

In general, you should try to avoid any changes that annoy or displease your players. If you are convinced, though, that the change will improve the game, you shouldn't let a few complaints stop you. Accept that you can't make everyone happy all the time, and do what you think needs to be done.

Player-Created Content

Another way to improve your game over time, while keeping your players interested, is to let them use your game to make their own. Some players really enjoy tinkering with the mechanics of a game, even if they never change anything. Many players fancy themselves game designers and want to learn more about how games are made. The perennial 'mod' communities of games like *Half-life* and *Neverwinter Nights* are evidence of this desire.

If you provide the tools for level building, map making, puzzle creation, and so on, your players will find them and use them. Besides allowing the players to express themselves, you can use such tools as the basis for contests and other community-oriented activities. You might even be able to incorporate some of the higher quality content and changes into the base game.

In general, if you've made design tools for your own purposes, you can release them to your players. Since only a small percentage of your players are going to use these tools, you don't have to devote too much time or resources to make them 'market ready.' Just put in enough effort to make the tools functional. Don't let your concentration on tools support divert resources that could be better spent on the game itself, or even on a new game.

Another option for player-created content is to incorporate it into the actual game. You might want to set up some kind of editorial review process to make sure that the content is appropriate, though. A contest could be used as a way to get submissions, as well as provide a framework for deciding what entries are acceptable.

Samu Games has used contests with good results. In *Artifact*, players have small 'flags' that are attached to their units in a game as well as displayed beside their name in the global chat channels. By allowing the players to choose up to three colors for their flag, only a set of 256 flag

patterns had to be supported, which still provide nearly infinite variety. In the initial release of the game, though, only 128 flag patterns were included. The rest of the available patterns were left for players. Since the release of the game in 1999, a number of "Flag Contests" were held, and these proved very popular. Prizes were offered for the winning flags, usually free subscriptions. In addition, the flags were incorporated into the actual game, permanently, and the players who submitted them were named in the help file. As a result, players created many unique and interesting flag patterns.

BALANCING IMPROVEMENTS WITH NEW DEVELOPMENT

You might think this chapter is advocating a never-ending development cycle, that once you complete your first game, you will be stuck with maintaining and improving it forever. But that is not the case.

It *is* possible to devote the rest of your productive life to tweaking and polishing your first game. If this is what you want to do, go for it. You're an indie, after all. You can do anything you want. If, however, your plan is to create more games, then you will have to learn how to manage the post-release period of your first game as well as the development of new games.

Once you have self-published your game, you may be tempted to launch a new project immediately. Something you have to consider now, which you didn't have to consider with your first project is: you will be dividing your available time and resources between *two* projects—your new project and the customer support, maintenance, and continued improvement of your previous project.

You might find that, with the many demands of the game you thought you had finished, work on the new game is going much slower than expected. You might even despair of ever getting your new project finished.

The good news is that you *can* work on a new project and continue to support your existing games. You will have to apply your organizational skills, though, just like you did to finish your first game.

You may also have to accept the fact that you cannot devote as much time to development on the new game as you did to the first one. As a quick side note, you may be able to mitigate this reduction in your available time by making new games that are similar in content, presentation, or underlying technology to your first game (see Chapter 28, Leveraging Existing Products and Customers).

The even better news, though, is that by learning how to manage your time and your game in this post-release period, you take advantage

of market forces that can help this game and all your future games grow indefinitely.

So don't begrudge the time you're having to spend at supporting and evolving your first game. As you get comfortable with providing customer support, and as you address the players' issues and implement their suggestions for improvements, you learn valuable lessons in many areas. You create a better, more stable, and player-friendly game, and you lay a foundation of organization, resources, and loyal customers that will you will be able to build on for years.

CONCLUSION

For the independent game developer, the process of game development doesn't end with the release of the game. You can continue to improve your game long after its initial release if you only have the humility to accept the willing help of your players in the form of feedback and suggestions. Being accessible to your players and taking their suggestions to heart will help your game to grow and evolve much further than the relatively short shelf life of retail games.

LEVERAGING EXISTING PRODUCTS AND CUSTOMERS

IN THIS CHAPTER

- Leveraging Your Game Resources
- Leveraging Your Game's Players
- Leveraging Your Team

This chapter will continue the theme of Chapter 27, After Shipping: Game Evolution via Player Feedback, and focus on the indie future that is built on the past foundations. Once you have completed and self-published a game, you have many more options available than you did before. Besides proving you could do make an independent game, you created processes, resources, and contacts that you will be able to use again and again throughout your career.

A game project that is finished and released is a very valuable resource for the indie game developer. Art and sound resources created for the game may be useable in future projects. The same is true for program source code. And even a small community of active players provides a strong foundation on which you can build. Possibly most important of all: you have forged a team that knows how to work together.

This chapter presents a number of ways you can leverage your new base of resources, store of intellectual property, and new community of players. And what's even better, all of these expand and grow with each new game you create.

The most important thing to glean from this chapter is that even though you are an indie, it's in your best interests to think long term. Even as you focus on getting your projects completed, be aware of how you can use these projects as the foundations for even more projects in the future.

LEVERAGING YOUR GAME RESOURCES

When you start your next project, whether it's an entirely new game or a sequel to your first game, you are not starting from 'square one' this time. You have an advantage this time around. You can create new games faster and/or take on larger projects. Either way, you are building on your own successes and learning from your own mistakes.

Leveraging Resources for New Content

To make your first game, you created a collection of art, sound, and music resources that you might be able to reuse. Reusing source code has been a cornerstone of software development for decades, but there's no reason to stop there. Reuse and recycle everything you can.

It's inevitable that a new game will require new resources. Every game is different, after all. But don't throw out what you have just because it's not what you want in the release version.

Even if your new game needs a very different 'look and feel,' having these resources readily available as placeholder art, sound, and music can be incredibly useful. On the other hand, if you want your games to have

a very similar look and feel, you can avoid the issue entirely. With some planning while creating resources for your first game, you can maximize reusability by building it in from the beginning.

There is a caveat, though. If you did not create the resources yourself, then there are issues that must be dealt with. If a team member (not an employee) created the resources, then how those resources were added to the overall project affects any other use you (or they) could make of them. At the very least, if you are using resources from one project for another, you should get permission from the team member who created them. If you are uncertain about who owns what, don't hesitate to talk to a lawyer who has experience with intellectual property rights.

Never hesitate to *not* make something from scratch if you have the chance and ability (see Chapter 17 and its discussion on the advantages of third-party components and libraries). Besides the advantages of using third-party resources, there are great opportunities in leveraging your own precreated source code and other resources.

Sequels

Sequels are probably the most obvious way to leverage a successful game. A sequel could also be the easiest kind of new project to tackle. The trick with sequels, though, is keeping enough of the original game that players recognize it, while simultaneously adding enough new material to keep the same players from getting bored. A sequel, in this case, is meant to be a totally new game, not just an improvement to the original game. Minor feature updates and bug fixes are not sequels.

Why make a sequel? There are several reasons why sequels can be a good idea. First, as Hollywood has repeatedly demonstrated, people *like* sequels. Assuming the original game was popular enough, you could easily make a new game with the same characters, settings, and situations that the players liked the first time.

Also, sequels leverage existing *intellectual property* (IP), while also creating new IP. Intellectual property, in this context, refers to the unique collection of characters, settings, and situations that were created in a game. In a way, a game doesn't really have intellectual property until it's been proven with a sequel. At the same time, the sequels create additional IP by expanding on the original game.

Finally, in computer software development, as in many engineering disciplines, you only *really* learn how to build something by building it the first time. That is, until you've done it once, you don't know how you *should* do it.

No matter how well you plan your design, by the time you finish the project, you can see how you should have designed it. Succumbing to

this need to 'do it right,' however, keeps a lot of software locked in perpetual development. At some point, you have to declare it 'done enough' and ship it. Sequels, then, give you the opportunity to go back and 'do it right'—at least in a few areas.

Resist the temptation, though, to start over from scratch and create a complete remake of your own game. If you throw out everything you've created thus far, you're ripping up the foundation you so carefully laid the first time around. Instead, try to separate out the parts of your game that are unique, that distinguish your game, and that give it a personality and a feel all its own. Then work to create a new game concept that leverages those parts.

A remake of an earlier game could be considered a sequel if the original game is no longer available. Perhaps new technology is available now that wasn't then, or maybe you're just feeling nostalgic. Samu Games originally considered doing a 3D version of *Paintball Net* in 1997–1998. At that time, however, 3D engines were still expensive and required not only a lot of in-depth knowledge, but a willingness to tinker. By 2002, though, the situation had changed considerably. There were a number of 3D engines available, many for very little cost, which had a high level of functionality. Thus, they started remaking their own game—with the added intention of leveraging what was learned with this new version of *Paintball Net* to create other 3D, multiplayer games.

Funding New Projects

If you aren't interested in creating a sequel to your game (yet), and you still have other sources of income (e.g., you haven't quit your full-time job), you can use the income from your current game to fund development of a new game. With even a little bit of funding, the options available to you expand considerably.

Since your first game is unlikely to provide enough money for you to live off of, it makes sense to treat income from that game as 'seed money' to be reinvested.

One way to reinvest the money is to funnel it into new development. This can ease the financial burden of development significantly. Since your main source of income is still intact, you can allocate more funds for new development—and you can do this without putting additional strain on your primary income stream.

You'll discover that even a few hundred extra dollars can make a big difference. If you had to contract artwork for your first game, you probably paid for it out of your own pocket. You might have to contract artwork for this new game, as well; but this time, at least a portion of the money you use is 'free.' You will still treat it as a project expense to be

paid back later, of course, but it's not coming directly out of your own pocket. You might even decide to invest even more for artwork on this game, using as much of your own money as you did on the last game plus your profit sharing money.

Note that the funds you're using will almost certainly be only your own piece of the profit-sharing pie. Whether the other team members will be interested in investing part of their share in the profits from the first game is up to them. Remember, though, that you can recoup your expenses from the proceeds of the new project. So you'll probably at least get your money back. Even if you don't, though, there is still something very satisfying about investing your own money in your own future.

Focus on creating multiple streams of income, rather than relying on just one. By taking the income from your first game and leveraging it to create additional games, each with their own stream of income, you stand to earn a good return on your investment. By doing this, each game you create also gets access to an ever-increasing budget pool and provides a foundation for increasingly higher production value in your games.

Episodic Content

Episodic content refers to creating a core game engine with a small collection levels, known as an *episode*. The goal is to leverage the initial development effort to create a full-size game over time, releasing new episodes as they become available. In some models, the core engine and the first episode are given away for free, and the players are expected to buy the sequels, one by one.

Selling new episodes can prove to be a useful way to incrementally increase the value of the basic game, while also creating new content. New episodes can be considered minisequels as well as new chapters in an ongoing story. By selling your game this way, you get to leverage your players (as will be discussed later on in this chapter), providing them with new parts of the game they can buy, possibly with little extra cost for you.

While using an episodic format can result in some content creation costs being spread over time, the upfront development of the game is not significantly reduced. The core game engine and first episode still have to be completed before the game can be released. And while the future episodes can be built on the content created for the first episode, that first episode represents a large part of the initial development. So the episodic content model does not grant any significant development advantages.

Episodic content provides a way to leverage your players and your game resources over a period that might extend for years. However, don't expect it to significantly reduce your initial development costs; episodic content is more of a marketing plan than a way to cut development costs.

LEVERAGING YOUR GAME'S PLAYERS

The chapters on customer support and game evolution repeatedly stressed that your active players are the most valuable resource you and your game have. This remains true, even as you consider and plan for new games.

Your community of players can be one of your best—and easiest—marketing investments for not only the game(s) you've already released, but for future games. If you keep your players happy by providing exceptional customer support and listening to their suggestions, they will provide the word-of-mouth marketing that is so important for indies, convince their friends to play your game, and help new players get started. Also, since you have created at least one game that they like, they will be inclined to check out any new games you make. They may even be able to help you with your new games.

A Pool of Testers for Future Projects

Remember how much of a chore it was to find testers for your first project? Once you have a completed game, though, you will probably have found as many enthusiastic testers as you'll probably ever need.

Even if your first game isn't a big hit and attracts only a few hundred players, these players will be very supportive of you and your games. You've proven to them that you can create a game that they like to play, and they will be anxious to see what else you're capable of.

By tapping your existing players this way, you collect a stable of good testers. You'll find that you're using the same core group of testers on new projects, time after time. And since they have experience with you, they'll require much less management than new testers who just want to try out your new game.

Potential Team Members

Game developers—retail, indie, and aspiring—are some of the most avid game players you are likely to find. The reverse is also true. Depending on the type of game you've created, there is a very strong chance that you have at least a few developers or aspiring developers among your players.

As word of your new project spreads through your community of players, be open to the possibility that one of your players could be exactly the person your new project needs. Even if all the people you hear from are enthusiastic, aspiring amateurs, keep in mind that everyone has to start somewhere. If they seem to have the potential, give them a trial run. See what they can do. They may surprise you.

In the same vein, be open to mentoring aspiring game developers who play your game. Even if the two of you never work on the same project, you can help them learn from your experience. Over the years, there have been a number of players of *Paintball Net* and *Artifact* who have gone on to make their own independent games. A few of these have even become lifelong friends.

Ultimately, what they accomplished is to their own credit. But it's a very satisfying feeling to know that you were able to help someone through the uncertain early stages.

It's Always Easier to Sell to Someone You've Sold to Before

Finally, common marketing wisdom says that it's easier to sell a product to someone you've sold to before. The cost of marketing to an existing customer is much lower than the cost of creating a new customer. Once you've convinced a player to buy your first game from you, you don't have to work as hard to sell them your future games. If you stay in contact with your players and help them to create a community around your games, then you have taken the first step toward turning your players into an annuity.

Not all of your first game's players will buy your second game, or any other game you create and release. Like download-to-purchase conversion rates, there are no guarantees. However, players who purchase one game from you are often predisposed to purchase another.

You're not limited to selling your players only new games. Depending on your particular game, you may be able to sell expansion sets or other upgrades to the game they've already purchased. Some puzzle games, for instance, do well by selling collections of new puzzles to solve.

Chapter 23, Pricing, discussed Samu Games' original *Paintball Net*, which offered 14 different access levels for $10 each. Each level required only a single, one-time payment. However, over time, they saw that a player who paid for any one level was 50% likely to pay for another. Even in *Artifact*, before it was changed to a subscription-only payment structure, players who purchased the basic "Citizenship" access level were 30% likely to buy at least one upgrade.

LEVERAGING YOUR TEAM

Last, but certainly not least, if you formed a team to create your game, then you have forged relationships that will last for years, possibly even a lifetime. The nature of these relationships is both professional and personal—professional because you worked together (and may again), and personal because of the nature of indie game development.

Everyone who is involved in a completed indie project learns something as a result of that project. They grow both professionally and personally. They hone their skills, they learn to work both independently and as part of a team, and they improve their ability to relate to other people.

The most obvious way to leverage your first game's team is to bring them back to tackle another. The group of you worked together once, so it is highly probable that you could work together again. As you were working on the first game, new game ideas were undoubtedly generated and considered. Now that the first game is done, you can bring those ideas back up and choose a new project. Maybe it will be like the first one, or maybe it will be completely different.

But, when the game that brought the team together is completed, the team members might each go their own ways to do their own things. People change over time, and their goals change as they do. It's not always possible to work with the same team.

Even if you don't work together on a new project right away, you have formed the basis for a 'professional indie network.' If you stay in touch with your team, you can leverage their experience and contacts to help with your future projects. And of course, you can do the same for them. You might participate in one of their projects now, or you might swap off contract work as you each pursue your own dreams.

Professional friendships are a hard-won commodity. Don't let them slip away.

Conclusion

A completed, released game is a very valuable asset for any game developer, indie or otherwise. Not only does it prove that you can design, develop, and publish a game on your own, it provides benefits above and beyond a single income stream.

To complete your game, you had to create source code and content resources that you may be able to use in future games. Whether you're creating sequels to your first game or entirely different games, there will be opportunities to reuse and recycle resources.

In addition, your players can not only help you improve your finished game, they can be tapped to help with future products as play testers and maybe even team members. The players of your first game are also your first audience for your next game.

Finally, you and your team may be able to create other games and form the basis for an entirely new game development dynasty. Even if you don't work together again, you and your team members will be valuable contacts for each other as you pursue your separate careers and goals.

A FINAL WORD

Hopefully, this book has helped you see how you can succeed as an independent game developer. Keep in mind that just because you're independent doesn't mean you have to work alone or in isolation. There is a growing community of indies on the Web, located at places like Garage Games (*http://www.garagegames.com*) and GameDev.net (*http://www.gamedev.net*). Reach out and make contact. Often, it's as simple as saying, "Hello!"

Never forget that you are part of the greater community that is the computer game industry. Learn from those who have walked the path before, and help those who are following in your footsteps.

Look for opportunities everywhere, and always remember that when one of us succeeds, we all succeed.

THE INDIE GAME DEVELOPER SURVEY

*T*he *Indie Game Developer Survey* was conducted in the fall of 2002. The survey was posted on a handful of game development sites and e-mailing lists, especially those with an independent developer slant, as well as on the member forum of the Association of Shareware Professionals.

The survey had a total of 63 respondents representing a wide spectrum of independent game developers. From new indies still working to complete their first project, to established professionals, their responses provide a cross-section of what they're doing and how they're doing it.

SURVEYOR'S NOTES

A lot was learned by conducting this survey and summarizing its results, not only about indie game developers, but also about creating and conducting surveys. Some of the questions made perfect sense when they were added to the survey, but they seemed redundant or unnecessary when it came to reviewing the results. Where this has happened, questions in this appendix were removed and/or the results of two or more questions were consolidated.

The total responses to each question are noted, as well as the tally of each particular answer. These have been converted to percentages to make the information easier to read. Questions that asked free-form or 'short answer' questions have been summarized for brevity, with similar responses combined. Since the survey was conducted as this book was being planned, the survey is divided into sections that reflect the sections of the book.

SECTION I: INDIE PRELIMINARIES

1.01. Do you consider yourself an indie game developer?

Yes 94% (59)

No 6% (4)

Total Responses: 63

1.01A. If so, what does it mean to you to be an indie developer?

A number of responses to this question boiled down to: "No outside funding," which is arguably the most obvious definition of being an indie, including those games that are eventually sold to a publisher. Some took the 'no outside funding' concept a bit further with, "Using your own funds to create a game and selling them directly to players." This moves past the funding issue and positions the indie closer to their market of players.

There were also a number who said, "Being your own boss and making the games you want to make," as well as: "Making your own games for your own reasons," and: "Freedom to try unconventional game ideas and interact directly with players to make the games better." Combining the source of funding with the freedom to choose elicited this somewhat dark, but also somewhat humorous response: "Creative freedom and lack of money."

Some respondents saw indies as game developers who could take advantage of smaller niche markets that the traditional publishers were overlooking. Some considered indies were those "working outside the established industry" altogether.

There were also a number of responses that eschewed potential profitability, focusing on the creative process and having fun: "Making games for fun, and not being concerned with finishing the game or making a profit on the game if it is completed."

1.01B. If not, what do you call what you do?

There were only a few responses to this question. The most notable were:

• An incredible waste of time. (More dark humor.)
• An ambitious hobbyist.
• An open-source game developer.

1.02. What do you like best about what you do?

Most of the responses to the question could be summarized as: "Creative freedom." In the same vein were: "Independence. Doing my own thing," and "Experimenting with new things."

Some respondents expressed their thoughts more completely: "Being able to design and build a game the way *I* think it should be designed and built, and only releasing it when it's *done*, ignoring external demands and schedules." Taking this even further were those who said: "Keeping control of my ideas and building my own intellectual property."

Quite a few were happy just 'making games,' as well as "Seeing players enjoy the game I imagined and created," and "Playing the games I've made or helped make." There was also 'the challenge,' 'creating worlds,' 'being in control,' and 'learning new skills.' Finally, there were those who liked 'the community of indie game developers.'

1.03. Why do you do what you do?

This question proved to be somewhat redundant, asking almost the same thing as Question 102. Still, there were some good responses.

Most of those who didn't just refer to their response to Question 102 said they did what they did because they enjoyed doing it; or, as one respondent put it: "I can get away with it and not have to get a 'real' job." They found the challenge of designing games stimulating and satisfying. It's their passion. Those who weren't already doing indie game development full-time were looking forward to someday being able to.

1.04. (Optional) How did you become an indie? Was it planned, or did it 'just happen?'

The responses to this were about evenly divided between 'planned' and 'just happened.' Many of the respondents had wanted to make games since they were teenagers or preteens, and had pursued their goal of making games since then. A few indicated they had tried to get into the traditional game development industry, but had failed or had decided (for a variety of reasons) that to make the games they wanted to make, they would have to go it on their own.

Some of the 'just happened' group had their indie businesses grow out of their hobby, which was making games.

Not everyone who 'planned' to become an indie followed their plan. Some moved gradually from working full time to being an indie. Others got fed up with their full-time jobs and simply quit.

1.05. How long have you been an indie?
 Less than one year 22% (14)
 One to three years 37% (23)
 Four to five years 25% (16)
 Six to nine years 8% (5)
 More than 10 years 8% (5)
 Total Responses: 63

1.06. Are you a full-time indie?
 Yes 38% (24)
 No 62% (39)
 Total Responses: 63

1.07. Do you make your primary income from being an indie?
 Yes 25% (16)
 No 75% (47)
 Total Responses: 63

1.08. How much do you make yearly (before taxes) from your indie prod-
 ucts?
 Less than $1,000 43% (27)
 Less than $10,000 14% (9)
 Less than $50,000 8% (5)
 Less than $100,000 6% (4)
 More than $100,000 2% (1)
 Undisclosed 27% (17)
 Total Responses: 63

1.09. How many indie products (games or other software) have you re-
 leased?
 Working on my first 44.4% (28)
 One 12.6% (8)
 Two to three 25% (16)
 Four to five 6% (4)
 Six to nine 8% (5)
 More than 10 3% (2)
 Total Responses: 63

1.10. (Optional) Do you sell only games?

Yes 49% (30)

No 51% (31)

Total Responses: 61

SECTION II: INDIE GAME DESIGN

2.01. Do you make only the kind of games you like to play?

Yes 62% (39)

No 38% (24)

Total Responses: 63

2.02. (Optional) What kind of games or products do you prefer to work on?
The responses to this question covered the gamut of game genres:

- Mecha-anime
- Real-time action games
- Games using cutting-edge technology
- Games with a unique gameplay mechanic or 'gimmick' games
- Puzzle games
- Strategy games
- RPGs
- FPSs
- RTSs
- Arcade shooters
- Fighting games
- Card games
- Realistic, non-frustrating games
- Educational games for children
- 2D platform games
- Sim-type games
- Games that require you to think more than twitch
- Time-killer games
- Classic/Parlor-type games
- Online games
- Turn-based strategy games
- Story-based games
- Adventure games
- Racing games
- My own games
- Cyberpunk or high-fantasy themed games

- MMPs
- War games

 In other words, indies like to make games. All sorts of games.

2.03. How do you choose the games or products you're going to work on?

As would be expected, most indies have their own ideas, and they choose from these. For those who were part of a team, they said that they would discuss game ideas with the whole team, and then they would all participate in choosing the idea to pursue.

A few said they used various forms of market research; some look for what's doing well now, and others looked for holes in the market or niches that weren't being serviced.

This one response summed up the process quite well:

1. What kind of development cycle can I support with my current income and savings?
2. What categories of games can I create within that duration?
3. What does the market research tell me about games in that category that sell?
4. What do I want to explore within that framework?

Some of the respondents discussed where they got their ideas. Popular inspirations were games played when they were younger, as well as mass-culture media such as movies, books, TV, and music. There were also those who got their ideas from figuring out how to use a particular technique or technology in a game. Finally, this response spoke volumes: "Delusions of grandeur."

2.04. What is the scope of projects you have completed (e.g., number of people required, budget, etc.)? If you have completed multiple projects, then answer for each project, unless all projects have about the same details.

A significant number of the responses were: "Just me." Several of these were working on their first project, but there were those who had completed as many as 17 projects, all by themselves. Sometimes these projects used contract work to augment the developer's skills. Time frames for these solo projects ranged from a month to as much as a year and a half. The following projects had more than one developer involved:

- First project, three team members
- Five team members, six months, self-funded
- Multiple projects, small teams, no budget
- Five team members, two and one-half years
- Multiple projects, three to four team members, six months to a year

- Three team members, 12 weeks, self-funded
- Twelve months, 12 team members
- One programmer, one artist, all free stuff
- One programmer, one designer
- Three to five people, full time for four to six months
- Multiple projects, one to three team members, 3–12 months
- One year, four team members, no budget
- Six months, four team members
- Three team members, no budget

2.04A. Number of team members:

One	52% (32)
Two to three	27% (17)
Four to five	13% (8)
Six to nine	2% (1)
More than 10	6% (4)

Total Responses: 62

2.04B. Length of development time:

Less than three months	15% (9)
Three to six months	43.3% (26)
Seven to 12 months	18.3% (11)
One to two years	10% (6)
More than two years	13.3% (8)

Total Responses: 60

2.04C. What was your budget, or actual money spent toward the completion of the project (e.g., for components, contractors, servers, etc.):

Eh? Budget?	56.7% (34)
Less than $1,000	16.7% (10)
Less than $10,000	20% (12)
Less than $100,000	5% (3)
More than $100,000	1.6% (1)

Total Responses: 60

2.05. Is project scope a factor in deciding whether you will proceed with a project?

Yes	81% (51)
No	19% (12)

Total Responses: 63

2.06. What factors affect your decision? (Indicate all that apply.)

Length of time required	79% (50)
Subject matter	68% (43)
Budget required	65% (41)
Size of team required	56% (35)
Ability to complete the project	11% (7)
What I want to make	5% (3)
Market research	5% (3)
Contract	3% (2)
Time required	2% (1)
Other	75% (47)

Total Responses: 232
Total Respondents: 63

2.07. How important is a completed design document to your projects?

Very important—it's all mapped out before I start.	10% (6)
Important—I create a detailed description before starting, but I'm flexible.	35% (22)
Sometimes I jot down a few notes before I start.	21% (13)
Varies with the scope of the project.	29% (18)
I'm an indie, so I can do what I want.	5% (3)

Total Responses: 62

2.08. (Optional) What other types of projects or games would you like to pursue?

Most of the responses to this question were: "I'd do more games." Some people wanted to do games that were less commercial and more experimental, including games with religious themes. Other responses:

- Source code control system
- Designing a programming language
- Game-related utilities
- Console games
- Generic game systems (e.g., animation, AI, etc.)
- Writing/designing pen-and-paper RPGs, books, and board games
- Theatre, festivals, and events; filmmaking
- Web-based media
- Compose music

SECTION III: INDIE BUSINESS

3.01. What kind of business structure do you use for your company, if you have one?

Sole proprietorship	61% (37)
LLC/Ltd.	15% (9)
None	12% (7)
Limited partnership	7% (4)
S Corporation	3% (2)
C Corporation	2% (1)

Total Responses: 60

3.02. Do you have any partners in your company?

Yes	26% (16)
No	74% (46)

Total Responses: 62

3.02A. How many?

Just me	72% (41)
Two to three	26% (15)
Four to five	2% (1)

Total Responses: 57

3.03. Do you keep your company ownership separate from ownership of your projects?

Yes	27% (16)
No	73% (43)

Total Responses: 59

3.04. Have you ever created a project-specific company?

Yes	10% (6)
No	90% (55)

Total Responses: 61

3.04A. What kind of project-specific company structure did you use?

None	25% (1)
LLC	25% (1)
Limited partnership	25% (1)
General partnership	25% (1)

Total Responses: 4

3.05. Do you consult a lawyer for business purposes?

Yes	32% (20)
No	68% (42)

Total Responses: 62

3.06. How often do you talk to a lawyer about your business?

Monthly	4% (2)
Quarterly	10% (5)
Annually	4% (2)
Never	32% (16)
As needed	20% (10)
Other	30% (15)

Total Responses: 50

3.07. (Optional) Do you have a collection of standard agreements you use with your projects and team members?

Yes	36% (21)
No	64% (38)

Total Responses: 59

3.08. Do you retain an accountant for business purposes?

Yes	32% (20)
No	68% (42)

Total Responses: 62

3.09. How often do you talk to an accountant about your business?

Monthly	9% (4)
Quarterly	12% (5)
Annually	19% (8)
Other	60% (26)

Total Responses: 43

3.10. How do you handle income division/profit sharing for team-based projects?

Since many indies work alone, they don't have to worry about sharing any profits. A handful indicated that they had no profits to share, so they also weren't worrying about it. On the other end of the spectrum were those who didn't do profit sharing per se, because their team was composed of employees who were paid regular salaries with the possibility of bonuses. Of those who did do

some form of profit sharing, there were a number of ways they handled it:
- Equal shares for all team members.
- A percentage or share agreed upon in a signed team member agreement.
- Percentages and bonuses based on contribution to the project.
- 'Core' team members dividing most of the profit, with other team members dividing the rest.
- A 'royalty' percentage that is set aside and divided among team members.

3.11. How often do you inform your team members about revenues and expenses?

Monthly	20% (10)
Quarterly	10% (5)
Annually	4% (2)
As needed	12% (6)
Never	30% (15)
Other	24% (12)
Total Responses: 50	

Section IV: The Indie Team

4.01. Have you ever completed a project that required more than just one team member (yourself)?

Yes	47% (29)
No	53% (33)
Total Responses: 62	

4.02. What kind of team members do you look for?

I'll take anybody.	8% (3)
Enthusiastic amateurs who display talent and potential.	39% (14)
Enthusiastic hobbyists with some professional experience.	25% (9)
Professionals with a good track record and at least one completed project.	14% (5)
Seasoned professionals with multiple projects under their belts.	14% (5)
Total Responses: 36	

4.03. Do you prefer to make people part of the project team?

Yes 64% (23)
No 36% (13)
Total Responses: 36

4.03A. Or, do you prefer to use work-for-hire contractors?

Yes 45% (15)
No 55% (18)
Total Responses: 33

4.04. How do you usually find new team members? (Check all that apply.)
Posting on "help wanted" web pages
(e.g., on GameDev.net, Garage Games, etc.) 47% (17)
Posting on Usenet newsgroups/e-mail lists 14% (5)
Via professional contacts 36% (13)
Worked with them on past projects 67% (24)
No team 3% (1)
IRC 3% (1)
Publisher 3% (1)
Colleges 6% (2)
Friends/Family 6% (2)
Recruiter 3% (1)
Total Responses: 118
Total Respondents: 36

4.05. If you have used Web pages or Usenet newsgroups, where have you
had the best results?

A number of responses indicated success with e-mailing peo-
ple they were interested in, and also with people who contacted
them from their Web pages. A handful stated that they had no
luck at all, or had 'horrible' luck posting on Web pages. Web pages
that were specifically mentioned as good places to post were:

• *http://www.gamedev.net*
• *http://www.deviantart.com*
• *http://www.gamasutra.com*
• *http://www.flipcode.com*

4.06. How do you screen prospective team members? (Check all that apply.)

E-mail	76% (26)
Resume/CV	50% (17)
Testing for logic/skills	47% (16)
Face-to-face interview	26% (9)
Phone interview	21% (7)
Checking references	21% (7)
Portfolio/Samples	9% (3)
IRC/IM chat	6% (2)
Logic problems	3% (1)

Total Responses: 88
Total Respondents: 34

4.07. Do you have a standard team member agreement you have new team members sign?

Yes	17% (6)
No	83% (30)

Total Responses: 36

4.08. What kind of payment arrangements do you typically use with your noncontractor/non-work-for-hire team members (assuming net profits)?

I/my company takes a significant slice of the pie; team members divvy up the rest	16% (5)
Pure profit sharing, everyone gets an equal share	31% (10)
Some team members are paid as an expense prior to general profit sharing	6% (2)
Some combination of the above (please give details, if you can)	16% (5)
Percentage of net profit	6% (2)
According to contribution	6% (2)
Other	25% (8)

Total Responses: 32

4.09. Do you pay your noncontractor/nonwork-for-hire team members prior to the end of the project?

Yes	32% (10)
No	68% (21)

Total Responses: 31

4.09A. If so, how do you track this? Is it an 'advance on royalties' or something else? Please explain.

'Advance on royalty' was by far the most usual circumstance. Several responses, though, said they purchased modules or tools that team members needed. Others said they would front money to team members who were hard up, based more on an 'honor system' than any advance or expense setup.

4.10. (Optional) Do you see yourself as a project manager, a project leader, or as something else altogether?

Most of the responses indicated that they (sometimes reluctantly) wore both hats, project leader as well as project manager.

Project leader	29% (7)
Project manager	8% (2)
Both	63% (15)
Total Responses: 24	

4.11. How do you keep your team motivated throughout the project?

The most common motivational technique mentioned was: "Visible progress with frequent releases and screen shots," also: "Clear goals, and fast, achievable milestones." Progress reports, status meetings, and other kinds of communication made on a regular basis were frequently mentioned, as well as appreciating the team's work.

Some responses stated that they didn't attempt to motivate their teams. They tried to build a team of self-motivated people or relied on shared circumstances (and the potential for shared tragedy). Some weren't sure *how* to motivate their teams.

4.12. How often do you keep in contact with all your team members?

Daily	26% (9)
Two to three times per week	46% (16)
Weekly/Semi-weekly	28% (10)
Total Responses: 35	

4.13. How do you stay in contact with your team members? (Check all that apply.)

E-mail/Web	100% (35)
IM (e.g., ICQ, AIM, etc.)	66% (23)
Phone	43% (15)
Face-to-face meetings	43% (15)
Total Responses: 88	
Total Respondents: 35	

SECTION V: BUILDING THE GAME

5.01. What platforms do you target with your projects? (Check all that apply.)

Windows	100% (60)
Mac	18% (11)
Linux	23% (14)
Palm/Pocket PC	3% (2)
Cell phone	3% (2)
Game console	3% (2)
DOS	2% (1)

Total Responses: 92
Total Respondents: 60

5.02. What development language(s) do you use? (Check all that apply.)

C++	78% (47)
C	33% (20)
Java	13% (8)
Python	12% (7)
Delphi/Pascal	10% (6)
Visual Basic	8% (5)
Assembler	5% (3)
Flash/Shockwave	3% (2)
Web	2% (1)
C#	2% (1)
Other	12% (7)

Total Responses: 107
Total Respondents: 60

5.03. How many third-party development libraries/components do you use?

I build everything myself.	17% (10)
One to three significant libraries/components.	68% (41)
Four to 10 significant libraries/components.	13% (8)
11-100 significant libraries/components.	2% (1)

Total Responses: 60

5.04. Which kinds of third-party libraries/components do you typically use? (Check all that apply.)

Sound/Audio	60% (35)
Graphics—2D	50% (29)
Graphics—3D	47% (27)
Networking/Sockets	31% (18)
User interface	21% (12)
Containers	16% (9)
Physics	14% (8)
Database	12% (7)
Resource management	10% (6)
Class hierarchies	9% (5)
Artificial intelligence	3% (2)
Allegro	2% (1)
Other	5% (3)

Total Responses: 162
Total Respondents: 58

5.05. Do you use mostly:

Freeware components/libraries	66% (37)
Shareware components/libraries	11% (6)
Commercial components/libraries	23% (13)

Total Responses: 56

5.06. (Optional) Would you mind listing the third-party components/libraries you have most enjoyed using?
The most popular libraries mentioned were:
- SDL
- FMod
- Allegro

Others that were mentioned:
- SDL_mixer
- Topaz
- BASS
- Miles Sound System
- Tsock and Flat components
- Renderware
- HawkNl
- Havok
- mTropolis

- SpriteWorld
- GLFW
- Boost
- Reality Factory
- PyGame

5.07. What libraries/components do you prefer to build yourself? (Check all that apply.)

Artificial intelligence	67% (39)
User interface	66% (38)
Graphics—2D	47% (27)
Class hierarchies	45% (26)
Resource management	45% (26)
Physics	43% (25)
Database	34% (20)
Containers	34% (20)
Graphics - 3D	29% (17)
Networking/Sockets	29% (17)
Sound/Audio	28% (16)
Everything	3% (2)
Debug tools	2% (1)
Scripting	2% (1)

Total Responses: 275
Total Respondents: 58

5.08. (Optional) Have you built a 3D engine of your own?

Yes	37% (22)
No	63% (38)

Total Responses: 60

5.08A. (Optional) Have you used your 3D engine in a completed project?

Yes	13% (7)
No	87% (46)

Total Responses: 53

5.08B. (Optional) Would you create a 3D engine again (instead of licensing one)?

Yes	43% (20)
No	57% (26)

Total Responses: 46

5.08C. (Optional) Why or why not?

Why they would:
- Because I love to learn.
- Prefer to build my own.
- Can't afford to license the 3D engine I want.
- Need specific functionality.
- Experimenting.
- Planning for future use.
- Don't like how existing 3D libraries are built.

Why they would not:
- Beyond our scope.
- Too much time/effort.
- Not necessary for the game(s) we're making.
- Don't have the technical skills.
- Would rather focus on making games over making (and maintaining) an engine.

5.09. What kind of project management software do you use?

None. I do it all by hand.	75% (46)
Microsoft Project	8% (5)
Other	7% (4)
Web-based	5% (3)
Excel	3% (2)
None at all.	2% (1)
Total Responses: 61	

5.10. What kind of project 'resource' management software do you use?

CVS	35% (18)
None	25% (13)
Visual SourceSafe	18% (9)
Other	10% (5)
Manual file- or folder-based	6% (3)
Back-ups	6% (3)
Total Responses: 51	

5.11. Omitted (redundant question).

5.12. (Optional) Can you give a brief overview of how you manage the development phase of your projects?

A number of the responses to this question boiled down to: "Keeping lists of what needs to be done and who's doing it, some-

times with deadlines and due dates," also: "Very freeform, based on team members communicating with each other." In some case, team members were specifically given nonoverlapping responsibilities to reduce task/resource dependencies.

Milestones were important to several people, as well as iterative development, frequent testing, and Extreme Programming techniques.

5.13. How do you find testers for your game? (Check all that apply.)

Players of other games you created	66% (33)
Posting on 'help wanted' Web pages (e.g., on GameDev.net, Garage Games, etc.)	40% (20)
Friends/Family	40% (20)
Posting on Usenet newsgroups	18% (9)
Colleges/Schools	8% (4)
Professional contacts	6% (3)
Built my own 'test lab' with cheap computers	2% (1)
Other	2% (1)

Total Responses: 91
Total Respondents: 50

5.14. (Optional) How do you manage testers?

Responses to this question ranged from their surprise that managing testers was even needed, to admissions that they were still trying to come up with a good system, all the way to fully managed testers who followed test plans and provided detailed feedback. Here are the summarized responses:

- Still experimenting. Looking to improve.
- I use inexperienced users to test the user interface and ease of use.
- Made the installation available via download and handled bug reports via e-mail as they arrived.
- Private Web page for downloading test builds, with bug reports submitted by e-mail.
- I don't.
- Bug reports sent in by e-mail/instant messaging.
- Test build creates an information file that is sent in by e-mail.
- Daily feedback about bugs encountered.
- Bug-tracking software.
- Free demo, and volunteers send in bug reports.
- Test plan.
- Clear direction and limited instruction, followed by detailed feedback.
- Web-based message forum for testers.

Section VI: Selling the Game

6.01. What kind of self-publishing have you used with your projects? (Check all that apply.)

Shareware via Internet	65% (39)
Freeware	43% (26)
Retail	23% (14)
Shareware via mail/floppies/CD-ROMs	13% (8)
None	7% (4)
Open Source	3% (2)
Sub-licensing	2% (1)
Total Responses: 94	
Total Respondents: 60	

6.02. What third-party services do you use for your self-publishing? (Check all that apply.)

Credit card/payment processing	57% (34)
Download hosting	48% (29)
Server hosting	37% (22)
Web promotion	18% (11)
None	13% (8)
Web page development	8% (5)
Customer service	8% (5)
CD-ROM/Merchandise fulfillment	3% (2)
Total Responses: 116	
Total Respondents: 60	

6.03. What do you handle on your own? (Check all that apply.)

Web page development	80% (48)
Customer service	57% (34)
Web promotion	53% (32)
Download hosting	25% (15)
Server hosting	17% (10)
None	7% (4)
Credit card/payment processing (merchant account)	5% (3)
Other promotion	2% (1)
Total Responses: 147	
Total Respondents: 60	

6.04. Do you have a marketing plan?

Yes 37% (22)

No 63% (37)

Total Responses: 59

6.05. Are you following your marketing plan?

Yes 44% (23)

No 56% (29)

Total Responses: 52

6.06. How much time do you spend on marketing each week?

Less than one hour 53% (30)

One to three hours 33% (19)

Four to five hours 7% (4)

Six to 10 hours 3.5% (2)

More than 10 hours 3.5% (2)

Total Responses: 57

6.06A. How much time do you think you *should* spend on marketing each week?

Less than one hour 17.5% (10)

One to three hours 30% (17)

Four to five hours 17.5% (10)

Six to 10 hours 5% (3)

More than 10 hours 30% (17)

Total Responses: 57

6.07. What do you consider is the most important part of marketing for indie developers?

A surprising and sobering number of responses to this question were simply: "I don't know." Marketing seems to be one of the hardest topics for indies to learn, as evidenced by responses like:

• Focus on making games, and let someone else handle marketing.
• Get a good reputation among other game developers.
• Have connections.
• Focus on story and content.

Other responses read like a series of quick 'marketing blurbs':

• Learn to market your games effectively.
• Find the community of potential players.

- Use word of mouth.
- Use publicity and exposure.
- Get listed on the major download sites.
- Make a good demo. Show good screen shots.
- Use direct-marketing techniques.

More in-depth responses were:
- Have a marketing plan.
- Attract players, convince them to download, and then compel them to buy.
- Take small steps, focusing on incremental improvement.
- Track what you are doing to make sure it's working.
- Break out of the indie game community and promote your game to the mass market.
- Find new and unique ways to make your game stand out.
- Concentrate on your target market. Don't waste time and energy promoting your game to people who aren't interested.
- Find ways to make new sales to existing customers.

6.08. How do you plan to leverage your existing products for future projects?

I try to keep the products distinct, but there is some overlap in player interest.	24% (14)
I like distinct products, but I want them to have very similar appeals.	19% (11)
Sequels, sequels, sequels—it's what I do.	16% (9)
I'm always looking to create something new and different.	19% (11)
No plans. Each product is on its own.	22% (13)

Total Responses: 58

6.09. Does your product have an active community of players/users?

Yes	33% (19)
No	67% (39)

Total Responses: 58

6.10. How do you communicate with your players/users? (Check all that apply.)

Web page	79% (46)
Newsletter—e-mail/Web page	47% (27)
E-mail list	34% (20)
In-product announcements	34% (20)

Direct e-mails	26% (15)
I log on and play with them openly	14% (8)
Newsletter—direct mail	12% (7)
IRC	2% (1)

Total Responses: 144
Total Respondents: 58

6.11. How do you handle customer service? (Check all that apply.)

E-mail	83% (48)
Web-based forums	48% (28)
Phone	14% (8)
IRC/IM	2% (1)
In-game	2% (1)

Total Responses: 86
Total Respondents: 58

SECTION VII: THE FUTURE

7.01. How long do you plan to continue as an indie?

Forever! *Vive la indie!*	61% (37)
Six to 10 years	5% (3)
Three to five years	11% (7)
One to two years	5% (3)
Until I find a publisher	18% (11)

Total Responses: 61

7.02. What do you think is the most important thing for an indie to succeed at?

The responses have been summarized, but they still speak for themselves:

- Persistence and more perseverance; focus on the long haul and don't give up.
- Time management, motivation, and organization.
- Marketing.
- Patience.
- Find a niche and fill it.
- Enjoy it and love it—or forget it!
- Enthusiasm.
- Finishing projects and having fun.

- Accepting your limitations as an indie and working within them.
- Sales.
- Commitment, originality, and guts.
- A vision and clear goals.
- Passion.
- Skill.
- Be innovative, but still treat it as a business.
- Time and money.
- Determination.
- Have realistic goals.
- Dedication.
- Tenacity.
- Don't quit your day job.
- Understand that you are responsible for your level of success; if you believe you are going to succeed, then you will do what you have to in order to make it come true.
- A mix of technical and business skills.
- I don't know.
- Be happy.
- Never stop.
- Make a good plan, then follow the plan; also, have good team members.
- Entertain the player, first and foremost.
- Do what you like.

7.03. What do you see as the future for indies?

Again, the summarized responses speak for themselves. Not all of them agree, but in general, the outlook is positive:

- Sponsorships, like in professional sports.
- Indies will continue to profit in niche markets that publishers are missing. The indie community will continue to grow and become stronger, providing more support for new indies.
- The growth of the Internet is diminishing the power of the big publishers and fueling the growth of indie game developers. I predict that as indies grow, there will be consolidation, resulting in a situation like the music industry's.
- The future is wide open.
- The future will be much the same as it is now. Indies will continue to make games that the publishers don't think they can make money on.
- There will always be indies, and it will always be tough. Only the best will succeed.

- There will be more and more people becoming indie game developers.
- Being an indie can be expensive and risky. If we don't share and cooperate, most indies will be stuck on the sidelines.
- The public at large will become more comfortable buying games from small indies, and broadband will allow larger games to be easily downloaded over the Internet.
- The best new game developers will come from the ranks of indies.
- The future for indie game developers is bright—if they are smart.
- The indie game market will always be small, but it will always exist, much like the indie movie market, which 80% of Americans don't even know exists.
- Internet distribution will enable the indie to thrive while the retail PC market dwindles.
- Indies will be more creative, attracting players less with 'eye candy' and more with depth and solid gameplay. Indies will make the games that the big publishers are scared to make.
- Indies are creating the future of computer games. There is room for everyone, not just a few big companies.
- The future is a bit grim. Things used to be better, but once companies started consolidating in the 1990s, it became tough to make it on your own.
- It's going to be harder, because games require more and more content, unless you focus on smaller games.
- It's becoming more difficult, but not impossible. As long as you enjoy doing it a lot (and have the perseverance to complete projects) it can be a great future.
- With the indie game scene becoming more stable, there is a lot of opportunity for small teams to make good games. So, the future is bright.
- In the future, it may be harder to keep up as new technologies arrive. But those new technologies will also provide new possibilities and opportunities.
- There will always be a market for indie games.
- The indie will be able to get into more complex games as the tools to create such games become quicker, cheaper, and easier to use.
- There will be more experienced developers from the computer game industry becoming indies. There will be a shift from 'indie/novice' to 'indie/self-directed developer.'

- Indies from music, modeling, games, movies, and other industries will join forces to make our presence better known, and better respected.
- As long as we keep making fun, enjoyable, addictive games, we will have a future.

"RAW" SURVEY RESULTS

If you would like to see the "raw" survey results, you can find them online at *http://www.samugames.com/indiesurvey/IndieSurveyResults.html.*

THIRD-PARTY LIBRARIES, COMPONENTS, AND SERVICES

This appendix provides a short list of the third-party libraries and components that are available on the World Wide Web, which might be of interest to indie game developers. They are categorized by primary function (e.g., 3D rendering/engines, 2D drawing/engines, etc.).

The libraries and components listed are those judged to be of interest to independent game developers. Thus, some of the more expensive third-party products aren't mentioned, such as the *Quake 3* engine (Id Software), NetImmerse (NDL) or Renderware (Criterion Software). While these are outstanding products that are used in numerous successful games, they are probably outside the reach of most indies.

Note: Prices quoted in this chapter are in constant U.S. dollars, and are current to the best of the author's ability, as of 2003.

3D RENDERING/ENGINES

6DX

http://www.aztica.com/
License: Commercial, $195
Programming Languages: C++, Delphi, Visual Basic, and other languages that support COM
Platforms Supported: Windows

Crystal Space 3D

http://www.crystal.sourceforge.net/
License: Free, LGPL (Open Source)
Programming Language: C++
Platforms Supported: GNU/Linux, Unix, Windows, and MacOS/X
using OpenGL (on all platforms), Allegro (GNU/Linux), X11
(Unix or GNU/Linux), and SVGALIB (GNU/Linux)

DelphiX

http://www.yks.ne.jp/~hori/DelphiX-e.html
License: Free
Programming Language: Delphi (Pascal)
Platforms Supported: Windows using DirectX

Notes: As of this writing, DelphiX had not been updated since late
2000, so you might be better served with UnDelphiX (*http://turbo.
gamedev.net/undelphix.asp*).

Genesis 3D

http://www.genesis3d.com/
License: Free, Open Source (see Notes)
Programming Language: C++
Platforms Supported: Windows using DirectX

Notes: The free, Open Source license requires that developers release
any modifications to the engine source code or to the accompanying
tools. There is a $10,000 licensing fee that will remove this requirement.

Nebula Device

http://www.radonlabs.de/nebula.html
License: Tcl/Tk (free)
Programming Language: C++
Platforms Supported: Windows and Linux, using DirectX and
OpenGL

OGRE

http://www.ogre.sourceforge.net/
License: LGPL
Programming Language: C++
Platforms Supported: Linux, Windows, and MacOS/X, using DirectX
 (Windows) and OpenGL

PowerDraw

http://www.turbo.gamedev.net/powerdraw.asp
License: Free for commercial and noncommercial use
Programming Language: Delphi (Pascal)
Platforms Supported: Windows using DirectX

Notes: Also supports 2D drawing.

PowerRender

http://www.powerrender.com/
License: Commercial, $89.95 (Lite version); $289 (shareware)
Programming Language: C/C++ and Delphi
Platforms Supported: Windows using DirectX

Quake 1/Quake 2 from Id Software

http://www.idsoftware.com
License: GPL (free for noncommercial use)
Programming Language: C/C++
Platforms Supported: Windows using OpenGL

Notes: There is also a $10,000 per title licensing option, with no back-
end royalties.

Torque Game Engine from Garage Games

http://www.garagegames.com
License: $100, Commercial
Programming Language: C++
Platforms Supported: Linux, Windows, and MacOS/X, using DirectX
 (Windows) and OpenGL

Notes: For game developers or publishers with over $500,000 in an-
nual revenues, the licensing fee changes to a one-time payment of
$10,000.

WildTangent

http://www.wildtangent.com/
License: Free for personal use
Programming Language: C, C++, Java, JavaScript, and other COM-
 based languages
Platforms Supported: Web browsers on Windows

Notes: Commercial Technology License required for commercial projects.

2D DRAWING ENGINES

Some of the 3D engines previously listed will handle 2D drawing, as well.

Fastgraph by Ted Gruber Software
http://www.fastgraph.com/
License: Commercial, $149–$399
Programming Language: C, C++, Delphi, Visual Basic, .NET
Platforms: Windows and DOS

USER INTERFACE

Developing a GUI Using C++ and DirectX, Part 1

http://www.gamedev.net/reference/programming/features/gui/

Developing a GUI Using C++ and DirectX, Part 2

http://www.gamedev.net/reference/programming/features/gui2/

Developing a GUI Using C++ and DirectX, Part 3

http://www.gamedev.net/reference/programming/features/gui3/

Developing a GUI Using C++ and DirectX, Part 4

http://www.gamedev.net/reference/programming/features/gui4/

GLUT/GLUI

GLUT: *http://www.opengl.org/developers/documentation/glut.html*
 GLUI: *http://www.gd.tuwien.ac.at/hci/glui/*
 License: LGPL
 Platforms Supported: Any with OpenGL

AUDIO LIBRARIES

BASS

http://www.un4seen.com/
License: Shareware, $100
Programming Language: C/C++, Visual Basic, Delphi, MASM, and
 TMT Pascal
Platforms Supported: Windows

FMOD

http://www.fmod.org/
License: Free for noncommercial use, otherwise varies by platform
Programming Language: C/C++, Visual Basic, Delphi, MASM
Platforms Supported: Windows, Windows CE, Linux, Macintosh,
 GameCube, PS2, and XBox

OpenAL

http://www.openal.org
License: Free
Programming Language: C/C++
Platforms Supported: Windows, Linux

CROSS-PLATFORM GRAPHICS & AUDIO

SDL: Simple DirectMedia Layer

http://www.libsdl.org
License: LGPL
Programming Language: C/C++
Platforms Supported: Linux, Windows, BeOS, MacOS, MacOS X,
 FreeBSD, OpenBSD, BSD/OS, Solaris, and IRIX

NETWORKING

HawkNL/HawkVoice

http://www.hawksoft.com/hawknl/
License: LGPL
Programming Language: C++
Platforms Supported: Windows 9x/ME/NT/2000/XP/CE, Linux, Solaris, IRIX, AIX, BSDs, MacOS 7-9, and MacOS X

DATABASE

MySQL

http://www.mysql.com/
License: LGPL
Programming Language: C, C++, Perl, Tcl, Python
Platforms Supported: Windows, Linux, Mac

SQLite

http://www.hwaci.com/sw/sqlite/
License: Free, public domain
Programming Language: C, C++
Platforms Supported: Most C, C++ compilers

INSTALLERS/UNINSTALLERS

InnoSetup

http://www.innosetup.com
License: Free
Platforms Supported: Windows

NSIS

http://www.nullsoft.com/free/nsis/
License: Free
Platforms Supported: Windows

MISCELLANEOUS

Boost C++ Libraries

http://www.boost.org/
License: Free
Programming Language: C++
Platforms Supported: Most C++ compilers

GAME 'BUILDER' PACKAGES

3D GameStudio

http://www.conitec.net/a4info.htm
License: Commercial, $49+

Platforms: Windows

IsoWorld

http://www.spritec.com/isoworld.html
License: Commercial, $99
Platforms Supported: Windows and Macintosh

Notes: License price given is for freeware and shareware game creation.

Multimedia Fusion by Clickteam

http://www.clickteam.com
License: Commercial, $99
Platforms Supported: Windows

Reality Factory

http://rfactory.uber-geek.ca/
License: Free, Open Source
Programming Language: Based on the Genesis 3D engine
Platforms Supported: Windows

Notes: Reality Factory is intended to help 'non-programmers' create games.

DarkBASIC

http://www.darkbasic.com/
License: Commercial, $14.99–$125.99
Platforms Supported: Windows

THIRD-PARTY PAYMENT SERVICES

This is a list of the most popular third-party payment services. The services offered by these companies vary widely. You can compare and contrast these and other services online at *http://www.regshare.com/*.

BMT Micro, Inc.

http://www.bmtmicro.com/

DigiBuy

http://www.digibuy.com

Kagi

http://www.kagi.com

RegSoft

http://www.regsoft.com

Register Now!

http://www.regnow.com

share*it!

http://www.shareit.com

SWREG

http://www.swreg.org

C

FESTIVALS AND ORGANIZATIONS

Not all of the organizations and conferences mentioned in this appendix are specific to independent game developers. However, that doesn't mean they cannot be very valuable to the new indie. The Association of Shareware Professionals, for example, has a lot to teach indie game developers about promoting and selling independently created software of all sorts.

THE INDIE GAMES FESTIVAL

http://www.indiegames.com

Created in 1998, with its first awards ceremony held at the 1999 Game Developer Conference, the Indie Games Festival (IGF) was created to "encourage innovation in game development and to recognize the best independent game developers." Like the Sundance Film Festival for independent filmmakers, the IGF provides a forum for indie games to be seen and possibly picked up by the large publishers. As of this writing, the IGF is in its fifth year, and it continues to support the interests of independent game developers.

Currently, the IGF has two competitions. The first, the IGF Competition, is for indies who either self-publish or are looking for a publisher for their game. The IGF Competition gives awards for Technical Achievement, Innovation in Visual Art, Innovation in Audio, and Innovation in Game Design. There are also the Audience Award and the Seumas McNally Award for Independent Game of the Year.

If you are interested in finding a publisher for your independent game, the IGF Competition provides one of the best opportunities to do that. Even if you don't want to be picked by a publisher, the IGF

Competition is a great marketing and PR opportunity. Finalists in the IGF Competition receive significant exposure in the game industry press, both online and in print.

The second part of the IGF is the IGF Student Showcase, which is open to high school and college students who are developing a game or game demo. To be eligible for the IGF Student Showcase, the game or demo must have been entirely developed by students, including all programming, art resources, and music. The IGF Student Showcase does not offer prizes per se. Being selected for the showcase is the prize, and the IGF contributes money to help the winning student(s) attend the festival at the Game Developer Conference.

For all the IGF's rules and eligibility requirements (there are quite a few), see the Indie Games Festival Web page at *http://www.indiegames.com.*

THE INDIE GAMES CON

http://www.garagegames.com
Founded in 2002, the Indie Games Con (IGC) was conceived and hosted by Garage Games as an outgrowth of the community that grew around their Torque Game Engine. Jeff Tunnel, president of Garage Games, is quoted on the IGC Web page: "After meeting with several GarageGamer's at the Game Developers Conference in 2002 we realized that a conference aimed at the specific needs of Indies was needed. . . . We need to get back to our roots of talking about game development, and especially the needs of the small, underfunded indie developer."

Unlike the IGF, the IGC is not a competition. Following the vision outlined by Jeff Tunnel, the IGC is more like an indie-specific Game Developers Conference. It features keynote speakers and presentations from veterans of both traditional and indie game development, with demonstrations of indie games in progress and a chance for indies to meet each other. In this spirit, the IGC takes a more holistic approach.

Indies are notoriously isolated, often working alone and never meeting even the other indies on their current team. Events like the Indie Games Con help you become part of the larger community.

GAME DEVELOPERS CONFERENCE

http://www.gdconf.com/
Originally known as the Computer Game Developers Conference, the Game Developers Conference (GDC) is the premier conference for game developers and publishers. The GDC offers nearly a week of tutorials, presentations, demonstrations, and general hobnobbing.

Industry leaders give presentations and demonstrations of the latest games and techniques. All electronic game platforms are represented: consoles, Windows, MacIntosh, handheld devices, cell phones, and more. Though most of the presentations focus on the retail game industry, there is a lot that indies can learn. It's virtually impossible to attend the GDC and not learn something.

Perhaps even more than what you can learn at the GDC is who you can meet. Meeting the 'celebrities' of game development is as difficult as meeting celebrities anywhere, but the real stars of game development are probably people you've never heard of. The entire game development industry is full of intelligent, motivated, and passionate people. The friends and contacts you can make at the GDC provide one of the best reasons for attending.

Finally, attending the GDC is the single best way to learn that you truly are a part of a much larger community than you ever realized: the game development industry. You get to see the industry close up, from top to bottom, and gain a better understanding of how it all happens.

INTERNATIONAL GAME DEVELOPERS ASSOCIATION

http://www.igda.org/

The International Game Developers Association (IGDA) is a nonprofit organization created by game developers to foster the growth of a worldwide community of game developers. With the goal of being a place where game developers help game developers, the IGDA's Web site provides many business resources, as well as financial, legal, and strategic planning resources. For aspiring developers, the IGDA includes a lot of information on how to get into the industry. The IGDA also attempts to provide a public voice on issues that affect the game development industry, such as violence in games and women/minorities in game development.

IGDA membership spans the globe. Most metropolitan areas have active chapters that meet on a regular basis. But even if there isn't a large chapter in your area, you can probably a number of IGDA members there.

ASSOCIATION OF SHAREWARE PROFESSIONALS

http://www.asp-shareware.org

Founded in 1987, the Association of Shareware Professionals predates both the IGF and IGC by more than a decade. Though not specific to indie games, the ASP has a lot to offer to independent software developers of

all types. Members of the ASP have been designing, developing, and selling their own software since the late 1970s.

The ASP focuses on bringing together independent software developers of all disciplines—whether they make games, utilities, or applications—and provides a forum where they can learn from each other. ASP members represent a wealth of experience that the indie game developer would be foolish to ignore. The ASP also spearheads efforts like PAD (Portable Application Description), which makes self-publishing on the Internet much easier.

The ASP has an annual convention as well as periodic local 'schmoozing' events where developers can meet and network. The ASP also gives out annual Shareware Awards and sponsors a Shareware Hall of Fame.

The indie game developer would benefit greatly by joining the ASP. Its annual membership dues aren't high, and with the information and contacts you can make, you will likely consider your dues one of the best investments you've made. ASP members, in general, like helping new members. It's not uncommon to get free advice or free critiques of your Web pages and software, even from members whose businesses are building on selling those exact same services.

D

EXAMPLE PRESS RELEASE

This is the press release template presented in Chapter 24.

PRESS RELEASE

FOR IMMEDIATE RELEASE:

(or **RELEASE DATE: <date>**)

CONTACT:

Contact Person

Company Name

Telephone Number

Fax Number

E-mail Address

Web site address

HEADLINE

City, State, Date—Your opening paragraph should contain the most basic information about your game: who designed it, what is it, when was it released, where it can be found, and why it's the greatest game ever.

The remainder of body text: include any relevant information about your game or team. Describe what makes your game unique. If possible, include quotes from team members or excited players.

-more-

(if there is more than one page)

(the top of the next page):

Abbreviated Headline (page 2)

Remainder of text, should you still have more to say.

For additional information or a sample copy of the game, contact:

(all contact information)

Summarize game the game's description one last time, possibly adding the system requirements required to play it.

Company (or Team) History: Give a quick history of your team. Don't be longwinded.

<div align="center">

###

-30-

(Indicates the press release is finished.)

</div>

The following press release was submitted by James Hills of CyPR Media for *A Tale in the Desert,* by eGenesis. See how well it adheres to the structure given above, and see how clearly it specifies what the press release is about. Note also how the contact information is easily available.

Media Contact:

James Hills

CyPR Media

james@ . . .

mobile: +1 999 999 9999

office: +1 999 999 9999

FOR IMMEDIATE RELEASE

Pharaoh Talks, Shares Secrets of Egypt!

A Tale In The Desert Video Series Goes Live on Happy Puppy

PITTSBURGH, PA May 6, 2003 // eGenesis (*http://www.egenesis.com*) in co-operation with Project-9 Multimedia (*http://www.project-9.com*), Jesper Kyd Productions (*http://www.jesperkyd.com*) and Happy Puppy (*http://www.happypuppy.com*), is proud to announce that the first of an eight-part *A Tale In The Desert* video interview series has been released. The series features lead designer, Andrew 'Pharaoh' Tepper as he discusses topics including

currency and ecology in the game, the Seven Disciplines of Man and even insight into the game's conclusion.

The first video can be downloaded here:

http://www.. . .

A new video from the series will be released every other week exclusively on HappyPuppy.com, but the whole series will be available for members of the media at E3, or by request after the show.

For full details of how to meet with eGenesis at E3, please contact James Hills, *james@ . . .* or call 999-999-9999 during the show. *A Tale In The Desert* (*http://www.ataleinthedesert.com*) began commercial service in February, 2003 and has captivated the attention of thousands of gamers from around the world, and also includes a dedicated German server run by MDO Games. The game is distributed as a free download, with a monthly cost of $13.95 (€13 for the German server). The free trial includes 24 hours of game-time, or one month of service, whichever comes first.

Set in a world modeled after Egypt of the pharaohs, *A Tale In The Desert* lets players work to create the perfect society by mastering the "Seven Disciplines of Man." The game represents a departure from similar games in that it has a definite set of goals and an unfolding storyline. Upon its completion, the developers will restart the game with a new "tale in the desert."

Members of the media who would like to receive a personal tour of the game from Andrew 'Pharaoh' Tepper of eGenesis may email him at *pharaoh@ . . .* or contact James Hills, *james@. . . .* Review accounts are also available.

About eGenesis: Based in Pittsburgh, PA, eGenesis was founded in 1998 to focus on creating a new genre of online role-playing games. *A Tale in the Desert* is the team's first major release.

###

James Hills

Senior Media Relations Manager

CyPR Media

http://www.cyprmedia.com

PAINTBALL NET DESIGN DOCUMENT

This is the design document for *Paintball Net*, Samu Games' current project. This design document is presented here to provide an example. It's not perfect, and because *Paintball Net* is still in development as of this writing, it's not complete. Some sections have more detail than others.

DOCUMENT DRAFT VERSION

1.0 - begun 19 Feb, 2002
2.0 - begun 21 Feb, 2002
3.0 - begun 22 Feb, 2002
4.0 - begun 25 Feb, 2002
4.1 - 7 April, 2002
- added "maintenance factor" to gun physics model
- minor editing for consistency
- adjusted zoom factors for scopes and HUD zoom kits
- adjusted maximum number of players per field to 64 (from 128)
- moved Torque SDK questions to a separate document

4.2 - 12 April, 2002
- expanded Ready Room chat features description
- reduced between-match restart wait from 3 minutes to 2 minutes
- expanded description of "Switching Weapons" under the Matches section
- added "Base Object Properties" to the Equipment section

4.3 - 11 May, 2002
- minor editing in overview and "storyboard in text"
- reduced hopper size of free paintball gun
- added "Free Face Mask" to the Free Equipment section

- specified clothing as "non-switchable" during a match
- added "Clothing Properties" section
- added "mount locations" and "mounts on locations" to Base Object Properties
- added "salable" property to Base Object Properties
- added player wear locations to Player Model section

4.4 - 28 May, 2002

- added range distance notes to the gun physics model
- revised player mount locations
- revised object properties
- added "Player Inventory" description to the Player Model section
- revised mount locations of some objects to reflect Torque Game Engine limitation of a single mount

4.5 - 2 August, 2002

- removed maintenance from guns and equipment
- removed gun "maintenance factor"
- added "quality factor" and "quality variance" to gun properties
- updated player equipment and clothing mount locations

DESIGN SUMMARY

Paintball Net is a multiplayer paintball game. Players compete individually or in teams, running through wide-open outdoor landscapes and tight-quarters indoor arenas trying to splat their opponents before they get splatted. Each player begins with basic "free" equipment and a small budget. By competing in paintball matches, players earn additional money that they can use to upgrade their equipment. Players can join established teams, create their own team, or remain solo.

Elevator Pitch

Paintball Net is paintball the way it *should* be! With a full arsenal of modern and sci-fi weapons and equipment, from pistols to grenades to rocket launchers to jetpacks to "refracto" suits (think *Predator*, the movie), *Paintball Net* gives you the thrill of paintball like you've never known it—and without the nasty welts and bruises!

Play as part of a team or go solo.

Charge through the brush in outdoor environments, or lurk in the shadows of cramped indoor arenas, hunt your friends, and make them eat paint!

Everyone begins with the same free equipment and a small budget of cash. As you play, you earn additional cash to upgrade your equipment. But everyone also has the same limit on what they can carry, forcing you

to decide what you will use in the next match. . . . Should you carry that heavy rocket launcher? Or just stuff a few extra grenades in your pouch and stay light on your feet? Or strap on the jetpack and pick off your opponents from the air? Decisions, decisions. . . .

Storyboard in Text

When the new player first logs onto *Paintball Net*, he has to create an account. This involves name and gender, address, plus a few other characteristics, such as skin tone, hair color, and so on.

The new player will be created with "freebie" equipment: camo trousers, dark t-shirt, high-top shoes, protective face mask, and a free paintball gun. He will have a "full load" of free paintballs (which at the rate the free gun fires should last for several matches).

Once the player has created his account, he must choose a paintball field to play on. The Field Manager lists all available *Paintball Net* fields and how many players are currently on each one. The player can join any field that isn't full.

When the player joins a field, the first place the new player sees is the Ready Room. From the Ready Room, the player can visit the various stores (Weapons, Ammunition, Armor, etc.), exchange carried equipment with what he has stored in his locker, chat with the other players on the server, or get ready to join the next match.

The Ready Room is essentially a chat room where players wait for the next match to begin. The player can chat with all the players on the server in the "general chat," or with his teammates in a private "team chat." It will also be possible to have private conversations with another player. There will be a "display" section in the Ready Room that normally displays the player with his current equipment. Any other player on the server can also be displayed in this fashion. The chat aspects of the Ready Room are available in the locker room and stores.

In the stores, the player can try on and purchase additional equipment. The stores allow the player to use his storage locker while shopping, and also provides an "action display mode" that shows the player with his current equipment and the equipment he is trying on. The player can specify that purchased items are placed in his locker or on his person.

The locker room is where the player can store his extra equipment. The player can move items to and from storage quickly to allow for in-between-match equipment changes. There's an "action display mode" that switches to a "chase cam" view of the character running so he can see what he looks like and how the equipment augments his style. There'll be a "switch to alternate weapon" ability, as well, to test how

well certain combinations work together. The contents of a player's locker are available on any full-time (dedicated) *Paintball Net* field.

Finally, there are the actual matches. The primary matches are free-for-all (Survival) and team-based. Players indicate the types of matches they are interested in. When such a match begins, the player will be included.

The player must be "ready" to be included in the next match. Players in a store or the locker room when a match begins will not be included in a match, even if they have indicated that they are "ready."

Survival matches are the simplest matches, involving variations of splat-or-be-splatted. In most free-for-all matches, all participants are "teleported" to random locations with random facings on the selected playing field. The players then attempt to find and eliminate the other players in the match.

Team matches are of two primary varieties: "real" teams and random-pick teams. Team matches are divided into two teams. The teams for the match are created based on each player's global team, with some balancing to prevent one side from significantly out-numbering the other. Random-pick team matches are when the server chooses the teams, using the various player statistics to create more "balanced" teams.

In a match, the Ready Room's chat area disappears. Only in-match chatter is available, and is limited to "global" and "team." All chatter is overlaid on the map, either on the top or bottom of the main display. If the player has special "locators" or other display devices, these will be placed around the edges of the screen in "appropriate" locations.

The match can be displayed in either "first person" (the default) or "chase cam" viewpoints. The first person view is the most useful for aiming and firing. The chase cam view provides a wider field of vision, so it can be useful in scouting.

If the player has equipment that adds to the HUD (Heads-Up Display), such as player locators or satellite viewers, these overlay the main display.

Paintball Net's Unique Selling Proposition

There are a lot of FPS games available, including some paintball-themed "mods" of those games, some with better "technology" driving them. What makes us think that *Paintball Net* will find a place among them?

- **Player progression against competition.** Players learn the game while playing against other players in a well-balanced environment. All players have the same "weight limit" of equipment carried, so even advanced players with better equipment must choose their weapons and equipment carefully.

- **Player persistence.** All player information is tracked and maintained. Whichever field a player plays on, his statistics and equipment are there waiting for him. Players can also customize their equipment to fit their own playing style.
- **Community emphasis.** *Paintball Net* is designed to support a real sense of community. With full-featured chat in the Ready Room, players can interact (or not) and get to know each other. Also, *Paintball Net* supports global teams of players that play together.
- **Unique paintball equipment with a "real" paintball feel.** *Paintball Net* uses 3D technology to create unique and outlandish paintball equipment, such as "refracto suits" and "jetpacks", while preserving the thrill of real paintball. And unlike a lot of paintball "mods" based on "deathmatch" games, *Paintball Net* uses a single-hit match elimination model, no endless "respawning" of players.

DESIGN DETAILS: ECONOMY

Every player begins with the same equipment: A fully-loaded, free paintball gun, a face mask, camo trousers, dark shirt, and boots. The player also begins with a small amount of cash.

The "house" provides free compressed air/CO2, but everything else must be purchased by the player: ammunition, guns, equipment, and so on. "Welfare," in the form of free paintballs, is available to any player who has no available cash and a net worth of less than some specified amount.

Players earn money by scoring a hit in a match, by collecting "tokens" that are scattered throughout the battlefield during a match, or by being on the winning side of a teams-based match.

Cost-of-Living Expenses

Ammunition is generally inexpensive, but cannot be sold back to the store. Also, once shot, it's gone.

Guns and equipment can be sold back to the store for the full price, so long as they have not been used in more than five matches. After five matches, the equipment loses 1% value every 10 matches, until it reaches its minimum value (25%).

Kits mounted onto a gun or other equipment contribute 100% of their value to the value of the item. So long as the kit has been on the item for fewer than five matches, it can be removed from the item with no charge. After five matches, removing the kit from item costs 5% of the original cost of the kit.

Clothing can be returned for full value so long as it has been used in no more than three matches. After three matches, clothing loses 1% value every five matches until it reaches its minimum value ($0). Clothing does not need to be maintained.

Patches added to clothing add no value to the item. Removing patches costs the same amount as the patch.

Designer's Notes: A Historical Perspective on Economy

In the original *Paintball Net*, the economy tended toward inflation. There were several reasons for this. First off, we offered totally free guns and ammunition. So players could invest $0 and make a profit with any shot that happened to hit, while having no worries about losing money with a "spray-and-pray" strategy.

Second, by a strange fluke, it became popular to utilize the somewhat odd combination of a jetpack and a can of spray paint. The can of spray paint would automatically fire at someone if it was targeted on them. So players would set their target to be just in front of them and zoom back and forth across the field.

Also, equipment never wore out. Whatever you paid for an item, you could get it back just by selling the item back to the store. This was done on purpose to allow players to try out different combinations of equipment without losing money. The downside was that if a player spent $15,000 on a jetpack, he could still get that $15,000 back just by deciding to get rid of the jetpack—even two to three years later.

Some attempts to counter the inflation were: reducing the payoff of a splat using free ammunition; creating specialized, expensive ammunition; and a few other things. For the most part, though, money continued to pile up inside the game.

If possible, we'd like to achieve a more balanced economy this time around, or at least an economy that takes longer than a few years to spiral into inflation.

DESIGN DETAILS: READY ROOM

The Ready Room is where players wait for the next match to begin. From the Ready Room, players can visit the various stores or the Locker Room.

In the Ready Room, there is a 3D display of the player, decked out with his currently selected equipment. This display can be rotated left, right, up, or down. Also, the display can show the player in several action poses, such as running or jumping. Other players online can be viewed by selecting them.

Weapons & Ordinance Store

The Weapons and Ordinance Store (W&O) is where the player can purchase guns, ammunition, grenades, and even "heavy" weapons, like launchers.

Outfitters

At Outfitters, the player can try on and buy clothing, like boots, jackets, backpacks, and so on.

Chop Shop

The Chop Shop allows players to customize their equipment with kits and patches. Kits and patches have to be applied to items while in the Chop Shop.

Locker Room

In the Locker Room, the player can store his extra items and equipment. The player can maintain several custom "outfits" that he can change into quickly between matches.

Chat Features

While in the Ready Room, the stores, or the Locker Room, the player has access to a variety of chat features. There will be a "global" (all-server) chat channel, as well team-specific chat channels. Players will also be able to send private messages to other players, one-on-one.

The "Ready Room Chat" is visible to all players currently playing on the field server, who are not in a match.

"Match Chat" is visible to all players still in the current match. Only players in the match can use this chat option.

"Team Chat" is a private, team-only channel that is visible in the Ready Room. "Team Chat" can not be seen during a match. "Team Match Chat" is the private, team-only chat channel that is available during matches.

"Private Messages" (PMs) are private player-to-player messages. PMs can be read and sent while in the Ready Room. If a PM arrives while the player is in a match, he will be able to read the PM after the match is over (or after he is eliminated from the match).

DESIGN DETAILS: EQUIPMENT

Paintball Net uses 3D graphics technology to make available both traditional paintball equipment as well as some unique and truly outlandish equipment.

All players are limited in how much equipment they can carry. This limit is expressed in weight (pounds). This limit forces players of all levels to choose what equipment they will carry into a match with them, and what they will leave in their locker.

Normally, a player is limited to carrying only what he can hold in his hands. Equipment like backpacks and belt holsters allow the player to carry additional ammunition and even additional weapons. If a player overloads himself with equipment, however, he will slow down his movements and become an easier target.

All players are required to wear their face masks at all times. Because of this requirement, it's impossible for a player to sell the face mask he was issued when he first joined the game.

Free Equipment

Free Paintball Gun—low muzzle velocity, slow reload, small hopper, medium spread, low maintenance; single mount for hopper expansion.

Free Face Mask—basic face mask; no mounts.

Guns

Semi-Automatic Paintball Gun—medium muzzle velocity, fast reload, small hopper, low spread, medium maintenance; mounts for barrel, hopper, burst, full auto, scope.

Mini-gun—high muzzle velocity, very fast reload, huge hopper; no mounts.

RPG Launcher

Can of Spray Paint

Ammunition

Paintballs

Thin-Shell Paintballs

Hand Grenades

Rocket-Propelled Grenades

Proximity Mine—time-delay, motion-sensor "land mine"

Equipment

Backpack—uses back mount
Backpack, large—uses back mount
Backpack, padded—uses back mount
Grenade Bandoleer—uses chest mount
Face Mask—w/ HUD mounts
Scuba gear—uses chest mount
Jetpack—uses shoulder mounts, belt mount, and chest mount
Torque Game Engine limitation—While the player can have up to 32 models mounted on it, no model can use more than one mount point.

Clothing

Trousers
Shirt (t-shirt)
Tank top
Suit (One-piece)—a suit covers the entire body, with built-in boots, gloves, and a hood for the head. Only the face is exposed. A suit provides shoulder and belt mounts, in addition to normal weapon mounts on the hands.
Suit, padded
Suit, refracto (e.g., *Predator* suit)
Boots
Jacket, padded
Vest, padded
Leggings, padded
All clothing items are applied to the "skin" of the player model. They are not separate 3D models. Clothing can be assigned either a solid color or a "print" that is based on a graphic image (like forest camo).

Clothing covers no mount points and is not "switchable" (see below). Clothing is either worn by the player or stored in his locker. Thus, clothing cannot be carried around inside backpacks or other containers.

Kits

Barrel (barrel mount)—reduces the spread factor of the gun by 50%.
Belt pouch (belt mount)
Belt holster (belt mount)
Burst (burst mount)—causes each shot with the gun to release three paintballs in rapid succession.
Full Auto (burst mount)—causes the gun to continue shooting until the trigger is released or the hopper is empty.
Hair-Trigger (burst mount)

Hopper Expansion (hopper mount)

Interference Generator (belt mount)—prevents the player from being sensed by a Player Locator.

Player Locator (scope mount or HUD mount)—points to nearest locatable player with distance indicator; can be blocked by interference.

Satellite Viewer (scope mount or HUD mount)—provides a small display of the entire battlefield during a match.

Scope (scope mount)—provides a toggle-able 6X zoom, though the field-of-view is limited to shape of the scope (circular).

Scope, high-powered (scope mount)—like a regular scope, but with a 10X zoom.

Zoom (HUD mount)—provides a toggle-able 3X zoom.

Gun "Physics"

Guns have a muzzle velocity, refire rate, reload base time, hopper capacity, and spread factor.

Muzzle velocity is how fast the paintball is going when it leaves the gun. Muzzle velocity has a big effect on range. Seventy-five meters/second to 100 meters/second will be the standard velocity ranges.

Refire rate is the minimum time (assuming ammunition is available) between shots with the gun.

Hopper capacity is how many paintballs the gun can carry unmodified.

Reload base time is the minimum time to dump more ammunition from a separate container into the gun.

Spread factor is how likely the trajectory of the gun is to deviate from a perfect arc. The higher the spread factor, the less accurate the gun is at longer ranges.

Quality factor is how often the gun may have a variation in its muzzle velocity, refire rate, reload base time, or spread factor. The lower the quality factor, the more likely the gun will suffer a variation. A quality factor of 1.0 is "perfect" quality.

Quality variance is the maximum amount of variance any one aspect of the gun will be modified. Quality variance ranges from zero (no variance) to 10 (10%).

Range: The standard range will be ~50 meters. The free gun range will be lower, while the range of the more expensive guns will be higher. Muzzle velocity is the biggest factor in overall range. The effective range of a gun will also be affected by the spread factor.

Paintball "Physics"

Paintballs have only a single attribute: shell thickness.

Shell thickness determines the chance that a paintball will burst on impact or "bounce" off. The smaller this value, the more likely the paintball will burst on any impact.

Padded Equipment

Padded equipment, such as padded jackets and padded backpacks, create a softer impact surface. Regular paintballs striking a padded surface have a significant chance of bouncing off instead of bursting. If a paintball bounces off the target, then that target is not eliminated from the match.

Thin-shell paintballs virtually eliminate the benefit of padding, but are significantly more expensive than regular paintballs.

Object Definitions

Some objects are 3D models (guns, grenades), and some are more like texture changes (trousers, boots).

The object definitions are mostly of value when saving a player's equipment to the Player Database. They are also useful for defining what items are available in the various stores.

Base Object Properties

All game objects have certain properties.

The **weight** of an object determines whether the player can carry the object. All objects carried by a player subtract from his available "carry weight." If an object's weight exceeds the player's available carry weight, the player cannot pick up or carry the object.

The **volume** of an object is how much free volume capacity is required by the player in order to carry the object when it's not being worn (or if it can't be worn, like ammunition).

The **volume capacity** of an object sets the maximum amount of volume that an object adds to the player's volume capacity when worn. (0 = no capacity; −1 = infinite capacity).

The **switchable** property of an object determines whether the object can be taken off and stored (or exchanged) during a match.

The **mounts on location** property indicates where the object is to be mounted on the player model (if at all).

The **mount locations(s)** indicate what mount points the object makes available to other objects (if any).

The **salable** property determines whether the player can sell the item. If false, the player must keep the item, either on himself or in his locker.

Clothing Properties

Clothing is a special case of in-game "objects." Clothing properties derive from the standard Base Object Properties.

Clothing is not switchable during a match.

The **wear location** defines what part of the player model the clothing is applied to (body, arms, legs, feet).

DESIGN DETAILS: PLAYERS

Players can be either male or female.

Player 3D Models

Besides choosing a gender, players can also choose between several basic model types: short, medium, and tall. Each gender has its own definitions of the various heights.

Players can also choose their skin tone.

Player mount points: primary hand, head, chest, back, hip, right ankle, and left ankle.

Player clothing "wear locations": head, face, body, hips, legs, feet.

Player Inventory

Players have an inventory of items that they are currently carrying and wearing.

An item is considered "worn" if it is mounted on the player model. Otherwise, the item is considered "carried." Either way, all items in the player's inventory count against his available carry weight.

An unequipped player can carry no items (zero free volume capacity). Certain objects add to the player's free volume capacity when worn (e.g., backpack). All objects that contribute free volume capacity are "pooled" to determine what the player can carry. Thus, an item is not "in" any particular container. It is "in" all of them.

Worn objects do not reduce the player's free volume capacity. If they are removed, though, then they are considered "carried" and do reduce the player's free volume capacity. If the player does not have sufficient free volume capacity for the object, then it cannot be removed. The only

exception to this is "switching" between two items (one currently worn, the other carried).

Player Match Statistics

- Shots fired—all shots fired during a match (a burst- or full-auto-shot counts only once).
- Splats scored—total number of splats scored in a match.
- Player splats—number of splats of human players.
- Bot splats—number of splats of bots.
- Games played—all matches started.
- Games "survived"—all matches the player was still in when the match ended.
- Games "won"—all matches the player (or his team) has won.
- Tracked globally.
- Tracked per team (including past teams).

Player Awards

Player awards are special "badges" that are given to a player when he achieves certain levels of play. These awards are displayed beside the player's name in the Ready Room.

Trading Between Players

Paintball Net will not support any mechanism for players to give or loan equipment or money to other players. This includes no ability to "drop" items.

DESIGN DETAILS: TEAMS

Players can create and join teams.

Teams get a private chat channel. Players on a particular team are on the same side in Team matches.

Team Match Statistics

- Total number of players
- Current number of players
- Shots fired
- Splats scored
- Player splats

- Bot splats
- Games played
- Games "survived"
- Games "won"
- Tracked globally

Team Awards

Team awards are similar to player awards, but apply to the team. These awards are displayed in the team rankings list.

DESIGN DETAILS: MATCHES

Matches start two minutes after the end of the last match. There is a countdown to the next match displayed in the Ready Room. Matches run a maximum of 10 minutes.

Matches teleport all participants onto the battlefield. Players then run about, shooting at everything that moves, using strategies as diverse as sniping and "spray-and-pray," and maybe even some coordinated team efforts.

Any hit that isn't "friendly fire" (see below), results in the player being immediately teleported back to the Ready Room to wait for the next game, or (in team-based matches) switched into "observer mode." If the player still has "live" paintballs/grenades in flight or live proximity mines, hits from those will still be credited to him.

Which type of match starts and what map is used is determined by player voting. Players can cast a vote for one or more types of match.

Map

The map a match occurs on is selected by the field, based on which maps are available on the field server and which maps are voted for by the players.

If a player does not have the map chosen for the match, the field server will "push" the map to the player.

Tokens

All matches include a random number of tokens that are scattered about the battlefield. These tokens are worth various amounts of cash when picked up by a player during a match.

Picking up a token requires only that the player run or walk "over" the token.

Bots

Bots in matches are scripted-AI participants. Not all matches have bots.

Bots do not look like human players. They look like floating robots, like in the movie, *The Black Hole*. Bots do not shoot. Instead, when they come within a certain proximity of a human player, they explode, spraying paint within a specified area-of-effect. Bots are not intended to be *too* smart. Mostly just annoying.

Bots can be eliminated from a match in the same way a human player can be.

A player's "bot splats" (when he shoots a bot) are tracked separately from his normal, human player splats.

Historical Note: The original *Paintball Net* included bots primarily so that in the early days, the lone player on the game by himself would have something to shoot at. They became an important part of the game over time, though the popularity of games like *Invaders* meant that we had to start tracking "player splats" and "bot splats" separately.

Friendly Fire

In the military, it is a truism that "Friendly fire ain't."

In *Paintball Net*, friendly fire has no effect. A shot blocked by an ally is wasted. Likewise for area-of-effect.

Justification: In the original *Paintball Net*, we originally made friendly fire from grenades take out the target. However, it was found that "spoiler" players would use this to ruin the game for anyone unlucky enough to be on their team during a game. It was particularly bad, because in that version of the game, all players on the same team started on the same map location.

Observer Mode

In team-based matches, the player can elect to be switched into "Observer Mode" when eliminated from the match.

In Observer Mode, the player is shown the view of one of his still-remaining teammates. The player has no control of the view. He sees what his teammate sees. The player can, however, switch between any other teammates that are still in the match.

Newbie Protection

Some matches provide "newbie protection." Newbie protection prevents players with 10 or more total splats from scoring splats on players with less than 10 total splats. Newbies, however, can splat any other player (including other newbies).

This allows new players a window of opportunity to learn the game's controls without being too pressured.

Team-based games generally do no require newbie protection. This is because the newbie will benefit if his team wins the match, even if he was eliminated.

Reloading Weapons

When the active gun's hopper is emptied during a match, reloading happens automatically, so long as the player is carrying extra ammunition.

Players can carry extra ammunition in whatever items they want to dump them in. A single container will be "dumped" into the weapon. If there is more ammunition in the container than the gun's hopper will hold, only as much as will fit in the hopper is added. If there is less, then what's available in that container is dumped into the gun, and the reload action is considered completed.

Reloading takes a certain amount of time to happen. How much time varies according to the weapon and the container the ammunition is dumped from.

Switching Weapons/Equipment

The player will be able to switch to any weapon he is carrying during the match. The time required for the switch depends on the actual weapons and the containers they are carried in.

Clothing cannot be changed during a match. Certain other equipment, however, such as scuba gear and face masks, can be carried in container items and brought out and used during matches. The time required for readying the equipment for use varies.

Swimming

Players don't swim. . . . By some quirk of physics, they run along the bottom of pools of water.

If a player remains completely submerged for more than 30 seconds, they are considered eliminated from the match and teleported back to the Ready Room. No one is credited with the splat.

The scuba equipment can allow a player to remain submerged indefinitely.

Falling

If a player goes into an uncontrolled fall that exceeds 20 meters, they are considered eliminated from the match and teleported back to the Ready Room.

Winning a Match

Each match has a "purse" that is created based on the number of players and bots in the match. This purse is divided among the winners of the match.

The winner of a match is the player or team of players with the most splats that is still in the match when it ends. In a team-based game, the purse is given entirely to the winning team, divided equally among those players who were a part of that team when the match started.

If all human players are eliminated from a match, then no one is given the purse.

Survival Match

All players are teleported onto random locations on the map, facing random directions. A minimum distance between players is guaranteed.

Survival games may include from zero to five bots. The fewer players in the game, the greater chance of more bots.

Survival matches provide newbie protection.

Survival matches are over after 10 minutes, or when only one player remains.

If there are multiple surviving players at the end of the match, then the purse is split among the top players for that match, based on splats. Only players who actually scored a splat in the match will be awarded any part of the purse.

Two-player split: 66%/33%, three-player split: 50%/35%/15%, four-player split: 50%/25%/15%/10%, five-player split: 50%/20%/15%/10%/5%.

Team Survival Match

Team Survival is similar to a regular Survival match, except that members of a particular team are considered allies, and all are dropped on the map close together.

Team Survival matches are over after 10 minutes, or when members of a single team are all that remain.

If there are multiple surviving teams at the end of the match, the team with the most total splats for the match divides the purse equally among the players who were on the team during the match.

Team Matches

Team matches create two teams. Players who are all on the same global team are grouped together. The two teams may not be evenly matched, but the game will make sure that one side does not out-number the other by more than 50%. If this criterion cannot be met, then the match does not begin, and the match type with next most votes is started instead.

Team matches are over after 10 minutes, or when members of a single team are all that remain.

If both teams have surviving members at the end of the match, the team with the most total splats for the match divides the purse equally among the players who were on the team during the match.

Random-Pick Teams Match

Random-pick Teams matches create two teams from all participating players. Each player is weighed according to his overall standings so that the teams are as balanced as possible. The player's global team is not considered when determining which in-match team he will be placed on.

Random-pick Team matches are over after 10 minutes, or when members of a single team are all that remain.

If both teams have surviving members at the end of the match, the team with the most total splats for the match divides the purse equally among the players who were on the team during the match.

Invaders Match

Invaders matches are simply bots versus players.

Invaders has five bots per player (with some minimum, up to some maximum). The bots are placed in a solid line along the edges of the battlefield. The players are placed in a group in the center of the battlefield. The bots march forward, inexorably, hunting players. The players scramble about trying to get out of each other's way, while shooting bots and trying to watch all directions.

Invaders games are over after 10 minutes, when all human players are eliminated, or when all bots are eliminated.

If there are multiple surviving players at the end of the match, then the purse is split among the top players for that match, based on splats. Only players who actually scored a splat in the match will be awarded any part of the purse.

Two-player split: 66%/33%, three-player split: 50%/35%/15%, four-player split: 50%/25%/15%/10%, five-player split: 50%/20%/15%/10%/5%.

DESIGN DETAILS: SERVER STRUCTURE

Field Manager
Dedicated Fields
Player Database

The Field Manager is the common entry point for all players. The Field Manager provides support for new player account creation, player login verification, list of Dedicated Fields, list of player-hosted fields, and so on. The Field Manager maintains a connection to the Player Database as well as all Dedicated Fields (player-hosted fields are handled differently). Once a player chooses a field, then the player connection to the Field Manager is dropped.

Dedicated Fields are those servers that are hosted by *Paintball Net*. A field is limited to 64 players. Only a single match at a time occurs on a field.

The Player Database is the central repository of all player information: account information, equipment (on the player and in his locker), player statistics, and so on. A player can be "checked out" by only a single field at a time (dedicated or player-hosted). Only a Dedicated Field can "check in" a player with modifications.

Player-hosted fields that want to be listed on the Field Manager must connect to the Field Manager every 10 minutes.

Linux

The Field Manager, the Player Database, and Dedicated Fields will be Linux-based servers.

The Player Database will be written from scratch. The Dedicated Fields, obviously, are based on Torque. For the Field Manager, we may be able to pull from existing Torque resources.

BUSINESS MODEL

The business model for *Paintball Net* will be based on quarterly subscription fees paid by players. For $24.95, the player can play for three months (or $9.95/month if we can get monthly subscription payment processing).

Players will be able to create an account that has all the advantages of a paid account, but with a 30-day time limit. After the 30 days, unless the player pays for a subscription, the account is closed. After the first account created by a player, the free trial period of new accounts is reduced to 10 days.

When a player attempts to log into an account that has expired, he will be told that he needs to pay, and he will be able to click on a "Buy Now" button that takes him to the payment Web page.

Free Game vs. For-Pay Game

The client software for *Paintball Net* will be given away for free. However, certain features of the game will be available only if the player first logs into the Field Manager with a paid (or active free) account.

Without an active account, player-hosted fields will not be listed on the Field Manager. Also, the guns and equipment available in the local stores will be limited to basic paintball gear. Matches will be limited to Survival and Random-pick Teams.

GLOSSARY

Field: A field is where players come together to play paintball. Only a single match happens at a time at a field. A field is a single Torque server, running on Linux (or possibly on a player's PC).

Field, Dedicated: A Dedicated Field is a field server hosted by Samu Games. Only matches on a Dedicated Field affect the player's statistics.

Field Manager: The Field Manager is the common entry point for all players. All Dedicated Fields are listed, as well as all public player-hosted fields. The Field Manager is separate server software, running on Linux.

Match: A match is a single paintball "battle."

Newbie: A player who has just started playing the game, who has fewer than 10 total splats.

Newbie Protection: A match feature that prevents players with 10 or more total splats from being able to successfully hit newbies.

Padded: Padded equipment, such as jackets or backpacks, create a softer impact surface that improves the chance of a paintball bouncing off rather than bursting.

Player Database: The Player Database is the central repository of all player information: account information, match statistics, equipment, and so on.

Ready Room: The Ready Room is where players hang out, waiting for the next match to begin.

Token: A token is a "free cash giveaway" in a match. The player who finds the token, gets the cash.

QUESTIONS

Why use Torque?

The Torque engine from Garage Games is being used for this project because by doing so we trim the project schedule (and budget) considerably. After all, we're not trying to create the next whiz-bang, gee-whiz 3D technology. We're trying to create a 3D paintball game. By not having to create a multi-player, 3D engine from scratch, we can focus our energies on making the gameplay as satisfying as possible.

FUTURE FEATURES

These are features that we think are good ideas, but which should probably wait until after the initial release of the game to implement.

Ladder Matches
Capture-the-Flag Matches
Tournament Games
Vehicles (four-wheelers)
Weather
Time of Day/Night
Team Voice Chat

Guns

Semi-Automatic Paintball Gun w/ Burst—medium muzzle velocity, fast reload, small hopper; mounts for barrel, hopper, full auto, scope

Paintball Rifle—high muzzle velocity, slow reload, small hopper; requires both hands; mounts for hopper expansion, burst, scope

Semi-Automatic Paintball Rifle—high muzzle velocity, medium reload, small hopper; requires both hands; mounts for hopper expansion, full auto, scope

Clothing

Suit, Insulated

Kits

Infrared Viewer (HUD mount)—overlays the display with a heat-sensitive infrared display; blocked by insulation

Patch (clothing mount)

X-ray Viewer (HUD mount)—overlays the display with an x-ray display; can be blocked by interference

Captain-Pick Teams Match

Captain-Pick Teams matches require a bit of setup.

All players who want to be involved in the Captain-Pick Teams match must indicate this. Once they sign-up for the match, they will not be automatically included in other types of matches.

Players then vote on the two team captains. Once the captains have been selected, they alternate picking one player each until all players have been picked.

Once all players have been picked, the Captain-Pick Teams match will be possible matched. It *will* be the next match that starts. After that, though, it will be subject to the regular match type rotation.

New players can join the roster, but they will have to be picked before a new match will scheduled.

Captain-Pick Team matches are over after 10 minutes, or when members of a single team are all that remain.

If both teams have surviving members at the end of the match, the team with the most total splats for the match divides the purse equally among the players who were on the team during the match.

BIBLIOGRAPHY

Section I: Indie Basics

Buscaglia, Thomas H., "Getting Published Part 2: Initial Legal Issues," available online at *http://www.gignews.com/dev2pub/legal1.htm*.

Schmidt, Rick, *Feature Filmmaking at Used-Car Prices*, 3rd. Ed., Penguin Books, 2000.

Sutton, Garrett, Esq., *Own Your Own Corporation*, Warner Books, 2001.

Section II: Game Design for Small- or No-Budget Games

[Dersham02] Dersham, Randy, "Publishers View of Developers," presented at the Indie Games Con, 2002.

[Pavlina02] Pavlina, Steve, "If You've Tried Everything Imaginable And Your Product Still Won't Sell, Here's What You're Missing," available online at *http://www.dexterity.com/articles/basic-market-research.htm*.

[Rollings00] Rollings, Andrew and Dave Morris, *Game Architecture and Design*, Coriolis, 2000.

[Tinsman02] Tinsman, Brian, *The Game Inventor's Guidebook*, Krause Publications, 2002.

Section III: Production Planning

Brooks, Frederick P., Jr., *The Mythical Man-Month (Anniversary Edition)*, Addison-Wesley, 1995.

Section IV: The Team

[Bennis97] Bennis, Warren, "The Secrets of Great Groups," *Leader to Leader*, Vol. 3, Winter 1997: pp. 29–33.

[McConnell96] McConnell, Steve, *Rapid Development*, Microsoft Press, 1996.

[Michael99] Michael, David, "Contracting Artwork for Your Game," available online at *http://www.gamedev.net/reference/business/features/art_contract/default.asp*.

Section V: Building the Game

McCarthy, Jim, *Dynamics of Software Development*, Microsoft Press, 1995.

McConnell, Steve, *Code Complete*, Microsoft Press, 1993.

[Rollings00] Rollings, Andrew and Dave Morris, *Game Architecture and Design*, Coriolis, 2000.

Section VI: Selling the Game

Levinson, Jay Conrad, *Guerrilla Marketing*, 3rd Ed., Houghton Mifflin, 1998.

[Pavlina00] Pavlina, Steve, "How to Permanently Increase Your Sales by 50% or More in Only One Day," available online at *http://www.dexterity.com/articles/registration-incentives.htm*.

[Pavlina02] Pavlina, Steve, "If You've Tried Everything Imaginable And Your Product Still Won't Sell, Here's What You're Missing," available online at *http://www.dexterity.com/articles/basic-market-research.htm*.

Ries, Al and Jack Trout, *Positioning: The Battle for Your Mind*, Warner Books, 1981.

INDEX